THE MASK

OF

ART

THE MASK OF ART

■

Breaking the Aesthetic Contract
—Film and Literature

CLYDE R. TAYLOR

Indiana University Press
Bloomington and Indianapolis

This book is a publication of
Indiana University Press
601 North Morton Street
Bloomington, Indiana 47404-3797 USA

www.indiana.edu/~iupress

Telephone orders 800-842-6796
Fax orders 812-855-7931
Orders by e-mail iuporder@indiana.edu

The paper used in this publication meets the minimum
requirements of American National Standard for Information
Sciences—Permanence of Paper for Printed Library
Materials, ANSI Z39.48-1984.

Manufactured in the United States of America

Library of Congress Cataloging-in-Publication Data

Taylor, Clyde.
The mask of art : breaking the aesthetic contract—film and
literature / Clyde R. Taylor.
p. cm.
Includes bibliographical references and index.
ISBN 0-253-33403-9 (cl : alk. paper). — ISBN 0-253-21192-1 (pa :
alk. paper)
1. Afro-Americans in motion pictures. 2. Afro-American
aesthetics. 3. Afro-Americans—Intellectual life. 4. American
literature—Afro-American authors—History and criticism.
5. American literature—20th century—History and criticism.
I. Title.
PN1995.9.N4T38 1998
791.43´65296073—dc21 97-50462

1 2 3 4 5 03 02 01 00 99 98

IN MEMORY OF E. ALICE TAYLOR,
AND FOR MY INSPIRATIONS,
ZINZI, RAHDI, JO ANN AND MARTI

The slaves' suffering and the fury of their revolt is united in a belief: freedom. The means for this freedom cannot adhere to the concept of beauty prevalent in white aesthetics; it necessarily has to be a subversion of those aesthetics.

—Jorge Lima Barreto[1]

CONTENTS

■

LIST OF FIGURES AND ILLUSTRATIONS

■

PREFACE AND
ACKNOWLEDGMENTS

■

This book tries to make a contribution to an important but still scattered discussion. The way people, things, and ideas are influenced by the social and political interests mediating their presentation—the politics of representation—has become increasingly relevant with the enlarged role played by filtering and reproduction in our diet of intellectual impressions. My immediate focus is an interrogation of the assumptions that dominate the present art-culture system. Specifically, I challenge the veracity and probity of "the aesthetic," the overdeveloped paradigm for control of our values regarding art and beauty, an eighteenth-century intellectual plantation from whose grip most of us have yet to free ourselves. Part II tries to introduce directions for a more useful analysis, the critique of representation. In Part III, I attempt to look further at ways questions of art and beauty can be approached with more even-handedness and less false consciousness.

The many debts I incurred in making this book include Cheryl Chisolm, for an expert and essential critique of an early draft. I am also indebted to her for prodding me to start on this book in a very different form. That study was intended towards Black independent cinema. That project was interrupted on my way to the Third Cinema Conference at the Edinburgh Film Festival to discuss the possibility of a Black cinema aesthetic. It was at this point that I read a ground-breaking essay by my friend and former colleague, the formidable Jamaican philosopher, Sylvia Wynter. The massive halt and re-direction in her own thinking, toward a fundamental and fertile critique of Western knowledge, emboldened me to ask myself why I was still accepting the premises of aesthetic reasoning, and then, whether a Black film aesthetic was necessary or useful. The experience of writing my doctoral dissertation, "William Blake and the Ideology of Art," many years ago left me more familiar with aesthetic discourse and its origins than most people who accept its arguments as verities of educated knowledge. With this background experience plus Wynter's provocative example, and my longtime appreciation of the un-

inhibited thought of people like Fanon, Richard Wright, Toni Cade Bambara, William Blake, Morrison, Baraka, Ngugi, June Jordan, and Bernice Johnson Regan, I set out on a deliberate course of defamiliarization and reconsideration that resulted in this book.

My large intellectual debts extend to Manthia Diawara, generous and leading idea-trading partner from whose insightful discussions I snatched my subtitle and several other valuable ignitions. My indebtedness to Herman Gray and Tommy Lott remains brotherly and nourishing since we bonded within a weekly and now sometimes bi-coastal study menage. Both have offered critical challenge as well as encouragement throughout this project.

I am also grateful to many friends and colleagues, individuals and institutions for acts of assistance, service, encouragement and material support. Elizabeth Ammons, Saul Slapikoff, Isaac Julien, Kobena Mercer, Linda Bamber and Robert Stam gave me profitable leads for further research. I was fortunate that a Ford Foundation Resident-Fellowship at the DuBois Center at Harvard University was hosted by my friend Nathan Huggins. The challenging discussions I experienced there were bracing. I also benefited from a Rockefeller Foundation Resident-Fellowship at the Whitney Museum of American Art, particularly through John Handhart, coordinator of that program and co-organizer of a Bellagio Conference on Media and Representation where I submitted ideas for shake-down. The draft of three chapters was written during a productive residency at the Rockefeller Research Center at Bellagio, Italy. Research and trial of ideas were also furthered by a grant from the Monroe Trotter Institute at UMASS Boston. Other productive sites for debate and discussion of this project were the Center for Literary Studies Seminar at Harvard University; the Speaking for the Subject Conference at the University of California at Santa Barbara; and the Crisis of the Negro Intellectual Revisited Conference at Stanford University. I am also grateful for the supportive wisdom of Faye Ginsburg and Barbara Abrash at the Center for Media, Culture and History at New York University during my Rockefeller Fellowship there. Marie Dutton Brown gave me invaluable advice on matters literary, as always.

Chapter Five, "Rebirth of the Aesthetic, *The Birth of a Nation*," has already appeared in a special issue of *Wide Angle* devoted to Black Cinema, guest edited by Manthia Diawara, and in *The Birth of Whiteness: Race and the Emergence of U.S. Cinema*, edited by Daniel Bernardi. Much of the material in Chapter Seven, "Ironies of Majority-Minority Discourse" has been published as "Ironies of Palace-Subaltern Discourse" in *Black American Cinema*, edited by Manthia Diawara.

PART I

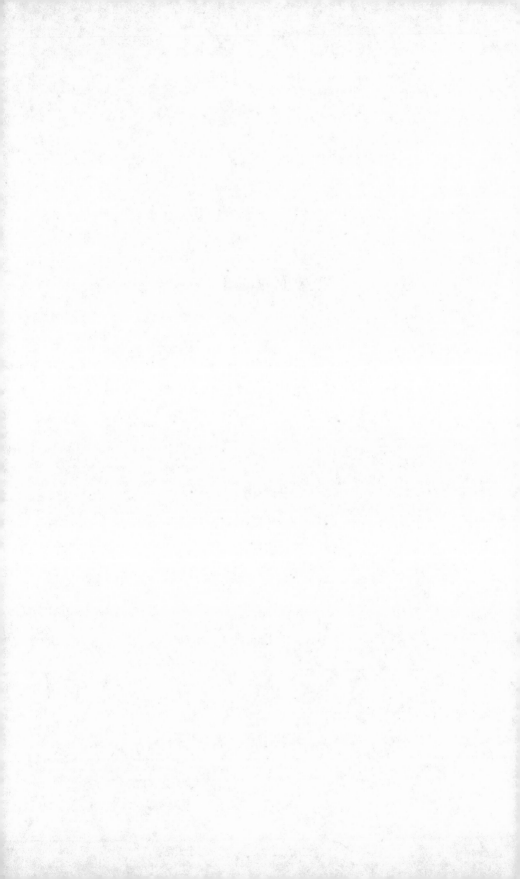

CHAPTER I

■

Color-Coded Art Theory

In its own eyes, Western humanism is the love of
humanity, but to others it is merely the custom and in-
stitution of a group of men, their password, and some-
times their battle cry.
 —Merleau-Ponty, White French philosopher[1]

CHANTAL: The main thing is that the wounded be
attended to.
 GEORGETTE: The main thing . . . is that the rebel-
lion start off by despising make-believe. (A pause.)
And complacency.
 —Jean Genet, *The Balcony*

The present crisis of knowledge arose out of that moment in the 1960s
when the monologue of cultural and social discourse was shattered by
dissident voices. In the United States, these voices included the vocal in-
surgence of Black liberation movements, the rebirth of feminism, youth
culture, the articulation of gay identity after the Stonewall incident, the
sexual revolution, the Chicano-Latino movements reclaiming cultural
identity. These movements had their parallels in Europe which reached
a peak in the May 1968 movement that threatened the stability of the
French government. At the same time, Third World anti-colonial revolu-
tions ruptured the world colonial structure and provoked legitimation
crises in the colonizing nations.

One of the new perspectives pressuring the art-culture establishment
was the "Black aesthetic."[2] The Black Aesthetic was the critical, theoreti-
cal manifestation of the Black arts movement, and both together articu-
lated cultural facets of "Black Power." The claims of the Black Aesthetic
were simple, but held profound consequences. Black cultural production
betrayed itself by remaining circumscribed within Euro-American cul-

tural norms. The unifying premise among Black aestheticians, according to a leading spokesman, Addison Gayle, was that "art derived from unique cultural experiences mandates unique critical tools for evaluation." "Further than this," he adds, "agreement need not go!"[3] The theoretical interventions of the Black Aesthetic were blunt but largely limited to a series of manifestoes and declarations calling for more elaborate vocabularies of Black cultural production. Nevertheless, the announcement of this new program for cultural empowerment released enabling psychic energy into much new and powerful work.

The gatekeepers of honorable culture responded to the idea of the Black Aesthetic with much the same neglect, indifference, skepticism, or hostility that they usually directed to African American cultural works. They maintained, as many still do, that standards are indivisible, and that aesthetic values are universal, disallowing a specifically Black aesthetic. As a consolidated rhetorical position, the Black Aesthetic gradually faded from the scene, but not before forcefully establishing its arguments that a society or community's cultural productions are rooted in its political, social, and historical contexts and that African Americans were favored with a reservoir of vernacular speech and traditions upon which Black cultural workers were erecting self-identifying and empowering cultural images.

What gave the formulation "Black Aesthetic" its force was that, like its parallel concept, "Black Power," it had the effect of a profanity screamed in a chapel, a disruptive challenge to orthodoxy and tradition. Like "Black power," it was "unspeakable." To base an aesthetic on Blackness was to situate the classically unaesthetic in the place of "the best that has been thought and said in the world." As Black aestheticians never tired of pointing out, the associations of Blackness had always been placed at the opposite end of civilizing light, as in black-balled, Black Friday, black-hearted, blackmail, blacklist, blackguard, black market, etc. The most ruptive intervention of the Black Aesthetic was an argument validating its existence as an ethnic discourse, since the dominant tradition had all along been "a White aesthetic": "The acceptance of the phrase 'Black is Beautiful' is the first step in the destruction of the old table of the laws and the construction of new ones, for the phrase flies in the face of the whole ethos of the white aesthetic."[4] In this moment, the Black Aesthetic had named the unnamable.

As a gesture toward cultural self-definition, the Black Aesthetic had many historical precedents, such as the assertions of Emerson's "The American Scholar," the Young Democracy movement associated with

Whitman, or all the movements toward national literatures drum-beaten by Herder, and before that the emergence of vernacular literatures linked to figures like Chaucer, Dante, Cervantes, and Robert Burns. Most of these movements arose as though from the margins, the frontiers of culture, claiming new centers for themselves. The Black Aesthetic arose, in the eyes of its critics, as though from the basement, with claims decentering the cultural foundation, less through rivalry than delegitimation.

To speak the unspeakable has become an important strategy of resistance. The unspeakable is always, whatever else it is, a political category, a form of censorship. The unspeakable is rendered mute in order to throw a polite silence over contradictions felt as socially unbearable. The voices of the repressed break a silence that respects the sacred, profanes the rituals that propel correct action, unravels the unspoken law of hierarchy, pollutes the codes of purity, and threatens language with division. After it is spoken, the unspeakable may be assimilated, but not without new anxieties, new rigors demanded of polite discourse. Such was the case with the Black Aesthetic.[5]

The Black Aesthetic movement showed all the marks of a revolutionary action, where slogans carried more force than extended analysis. Its proponents understandably were much focused on the very real, fundamental interruption of the usual routine they were making. What St. Clair Drake said of Black studies is perfectly applicable to the Black Aesthetic:

> The very use of the term Black Studies is by implication an indictment of American and Western European scholarship. It makes the bold assertion that what we have heretofore called "objective" intellectual activities were actually *white* studies in perspective and content; and that corrective bias, a shift in emphasis, is needed, even if something called "truth" is set as a goal. . . . the present body of knowledge has an ideological element in it, and a counter-ideology is needed.[6]

Caught up in the excitement of this triumph of counterstatement, and focused on the cultural emancipation of their own community in a moment of crisis, the Black aestheticians proceeded to cut the knot that bound them rather than to unravel it. They mostly left mute the radical revaluation of aesthetic knowledge implied by their intervention. They were seeking space for a more respectful appreciation of their cultural personality. They were aware that their contributions to aesthetic theory had revolutionary consequences for the prevailing assumptions of the art-cultural system. By asserting the validity of a specific cultural matrix, they problematized the universal value of art. They challenged formalist critical assumptions and the notion of the autonomy of art: "The question

for the Black critic today is not how beautiful is a melody, a play, a poem, or a novel, but how much more beautiful has the poem, melody, play or novel made the life of a single black man?"[7] Such arguments relocated symbolic and cultural expression within the broader social spectrum in ways that pointed to a direction altogether beyond the aesthetic.

Having made this significant break in search of cultural validation, Black Aesthetic theorists did not press the delegitimation they had saddled on the aesthetic tradition. Once placing the phrase "Black is Beautiful," Gayle asserted, "This step must be followed by serious scholarship and hard work. . . . "[8] But long after James Emanuel wrote in 1971, it remained true that "the black aesthetic, as a formally accepted set of literary principles, has not yet been born."[9] In attempting to essentialize their own cultural articulation they were deessentializing the concepts of art and the aesthetic. In retrospect, they were faced with two tasks at once, and in the heat of resurgence it was not noticed that these tasks were ultimately irreconcilable. One task was to assemble criteria for the appreciation of African American cultural works within a self-authenticating aesthetic framework. Critically surveying one year of Black Aesthetic theorizing Emanuel hoped that the movement's "ultimate mission is the salvation of a group larger than their own."[10] By this caveat he pointed to another necessity. This other task might be perceived as contributing to a liberative politics of representation which, almost by definition, would not be limited in application to one group, and almost by definition could not be contained within the limits of aesthetic discourse. Meanwhile, defenders of Eurocentric cultural dominance refused to understand this move toward a revisionary aesthetic, so where before the work of African Americans was dismissed as crude and inartistic, and then marginalized as "protest," now the transaesthetic assertions of the new cultural movement encouraged these gatekeepers to invalidate this work as "sociology."

At the same moment that witnessed the Black Aesthetic, another movement rose to its pitch of influence. The Situationist International was a wild, avant-garde group based in Paris and other European cities that staged happenings and a number of manifestations and experimental art-gestures and "actions." The peak of their influence came through the impact of their organizing, and particularly one pamphlet, "On the Poverty of Student Life," that lent fire to May 1968, the mass destabilization of Paris and France. Led by their principal ideologist, White Frenchman Guy Debord—aptly described as a dada Marxist—the Situationists were determined to wed art and politics, through *detournement* (the send-

ing of familiar cultural images through derisive detours), visionary communal architecture, and pastiche cinema.[11] An intellectual symptom of the malaise that produced poststructuralism in French thought, the Situationists saw art as one more form of the commodification of experience that Debord dubbed "the spectacle."[12] The Situationists launched a full-scale propaganda war against the art-culture system, one of the few European avant-gardes that repudiated the aesthetic altogether: "The point is not to undertake a critique of revolutionary art, but rather to undertake a revolutionary critique of all art."[13]

In retrospect, there are important synchronicities between the Black Aesthetic and the Situationist International, easily missed at first glance. The Situationists were part of that radical upheaval in French thought that took the academic form of deconstruction theory, the same upheaval that produced huge effects in Michel Foucault's ideas, for instance. The Situationists also inherited and culminated the disenchantment with art institutions central to dada and the European avant-garde. The other, repressed side of the disenchantment with Western social philosophy was decolonization theory, collecting around Frantz Fanon, Ho Chi Minh, Debray, Adotevi, Sekou Toure, Ousmane Sembene, Malcolm X, and the Black Power movement which inspired the cultural revisions of the Black Aesthetic.

On other scenes, the outbreak of the formerly silenced provoked new agendas for research and study, revisions of history displacing the institutional centers and their legitimizing charters. The grounds of the symbolic order were reexamined according to new assumptions. One of these revisions was the rise of aesthetic pluralism, largely an unacknowledged response to the impact of the Black Aesthetic. While cultural fundamentalists attempted to hold the line, those committed to a transformative view of history accepted the possibility of many aesthetics, a position that is more modest than it first looks.

By the mid-1970s, Black independent cinema, which had experienced a revival in the United States in the 1960s, began searching for a Black cinema aesthetic.[14] This search would have powerful effects in cinema, as in drama, fiction, music, and visual arts. While on the one hand, the declaration of a new aesthetic mandate had an invigorating effect on the production of new and powerful works, this success clouded another perception: that the aesthetic itself had become a moribund category of knowledge, an obstacle to liberative energies, if not in the sphere of specific art practices, then in the wider struggle for cultural and societal emancipation.

THE AESTHETIC HAS NO CLOTHES

"Aesthetic" has been the most reliable buzzword in the art-culture arena for centuries. But few of its users have any idea of its meaning beyond a restricted sense or two: "I put the lamp next to the armoire for aesthetic reasons"; "We were drawn to the distinctive Southwestern aesthetic." The awareness of the meaning of aesthetics in a philosophical context is limited to those with some acquaintance with Western philosophy. These are likely to be familiar with aesthetics as one of the four branches of philosophy, the other three being metaphysics, ethics, and logic. They may have routinely encountered the aesthetic philosophy of one or several Western thinkers who routinely have included a chapter or book on the subject within their collected labors. But rarer still, except for specialists, is knowledge of the history of the idea. Those who do not know this history or the bodies of analysis running through it may be none the worse for their inexperience. Nevertheless, "aesthetics" is one of those key words whose historical roots are worth examining to reveal buried, but still influential significance.

The Cambridge Dictionary of Philosophy is a good place to start:

> **aesthetics**, the branch of philosophy that examines the nature of art and the character of our experience of art and of the natural environment. It emerged as a separate field of philosophical inquiry during the eighteenth century in England and on the Continent. Recognition of aesthetics as a separate branch of philosophy coincided with the development of theories of art that grouped together painting, poetry, sculpture, music, and dance (and often landscape gardening) as the same kind of thing, *les beaux arts*, or the fine arts. Baumgarten coined the term "aesthetics" in his *Reflections on Poetry* (1735) as the name for one of the two branches of the study of knowledge, i.e., for the study of sensory experience coupled with feeling, which he argued provided a different type of knowledge from the distinct, abstract ideas studied by "logic." He derived it from the ancient Greek *aisthanomai* ("to perceive"), and "the aesthetic" has always been intimately connected with sensory experience and the kinds of feelings it arouses.[15]

Already this historical sketch reflects the revisionism going on around aesthetic theory. An older school of thought, sampled in the article on aesthetics in the *Encyclopedia of Philosophy*, starts its discussion with Plato. The eighteenth-century site of its invention is important, because it establishes aesthetic reasoning as a historical production, not something that

has always been with us, and it disturbs the constructed narrative of this "science" as a self-evident *discovery* of something universally and always present in nature and humanity. From here on, aesthetics will be treated as a local if influential theory, not a category of thought necessary to the well-developed mind, or essential to the expression of human character.

Aesthetics is a discourse involving many schools and several complex, contradictory arguments and shifting issues. Almost anything said about the field generally can raise particular objections. The lack of consistency in what is being said about traditions of aesthetic reasoning belongs to the discourse itself. Yet some of the landmark interventions of aesthetic philosophy make its reasoning clearer, and indicate borders where this ideology shades off from other forms of thought.

We know when aesthetic reasoning was established. A more challenging question is, how? and along with that, why? Many answers are lodged in the Renaissance. The aesthetic never depended principally on the exalted Renaissance concept of the artist as genius, as divinely inspired repository of faculties that made him an exceptional being to whom usual rules of psychology and behavior could not apply. But the artists who find ego satisfaction in that characterization and aesthetic philosophers intoxicated by their own rhetoric have enjoyed a mutual, if polite relationship of co-celebration. Only such artists could make such extraordinary works, and only the aesthetic philosophers could have the educated insight required to appreciate them. The elaboration during this period of neo-Platonist ideas where the arts were taken as ideal forms reachable by the soul as it withdraws from the body helped set the stage for increasingly abstract and isolated concepts of the art-making process. The special skills demanded of the painter in the arguments of Italian art historian Leon Battista Alberti were meant to elevate painting among the liberal, as opposed to the mechanical arts. One goal of all this elevation and idealization of art was to hike the monetary value of the artist's labors. This social-economic motivation should never be underestimated as one of the sources of aesthetic ideology. Many studies have followed the professionalization of art and literature shuttling from dependency on patronage to precarious survival in the marketplace. Martha Woodmansee's book *The Author, Art, and the Market* brings new insights into the ways elitist aesthetic rationales in the eighteenth century were linked to reconfigured concepts of authorship and strategies to protect its rewards, like copyright laws.[16]

As it developed, aesthetic reasoning grew increasingly acquisitive, suc-

tioning to its center almost any desirable outlying theories of beauty, art, or nature. The ideas of beauty, art, and morality of the classical and Christian ancients—of Western philosophy generally—were enlisted as components of the new science, even though they did not serve those ends in their original settings. But one of the key developments that made aestheticism possible was the steady isolation of the aesthetic as a distinct category of perception, more and more as a special faculty within humans, with its own laws. And the absence of this peculiar categorization among the ancients was quietly ignored, as though Plato, Aristotle, Augustine, and other worthies had merely overlooked the need to declare their random thoughts on poetry, beauty, music, tragedy, architecture, and so on, as the basis of a separate science.

A necessary step in the formation of the new addition to philosophy was the fusion of painting, sculpture, poetry, drama, dance, architecture, and other forms of cultural production as merely varying extensions of a unifying, transcendental plane of existence, comprehensively called "art." This became a received truth in the invention of the new science, another article of faith for those who would accept its arguments as unarguable. The title of the Abbe Charles Batteaux's *Les Beaux Arts reduits à un même principe* (1746) shows the direction of much enlightened thought on this new, metaformal application where the idea of art rose above concrete practices. Here, you can see the notion of *high* art germinating. Of course, which arts became candidates for high status and therefore inclusion within the transcendental category had heavy social and economic consequences. The fact that Lessing's famous essay on *The Laocoon* (1766) made a pointed attack on sloppy conflation of different art forms suggests how far this reasoning had gone. But by this time, even the examination of empirical differences among the arts was subsumed as among the materials of aesthetic discourse.

The field of aesthetic reasoning continued to expand the easy, enthusiastic conflations that Lessing refuted. For all its influence as a division of philosophy aesthetics ultimately came to have more success and influence as the center of a popular ideology, providing much fun and ego satisfaction through its practice more or less as a middle-class parlor game. This is something that cannot be said for metaphysics, ethics, or logic as the other divisions of Western philosophy. The signs are clear that aesthetics is on the decline as a respected branch of formal philosophy. But its role as a popular ideology is what still demands attention. And as such, the hows and whys of aestheticism must continue to be reexamined.

The significance of the momentous career of aestheticism lies within larger, more resonant histories. In Jamaican philosopher Sylvia Wynter's analysis, contemporary society is passing through a crisis of knowledge reminiscent of an earlier crisis. In that earlier paradigm shift, the medieval order of knowledge was overthrown by Renaissance humanism and its heretical elaboration of a new knowledge. The installation of humanism with the principle of human reason as its governing concept came at the expense of an atrophied medieval authoritarianism and effected a momentous revolution in thought described by Wynter as "the re-writing of the human." A key role in this reconstructed new knowledge was played by Rhetoric, out of which was shaped an act of symbolic self-representation, producing "a new human Self, self-imaging, self-troping." What happens with these rhetorical-figurative systems of group bonding and self-definition is central to Wynter's reading of history. In the medieval period, the Order/Chaos opposition came to figure as celestial/earthly and as Divine Man/Natural Man. The rewriting of knowledge subversively accomplished by Humanism overturned this last pair of oppositions, moving the ordering system of recognitions from religio-aesthetic modes into the "new profane narrative representations that we have come to call 'literature.' "[17]

A controlling maneuver of Renaissance humanism was the projection of the new European man as man-in-general; his reasoning process was portrayed as being isomorphic with reason-in-general. And in the new-order orientation of knowledge a governing discrimination of Same/Difference sought to privilege reason-in-general against alternative modes of reasoning. Hence followed a sequence of what Foucault called "internments," such as the isolation of "the Mad," or, adds Wynter, of New World peoples in encomienda systems, followed by the general internment of African peoples.

Wynter's arguments constitute a forceful historical allegory. In the likeness between the period when Euro-humanism extricated itself from the medieval worldview and the insoluble crush of present-day knowledges lies an explanatory thrust that domesticates troublesome contradictions and unifies random dislocations. Among the most promising options for resenting human experience made possible by this historical trope are those that focus on the dogmas of Euro-humanist aesthetics as a repressive, secular theology that must be rejected and replaced, much as emergent humanism arose to displace and transform the socio-religious energies of the European Middle Ages.

After World War II and increasingly after the 1960s, researchers into

the dependency of art and literature on their historical contexts developed a mass of evidence that embarrassed the expansive claims of aesthetic discourse and introduced intellectual discomfort to the thinking of some art historians. Reflecting on this creeping doubt, Sally Price summarizes, "There is something unsettling indeed about the possibility that our judgments and those of our cultural heroes are in a sense the product of the particular setting in which we and they happen to have been born; and it is sometimes the case that the more professionally people devote themselves to an interest in art, the more threatening the specter becomes."[18] These disquieting interrogations came from anthropological theory, neo-Marxist interpretations of ideology, revisionist critiques of the New Criticism in literature, the influence of the Frankfort School of social philosophy, semiotics, the new field of cultural studies, and the sociology of knowledge (and art). This accumulation of theory and argument would have pressured the cultural assumptions of the aesthetic even without Karl Mannheim's work on ideology or Foucault's formidable articulations of the power/knowledge concept.[19] Thus the crisis of knowledge cited by Wynter surrounded aesthetic reasoning before closing in on it.

"Reality is socially constructed."[20] The application of this axiom came to politics, religion, law, journalism, science, sports, history, psychiatry, criminology, and many other fields of knowledge before it approached the aesthetic, defended by its definition as an autonomous sphere with rules of its own. We may conclude, however, that when such interrogations collide with the aesthetic, the potential damage is all the greater, because of its character as a construct without a ground in reality apart from its own self-assertion.

Awareness mounts that the aesthetic is an eighteenth-century bourgeois construction (taken over from aristocratic beginnings) for the control of knowledge, specifically of the "beautiful." The central place set aside for the aesthetic experience in the arena of culture is increasingly identified with the ruler-of-the-roost posture assumed by imperial Western knowledge. The position occupied by the man of taste scrutinizing the art-object reverberates the arrogance of the subject-object relation in Western philosophical discourse, describing the distinction between the thinker and the thing being thought. For artist and theorist Laura Kipnis, then, aesthetics "is a key instance in the formation of the bourgeois subject and in the constitution of subject positions from which first world domination is effected and reproduced."[21] The enabling event of the aesthetic was the construction of this subjective individualism. "In the po-

litical realm of reality," notes Susan Kappeler, "very different values adhere to the possibilities of subject and object: the role of the subject means power, action, freedom, the role of the object powerlessness, domination, oppression. The two roles are not equally desirable. Hence the role of subject constitutes a site for a power struggle."[22]

But the invention of the aesthetic first appealed to its fashioners as an alternative to power. The aesthetic emerged out of a fusion of concepts of morality and beauty, inherited from the neo-Platonist ideas of the Renaissance; a crucial difference however was that the morality of the first aesthetic philosophers was more thoroughly secular than seventeenth-century neo-Platonic thinkers whose notions of beauty and morality were more spiritual, deeply implicated with ideas of the soul. Englishman Francis Hutcheson, who is credited with being the first moderm philosopher of the aesthetic, indicated by his titles the chief concerns of the new discipline. *Inquiry Concerning Beauty, Order, Harmony and Design* was the first part of his *An Inquiry into the Original of Our Ideas of Beauty and Virtue* (1725).

The aesthetic became a philosophical growth industry, although it should be noted that the concept has never existed without formidable philosophical refutations.[23] As it grew, it incorporated ideas about the imagination, taste, morality, beauty, art, the senses, into an expansive category of knowledge and experience. The ecstatic spread of aesthetics in European thought profited from the appeal to (and maybe the corruption of) the desire for beauty, for sensory satisfaction for an emerging upper middle class whose accumulations of wealth and power were outgrowing their pioneering values of puritanical self-denial. The seduction of the aesthetic as a body of principles concerning taste also served the desire to regulate social distinction for a class which, having gotten money, now hungered for status. White British theorist Terry Eagleton makes the compelling argument that, having acquired dominance in the material sphere, the bourgeoisie used the aesthetic to extend control over the senses and the feelings of interior life, thus ensuring further compliance with its social order.[24]

The opacity of the aesthetic, its endless definitions and clarifications, may be reduced by noting its two institutionalized functions. One boundary of meaning organizes it as a foundational principle in art criticism. The other reference, the philosophical, relates it to cognition, in which a space of contemplation is marked out as characterized by the aesthetic gaze or experience. In most of its incarnations, this aesthetic gaze is identified as disinterested, removed from considerations of politics, money,

self-interest, in favor of a higher inquiry. The ideal object of this aesthetic experience is autonomous, autotelic, an end in itself, when bracketed by the gaze of the observer. It is both transcendent and universal, unbounded by history or geography.

The capacity for aesthetic appreciation, placing a priority on form over function, is, as Bourdieu notes, a disposition affordable by individuals who have lifted themselves above the imperatives of necessity and survival—is in fact, celebrated as a sign of that deliverance.[25] The aesthetic disposition functions as a base for the fabrication and exploitation of countless social distinctions separating the cognoscenti from the benighted, the privileged from the pitiful, the elect from the damned, through what Baudrillard calls a "political economy of signs."[26] Grounded in this base is the mechanically reproduced normative superiority of bourgeois knowledge, experience, and practice. The aesthetic, then, is a system of representation and reception encoding the world for the spectator position of the Western upper middle class. Or as seen by Susan Kappeler from a slightly different angle, "culture, as we know it, is patriarchy's self-image."[27]

But the aesthetic serves an even more powerful function than individualistic self-empowerment. Not only is the aesthetic an ideology, it gives crucial support to general ideological stability. Hadjinicolaou points out "different spheres or forms of the ideological level: for example, the moral, legal, political, religious, economic, philosophical and aesthetic spheres. The process by which one sphere dominates the others is extremely complex."[28] Despite this complexity, it is plain to see the role of the aesthetic in uniting, rationalizing, legitimating—bringing order to these other levels. Just as the aesthetic arose as a body of knowledge uniting but transcending principles located in literature, the graphic arts and music, its influence including harmonizing the divisions of social order. Part of its spell is its claim to function as an imaginative model of the dynamic by which these spheres, indeed, the natural world, are held together: "The aesthetic, one might argue, is in this sense the very paradigm of the ideological."[29] In Fanon's calculation, the aesthetic functions like internalized psychic policemen operating throughout the body politic, maintaining the society's symbolic order:

> In capitalist societies, the educational system, whether lay or clerical, the structure of moral reflexes handed down from father to son, the exemplary honesty of workers who are given a medal after fifty years of good and loyal service, and the affection which springs from harmonious relations and good behavior—all these aesthetic expressions of re-

spect for the established order serve to create around the exploited person an atmosphere of submission and of inhibition which lightens the task of policing considerably.[30]

The premises of the aesthetic raise it above ideology. Among these premises are the assertions that the work of art is autonomous and autotelic on the one hand and universal, transcending geography and history on the other. One of the more ambitious recent efforts to support the universality of aesthetic consciousness is White anthropologist Jacques Maquet's *The Aesthetic Experience*.[31] Much of his argument is based on a search for the purely ornamental in the artifacts of a wide range of the world's cultures. His argument is that the ornamental dimension of such work expresses its autotelism, its existence for its own sake, outside of function. But his illustrations range from instances in the West where the work for its own sake has achieved great respect in some social contexts to artifacts from cultures where the ornamentation of objects may be epiphenomena of entirely different values. The demonstration of the widespread appeal of ornamentation makes a thin support for the universal presence of "the aesthetic experience" as defined in the West.

The point is that if the appropriate definitions were expanded to a neat capsule of aesthetic discourse, many of their elements would be found in societies around the world, but in very few societies outside the West would they be synthesized as a category of knowledge. Just as they did not appear in Europe in that form until the eighteenth century. The aesthetic, then, is an ethnic gaze, and a class-bounded one at that. It operates in that region where the beliefs of its converts grant it an undeniable reality as a mental object. It is only when that provisional reality is exceeded and the aesthetic is underwritten as a universal category that it becomes identifiable as false consciousness, on a staggering scale. The fragility of its universalist claims, however, undermines its authority and weakens the whole of its discursive reach. If its face-value definition in dictionaries were replaced by a more practical one, such as "the taste and appreciative conventions of the Western ruling and bourgeois classes," we could begin to see how deeply its history has strained under false illusions.

This study will resist the weak temptation to refute the philosophical validity of aesthetic discourse at length. A much briefer and even summary discussion seems adequate to establish its dishonesty in the terms of the politics of representation. Of course, the discipline of aesthetic reasoning would have it otherwise, would insist on an entry into the Sumaoro's chamber of finely spun, devious, casuistic argument recalling the vacuous medieval reasoning that has characterized its discussion

from the beginning.[32] And once one enters into this chamber, arguing the issue on its ground, an honorable exit is unlikely, without great loss of time and energy. (From experience, I have found defenders of aesthetic knowledge unable or unwilling to grant any presuppositions except that such a mental category exists in all of us, thereby making all argument circular and pointless—it exists because it is there.) But in fairness to those who cannot proceed without such confirmation of their doubts, we might pause to consider two cogent recitations of aesthetic logic.

The first is from White philosopher George Dickie (of the United States), who considers the much reputed "aesthetic attitude" or aesthetic gaze. This gaze is crucial to the "aesthetic experience" and different from other ways of knowing. In aesthetic theory, the special mode of being of the work of art demands a disinterestedness, an "aesthetic distance." The condition of art can theoretically only be approached and appreciated through this mode of mental cognition in order for its character as art, as opposed to everyday life and artifact, to stand forth. Dickie's close analysis, however, determines that no such unique mode of appreciation or recognition can be isolated. He concludes, "But the aesthetic attitude ('the hallmark of modern aesthetics') in this formulation is a great letdown—it no longer seems to say anything significant. Nevertheless, this does seem to be all that is left after the aesthetic attitude has been purged of distancing and disinterestedness. The only thing which prevents the aesthetic attitude from collapsing into simple attention is the qualification closely."[33]

Tony Bennett's critique begins with an acknowledgment of the general existence of "discourses of value" (which I have called "hierarchies of value"). These discourses of value make sense only with an ideal valuing subject in mind, someone capable of responding adequately to the prompt of experience, and of being a good citizen in the "valuing community" where such values are legislated and shared. Such discourse for knowing thus depends on "the individual's valuation of self as both subject of discernment and ultimate valued object. Their structure is thus narcissistic."[34] This seems to be a normative condition of human behavior, though one that can place severe limits on the human capacity to understand and cope with difference. But these hazards are compounded by aestheticism, specifically by its reach toward hegemony and its claims to universal validity.

For aesthetic reasoning to go forward it must rely upon a "universal valuing subject" (or privileged collective consciousness) much more commanding and absorptive than the "particular valuing communities" that

are to be found everywhere. This universal valuing subject relies on an "already elaborated theory of knowledge." Given what has been said, it is not merely unlikely but impossible for this universal valuing subject of aesthetic discourse to reflect any origin but its own, namely Western, ruling-class ideology. Bennett's analysis revolves around the crucial point of the receptor of "aesthetic" information, the subject located in the subject-position from which judgments of taste are confirmed or rejected. His critique assures that once again, the logical process is circular: the object is beautiful because I think it is beautiful. He quotes White Scottish philosopher David Hume: "Thus, though the principles of taste be universal, and nearly the same in all men; yet few are qualified to give judgment on any work of art, or establish their own sentiment as the standard of beauty. . . . some men in general, however difficult to be particularly pitched upon, will be acknowledged by universal sentiment to have a preference over others."[35] Hume will give us clear indication in a footnote of this work of some who must be excluded from the considerations of taste, or even civilization. Kant's much subtler analysis affirms the necessarily subjective condition of aesthetic reasoning, as well as relying on a universal valuing subject, but fudges the difficult question of relativity of judgment by positing an ultimately true judgment of taste in posterity. In other words, the most refined elaboration of aesthetic theory ends by asserting that there ought to be final unanimity on the questions of beauty and taste, some day in the future.

It is worth recalling Bennett's conclusion at length:

> Notwithstanding the scientific claims which often accompany it, aesthetic discourse is ideological in the Althusserian sense that it functions as a discourse producing subjects. The universal valuing subject (man) it constructs interpellates the reader into the position of a valuing subject who is defined, in relation to the valued object (man), within a mirror structure of self-recognition. Yes, indeed, man is manifested in this object; yes, indeed, I recognize myself in it; isn't it/aren't I wonderful?— such is the effect of aesthetic discourse for the subject who takes up the position it offers. As ideology, however, aesthetic discourse is characterized by a number of contradictions and torsions, albeit ones which vary in their consequences depending on the political articulations of such discourse. In the case of bourgeois aesthetics, the production of a unified valuing subject, although necessary in providing a theoretical legitimation for the representation of class-specific aesthetic norms as universally valid, is also at another level, a sham, and necessarily so.[36]

As with both of these critiques, the validity of the aesthetic as a category of knowledge rests largely on the issue of universality. But the uni-

versality of the category carries different meanings. The category can be thought of as responding to a science of the beautiful whose rules are universally valid, regardless of regional variations: one aesthetic law for everybody. Or, the aesthetic can indicate a category found explicitly in many civilized societies and implicitly in less civilized societies, or even in all societies, but a category whose content varies with the cultural contexts in which it is exercised: we all have an aesthetic, but my aesthetic may be different than yours.

You don't have to be clairvoyant to guess which of these versions of universality arose first. The historical shift from one idea of universality to another is revealing. One aesthetic for all is the legacy of ethnocentric Euro-enlightenment. The first aesthetic philosophers considered themselves as uncovering a category of "Universal Reason," and anyone who differed from their opinions was merely exposing his or her backwardness. But even in this period, there were occasional and routine demurrers, raising the possibility of some relativity among nations and peoples when it came to perceiving the beautiful. Museology may have been responsible for the extension of aesthetic criteria to other societies whose arts and artifacts acquired vogues among Western consumers, i.e., Japanese scrolls, Chinese vases, Persian carpets, as well as greater knowledge of the architecture and other cultural forms of non-Western societies past and present. Then, the dogmas of taste became a criterion for the civilized. It has only been under the impetus of decolonization theory, reflected in comparative anthropology, that the aesthetic sense has been attributed to all societies.

The absurdity of one aesthetic of universal application for all cultures is transparent, though doubtless some philosophers and psychologists continue the search, despite its diminishing returns. In the place of this universal dogma, many are drawn to a multicultural notion of plural aesthetics. Yet the fallacy of this more modern, supposedly democratic multicultural notion of the aesthetic is epistemological. It needs to be repeated that the distribution of categories of knowledge among different cultures shows no pattern where they overlap around one category devoted to aesthetic knowledge. Instead, evidence shows that protocols of beauty are integrated within other categories in different societies and often are not isolated in any fashion resembling what Western knowledge has defined as the aesthetic. Notoriously, many languages have no word for art, just as no society in the world had a word for aesthetics until 1735.

Where anthropologists have ferreted out such hierarchies, they have

seldom shown them as they exist in the raw, i.e., integrated within their home cosmologies. The discovery of such "aesthetic systems" is much like the discovery of the Americas, bearing all the marks of the preconceptions and interests of the discoverers. They find aesthetic systems the way Columbus found "the Indies" in the Caribbean. Aesthetic universality is bourgeois cognition caught in a permanent "mirror phase." The question becomes, can such investigators who have invented a scheme of knowledge for their own self-fashioning locate the same kind of knowledge among foreign cultures without appending the biases of their self-fashioning, and if they could remove their "idols of the tribe," why would they not remove the category altogether, since the category is itself largely a repository of mental idolatry? In other words, only an investigator who had no preconceptions about the existence of the aesthetic as a category of knowledge could objectively locate one in a remote culture. Even more unlikely, though technically possible, would be for Western scholars, busy establishing the order of things in the 1700s, to discover a principle in a non-Western society and make that foreign principle the basis for a category of "Universal Reason" or a discipline of study.

The quest for the universality of the aesthetic mistakes the existence of hierarchies of values in all cultures around objects, performances, or events as evidence of "aesthetic" calculation. But value hierarchies operate within cultural cosmologies and ideological configurations. Two societies often venerate the same object, but for entirely different reasons, as we are reminded when a museum piece is reclaimed by its originating cultural community for its ritual or other value. Or the intensity of veneration in two societies may appear similar but be very differently motivated.

The world's diverse cultural hierarchies have been shanghaied into service of aesthetic theory in two ways. Non-Western value systems are sampled to disguise the isolation of the aesthetic as a local, Western middle-class preoccupation. But under the assumption that the aesthetic is a Western philosophical discovery (of universal import), and most highly developed in its articulation and intellectual finesse in the West, aesthetic theory is simultaneously used to establish the relative inferiority of these non-Western societies in this area of development, and by inference, generally.

Maquet's inquiry is part of a very recent anthropological effort, researching oral cultures to discover the nature of their "aesthetics." This research responds to a liberal ideological motive, to reverse the use of aes-

thetic criteria for inferiorization, and instead to use it to help establish the common humanity of all peoples. Not surprising, investigators have unearthed the criteria for stratified valuation of different objects. This is unremarkable, since very little human activity is undertaken without ideas for gauging anticipated success. Researches like this also have a double function. The "discovery" of scales of respect for different objects or experiences elevates that society in the ranks of civilization, in the liberal ethnographer's eyes. At the same time, the "discovery" tacitly confirms the universality of a specifically Western perspective. But this liberal gesture effects a "one way universality," as noted by two interrogators of the complex idea of the "primitive."[37] If ethnographers have only recently begun to inquire into the criteria of beauty and desirability among non-Western peoples, neither they nor other aestheticians have hardly ever inquired about response by "primitives" to objects from outside these cultures, like the Mona Lisa, for instance.[38]

LIKE BEARING GIFTS TO GREEKS

> In its origin, the word art meant science, knowledge or learning.
> —Ngũgĩ wa Thiong'o, *Barrel of a Pen*[39]

How the aesthetic acquired its status in intellectual discourse can be recovered from two historical narratives, one its own myth of origin and the other a historical interpretation from outside its self-imaging. The origins of "modern aesthetics" has traditionally been found among the ancient Greeks. Greek precedent, with some Roman supplements, formed the ancestry of both aesthetic philosophy and the highest practical aesthetic achievements. The simultaneous archaeological recovery of ancient classical relics and the development of Renaissance thought and artistic styles solidified the Greeks as the base of artistic canonization. Plato's dialogues on beauty, Aristotle's precepts on drama, rhetoric, and poetry, among other revered philosophical texts, together with the statues and architecture of the Parthenon, served as inspirations for eighteenth- and nineteenth-century ideas of art and beauty.

"The human form and the human mind," wrote Shelley in his Preface to "Hellas," "attained to a perfection in Greece which has impressed its image on those faultless productions whose very fragments are the despair of modern art; and has propagated impulses which cannot cease through a thousand channels of manifest or imperceptible operation, to

ennoble and delight mankind until the extinction of the race." Goethe was briefer but no less categorical: "Without the example of Greece, the highest form of life man could achieve is unattainable." To hold such opinions and include them in his writings became a necessary credential for the educated man for several European centuries.

Whether Greek art was ideal to the humanists because it was inherently so, or because they savored it as a way out of Christian religious art and thought, or because they needed it as an authorizing charter is unendingly arguable. But the notion that Greek thought established an earlier version of the aesthetic is an instance of rewriting history backward, the invention of a tradition, throwing a veil of authority over the cultural program of its eighteenth-century fabricators. By calling their new "science" aesthetics, the humanist philosophers unnamed and renamed historical Greek theory and practice and created a fictitious lineage for this upstart discipline, casting the aura of antiquity and cultural legitimacy over its enterprise with a well-chosen buzzword, a practice by no means out of date.

The notion of ancient Greek "aesthetics" is an example of an invented pedigree. It is an instance of aestheticians wrenching the desired homologues out of the cultural hierarchies of other societies. It is obvious that Greek philosophers labored over questions of artistic technique and judgment, many of them providing staple answers for eighteenth-century constructions of aesthetic principles. But they never conceived of this thinking within a cultural cosmology or ideological configuration constructed as an "aesthetic." The Greeks never used the word this way. All of the thought gathered together as "classical Greek aesthetics" took place in widely scattered coordinates, and served very different social functions than reinterpreted in the aesthetic. "Art," *techne*, was conceived as skill, simply, as any activity governed by rules, and applied to shoe making as well as sculpture. Beauty was the subject of speculation about morality. Poetics was related to the drama, which was an aspect of religion. Rhetoric was elaborated as a facet of politics. "Ancient Greek aesthetics" is a mythical construction that Greek philosophers might recognize with some difficulty as either a clever or dubious idea, but surely not one of their own.

The encounter with alien beings through exploration and conquest is noted for expanding and liberalizing European thought in the human sciences, as Montaigne predicts in his essay "On Savages." These encounters also had the opposite effect, in swelling and intensifying xenophobic

feelings about non-Europeans. This double-action response to difference prefigures a Self/Other dynamic of modern Western thought that has been identified by Wynter as an epistemological parasitism.[40] The European encounter with the non-European took two classical forms. The characteristics of the people encountered were forced into familiar patterns, analogous to European behavior, sometimes ennobled as proof of some benign unity of the human race. Or these same characteristics were viewed as intrinsically foreign, strange, repellent instances of difference, and the populations so viewed as outside the definitions of Western rational man.

We are now solidly within a narrative that might be called the illumination of Western transcendence. This is a mode of thought by-produced from the great leaps made by Western societies through rationalistic and scientific processes into a vast array of impressive accomplishments, and in which these societies appeared to themselves to have surpassed the limits of traditional social organizations and non-European societies. Within this historical paradigm, Western nations achieved real superiority in military power and organization, communications, industrial development, popular education, medicine, and virtually every department of material activity. But the reality of Western advantage must be distinguished from the myth of Western supremacy.

The reconstruction of knowledge during this period of expansion and conquest, and particularly during the intellectual consolidations of the Enlightenment, carried a subtextual leitmotif, the need to answer the question, why are we superior to the rest of humankind? Explanations and proofs in the human sciences and the arts were granted greater applause and credibility when they contributed to the growing evidence of Western supremacy than when they failed to do so. Many projects had their origin in the need to explain this supremacy, the location of higher societies in the temperate zone, etc. The actual superiority of Western technology and practice in many areas provoked the reasonable search for the explanation of this superiority within comparative study. But the mythical notion of inevitable Western supremacy became a starting premise of further researches and skewed the intellectual process toward foregone conclusions. The aesthetic was invented amid the developing, consolidating phase of the paradigm and, despite the many other motivations behind its invention, did not escape the seductions of the myth. Among the tasks it set for itself was the need to find an august, nearly divine source of the aesthetic idea and also to find there the echo of the beauty of mind and form of the discoverers.

TOWARD THE INVENTION OF WHITENESS

> The remark that did him most harm at the club was a silly aside to the effect that the so-called white races are really pinko-grey. He only said this to be cheery, he did not realize that "white" has no more to do with a colour than "God save the King" with a god, and that it is the height of impropriety to consider what it does connote.
>
> —E. M. Forster, *A Passage to India*

> A perfect gentleman of taste and proportion is what his toilet told you. All that was to hide the fact he'd made a bloody fortune running slaves and supplies for the British during the last war. . . . Buy beauty, if he couldn't produce it. Buy truth, if he was too busy to think. Buy goodness, even, for what blessed thing on God's earth don't have its price?
>
> —Charles Johnson, *Middle Passage*

Reason and the Understanding were to fill the void left by the decreased reliance on theological faith. "The understanding," a phrase iterated with a certain air, as though to insinuate that only those who possessed it could know what it meant, had encoded within it the presumption that it could be found only among a certain class of humans—men who by birth or training had certified a place in the directorate of civilized society. "The understanding" was synonymous with the common sense of the elite European male. The prodigious accumulation of knowledge undertaken through the Euro-enlightenment was consequently riddled with superstitions and gross prejudices. The formulations conducted from the subject-object position suffered from the disabilities of an insufficiently critical perception of this subject. For however much "the subject" might be scrutinized for bias, there was a core of subject characteristics that remained above questioning: that its judgments were superior because it belonged to men who were White and of superior class. This "understanding" was constituted as a blind faith—blind because it refused to recognize that it was a faith, and not scientific reasoning—that surrogated the religious faith of an earlier era. And in the blindness of its insights, the subject position supplanted the mind of God, for the atheistical, and for those who retained theological convictions, surrogated the only instrument capable of appreciating the divine mind. This cognitive revolution had two important effects. It removed the mass of humanity from the appeal to the highest authority, which

was no longer God or faith, but now "the understanding." And it reconstituted this authority as a kind of new secular religion.

"The rewriting of the human" per Wynter, from this new vantage point from the sixteenth century onward, has been described by White French philosopher Michel Foucault as the construction of grids of knowledge in which every perceivable datum of existence was described, classified, catalogued, and set in its proper place within the grid.[41] The ideal of this project was that the grid would be both complete and continuous; new knowledge might be added, but without disturbing the design of the grid. Another feature of this metaphoric design of knowledge is that the lines of the grid intersected, like the longitude planes of a global map, at a central, polar point, the site of the knowing subject.

The aesthetic invited itself along, first as an uninvited guest, but soon as an dispensable partner, on the far-ranging expeditions of Western knowledge, a companion to the historian surveying the borders between history and prehistory, as cohort of the anthropologist distinguishing between civilized and savage polities, as moral guide to the art historian, as the advance patrol of the archaeologist. A good traveler, cheap to keep, never seasick, immune to dysentery and other local diseases, the aesthetic, which rarely ventured beyond the study, traveled compactly amid the tools of the inquiring Occidental mind, mapping out the knowledge of the world. As fellow traveler of Occidental intellectual investigation, the range of explanatory power claimed by the aesthetic widened. Where Western philosophers had always considered morality as a major preoccupation, this guide to thought and behavior was uprooted and transformed by the link made in aesthetic thought between morality and beauty. The connection had of course been made before, but in aesthetic reasoning, the addition of the nomenclature of a "science of beauty" had served as a shortcut to an elusive and problematical science of morality. If one could find the good merely by finding the beautiful, why look further? The new philosophy aestheticized morality, removing it by stages from everyday life and the harder work of examining human behavior.

The broadest reach of aestheticism stretched to its convergence with the newly developed Western concept of "civilization." By conflating the aesthetic with high culture, the bourgeois art-culture system invented itself and at the same time grounded the moral and educational development of several generations along lines validating middle-class society. But by conflating the aesthetic with civilization, this system also extended its reach over all representation.

As the work of Reason expanded through the Euro-enlightenment, it

fashioned a new definition of Occidental man as transcendent human be-ing. Since the earliest conception of the Great Chain of Being, European man had been favored with the highest human position—closest to God. But with the extolling of Reason as the defining characteristic of human worth, and the location of Mind almost wholly among Europeans, a breech was opened between Europeans and the rest of humanity, people of color.

"I am apt to suspect the negroes, and in general all other species of men (for their are four or five different kinds) to be naturally inferior to the whites. There never was a civilization of any other complexion than white, nor even any individual eminent either in action or speculation. No ingenious manufactures among them, no arts, no sciences."[42] David Hume's language, from a footnote in his treatise on "aesthetics," *Of the Standards of Taste and Other Essays*, is merely a blunter and more categori-cal version of received truth circulating among Euro-enlightenment phi-losophers.

While medieval "anthropology" placed an ethnocentric and occasion-ally racist priority on Whiteness as a superior category of humanity, Euro-enlightenment reinvented Whiteness as a transcendent, and not merely normative category. By identifying European Mind with Reason, Enlightenment thinkers activated a subtle logic of superiority and domi-nance. In its more primitive form, the argument ran that White was a superior form of being because of an inherent, genetic linkage with Uni-versal Reason, an apt correspondence that Nature, in its wisdom had seen fit to legislate from the beginning. A more flexible version identified White savants with Universal Reason, by accident of geography, or his-torical development, in which case it was not Whiteness per se that con-stituted the source of superiority. But whether by choice of God or, later, by natural selection, the association between rational order and White advantage came to be assumed as natural, particularly since the vast ar-ray of rational knowledge was produced and controlled by people of Eu-ropean descent. The association became so natural that Occidental phi-losophers could ultimately dispense with the argument, relying instead on its embedded signification in the words "civilization," "culture," "rea-son," "progress," and later "modernity." Thus, Whiteness was constructed as a kind of super-ethnicity which retained a recessive reference to a lo-calized population of European origin, but functioned more implicitly and far-rangingly as the normative characterization of people fully equipped to function, reason, maintain order in a "modern civilization" that tran-scends regional borders and ethnic specificity.

The appeal of Whiteness as a transethnic category and as a system of representation of world-dominating significance was irresistible on a number of accounts. For the nation-states of expanding power, it offered a new, empowering source of national identification. It also helped to distance the miseries of a population ravaged by the Hundred Years War, plagues, famines, brute poverty, and for many, serfdom. At first a small club for those whose membership was guaranteed by conquest and power, and by no means vouchsafed for all Europeans, its tightly guarded gates were selectively cracked to admit other populations who were eager to exchange histories of degradation for fresh, commanding identities. Thus, the Irish who came to the United States to escape abject misery could not blunt the vilification they met as despised immigrants by claiming their identity as Irish Americans, nor as Catholics, but finally succeeded in slipping the yoke by asserting their definition as White people.[43]

The resulting Group Subject (per Sylvia Wynter) made possible the personality formation describable as "white skins/white masks," to put another spin on Fanon's memorable title.[44] What it suggests is the weight, the privilege, guilt, duplicity, security, etc., of the mask of Whiteness imposed and inherited on Europeans these last few centuries. The mask has become so familiar as the normative gaze into which each Caucasian child is born and culturally inserted as to need no elaboration.[45] The endless deliberation made necessary by the mask seeks to determine where the Group Historical Fiction leaves off and the "real person" begins. Some thought should be given to the many degrees of denial of the mask's presence since it was "outed" and confronted in the 1960s. What may be more necessary to think about (since the mask is continually being stripped, and redonned) is the phenomenon of individuals living in their "white" skins without the mask. The importance of the effort to put aside the mask of Whiteness since the 1960s cannot be exaggerated, nor the need to recognize the styles and values of individuals and sometimes groups who had managed to live without dependency on this mask before it came under public challenge.[46]

The aesthetic played a major role in the narration of transcendent Whiteness and an indispensable role in the development of modern, pseudo-scientific racism. Before the Enlightenment, Europeans indulged a folkloric, mom-and-pop racism, ethnocentricity combined with xenophobia. Racism was elevated during the European Enlightenment to an institutionalized corpus of scholarly knowledge, mainly as a rationale for the aggressions of global imperialism and trans-Atlantic slavery. This historical epoch of conquest and exploitation coincided with the Enlightenment, and there was no lack of philosophers and scientists such as

Locke, Berkeley, Hume, Montesquieu, Voltaire, Franklin, Jefferson, Buffon, Linnaeus, Kant, and Hegel, to corroborate the inferiority of non-White people.

The ideological history that unfolds might be told as the story of a pair of biological but not identical twins. They become separated at birth, and like twins in many gee-whiz studies, though separated and raised in different environments, show remarkably similar paths of development—tastes, habits, careers, and choice of life pursuits. So parallel are their lives that it can be imagined that their paths have crossed frequently, that they have worked in close association with each other, and that at times it becomes nearly impossible to identify the signature of one in the work of the other.

Do these twins—the aesthetic and modern European racism—realize their kinship? One suspects that they do, though they are inclined to deny it, for different reasons, mainly because to admit as much might restrict their independent careers. Both twins have found it convenient, in fact, at times, to deny their parents, since each claims to be immortal, the commonsensical, inevitable product of nature. But they are legitimate and mortal offspring, the products of history and culture, and bound by their origins and developments within those confines. Their parents—the European Enlightenment and the Atlantic slave trade—are themselves products of Western world dominance.

Regarding the paradox of the Enlightenment producing modern, "scientific" racism, Richard Popkin comes to perceptions similar to Cornel West's, that "authority of science, undergirded by a modern philosophical discourse guided by Greek ocular metaphors and Cartesian notions, promotes and encourages the activities of observing, comparing, measuring, and ordering the physical characteristics of human bodies."[47] For the highest form of beauty, as reasoned Johann Winckelmann of Germany, the preeminent art historian of his day and "the founder of archaeology," was human beauty, "which we exalt as we are able to elevate ourselves above matter."[48]

The connection between Occidentalized art and White identity can support a revealing commutation test. What Marcuse says about art in a typically expansive passage applies equally well when the word "Whiteness" is substituted for "art."

> . . . the radical qualities of [Whiteness] . . . its invocation of the beautiful image of liberation are grounded precisely in the dimensions where [Whiteness] *transcends* its social determinations and emancipates itself from the given universe of discourse and behaviour while perserving its overwhelming presence.[49]

The similarity of the language of the aesthetic and of Whiteness, in those Enlightenment thinkers who speak of Whiteness (accidentally evoked here by Marcuse) suggests the kinship of these two discourses.

The function of aestheticized beauty in the construction of transcendent Occidentalism relies on a system of "essences" and "correspondences," a wordy discourse remarkable for the self-deceptions and quirky, irrational beliefs that penetrate and uphold it still in the mystificatory talk that continues to use the fading authority of the aesthetic as a rationale. "This idea of beauty is like an essence," continues Winckelmann in a familiar vein of speech. While the arguments of anti-essentialism have been used to discredit much racial discourse, to place in question the integrity of genders, the authenticity of innumerable once-stable concepts, and even to support the denial of the human subject, the aesthetic remarkably remains protected from such interrogations.

Enlightenment preoccupation with ocularity, observation, classification, and stratification was synthesized within aesthetic reasoning through an assumed correspondence between appearance and moral quality. A typical instance was in the "scientific" or philosophical entrenchment of the idea that a pale skin indicated moral superiority and a dark skin moral inferiority. Like many of his contemporaries, Winckelmann would give this stereotypic notion a scientific twist: "As white is the color which reflects the greatest number of rays of light, and consequently is the most easily perceived, a beautiful body will, accordingly, be the more beautiful the whiter it is. . . . "[50]

The transcendence of Whiteness relies on chains of such supposedly significant correspondences. Winkelmann, again, argues that the highest form of beauty is the human being, because the human was made in God's image. And since the image of God in all the works that Winkelmann admired was of a White man, then that image presents the highest universal possibility of beauty. That of course, leaves in the shadows of aesthetic deprivation all those people not carrying the God-color. Winckelmann is here reflecting a characteristic of the thought of his times, a schema of knowledge that was at the same time a mirror image of the mind of its creators, the reliance on correspondences as confirmations of the accuracy of interpretations.[51] Correspondences functioned to harmonize interpretations within key concepts of the human sciences: civilization, race, and culture. The aesthetic played a crucial role in these formulations. The presence or absence of beauty among different populations, as interpreted by the "understanding," by those whom Winckelmann described as "those who have regarded and selected beauty as a

worthy subject of reflection,"[52] became a key to ranking those popula-
tions among the civilized or uncivilized. The presence or absence of the
aesthetic sense, similarly interpreted, was another key indicator.

Winckelmann illustrates the kind of non sequitur easily produced by
"common" or everyday, ideological sense when reflected through friendly
correspondences. These quaint similitudes that echo in orotund phrases
throughout the organizational projects of the Enlightenment are perceiv-
able as lapses into "common" sense as opposed to the scientific and skep-
tical observation appropriate to the task of ordering knowledge. Though
our familiarity with this kind of thinking may encourage us to indulge
them, they are, in fact, instances of what anthropologists observing re-
mote societies have facilely called primitive thought, le savage pensée.

The symmetry between beauty and morality is one of the pivotal sup-
ports of aesthetic reasoning, and one of the least defensible, though it
manages to linger in contemporary discussions that ought to know bet-
ter, as when we are encouraged to support the arts because they are good
for us. Of the many contraventions of this long-lasting correspondence
one remains in my mind. In Survivors, a documentary film about survi-
vors of the bomb blast at Hiroshima, an aging Japanese American woman
with leukemia recalls the sight of the detonation, from a Hiroshima sub-
urb where she was visiting as a child. The explosion was "the most beau-
tiful thing I could ever see or imagine."

The identification of moral goodness with aesthetic beauty is one of the
tenets of aesthetic reasoning that proves to be flimsiest on the slightest
testing. How do we explain the category "fascist art"? Or the many in-
stances where exceptional artistic skill is brought to bear for evil or ma-
licious ends? Can the pleasure we experience from some works be sepa-
rated from the ugly politics of their inventors? If so, then the essential
goodness of art is compromised. If not, it is also compromised. This di-
lemma is seldom thought through in aesthetic debates, but is usually re-
solved through a question-begging resort to the category of "true art."
True art turns out to be whatever the writer of the moment declares it is,
without any clearly defined rationale or criteria. We must take the de-
clarer's word for it.[53] The notion of the goodness of art cannot, in fact,
withstand the "blindfold test." Without prior knowledge of the work and
its origins, we cannot tell which painting was done by a murderer and
which by a saint, which piece of music was written to drown out geno-
cidal slaughter or which to heal troubled souls.

Consider Lentricchia, commenting on remarks of Kenneth Burke: "Not
only is Mein Kampf literature; it was highly effective literature.[54] If we

need to believe otherwise . . . if we need to believe that literature is somehow always involved in a noble, humane cause, a position common on the literary left as well as the literary right and center . . . then let us at least be shaken by Burke's subversion of the sentiment that literature is inherently humane. Literature is inherently nothing; or it is inherently a body of rhetorical strategies waiting to be seized. And anybody can seize them."[55]

If beauty is identified with goodness and Whiteness with both, then the notion of Blacks or non-Whites as morally good, or as beautiful (the same thing in this logic), becomes oxymoronic or a non sequitur. The idea of black humanity as beautiful was "unthinkable," threatening the universal order with chaos, only comprehensible through what contemporary essentialists would describe as moral relativism, destroying the foundations of universal standards, and even harboring the possibility that Whiteness is not universally good and beautiful. There were, of course, individuals who dissented from this consensus, and instances of Black beauty were sometimes cited as curiosities that demanded explanation.

In this fusion of Enlightenment preoccupations and convictions it becomes difficult to separate the aesthetics of racism from the racism of aesthetics. A sample:

> The first difference which strikes us is that of color. . . . And is this difference of no importance? Is it not the foundation of a greater or lesser share of beauty in the two races? Are not the fine mixtures of red and white, the expressions of every passion by greater or lesser suffusions of color in the one, preferable to that eternal monotony, which reigns in the countenance, that immovable veil of black which covers all the emotions of the other race? Add to these, flowing hair, a more elegant symmetry of form, their own judgment in favor of the whites, declared by their preference of them, as uniformly as is the preference of the Oran-ootan for black women over those of his own species. The circumstances of superior beauty, is thought worthy attention in the propagation of our horses, dogs, and other domestic animals; why not in that of man.[56]

From this logic, the author of the Declaration of Independence goes on to enumerate familiar racial stereotypes: their "disagreeable odor . . . in reason much inferior . . . in imagination they are dull, tasteless and anomalous. . . . "

These dicta from Thomas Jefferson emerge while he considers the most important matters for his state and nation, the moral status of slavery, and the future relations between the races. The kinds of knowledge

brought to bear here include anthropology, natural history, political science, and what in Jefferson's day was called "moral philosophy." Yet the role of aesthetic theory is not only crucial to his arguments, it is the scene of his most passionate expression, with the possible exception of his violent sexual animadversions against Black women, a sexual-aesthetic complex that has been analyzed as a displacement of his repressed desire.[57] The signifying chain of associations arranged into symmetrical grids and corresponding categories could not, given these aesthetic judgments, allow him to conceive of exceptional intellectual capacity in Blacks. Jefferson deemed them virtually ineducable and dismissed the accomplished poetry of Phillis Wheatley and the mathematics of Benjamin Banneker as inadmissible evidence of talent. The rule was simple: those who could not be beautiful according to the dictates of the aesthetic, could not possibly be producers of beauty or of knowledge.

The aesthetic functions broadly in the mental frame of transcendent Occidentalism, its anthropological gaze fixed on discriminations of self/other, sameness/difference, or identity/monstrosity. The parasitical reliance of White beauty on Black ugliness as a co-defining necessity was one of the most potent contributions of aesthetic reasoning to the developing narrative of Whiteness. Its appeal to philosophers and cultural theorists rose from its "self-apparent" evidence, on what, seated in the subject position of an imperial cultural symbolism, one could plainly "see."

A familiar conundrum from the study of visual perception can be taken as a trope for this co-dependent defining process; see Figure 1. This drawing and others like it demonstrate the figure-ground relationship that has obvious relevance for the interpretation of art and cinema. Edgar Rubin, the Danish psychologist who studied this phenomenon, made several observations about the way they were interpreted by his subjects.[58] It seems impossible for them to "see" both fields simultaneously. Either one or the other commands attention. The figure image takes on the character of a "thing," even when it is an otherwise unrecognizable image. Moreover, *"In Relation to the Ground, the Figure Is More Impressive and More Dominant. Everything about the figure is remembered better, and the figure brings forth more associations than the ground."*[59] Rubin points out the implications for art interpretation in the way subjects "read into" the figures rather like Rorschach tests. Because "the figure dominates in consciousness," affective feelings and "feelings of an aesthetic character can also occur. . . . In contrast, the objective figure which constitutes the ground is usually aesthetically indifferent."[60] Further, "A field experienced as figure is a richer, more differentiated structure than the same

1. Figure/ground (vase/faces), per Rubin.

field experienced as ground"; and "the color seems more substantial and more compact in the figure than in the ground"[61]; and "Ornaments frequently become aesthetically displeasing when the part intended as ground is seen as figure. . . . "[62]

Rubin makes it clear that the images, even when concocted as nonsense figures, are given "meaning" by experimental subjects. They do not remain "neutral" for long, if they were ever experienced as such. But other experimenters have amassed evidence that the "laws" of visual perception differ between cultures. The perception of depth in the "ambiguous trident" (Figure 2) is not experienced by many sub-Saharan Africans. Certain principles of depth perception are clearly learned, not "natural." But what is even more convincing of cultural difference is the difficulty many Western observers might experience when trying to see this figure as on a flat plane. Such evidence confirms the variance of cultural cognition; that learned habits of perception rule out or promote particular readings of physical information, even before it is consciously interpreted. These culturally acquired habits of perception form the unconscious ground over which an aesthetic interpretation can be inscribed,

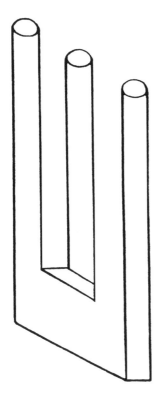

2. The ambiguous trident.

mistakenly supposing that the ground from which the aesthetic object is seized and given meaning is "nature" or "reality" itself.

Rubin points out that the figure-ground relation remains in effect even when the colors of the objects are reversed, the vase made black and the faces white. This is true of the perception as a physical psychological phenomenon. But a reversal of this sort will have considerable significance in the way cultural symbolism assigns meaning to the objects. In the illustration as it first appeared and is most frequently reproduced, the white space is likely interpreted as a vase, and from cultural association, quite possibly a Greek vase. Nor, in the context of a society constructing a particular, ego-driven meaning from whiteness/blackness, can the blackness of the faces remain neutral. Interestingly, when Salvador Dali adapted this motif for a lithograph called *Ace of Cups* (Figure 3), he did reverse the colors of the forms, making the faces White, and ethereal.

From this exercise in the psychology of perception we can draw some inferences for the politics of representation. First of all, even the most in-

3. Salvador Dali, *Ace of Cups*, lithograph.

nocent representations are charged with political meaning. Jefferson's aesthetic-moral characterization of Africans in Virginia reflects his choice of self-supportive readings along the figure-ground axis. There is the zero sum ratio erected between White and Black. This relates at one level to the digital inclination in Occidental perception, the either/or construction of information, as in the on/off of a light switch as contrasted to the possibilities of analog interpretation in which the determinants are arrived at through an open field of continuous data.[63]

The politicization of interpretation shows up in Jefferson's anxiety to recover White beauty from the background of Black repellence, to insist on its foregrounding, its survival as figure, for fear of extinction other-

4. "My Wife and
My Mother-in-law."

wise. As Rubin explains, "When the white field is seen as figure, the black piece of paper stops looking like a black surface. Usually it is seen as a dark, weak, space-filling color."[64] The seizure of transcendent Whiteness always remains haunted by the dreaded return of the repressed, the surfacing into figural meaning of the Black humanity that remains co-efficient with White beauty so long as it is kept in its place as complementary, background obscurity and ugliness. The pathos of this debilitating form of self-construction is compounded by its conviction that the digital, zero sum interpretation of reality is the only one possible.

The principle involved here is also famously illustrated in the drawing "My Wife and My Mother-in-law" (Figure 4). Some spectators see the old woman first, others the young one. The young woman's chin makes up the old woman's nose. The young woman's ear forms the old woman's eye. The phenomenon of co-dependent definition still applies, even though the political terrain might have to do with ageism rather than race.

The tension between foreground and background in the drawings illustrates representation as a stage for further conflict over privileged space. The foreground is obviously the position of superior signifying power, comparable to point of view in fiction, the subject position of the

observer—in theatrical terms, the limelight. I recall one of a thousand similar advertising pictures. A White woman whose blond hair and see-through veil flow over her shoulders and bikini bathing suit (faintly recalling "Venus on the half shell") is surrounded by seven or eight North African women robed and veiled in black and blue, with only their eyes showing. The caption says something to the effect that the swimsuit may have raised eyebrows in Morocco, but no one is certain. Once again Fanon provides us with the mise-en-scène for this peremptory strike against the humanity of women of color. "The Algerians, the veiled women, the palm-trees and the camels make up the landscape the *natural* background to the human presence of the French."[65]

However accurately the drawings work as instruments in the psychology of perception, they also carry equal if not heavier burdens of meaning in the politics of representation. The sociological reading, where the Greek vase and the black faces stand as polar oppositions between socially charged symbols exemplifies the conflict at the heart of the politics of representation, as premised by humanist knowledge. The images are far from being neutral. The "Greek" vase carries connotations of a cultural "Whiteness" which must disappear from sight, become negative space, according to these "laws" of perception, once the black faces come into focus out of that negative space the vase now enters. The drawing depicts the co-dependence of perceptions in Occidental cultural cognition, but it also makes another demonstration.

The Enlightenment made important scientific achievements through empirical and deductive reasoning at the same time that it persisted in irrational, medieval reasoning paradigms like the doctrine of correspondences, ultimately a legacy of the occult and spiritualist strains of the Renaissance. Aesthetic reasoning was more likely to rely on the uncertain logic of correspondence, an intellectual practice on the order of astrology and numerology, than to make good its claims as science. The irrationality of this logic resulted in a zero sum linkage between White as beautiful and Black as the unbeautiful. Immediately after asserting the greater beauty of a body the whiter it is, Winckelmann writes, "A traveler assures us that daily association with negroes diminishes the disagreeableness of their color. . . . "[66] Through this self-fashioning strategy Black ugliness and White beauty, in their co-dependency, merge toward an identity. This is one of the ironies poised in Jean Toomer's poem, "Portrait in Georgia":

> Hair—braided chestnut
> coiled like a lyncher's rope
> Eyes—fagots,

Lips—old scars, or the first red blisters,
Breath—the last sweet scent of cane,
And her slim body, white as the ash
of black flesh after flame.[67]

Toomer's mannerist composite not only frames "White beauty" as constructed from shadowy Black existence but goes on to figure an identity between the Southern belle and the tortured and monsterized flesh of the Black lynch victim.

CHAPTER II

■

The Art of Ethnic Cleansing

> There are still relatively cultivated Westerners who believe that before Giotto, no one *could* reproduce the human figure well, or that the Egyptians painted their figures in profile because they *could not* do it any other way.
>
> —LeRoi Jones, *Blues People*[1]

> The humanistic standards were actually worked out by the ages which followed. . . . The Greeks, unfortunately, were unable to have such a thing as a classical education.
>
> —Harry Levin, *The Broken Column*[2]

At what historical point did notions of European physical beauty become standardized? Was the new self-image the product of the overseas adventures of slavery and colonization? White historian Winthrop Jordan finds evidence that the normative traditions of European beauty predates this period of expansion, showing up in twelfth- and thirteenth-century poetry.[3] Possibly early encounters with invading aliens, the Mongolians and the Arabs, prodded Europeans into accelerated self-identification, iconizing blondness and blue eyes as the most dependable marks of "undiluted" White ancestry.[4] Nevertheless, one indisputable and decisive encounter between the Occidental self and its idealized appearance came with the rediscovery of classical Greek sculpture and art.[5]

Humanists of the Renaissance and the Enlightenment found among the ancient Greeks and Romans materials perfect for their project of rewriting the human and constructing a transethnic identity. Not only did they gerrymander a precedent for the "science" of aesthetics from the copious speculations of Greek and Roman philosophers. They found in Greek philosophy, politics, art, literature, and life-style the very type of

human perfection. So complete and satisfying was the example of the classical world that the humanist battle between "the ancients and the moderns" hotly debated whether history need necessarily fall downhill the rest of its course.

The exaltation of ancient Greece was a way of declaring and legitimizing the identity of those qualified to exercise refined taste and judgment. And soon, knowledge of ancient Greek and Latin (and occasionally Hebrew) became credentials of membership in the community of knowers and judgers. The feverish commitment to things Hellenic had a further motivation in the service of classicism to humanists as legitimizing valuable ways out of the repressiveness of medieval Christianity. The sensuousness of the Greeks, their love of human beauty, their eroticism, and for many like Winckelmann, their homophilia and fascination with male beauty, all validated the needs of large sectors of the educated European population. The invention of a Greek model of civilization served as an alternative liberating ideal for artists, art consumers, and aesthetes of the Romantic era much as the exploitation of an African and "primitive" scenario of art and culture was used by Euro-modernists as an intellectual escape hatch from the repressiveness of the Victorian age. There is a minor irony in these creations of instant cultural history. The celebration of things antique and Greek may not in itself have been racist, yet in the hands of Petrus Camper and his followers, the Greeks became the template of those who were both beautiful and capable of recognizing beauty, while those who might challenge ancient Greek primacy, the Africans, became the anti-type of beauty.[6] Still, it would be those same Africans who would provide the artistic stimulus for European modernism centuries later.

Camper, a Dutch anatomist and painter, pioneered the isolation of the essence of Greek facial beauty and gave it mathematical precision. "It is difficult to imitate the truly sublime beauty that characterizes Antiquity until we have discovered the true physical reasons on which it was founded," he contended.[7] So driven, he located the essence of beauty in a facial angle of 90 degrees or more on a line moving from forehead to jaw. Harmonious with the paradigm of scientific investigation he inhabited, Camper proceeded to draw a spectrum of perfection, descending from ancient Greek statues where he found a facial angle of 100 degrees, and contrasted them with Europeans next, Orientals in the middle, and African heads and skulls with a facial angle well short of the ideal 90 degrees, and corroborated this evidence by noting the facial angle of apes to be even lower (Figure 5). Camper made none of the usual racist infer-

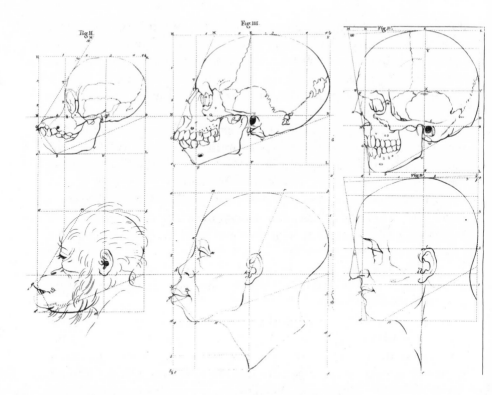

5. Petrus Camper's illustrations of the facial angle of an ape, a Black man, and an ideal Grecian head.

ences between appearances and moral worth, according to Stephen Jay Gould.[8] Like Winckelmann and other Enlightenment figures, Camper even speculated that Negroes might have different perceptions of the beautiful and ugly. But these speculations functioned as asides, provisos, and never interrupted the course of self-confirming reasoning. Seldom did the speculation arise that Europeans might seem ugly to Africans.

Camper's researches into the beautiful were followed by the speculations of Johann Kaspar Lavater's "Essai sur la Physiognomie" (1781), which is said to have invented physiognomical "science." The codifications of Lavater became topical in the academic pursuit of beauty in painting and sculpture, to the point where we can find no less an intelligence than William Blake insisting that the supremely beautiful foot was the Greek foot, in which the toe next to the big toe is longer than the big toe, and the rest descending from that peak. So harmless a fascination with physical characterization could take on other significations, as with

beauty as a science. ...

the stereotype of the "Jewish nose" which was another discovery of the eighteenth century, and became an object of Winckelmann's aesthetic inquiry, before becoming a figure of anti-Semitic caricature.[9] The commerce between aesthetics and science was intense during the Enlightenment, at a point where many artists still doubled as scientific investigators, producing aesthetic chimeras on the one side and pseudo-scientific racist schemas on the other. The ventures into craniology and physiognomy of Camper and Lavater became precedents for the craniometry of Lombroso and his "fool-proof" schemes for detecting criminal and degenerate types and racially inferior groups. "This continuous transition from science to aesthetics is a cardinal feature of modern racism," writes historian George Mosse.[10] Mosse, moreover, has no difficulty tracing this line of thought from the Enlightenment to modern fascism and the death camps.

BEARING GIFTS TO THE GREEKS

The pursuit of transcendent Whiteness clouded perceptions searching for correspondences predetermined to end with the symmetry between European identity and most things good and beautiful in nature and human society. The collapse of this preoccupation into false consciousness is nowhere more damaging to the credibility of Enlightenment thought than in the seizure of ancient Greek art and sculpture as seal of European superiority. The precision of self-blinded aesthetic deduction was rarely equal to that of Winckelmann, whose impact on art historiography was so great that Goethe admiringly called the eighteenth century "the century of Winckelmann." In his *History of Ancient Art*, Winckelmann made the invidious comparisons of non-Greek art with his Hellenistic ideal that became axiomatic in later European art criticism and art history.

Winckelmann figures in a debate that has recently been dramatically reopened by Martin Bernal. The ideal Winckelmann celebrated was of Greek beauty, youth, life-lovingness, the serenity and moderation of its art, its purity and essentiality. By contrast, "in a very early example of modern racial discrimination against ancient Egyptians, Winckelmann followed Aristotle's claim that they were mostly bandy-legged and snub-nosed. Thus, they had no beautiful artistic models."[11] White historian Martin Bernal's heavily documented thesis argues that ancient Greek religion, mythology, philosophy, the core of Greek culture, in fact, derived from the Egyptians, whom the Greeks themselves credited with founding their civilization through colonization. The eighteenth- and nine-

teenth-century celebrations of Greece as the fountain of Western civilization could not tolerate this knowledge as an impediment to the mythic charter of superior civilized development in Europe and, according to Bernal, dismissed the Greeks' own testimony and revised their statements to suit their ideological needs. Corroborating Bernal's thesis, we find Winckelmann "correcting" the evidence: "The opinion of a few Greek writers, that Greece derived its art from Egypt, will not be regarded as proof of the assertion, even though all of them assented to it, by those who know the fondness of the human mind for everything foreign. . . . "[12] As an alternative, scholars of this persuasion fashioned what Bernal calls the Aryan Model, in which the distinctive character of ancient Greece came from Aryan invaders out of the North:

> If I am right in urging the overthrow of the Aryan Model and its replacement by the Revised Ancient one [which adds some modern revisions to the Greeks' own testimony], it will be necessary not only to rethink the fundamental bases of "Western Civilization" but also to recognize the penetration of racism and "continental chauvinism" into all our historiography, or philosophy of writing history. The Ancient Model had no major "internal" deficiencies, or weaknesses in explanatory power. It was overthrown for external reasons. For 18th- and 19th-century Romantics and racists it was simply intolerable for Greece, which was seen not merely as the epitome of Europe but also its pure childhood, to have been the result of the mixture of native Europeans and colonizing Africans and Semites. Therefore the Ancient Model had to be overthrown and replaced by something more acceptable.[13]

Art history had another major contribution to make to the revised edition of Western man, a self-serving interpretation of Greek art, featuring the misrepresentation of Greek sculpture. From the Renaissance on, Greek sculpture was celebrated not for its particular values and interests, but for capturing the essence of human existence, the achievement of a Platonic idealization of human face and form. And this notion of original, abstract beauty was reinforced by the condition in which this statuary was found, sometimes with limbs missing and usually in eroded white marble. The whiteness of these sculptures could not fail to impress Euro-humanists committed to the interpretation of correspondences as an almost mythological signification. Such sculptures came to function as the very realization of the transcendent Whiteness that preoccupied European intellectual thought. Thus, the knowledge that the Greeks painted their sculptures did not meet with enthusiasm.

It is difficult to determine when this discovery was made. As in recent

scandals of U.S. government administrations, the crucial question becomes what did they know and when did they know it.

> Winckelmann's acquaintanceship with Greek works of art was rather limited. What he had seen for the most part consisted of copied material dating no further back than Roman times, sculptures of immaculate whiteness, scored by billions of raindrops and abrasive grains of sand. Hellas had not characteristically expressed itself in severely conceived and blindingly white forms set off against a luminous landscape. The plastic works of the ancient Greeks were deeply dyed with garish pigments. The marble figure of a woman found on the Athenian Acropolis was tinctured red, green, blue, and yellow. Quite often statues had red lips, glowing eyes made of precious stones, and even artificial eyelids.[14]

Art historians and archaeologists could not refute the material evidence, as they wrangled with the linguistic evidence of Greece's subordination to Egypt. The traces of tinting and paint, sometimes in large quantities could not be denied. Instead, they have dealt with it through silence and repression or reluctant, oblique acknowledgment. The clamorous discussion around such a discovery, disconfirming such basic assumptions about this model representation of the human, never happened (at least none leaving a clear trace in contemporary art history). Nor has it ever been allowed to enter popular knowledge, as has the supposedly supreme beauty of Venus de Milo, or the fact that some connoisseurs prefer her without arms. No book deals with the subject in English, apparently, and very few articles. Massive volumes on Greek art or sculpture make elusive references to "polychromy" in a paragraph or two and then pass on. The full realization of the original appearance of Greek sculpture passes through art history, like other notions embarrassing to the aesthetic paradigm, as barely whisperable, if not virtually unspeakable.

What little that can be pieced out is bizarre beside the received notion of Greek art. Winckelmann contributes the fact that some busts of clay were painted red: "Occasionally, marble statues were clothed with real cloth. . . . "[15] Other scholars tell us that "Pure white statuary did not, however, exist at any period in Greek art."[16] According to one scholar, a sculpture of Typhon, a triple-headed monster, "was painted in colors that seem almost violent to us today . . . blue for 'Typhon's' hair, beard, and moustache; greenish blue for the iris, which may have originally been blue; yellow for the ball; red for lips and cheeks; black for pupils and eyebrows. The exposed parts of the body were a vivid rose red."[17] Winckelmann seems to have "whitened" the coloration of flesh, reading the origi-

nal as "pink and white," but a later scholar asserts that "The flesh was tinted vermillion. . . . "[18]

Nor can there be any doubt that the painting of statues was an important, essential part of their beauty. "Praxiteles himself, when asked which of his statues he considered the finest, replied, 'Those which Nikias has painted.' Nikias was also a famous painter of pictures, but he apparently did not feel that painting Praxiteles' statues was beneath his dignity."[19] Winckelmann himself supports the importance of painting the statues by quoting Plato, though he can hardly believe his own translation: " 'Just as if someone who should find us bepainting statues should censure us because we did not put the most beautiful colors upon the most beautiful parts of the figure; for the eyes, which are the most beautiful, should be colored, not with purple, but with black, etc.' I translate these words in the sense in which I understand them."[20] Architectural monuments like the Parthenon were also blazoned in what we today might describe as day-glo colors, the better to hide material defects, according to Fowler and Wheeler.[21] So time and nature had played a great Nietzschean joke. They had transformed the image of ancient Greece into a vision of rational, serene, Apollonian monochrome from what had originally been a riotous, Dionysian orgy of color.

The realization of painted statues as the normal Greek practice apparently came in stages. The information Winckelmann had in 1764 was probably augmented by subsequent archaeological finds. An archaeological dig at Selinus in 1822 and 1823 produced enough evidence of color on statues to lead to "much discussion of the use of color in Greek sculpture and architecture," which seems to have subsided thereafter.[22] But this unfolding revelation did not alter imitation of the ideal of "pure" white Greek statuary. The apparent absence of color contributed to the emphasis on form in Greek art, and thence a formalist bias in the interpretation of artistic values. Nevertheless, according to White art historian Francis Haskell, the clamoring taste for copies of Greek and Roman sculpture abated before the middle of the nineteenth century. Further, "After the death of Canova in 1822 no living sculptor anywhere could command the attention, sometimes admiring, sometimes scornful, that was paid for instance to contemporary German painting. . . . "[23] Among the many reasons for this shift in taste might be the loss of interest as connoisseurs faced the knowledge that their copies differed vastly from the tinted originals. At any rate, the decline of sculpture after Canova's death also coincides with the excavations at Selinus.

But nothing stopped the influence of the white Greek ideal in the like-

ness of its mistaken identity. For most of its history, Western sculpture remained unpainted, following a firm principle of aesthetic taste that was acquired under false assumptions. But having learned or "remembered" that ancient Greek sculptures were once painted, we must also be reminded that sculpture in medieval Europe was also highly colored. It almost begins to look as if painting sculptures has been the "normal" practice for cultural artifacts—"normal" being no less awkward a concept here than in the assumptions of aesthetic theory.

Working from this mistaken identity, medieval artists reversed the "normal," or at least ancient, Greek practice. "This colouring of statues and monuments ceased suddenly with the sixteenth century," we are told by the authority of Heinrich Wolfflin.[24] White anthropologist Rhys Carpenter speculates that this disappearance of color from Gothic sculpture came in emulation of what was believed to be the ancient practice.[25] The decolorization of Greek sculpture had long-reaching consequences, one of them being the rigid separation of the genres of sculpture and painting, and perhaps also the transcendence of genres in the notion of the "aesthetic unity" of the arts.

"When the legend contradicts the facts, print the legend," says the cagey newspaper editor at the end of *The Man Who Killed Liberty Valance*. This sums up the policy of the Western art-cult, continuing to publish the myth of white marble while keeping the fact of bold colors under safe scholarly wraps. I have been told that when one antique Roman statue was found in the nineteenth century with the color intact, the color was removed. Efforts to restore classical sculptures never include replacing the paint. And frequent restorations of the Parthenon likewise restore the mythic white marble instead of the colorful original. ("Earth proudly wears the Parthenon, / As the best gem upon her zone," wrote Emerson, in his poem "The Problem.") This means, of course, that hundreds of the most revered classical buildings in the Western world, including the White House and the United States Capitol building, the Opera in Paris, La Scala, the Louvre, etc., perpetuate an architectural and historical fraud. To this historical false identity we owe the appearance of the nation's capitol, Washington D.C., as a beige, monumental graveyard. So much bombast and money have gone into this fabricated construction of ancestral homage that to acknowledge the mistake suggests admitting to cultural illegitimacy.

Not only did the Greeks use color in ways the art historian did not welcome, they used it according to a different "aesthetics" of color than that of European cultural symbolism. This is a difference of considerable

significance. Cultural symbolism is one way of describing the network of assumptions and interpretive strategies that process data differently from one culture to the next. To simplify a complex discussion, it is impossible for us to know raw reality, since the information of natural stimuli arrive to us already interpreted by our cognitive-cultural screens. We have just looked at evidence of the impact of cultural "laws" of visual perception on the formation of interpretations. A much-cited illustration of the impact of culture on cognition looks at variations in interpreting the color spectrum. Presented a spectrum of all possible hues, different societies name the colors differently and break off the separation points between colors at different places. In some cultures, one word is used for blue and green combined; in others two words may be used for what Western cultural symbolism describes with the one word "red." Varying color-codes are only a convenient illustration of a plenitude of discriminations that precede interpretation in the usual sense, that seem within the group to merely record reality, but are in fact culture-bound.

The ancient Greeks have mystified Western scholars by insisting that they used four primary colors in painting: white, yellow, red, and black. This has led to intense speculation: what happened to blue? One study concludes that the word the Greeks used for black was used synonymously for dark, and that Greek painters considered blue an admixture and lightening of black. The question of Greek use of color terms in literature and painting has been troubling enough to raise the speculation by more than one investigator that the Greeks were color-blind. And an even more extreme speculation has been entertained and sensibly dismissed that, using the naming of colors as an index, the Greeks were brain-damaged, or abnormal.[26]

The Greek preference in color values not only differs radically from Renaissance and post-Renaissance schemas, but stands them on their heads. The humanist fascination with white and with subtly shaded colors was not matched by the Greeks, or by Plato, at least, who favored unadulterated colors, or by Greek culture generally, which seems to have been attracted to deep purple and the darker tones. They seemed intrigued by black; according to Bruno, Vitruvius devoted a whole chapter to the color black.[27]

Curiously, when confronted with this "unorthodox" Greek practice and theory of color, Euro-humanist judgments applied to the Greeks the calculus of same/other or identity/monstrosity that is a familiar reflex of their gaze when "Othering" non-Western peoples. Most interpretations bend the evidence to support the identity between ancient Greek civili-

zation and Europe. Winckelmann decides, for instance, that the hair of the Diana of Herculaneum is blonde, when, the color eroded from that part of the statue might easily have been another color.[28] The suggestion of color-blindness or mental deficiency carries the response of those who cannot abide the differentness of the Greeks in their color schemes, one writer judging the color-coding of their art as "bad taste."[29]

The high valuation placed on the whiteness of these statues was not an accident. It was the result of a particular history, which prepared their reception at a somewhat inflated scale by an audience that somehow needed their blondness. It was an audience that needed their estrangement from the present, the sentiment of antiquity speaking to them directly over centuries, that needed their apparent "purity," their whispers of a beginning, an origin, nude of color as a newborn infant is nude. The bleached colorlessness of ancient Greek statuary and architecture invited a metaphor: their whiteness signified the ideal representation of the aesthetic, or as close to it as representation could come, and always in contrast to the tinctured, material, finite, ethnic art of the rest of the world. And for a population insistent on its transcendence of ethnicity and achievement of pan-human values, the Greek sculptures became something of an icon of Western modernity.

Nothing so deeply solidified the look of ideal European, and therefore human physical beauty, as the discovery of Greek art as a model. The settled notions of European physical beauty did not exist until this consensual adoption of a Greek ideal. If this model had not been "discovered" or invented, we might wonder if Westernized ideas of beauty would be the same as they are today, or perhaps even less narrow?

It gets to be hard to imagine how differently art history would have been written without this investment in ancient Greek "purity." Consider this dictum from Winckelmann: "The highest law recognized by Greek artists was 'to create a just resemblance and at the same time a more handsome one'; it assures of necessity that their goal was a more beautiful and more perfect nature."[30] One of the most exalted canons of Western critical taste is endangered here, the perfection represented by the achievement of the Greeks to reproduce human form naturalistically, but with this nature presented in its ideal, not idiosyncratic form. In the ironic reversal of the original Greek perspective by the classicist, the white statue with blank staring eyes is a "more handsome" resemblance than nature, with the whiteness specifically carrying much of the burden of the ideal, of transcendence. For the Greeks, obviously, the white, unpainted statue was only the beginning of a "just resemblance" which was

made "more handsome" and ideal by the addition of colors that classicists would rather not think about. This different notion of realism in art and idealism is enough to cause an upheaval in classical aesthetic theory, or else dismissal of Greek ideas of beauty. Or, if the pretended inheritors of ancient Greek ideas of beauty and art can do no better than this in interpreting the Greeks, whom they wish to count as their progenitors, why should they be trusted with any calculations of beauty or worth, except their own provincial, historical taste?

Canonical art history continues celebration of Greek statuary along traditional lines as though nothing had happened. This celebration usually insists on the uniqueness and superiority of these artifacts when compared to others. Winckelmann employed this technique, if he did not originate it, making elaborate comparisons of Greek art with Etruscan, Phoenician, Jewish, Persian, and Egyptian art, acknowledging small indebtedness of the Greeks to Egypt, and respecting all of these cultural traditions, but finding them all in one way or another illustrative by contrast of the superiority of the Greeks. Egyptian art, by contrast, and this has become de rigueur in subsequent art criticism, is found wanting because of its "rigid conventionalism." (In these judgments, Winckelmann seems to anticipate the strategies of dominance in a multicultural aesthetic field. The distribution of merit between Occidental and other art in all the succeeding centuries has fallen into narratives echoing this distinction between "Greek" and "Egyptian" civilization.)

The classicist and romantic writers of Europe waxed so eloquently about ancient Greece as the youth of mankind, the dawn of humanity, because they were unaware of or indifferent to discoveries that revealed the antiquity of humankind and civilization. Jonathan Z. Smith notates decipherment of ancient Near Eastern languages: Egyptian hieroglyphics, 1822–1823; Akadian, 1849–1857; Sumerian, 1915–1923; Ugaritic, 1930–1931; and Hittite, 1915–1942.[31] "Israel and Greece were not, as had been hitherto thought, the foundations of Western civilization. They were later, secondary, perhaps even derivative cultures. 'High' 'oriental' cultures had pre-existed them by millennia."[32]

But there was room for willed ignorance in this view of Greece as humanity's youth. It served a design of origin and lineage better than other candidates. The "youth" motif in the Western imagination of Greece was a way of insisting on the inconsequentiality of whatever came before—a dismissal that carried over into "aesthetic" evaluations of contemporary or earlier civilizations like that of Egypt.

One modern sample of this art-historical critique is provided in a book

called *Greek Art: The Basis of Later European Art* from a book series called *Our Debt to Greece and Rome*: "Civilization, as we know it today, has developed in two main streams, one from its source in India spreading out over China and the East, the other spreading westward from its fountain head in Greece."[33] Glancing at art from India and China, Persian or Moorish art, the art of Central America, the author finds much to admire, but repeatedly notes that "examples will suffice to show that art outside the classical tradition is foreign to our eyes, as that of ancient Greece is not."[34] An example of Egyptian art reveals its "rigid conventional mould. . . . this art is felt today as an alien art, impressive by its very foreignness."[35] The transcendent identity shaped by Euro-humanism still asserts itself in the author's statement that "only the art of Greece and Rome makes an appeal like that of modern art. . . . "[36] As poet and cultural essayist LeRoi Jones writes in *Blues People*, "There are still relatively cultivated Westerners who believe that before Giotto, no one *could* reproduce the human figure well, or that the Egyptians painted their figures in profile because they *could not* do it any other way."[37]

Where does the knowledge of coloration go to when it is disappeared within the art historians' rhetoric about the serenity, proportion, design, and organic unity, etc., of Greek sculpture? For as soon as we bring the original color back into the foreground, as an occasional hypothetical illustration with color restored helps us to do, Greek statuary no longer looks so different to "us" from other ancient art. In the painted version it can no longer be evoked as the material realization of Universal Reason. Distinctions between it and Afro-Asiatic art begin to dissolve. Then it, too, looks "alien" to "our" eyes, "foreign," more ethnic, pagan, in fact outright "Third World." Such a look seems to support Bernal's contention that ancient Greek civilization looked south and eastward for its global connections to an Afro-Asiatic world, and not northward to Europe.

But the mistaken identity cannot be avoided. It is the most monumental instance of aesthetic appropriation and misappropriation. The license taken by the Euro-humanist art-culture system to seize the world's objects from their original contexts and contort them to the gaze of the bourgeois connoisseur is one of the more exploitative functions of the aesthetic. It is ironic that the Greek statues are misappropriated into the categories and assumptions of the aesthetic no less than a "primitive" New Guinea mask, and further ironic that it was done less consciously and more damagingly, once discovered, to the imperial paradigm. To extract meaning from unpainted antique statues as holding a higher, more abstract significance than painted ones is much like abstracting prece-

dents for aesthetic theory from the intellectual environment from which these statues were produced. The original violence of imposing a Greek origin on the theory of aestheticism is neatly reproduced in the act of denying color to these icons.

The question comes down to an either/or dilemma in which the credibility of the aesthetic and its enshrined hierarchies of values are at stake. Either the statues are superior in their eroded, bleached, colorless condition, or superior in the blazing colors the Greek sculptors and their audience preferred them.

Let us suppose that the bleached version is the better, a serendipitous improvement. (This is a view taken by Rhys Carpenter, who forthrightly claims the whitened versions superior on the grounds of "practical aesthetics," without owning that practical aesthetics cannot exist separate from cultural training.) This judgment raises several problems. Aesthetic theory usually makes room for the happy accident that has improved many a work. But what kind of accommodation can be made for an "accident" on this scale, of hundreds of statues and architectural monuments, an accident that palms a mistaken identity upon one of the world's great civilizations? And what does this judgment say about the creativity and genius of the Greeks, that it needed ground burial and environmental erosion to complete its work to its highest realization? Was this genius not penetrating enough to know when to stop? Is not knowing when to stop a part of "genius"? "The fallacy of intention" argues that the author of a work is not the final authority of its interpretation. But can we disregard the intention of a culture and civilization deemed to be near perfection, and within the genre said to hold the surest proof of humanist superiority over all other civilizations?

By most principles of the aesthetic, the addition or subtraction of color fundamentally alters the meaning of the work. For the Greeks, color was organic to the work as a whole, a necessary dimension, an integral part of the end product from conception. To say that it makes no difference is to deny "the integrity of the work of art," to repeat a favored item of aesthetic cant. A recent debate over coloration of black and white movies invokes aesthetic principles that should also apply to ancient Greek sculpture. Many respected directors have organized their protests against the addition of color to black and white movies, arguing that the practice corrupts or perverts the original intention of the artist and the meaning of the work. If this post facto addition of color constitutes a gross distortion of original meaning, the same must be true for the subtraction of color from ancient Greek statues.

What happens to the eternal significance of the "fully achieved work of art" if it is appreciated radically differently centuries later, and in different material form? One might say that the appreciation of Greek sculptures ages later and in different manifestation only goes to prove their enduring quality, but that would only be a passing witticism. To prefer the unpainted version is to admit the radical mutability of taste, that appreciation of the beautiful is an acquired not innate characteristic, more complex but not unlike cultural discrimination of colors. The contradiction is one that should challenge the guardians of "the classics" who insist that certain great works have the same things to teach us in all ages.

Difficult as it is to live with these contradictions, it is probably easier for the Occidental art-cult to cope with them than the alternatives. These include the possibility that the great Greek artists knew what they were doing, as all cultural producers do, at least on some important levels that cannot be dismissed. And that the sculptures were superior in their original resplendent colors. But if they were superior in that form, why did not the learned founders and developers of aesthetics and art history intuitively come to that conclusion earlier, before the increasing traces of pigmentation made their painted condition no longer avoidable?

Accepting this body of work as it appears in the original has very heavy consequences. One is the need to face the discontinuity between ancient Greece and Europe from the Renaissance on, which claimed the Greeks as cultural ancestors. The problems of the alien Greek color discriminatory pattern raise the possibility that this discontinuity is deeply cultural, not just historical. If a discontinuity so large as this can go unnoticed for so long, and then remain so weakly acknowledged once recognized, then what kind of authenticity can be granted the Western inheritance of the mantle of originary Greek culture? What does this coat of paint do to those principles and precepts, the structures of aesthetic reasoning and art historiography predicated on its absence? Or even more problematic, what does this coat of paint tell us about the disciplines of aesthetics and art history that have known about it but have refused to address the challenges it poses in any serious, straight-up way? What kind of objective aesthetic and art-culture bureaucracy can proceed on assumptions of intellectual honesty and maintenance of standards with this kind of skeleton, this forged identity of Western civilization, knowingly kept in the closet of scholarly obscurantism?

Whichever option of this either/or dilemma is chosen, the problem of this missing coat of paint reinforces the conclusion drawn by Martin Bernal, while directing it specifically to their implications for the aes-

thetic: "it will be necessary not only to rethink the fundamental bases of 'Western Civilization' but also to recognize the penetration of racism and 'continental chauvinism' into all our historiography, or philosophy or writing history." A gentler but no less perceptive caution was voiced by Harry Levin in a refreshing instance of modernist realism in 1931:

> [P]erhaps it was the real secret of the Greeks that instead of practicing a cult of far-fetched aestheticism, they managed to invest the daily and commonplace concerns of life with a certain beauty and symmetry. . . . Our false conclusions result from confounding the idealized Greece, as it appears in the remains of its art, with the actual Greece, as it once existed. The concept of Greece is not pure but purified. We muse upon the whiteness of classic art and forget that the colors have faded. We prefer to disregard the garishness of ancient painting, as revealed at Pompeii, or the vulgarity of the chryselphantine Athena, whose gold trimmings were melted down for the public treasury in time of war. . . . The humanistic standards were actually worked out by the ages which followed. . . . The Greeks, unfortunately, were unable to have such a thing as a classical education.[38]

Don't we owe ourselves one moment of historical laughter at this grand illusion of classical, monochromatic purity? It is no more, but surely no less than the errant constructions, based on mistaken identities, of any cultural symbolism, with the role of myth playing its part as wildly as in the more bizarre findings of any anthropologist. Is it a less fatuous cultural construction that the self-identification of some Afrocentric enthusiasts with ancient Egypt? Is it any more or less "savage" a conceit than, say, the cargo cults of Melanesia?

CHAPTER III

Discipline and Punish

THE CONTROL OF CULTURAL MEANING

> The master discourse which is the common sense of
> "Art" is in the thrall of an antique, "nominalist" view
> of language—believing that because there is a singu-
> lar word, "art," then there must be some singular
> thing, some "essence," which the word names.
> —Victor Burgin, *The End of Art Theory*[1]

> When the outsider is excluded from the concern, he
> can only too easily be accused of incompetence.
> —Max Horkheimer and Theodor Adorno,
> "The Culture Industry: Enlightenment as
> Mass Deception," *Dialectic of Enlightenment*[2]

The aesthetic, then, may be decoded as the witch's mirror of the West-
ern upper middle classes, constructed to monitor and direct interior men-
tal life in coordination with styles of social existence. It is a conceptual
model drawn from the cultural symbolism or cognitive paradigm of
Euro-American societies, and then superimposed as a universal category
of human or civilized behavior. But while all cultures and societies may
have their hierarchies of values, there is no reason they would subdivide
and classify them according to the organizational design that takes place
in the aesthetic. Other societies do not break down the data of perception
following the models of Western knowledge, just as they do not all mark
the same division of colors at the same points along the color spectrum.
Nor do they place the same meaning or emphasis on activities that look
similar to outside observers. It is true that bullfighting holds a special
place in Spain, the tea ceremony in Japan, or the mass in Catholic Europe,
but they are special places within different social cosmologies. The an-

thropologist observes that people of a certain culture do not have a word for a concept familiar to Westerners. The challenge remains to forgo the notion of a gap needing to be filled, to refrain from inventing a native tradition. The more balanced use of such information is to note an epistemological difference, a point where two cultures symbolize the world differently, and where the non-Western culture is bound to absorb or integrate Western concepts within a different, home-bred gestalt.

Ousmane Sembene, the great Senegalese novelist and film director, asserts that "There is no word for 'art' in any West African languages."[3] Such important signals against the universalization of Western perspectives are not always respected. In some cultures, no distinction is made between music and medicine, and neophytes are trained in both. We may have to speak of the two functions separately in order to make sense to ourselves, but how can we remember that by doing so we are committing a violence to the worldview of others? If we could imagine some intellectual system that could mediate the radical contextual differences among the values and emphases reflected in the world's different cultural hierarchies, could we imagine that system emerging from the Euro-humanist tradition of the aesthetic, or with more difficulty, imagine it being established and scrutinized in a way that did not support the interests of the endorsers at the expense of the analyzed? The answer would have to be dubious in light of the modality of Identity/Monstrosity betrayed by the aesthetic at work vis-à-vis other cultures. We might recall the cliché about Egyptian art conforming to "rigid conventionality." Or the observation that while African cultural production includes sculpture of very high imaginative force, painting seems neglected by the Africans—as though noting a lack. The list is extensive of the occasions where difference from Western bourgeois cultural conventions assembled as aestheticism are registered as cultural deficits.

But from another angle, the question is moot. Though advocates of the aesthetic would have it otherwise, the debate over the nature of the "truth" of the aesthetic is far less important than the struggle over the control of the "truth," to paraphrase Foucault. The aesthetic would be merely another philosophical toy if it did not have the power of the art-culture system behind it, or better, if it did not provide invaluable service to that system. The present art-culture system took shape in the eighteenth century along with the institutionalization of royal academies, museums, state orchestras, powerful libraries, which merged their influence with universities and institutes of learning, professional societies, the formation of such concepts as "literature," the rather arbitrary distinc-

tion between the fine arts and the mechanical arts, to which should be added art galleries, publishing houses, newspapers, and other mass media.[4] The sociology of art and of literature has shown us how each of these institutions has been set up to protect the professional and other interests of the publics they serve. They function to control the territories they have appropriated, where they set standards, boundaries, and definitions. The art-culture system, or Artworld, as Arthur Danto calls it,[5] forms one of the machines of power/knowledge through which representations are dominated, a system that Ellison's *Invisible Man* tropes as "the Monopolated Light and Power Company." By interrogating the aesthetic we find an avenue into the defenses of the power/knowledge structure and enlarge chances of releasing cultural expression of the less powerful from its repression.

The art-culture system is one of those mutually supporting structures with which the aesthetic develops and extends its control over culture. Another is aesthetic historicism, which has been professionalized as art history. The capacity to historicize the past was a vital development for Western knowledge in the humanist period. Formal historical scholarship has been said to owe a huge debt to art history for its origins. The discipline of archaeology stimulated an interest in the past and a reconstruction of its significance. Moreover, in constructing a history of "art," Western scholarship extended the range and resonance of history beyond the chronicle of kings and political powers. As the founding art historian, Winckelmann's contribution was to assert a model of successive, stylistically identifiable ages upon the art of past societies, each generally moving through an organic process of birth, growth, maturation, and decay. The art of a society might be seen as being presented with a particular "problem," which became the object of a "movement." Once solved, this solution, combined with the changing social and political circumstances of a new historical era, presented its artists with a new "problem." The best solutions resulted in a classic period where the greatest art of the epoch was realized, as well as the subjective meaning of the period. One could then read any stretch of human experience as a meaning-laden historical narrative where history and art illuminated each other reciprocally. By this means history was aestheticized and art historicized. A feature of this construction was that the aesthetic as subject, the location of subjectivity, was implanted within each historical era of the past, more deeply humanizing the past for those who were coming to identify human consciousness with aesthetic subjectivity. It was one of the aesthetic's most powerful accomplishments.

The developing narratives of art history in which, for instance, High Renaissance was followed by Mannerist, Baroque, Rococo, Neo-Classical, Romantic, Realist, Naturalist, Impressionist, Symbolist, and Modernist ages locate aesthetic reasoning within a history from which there is no easy escape. As Tony Bennett points out, citing Brecht, "aesthetic discourse, when directed to the object side of the aesthetic relation, can result only in a politics of preserving what has already been preserved and consecrated in the judgments of the past, or of emulating, extending and adapting earlier aesthetic models to fit new circumstances."[6] A cultural producer is faced with this history much as an intellectual is faced with History in the Marxist paradigm; you either join it or are consigned to oblivion.

But joining is not always easy. The historicizing function of the aesthetic is like the classical tradition in philosophy as Rorty describes it, a conversation he wants to divert. But, as Frank Lentricchia notes, "the conversation is not and has never been as free as he might wish."[7] Like Western philosophy, aestheticism is one of those towered, moated conversations that many live by, fewer are invited to attend, and in which very few are allowed to speak. The aesthetic-historical reconstruction of human culture has become one of the principal means the Artworld uses to dominate representation. The design of this dominance follows a familiar pattern but now on a vastly extended scale. The representations of the world's societies, the means by which they discover or confer meaning on their activities and themselves, are brought within the system to be analyzed, classified, named, defined, interpreted, given their "real" meaning within the epistemological framework of this powerful system of knowledge, thus strengthening its claim to universal scope. At the same time Western structures of feeling are positioned as normative, as the events that give other cultural expression its global reference point and name, but also as transcendent, since occurring at the center of consciousness.[8]

The regulation of expression by Monopolated Light and Power (MLP) unfolds like a mythology insinuating itself as the embodiment of the natural order, shrouded in mystery. This mystification can be partly disenchanted by calculating the unequal advantage gained through MLP's control and manipulation of the relevant vocabularies. We might begin by recalling Nietzsche's unpacking the genealogy of morals while probing into the etymology of terms like "noble" or "vulgar" or "villainous" and finding terms that were once neutrally descriptive now functioning with honorific or pejorative connotations, depending on the class they

once described and the power of the aristocratic classes to form defini-
tions that legitimate their authority. The evolution of meaning relies on
the suppressed memory of root metaphors or etymologies. The denomi-
national class defines itself and its characteristics as essential and those
of others as ephemeral.

This unequal distribution of signifying power produces one of the
most reliable advantages of the powerful classes, the trope of the missing
qualifier. Here is an instance of this trope put into play on the subject of
art history:

> The history of forms evidently reflects the process by which the visual
> features of ritual, or those practices of imagery still functional in relig-
> ious ceremonies are secularized and reorganized into ends themselves
> in easel painting and new genres like landscapes then more openly in
> the perceptual revolution of the impressionists, with the autonomy of the
> visual finally triumphantly proclaimed in abstract expressionism.[9]

This is certainly not "the history of forms," but one history out of the
repertory of aesthetic historicism, of certain cultural forms where the
writer assumes the position of "universal valuing subject" in order to mo-
nopolize the interpretation of representation. The trope is possibly voiced
innocently, as a matter of habit, of scholarly convention, but it has the ef-
fect of a verbal colonization. If there is a genre of this kind of writing, it
might be described as colonial-anthropological, a mode which aesthetic
discourse shares abundantly with the human sciences and historians of
culture. The assumption of a steady march of progress, perhaps intended
half-ironically, imparts a quasi-scientific authority, a Darwinian inevita-
bility. At the same time, the rhythm is biblical: as easel painting begat im-
pressionism, which begat cubism. . . . We are being connected to an apos-
tolic succession.

The force and violence hidden in this missing qualifier, the residual
echo of prior acts of violence, is hinted in an episode of *All in the Family*.
Archie Bunker shares a hospital room with a man with a French accent,
and establishes a cozy relationship speaking through the screen that sep-
arates them. When the screen is removed, the bigoted Archie is outraged:
"Wait a minute! Youse didn't tell me you was Black!" To which Jean
Duval replies, "Neither did you tell me you were White." Archie: "But
White people don't have to go around telling people that!" The assumed
privilege echoes a kind of linguistic right invested in the subject position,
as well as a transethnic identity that carries with it a variant of unspeak-
ability.

The unequal signifying power behind this assumption is evidenced in its denial of this trope of generalized reference to all Other speakers. Writes bell hooks, "The force that allows white authors to make no reference to racial identity in their books about 'women' that are in actuality about white women is the same one that would compel any author writing exclusively on black women to refer explicitly to their racial identity."[10] The same force or principle extends even further to the need to label and delimit every other identity, including "women," that does not apply to White men. Nor could we imagine a book or television series called *Civilization* that did not refer to Western societies, as White art historian Sir Kenneth Clark's survey manages to do in reverse, referring *only* to the activities of the home team. Another familiar instance of the suppressed qualifier is the appropriation of the name "Americans" by the people of the United States, leaving all other inhabitants of the New World marooned among hyphens or localized identities. The inference of Western bourgeois centrality is also latent in such constructions as "international culture," "the world market system," or even "society."

To get to the core principle of this manipulated inequality, I propose modifying a concept from Aristotle, by way of the seminal White cultural philosopher Kenneth Burke: *entelechy*. Aristotle used entelechy to classify a thing according to the perfection or completion of which it is capable, the soul of the thing that otherwise appears in less than perfect realization. Burke identifies entelechy as placing actuality prior to potentiality, or again, as the principle involved in a form: "man is 'prior' to boy because man has already attained its complete form whereas boy has not."[11] The literal meaning of "entelechy," "having its end within itself," describes nicely the posture of entrenched, institutionalized power vis-à-vis the reality of "Others" whose ends are seen as scattered, undeveloped, or otherwise not fully realized. Taken as the dominant social structure's image of itself, the phrase also embeds the notion that this fictional social perfection "corresponds" to essential qualities in the natural order. In the critique of representation, we need to secularize the place given to soul in Aristotle's formulation in order to see how power, the power of the dominant class or social sector, establishes its practice or experience as the basis of definition for all similar instances. Entelechy, then, is a process of idealization through which the dominant class manifestation is framed as the generative and normative instance of all other manifestations.

An illustration can show how entelechy exerts a compelling force in the protection of dominant interests. I admit surprise when looking up

the etymology of the word "classic." I found that it derived from the Latin word "classicus, of the classes of the Roman people, of the first class, of the first rank." Is it too simple a reduction to say that the root meaning of "classic" is a work associated with the values of a particular, powerful social class? Not at all. This is another of those revealing etymologies of the sort Nietzsche probed in *The Genealogy of Morals*. Turn to the dictionary listing under "class" and note the relation between the idea of social strata and its root Roman use: "Latin classis class, men called to arms, fleet; akin to L calare to call, summon. . . . " Without the expertise of a professional etymologist, we can infer that the term was first taken from a group of men who answered calls to battle and were rewarded with highest rank in the society. Entelechial representation, as I conceive it, operates in just this fashion—where a category of people or activity acquires a name and definition and then that category becomes the master example for classification of "lower" forms. So that most vernacular uses of "class" as an adjective, as in "a class act," or "she's got class," carry the embedded connotation "like the upper class." There is nothing better in marketing than to have your product's name achieve this kind of totalitarian reference. Certain brand names have gained an entelechial preeminence over a genre of products, like *xerox, kleenex, Webster's*, or *Walkman*, so it becomes cumbersome and difficult to refer to them by any other than these brand names.

The entelechial moment comprises two actions, the act of violence and the act of forgetting. The violence is symbolic, the seizure of advantages of definition that deprives other people of the capacity to speak of themselves with equal resonance and conviction. But the violence of this operation must be concealed by the power of forgetfulness, at first willfully and later as a feature of "tradition." Illegitimate power always remembers what it wants to remember and forgets what it wants to forget. Once marginalized and systematically "disappeared," such knowledge sometimes falls into the category of the unspeakable. Both the violence and the forgetting are necessary to achieve the idealization, the entelechizing, that make up the dominant class's reach for transcendence. The values of the denominational class become sedimented in the activity, perhaps as "standards," and once sedimented, redefine the activity of the unchosen as unqualified or inferior. Western art becomes art, socially approved writing becomes literature, and so forth. When the cultural productions of Greece and Rome became "classic," entelechy was further duplexed by making the adjectives "Roman" and "Greek" dispensable.

The discourses of the art-cult—art, civilization, philosophy, culture, re-

ligion, class, history, the humanities, poetry, and more recently, theory—
have all undergone entelechial stratification. Once knowledge is framed
in entelechial format, it becomes canonical and functions as cultural
capital empowering students and applicants who inherit it through class
position, or who must laboriously acquire it, as Bourdieu observes, like
canonical poetry in the Mandarin examination system of education and
official promotion, or Latin and Greek language training in nineteenth-
century Europe and the United States.[12] Entelechy also helps us under-
stand why those who resist the control over meaning are handicapped
in expressing their positions or even voicing the grounds of their dissi-
dence.

Entelechy helps illustrate the way the master narrative of Euro-bour-
geois progress asserts the inflection of its supremacy upon language it-
self. It helps us to see how the aesthetic serves an ideological function far
beyond its assigned turf of the arts or sensory impressions. The aesthetic
was the means by which the Occidental middle class capitalized its hier-
archy of values over all others and attempted to designate all present and
future cultural practices as weaker variations of its own. Boxing in other
cultural practice was a part of this revolutionary restructuring of sym-
bolic value. At home, the culture of the "lower classes" was interned as
"folklore" or "popular culture," inferior variations of art. Abroad, the
categories of "traditional," "exotic," and "primitive" subordinated the
cultures of humanity.

One of the by-products of entelechy, bearing the give-away linguistic
trace of colonialist triumph, shows up in a rhetorical convenience we
might call "duplexing." A duplex term signifies on two levels, one de-
scriptive, and one promotional. The descriptive usage serves for both or-
dinary and elite social contexts. The honorific signifier is reserved for
elite usage. Key duplex words include "literature," "class," "philosophy,"
"civilization," "history," "religion," "poetry," "modern," "culture." A cer-
tain sign of duplexing is the denial by the cultural guardians of the em-
powering side of these terms to those being paganized, as in the routine
formula "They have no this, they have no that. . . . " One much-cited in-
stance of duplexing is Matthew Arnold's redefinition of culture as an at-
tribute of the acquisitive, high-achieving middle class, severing the term
from other common uses with a capital "C." But the same history can be
read into the other duplexes where the art-culture system of Europe dur-
ing its Imperialist phase italicizes its own practices and interpretations
away from the common run of humanity. For fear the point might be
missed, the modifier "true" is sometimes substituted for the suppressed

modifier "certifiable Euro-humanist." "True art is. . . . " The duplexing of the vocabulary of cultural interpretation puts those outside the conversation at an extreme disadvantage. They can hardly speak the name of such activities and interests without automatically invoking the scales and canons of an aestheticized history that insists that their intervention is marginalized, even before it is uttered. By manipulating the terms of value definition, Euro-humanism commandeers that language for its privileged use. In ancient Egypt, the use of hieroglyphic script by unauthorized persons was punishable by death.

The word "art" has undergone significant duplexing. As it now stands, there is the elevated form, often enunciated by initiates into its mysteries with an aspirated, awed vowel articulation, the very mark of affectation mocked by outsiders. And there is the lower-case, everyday denotation, as in "the art of lawn-mowing" or "the art of political canvassing." A duplexed word often betrays a linguistic-social history. The duplexing of "art" in Western societies obviously took place when the elite concept arose to distinguish itself from earlier conventional usage as skill, its neo-Platonist idealism developing as part of the systematic humanist rewriting of knowledge. This historical fissure within a previously simple expression was further consolidated during the Euro-enlightenment, when the distinction was placed between "folk art" and elite art, and then between the *fine* arts and the *mechanical* arts ("fine" being synonymous with "true"). The trail of successful duplexing is often found in dictionaries, in the gap yawning between definitions 1 and 2.

We can see how duplexing takes place in two ways. One is to bifurcate a word already in common usage, like "art," meaning "skill," and elevate, capitalize, and royalize one aspect of it into a new definition. A serious effect of this maneuver is the downgrading of the activity in the older, more conventional meaning. Where those who practiced "art" in the Middle Ages were all thought of as equals, after "Art" rose from the ranks into its self-appointed sovereignty, the other arts were transformed into commoners, discredentialed as "mere" skills. In these strategies the humanities keep company with advertising where a product will be presented boasting new features that put older versions out of date. There, it is called "product definition." The other mode of duplexing is less bifurcation than mutation. The practices of privileged or ascendant groups are extended as models into which the performances or characteristics of other groups are indifferently squashed.[13]

For aestheticist claims to universality, duplexing shares work with duplicity. On the upper, capitalized level, universality is applied to work

authorized by the Artworld. On the lower-case level, the practices and values of other human cultures are perceived as "aesthetics," enough to bring this activity within the defined space of the system (for which it is easy to be deluded into gratitude). But just as "class" always implicitly honors the values of the upper class, "the aesthetic" always draws its categorical authority from dominant cultural symbolism. Variants demand delimiting modifiers—Oriental aesthetics, Bantu aesthetics, Baule aesthetics, Mayan aesthetics.

Attempts to neutralize the colonizing distinction between the aesthetic and variants have been interesting. They include "general aesthetics" and "denominational aesthetics" as opposed to the more localized varieties.[14] But these turn out to be euphemisms. So we can see that the intervention of the Black aesthetic was both modest and revolutionary. It was modest in the sense that, despite voicing the unspeakable, it was in its mildest form demanding a place in the Artworld. The concept of a Black aesthetic at first carried a shock value, challenging White exceptionalism, as when the Greek vase in the Rubin illustration (see Figure 1) becomes negative space when the background black faces became the foreground. But the system can ultimately absorb the intervention of a Black aesthetic and other variants within the lower-case category of ethno-aesthetics, where they will occupy a domesticated, regulated space in the grand narrative. Despite the liberal and sometimes radical intentions of its formulators, the field of ethno-poetics proceeds toward a similar domestication.

But where the Black aesthetic asserted a truly revolutionary thrust was in unnaming the aesthetic as "the White aesthetic."[15] By supplying this repressed modifier, the Black aestheticians let a certain cat out of its ideological bag. They prepared the grounds for understanding that there is virtually no other animal in that zoo. That is, by retracing the invention of duplex universality, resisting the limitation of marginalized speech, and undoing the many acts of symbolic violence enacted in this invention, we arrive at the undercover identity of the aesthetic as an agent of Monopolated Light and Power.

The control of language by the art-culture system puts the resisting speaker in several difficulties. The "unnaming" of repressive concepts and narratives creates an awkwardness, the obligation to mint new verbal coinages that will doubtless be recorded as barbarisms by conventional humanists, that may confuse sympathetic readers, and that may be subject to the criticism of eccentricity. Another awkwardness arises from the itch to put suspect terms in quotation marks. In *Gone Primitive* Marianna Torgovnick ponders whether to place quotes around "primitive" as a mis-

representation, yet indicating something perceivable in reality; in the absence of an alternative description, she opts to use the term without quote marks. A similar dilemma is marked by the need to reframe the term "aestheticism," or the option of using a term like "Euro-aesthetics," which has the advantage of suggesting the limits of its reach, but the disadvantage of postponing the realization of its entelechial positioning. Yet these difficulties also constitute opportunities, they provoke thought, and wrestling with them becomes part of the process of extraction from the verbal malaise of the dominant symbolic order.

As an ethnic gaze pretending to be a universal perspective, the aesthetic maintains an ethnographic "watch" over the cultural productions of non-Western societies. Even when the aesthetician acknowledges the boundaries of his cultural scope, we hear the echo of that old Euro-enlightenment conversation starter, why are we so much better? This familiar genre of criticism is worth an illustration, from White film critic Vincent Canby, at the time the chief film reviewer for the *New York Times*, comparing two films, one Chinese and the other Euro-avant-garde, by Godard.

In two articles, Canby finds Chinese films, particularly *Red Sorghum* as representative of Third World films generally, to be lacking when compared to the more "advanced" cinema of the West, even while he acknowledges the dearth of important films coming out of the West in recent years. In "Before the Revolution—and After," he compares the Chinese film with one by Jean-Luc Godard:

> "Red Sorghum" is a large-scale, occasionally and unexpectedly ironic tale of rural Chinese life from the 1930s through the Japanese occupation to the triumph of Communism. The Godard work, the first of a planned television series, features Mr. Godard in profile, sitting before what seems to be a computer . . . as he talks about cinema for 26 sarcastic, witty, sometimes self-mocking minutes. This is the kind of idiosyncratic, personal film making that no revolutionary society could produce, nor, I suspect, tolerate.[16]

Canby's preference for Western over non-Western cinema is less interesting than his illustration of what Laura Kipnis calls "aesthetics as foreign policy." In this kind of criticism, "foreign policy becomes a lived relation of perception and knowledge that here exists in the practice of the aesthetic judgment."[17] The internalization of "rationalistic" processes to monitor private, sensory impressions that Eagleton perceives as a major achievement of the aesthetic, thereby extending institutional control, is demonstrated by Kipnis in the realm of ethnographic responses. Aes-

thetic judgment becomes the pretext for self-indulgent, inconsistent opinionizing. The duplex definitions assure the universality of perspective, including them and us, but then reneges on this inclusiveness by reverting to a monocultural universe of values. Canby adopts the patronizing irony of adults surveying the efforts of children in the game of culture—a position routinely adopted by the art-cult largely on the basis of its originary relationship to the aesthetic:

> "Red Sorghum" may well be a so-called personal statement by its director. If so, however, it again demonstrates that personal statements by artists in evolving societies tend to be far less personal than those of artists in societies a little further down the road. Neither better nor worse, but different.
>
> This is understandable. A culture still in the process of defining itself is full of hope and anticipation. There is tremendous excitement in the possibility of things yet to be realized. There isn't time to worry about identity crises and whether or not something is real or just the illusion of reality. These are the luxuries of advanced societies that are populated by the rich, the bored and the worn out.
>
> In this country, Western Europe and Japan, the most independently minded and talented directors turn inward, like Ingmar Bergman, Michelangelo Antonioni and at the moment, Woody Allen; or if they look outward, they satirize the world around them with varying degrees of amusement, affection and outright scorn. Think of the best work of Federico Fellini, Jonathan Demme, Juzo Itami, Francis Coppola and Martin Scorsese.[18]

The inconsistencies of argument allowed in this kind of criticism are rather remarkable. In both articles, Canby notes that "no Chinese Eisenstein has emerged," while forgetting to notice that no Eisenstein has emerged in any other country, either. "When the artist is of the stature of the innovative Serge Eisenstein, whose roots were in pre-revolutionary Russia, the effect of the work produced can be appreciated far beyond one country's borders." This is a strange observation for a film journalist who has himself just reported the popularity of *Red Sorghum* at Cannes and its award of the Golden Bear at Berlin.

Canby's rhetoric moves somnambulistically through a preordained aesthetic narrative so persuasive on its own that it does not require him to think what he is saying. The buzzword "identity crisis," goes unexamined, for instance. The revolutionary and emerging societies he speaks of are passing through such crises of identity that their intellectuals find time for hardly anything else. Nor are such crises absent from their films, as one might see from considering, for example, *Spring River Flows East,*

Memories of Underdevelopment, Xala, Heritage Africa. Canby doubtless fails to recognize such crises because they are simultaneously individual and societal, while those he imagines are more deeply concerned with the construction and consumption of one's "image."

The strategy of duplex reasoning is reflexively put into play here. The denial of bias is formulaic. The non-bourgeois films are "Neither better nor worse, but different." Yet later he patronizes them as "awfully provincial" and "not terribly exciting except as sociology." The duplex organization of aesthetic values is arranged through a sometimes predictable, sometimes pathetic set of oppositions: advanced/emerging; personal/sociological; bored and ironic/hopeful and excited; adult/immature. We know the genealogy of these attitudes and the license that privileges them. But Canby and his contemporaries are not as crude as Jefferson finding the impossibility of Black intellectual development, or Hume insisting that civilized achievements can only arise from White societies. The privileges of aesthetic judgment have shifted. Instead of the bourgeois gentleman of good health and good taste who was formerly the arbiter of aesthetic judgment, Canby privileges "the rich, the bored and the worn out" as the subject position from which criticisms of the poor can be ironically launched. Whatever happened, we might ask, to the dubious aesthetic value of universality of theme and reference? There is surely more of this quantity in *Red Sorghum*, a tale of a young woman trapped into a forced marriage and seeking her revenge against a society that has betrayed her possibilities, than in Godard's personal reflections about cinema that probably travel less well than the Chinese film.

The inwardness Canby sees as the reigning character of superior Western films may more accurately reflect a recent direction of aesthetic reasoning, away from the pretense of objective valuation and universal standards of judgment and into the attitudes and postures of small coteries gathered around narcissistic preferences. The serious pretenses of the aesthetic have worn away, by this testimony, replaced by the assurances granted by the discursive power of the Artworld that the writer speaks for. In this historical frame, the aesthetic authorizes any manner of arbitrary, self-contradictory arguments with the conviction that they may be accepted as reasonable. The recent fashion is to base aesthetic judgment on an ironic worldview limited to a particularist, subjective history. White film historian Gerald Mast echoes this posture in a recent Third World chapter of a much-reprinted college text: "Unlike the Marcel Ophuls documentaries, these Third World chronicles [*The Hour of the Furnaces* and *The Battle of Chile*] are ideologically simplistic and one-sided. . . .

enriching ironies and complexities are luxuries that only pluralistic democratic nations can usually afford."[19]

In the rhetoric of Canby and Mast, aestheticism as a defense of privilege is unmasked as chauvinism. Expressive ironies may exist between socially burdened individuals and powerful external forces—the irony of a pluralistic democracy like the United States manipulating the overthrow of the popularly elected Allende government in Chile, for instance. But such representations are dismissed by this kind of critic who respects only those ironies that depoliticize a text in favor of personal quiddities.

The context of Canby's pieces in the *Times* provides an interesting subplot to his rhetorical strategies. The first article was written from Cannes when the news broke of an intramural coup that had ousted the director of the New York Film Festival and replaced him with Richard Pena. Pena was known to favor more genuinely international material, including Third World films, than the francophile programming of his predecessor. Canby's second article, about films that "don't travel well," was written days later as a review of selections that Pena had programmed for the New York Festival, including *Red Sorghum*.

From the outside, dominant Western discourse looks much like a Crystal Palace inside which legions of residents, having accepted the inheritance of the subject position from which knowledge is universally contemplated, narcissistically discuss "the world." The Palace's many buildings rise in splendor from plains made barren by its levies of exorbitant tribute. Some of the tallest and most decorated structures are the towers of High Culture where the world's great art is housed, fetishized by guardians and hirelings who fabricate theories of aesthetics to lend credibility to the preservation and exaltation of these hieratic objects.

Huge batteries of light play across the facade of the Palace blinding those who approach it with unshielded eyes. At other moments the gigantic structures block out the sun. The surrounding plains have seen of late many bold and colorful structures rising from the marshes and weeds, only to be disassembled and erected elsewhere. These gypsy edifices are said to pose a nuisance to the Palace residents, who claim that the noises rising from them disturb the classic air and damage property values. Whether because of arrogant missiles hurled by the envious or because of the mounting cost of repairs, the Palace's pink magnificence has shown signs of recent decrepitude. At odd hours one can hear the shrill tinkle of crashing crystal.

A NOTE ON ASIAN PHILOSOPHIES OF ART AND BEAUTY

Throughout most of this discussion I write about aesthetics as virtually a Western phenomenon, insisting on its provincialism over and against its claims of universality. I have more than once been challenged and directed to consult ancient aesthetic traditions in Asia. Without firsthand linguistic or cultural knowledge, I can only comment on my findings after a cursory glance at the question. The issue of Indian philosophies of art is most germane, where the resemblance to Western aestheticism is most striking. What is clear is that ancient Indian winters developed philosophies of art, beauty, and taste that offered the most sophisticated and exquisite calculations of pleasure and emotional enrichment. These philosophies of art arose as poetics useful for explicating the great Indian epics and other versified works, as well as critical criteria for drama, but extended to the appreciation of food, sex, and everyday experience. The flavor of these philosophical theories causes them to resemble somewhat the neo-Platonic theories of art and beauty where idealism and spiritualism play a very central role. Speaking of two crucial concepts of Indian art-philosophies, one scholar writes, "When we talk of aesthetic experience or rasa-experience and the dhvani structure, we must keep in mind the Indian world-view in which it was developed. In this world-view aesthetic experience is not divested of its spiritual dimension. . . . "[20]

Even at a superficial glance, the breadth, depth, and thoughtfulness of these systems is transparent. Moreover, they produce constant reminders of analogues in the Western tradition of aesthetic philosophy. But these systems, dating from the eighth and ninth centuries A.D., are powerful enough to raise the suspicion of their forming the basis and origin of much European speculation about art and beauty, particularly of the sort common in Renaissance European writing. European philosophies of beauty may very well be indebted to these earlier Indian and Asian conceptions, though this is an indebtedness difficult to find documented in English.

But why should we be surprised that highly developed and intelligent systems of thought have occurred outside Europe, and at an earlier date, unless we subscribe to philosopher Hume's assertion that there never was a civilization other than that created by White men? The great beauty, ingenuity, and polish of much Asian creative work, like all the extraordinary cultural works produced by most peoples, must be read as achievements by design and not as accidents awaiting modern Western interpre-

tation. This design must necessarily be accompanied in most instances by theories or principles of guidance appropriate for the execution of the work. It seems likely as well that the richer and more powerful the social organization producing cultural work, the more expensive, labor-intensive, and grandiloquent the work may be, suitable for the accouterments of a refined court; and the leisure of such an aristocratic setting may advance the production of theories of taste.

Here we can easily read Indian philosophies of art as "aesthetics" only in the loose sense that fits that description after the Western ideology of art has extended itself into a universal category. In the more specific usage of the term, there is doubt. On a crucial issue, one writer points out: "It would appear to be wrong to speak of Indian Aesthetics until recently, for there was no such separate study or science in India corresponding to Aesthetics as a separate philosophical study of art as conceived by Western aestheticians."[21]

This finding brings us to a paradox. While Indian thought may not have preoccupied itself with a unified field describable as an aesthetic until recently and with the Western model in mind, the history of that thought is very rich in disparate discourses where idealization of beauty is abundant. A cursory glance convinces that "some of the aesthetic issues raised and theories put forward by aestheticians of India from about the beginning of the Christian era up to about the 10th or 11th century A.D., are vital issues of contemporary Western aestheticians."[22] It is Rao who completes the paradox: "If, in Baumgarten [who coined the term "aesthetics"], there was a name without a muscular body, here, in India, there was a muscular body without a name."[23]

This fine metaphor is all the more helpful under a fuller glance. There were many muscular bodies in many societies that might have supplied material from which aesthetics might have constructed itself. But that is surely true of all concepts and philosophical innovations. No theory springs into being from thin air. What Rao's figure of speech clarifies is the approximation, after the fact, of Indian philosophies of art and beauty to later, Western aesthetic philosophy, much as occurred with ancient Greek philosophies of art and beauty.

This issue is clouded by another problem created by entelechial Western definition. At stake in the question whether Indian philosophies of art and beauty constitute an aesthetic may be the role this question plays in another: does Indian systematic thought constitute philosophy as Western knowledge defines it? It is unfortunate that the arrogance of Western intellectual history leaves such questions in its wake. But I do

not see the need to assimilate Indian thought on art and beauty to aestheticism in order to grant full respect to Indian cultural and intellectual achievement.

A distance stretches between Indian art philosophies and aesthetics on the grounds of universalist claims. This is another instance where Foucault's notion carries persuasiveness: the struggle over the control of the truth may be more important than the struggle over the nature of the truth, when, in this case the truth applies to the character of beauty. Whatever claims of universality world powers may have made for their cultures, they are tame beside the Eurocentric claims of the aesthetic. Ancient or modern Indian or Asian systems of taste do not carry an overbearing impact on cultural expression outside their national boundaries, except maybe in a few isolated instances. However the elite, courtly, or imperial systems of taste in India, China, or Japan, control and/or oppress cultural production in those national contexts, that kind of influence is of another order beside the aestheticism that supports the Artworld stretching out from Western capitals. For as Tony Bennett writes: "Aesthetic discourse, by contrast, is the form taken by discourses of value which are hegemonic in ambition and, correspondingly, universalist in their prescriptive ambit. . . . "[24] By this measure, it is only aestheticism as concocted in the West that need preoccupy us. (As for a practical illustration, an examination of *Books in Print*, in the United States, for 1992 showed over eighty titles with only one of them indicating any interest beyond the familiar Occidental self-preoccupations.)

CHAPTER IV

∎

A Drowning Man Offers You His Hand

SALVAGING THE AESTHETIC

... I was obliged to stress the distinction between my position and the position that, in a world of massive brutality, exploitation, and sexual oppression, advocates an aestheticization of life. Here I must stress that I am also not interested in answers to questions like "What is the nature of the aesthetic?" or "How are we to understand 'life'?" My concern rather is that: 1) The formulation of such questions is itself a determined and determining gesture. 2) Very generally speaking, literary people are still caught within a position where they must say: Life is brute fact and outside art; the aesthetic is free and transcends life. 3) This declaration is the condition and effect of "ideology." 4) If "literary studies" is to have any meaning in the coming decade, its ideology might have to be questioned.

—Gayatri Spivak, *In Other Worlds*[1]

What is at stake in aesthetic discourse, and in the attempted imposition of a definition of the genuinely human is nothing less than the monopoly of humanity.... The opposition between the tastes of nature and the tastes of freedom introduces a relationship which is that of the body to soul, between those who are "only natural" and those whose capacity to dominate their own biological nature affirms their legitimate claim to dominate social nature.

—Pierre Bourdieu, *Distinction*[2]

What price does the barbarian pay for his or her participation in aesthetics?

—Christopher Miller, *Blank Darkness*[3]

Various camps have made the decentered subject a political program. This paper proposes a post-aesthetics as its counter-part.

—Laura Kipnis, "Aesthetics and Foreign Policy"[4]

> Words walking together without masters; walking
> altogether like harmony in a song.
> —Zora Neale Hurston, *Their Eyes Were Watching God*[5]

Even while undergoing a postmortem, the aesthetic might tempt us to consider it unhistorically, as an unchanging essence. And in the rush to dismiss it, we might make the mistake of viewing it as an entirely repressive exercise in all its phases since its invention. The aesthetic as re-membered in the previous chapter is seen primarily in its neo-classical formation. But its modes and motives altered as it evolved, picking up new functions and answering to the needs of new and different subgroups of the European intelligentsia. From the beginning aesthetic reasoning, with its confluence of morality and beauty, hosted a "feminizing" dimension, an appeal to a kinder, gentler mode of living, to "our" higher natures, as in Shaftsbury, Burke, etc.[6] With the Romantics, the aesthetic was transformed into an oppositional ideology against the materialism and utilitarianism of capitalist-industrial society. Poets found in the works of art and literature an organic structure that equivocated the reproduced world and made visible the essential qualities of humanness imperiled by rationalistic and mechanistic self-interest. The autonomy of the work of art became an even greater priority for the Romantics than for the neo-classicists because it was equated with the autonomy of the individual. A similar equation linked the ineffability of the art-piece and the human individual. By defending the inexplicable meaningfulness of art-work, Romantics saw themselves as defending the mysterious complexity and unexplainable richness of human personality. "A poem should not mean, but be" assimilates a Romantic theology, and implicitly argues that that being, like a human being, should be allowed to live and flourish in a condition similar to that of a poem's ideal existence.

At this point in the nineteenth century, the aesthetic took on its long-lasting role as a refuge from the world of material accumulation, claiming a privileged public sphere that tolerated, justified, and nurtured those wayward sons of the bourgeoisie emotionally unequipped to go into the family business. In interesting ways its career paralleled the religious sector that, after being dethroned from its position as authoritarian center in the Middle Ages, returned as the repressed in the form of a compensatory sanctuary from the brutal give and take of the rationalized workaday world. Under Romantic guidance, the aesthetic made much of this religiosity, returning to the comparison of poet and priest, aestheti-

cizing medievalism, and fashioning the "way" of art into a utopian ideology of salvation.

Yet in all this Romantic philanthropy, the aesthetic never surrendered its identity as a middle-class perk, never relinquished its patriarchalism (softened through feminization though it may have been), nor its racism. Some cultural philosophers aestheticized the common man, as creator of folklore, as resilient national stock, as fabricator of popular speech—which is to say they appropriated useful characterizations of the vernacular for their project, as they necessarily had to do in order to appropriate the human as an object only to be understood and properly valued when rewritten through the ideology of art. But as the grind of industrialism battered the working classes, a shrinkage also took place: aesthetic ideology moved away from grimy workers, aghast at the extent to which working people were apparently turning into soulless "mass men," already lost to the human experience that now only the work of art, and by association, its makers and refined appreciators, could redeem. The arguments of "bread and circuses," that the culture of the masses, or lack thereof, constituted a real danger to the more refined possibilities of life, returned in full force, along with the inclination of European elites to envision the mass with terror of being engulfed by their brute barbarism.[7] This shrinkage from mass man is apparent in Matthew Arnold's recreation of Culture as an opposition to mass democracy, or "anarchy," but was widespread in the later stages of the nineteenth century and became dogma among many modernists of the early twentieth century.

At this moment, high art ideology was positioned precariously between the capitalist employers and the drone workers who were their "hands," its arguments being pushed into extravagances of "decadence" and the social isolation that would become the mark of the modernist artist. The social consequences of this positioning have been icily but accurately summarized by White art historian Arnold Hauser, writing of the German "Sturm und Drang," in ways that apply to the later career of this worldview:

> Whole classes of society and generations do not voluntarily relinquish the world; and if they are forced into doing so, they often invent the most beautiful philosophies, fairy tales, and myths, in order to raise the compulsion to which they have succumbed into the sphere of freedom, spirituality, and pure inwardness. . . . The world that had become foreign and inimical did not propose to offer itself as material for the pre-romantics to mold into a finished shape, and so they made the atomized structure of their world-view and the fragmentary nature of their motifs symbols

of life itself. . . . From being the enemies of despotism they, therefore, be-
came the instruments of reaction and merely promoted the interests of
the privileged classes with their attacks on bureaucratic centralization.[8]

From the Romantic period onward, the aesthetic functioned as a sym-
bolic currency legitimating cultural producers whose social and economic
positions had eroded under the cash nexus of capitalism. In plainest
terms, the ideology of art justified its value as rationale for the profes-
sional and economic interests of artists. This social and economic self-
interest, mediated through symbolic terms, was never absent from the
construction of a sanctuarial aesthetic social sphere.[9]

The aesthetic public sphere earned its keep within the Western devel-
opmental powerhouse, not merely by offering "circuses" to distract atten-
tion from the shortage of bread. The nineteenth and twentieth centuries
produced a series of energetic and increasingly desperate art movements,
each more radical in commitment to extremist aesthetic positions than
the last. Each rebelled against the reigning academic code of aesthetic
knowledge, denounced as reactionary, only to form a new aesthetic vi-
sion, which in its turn would become a target of a still newer movement.
What this activity amounted to in the last instance is not easily deter-
mined. Maybe this "movementitis" merely helped to redecorate subjec-
tive consciousness in ways that would have occurred anyway, in make-
overs where artistic consciousness simply became the stalking horse for
popular consumerist orientations, much as the length of women's skirts
has been read as social barometer. More certain is that these movements
never completely defeated classical aesthetics, but left in their wake a resi-
due of neo-classical truisms that were delivered as gospel to working-
class populations by way of the educational system.[10] The democratiza-
tion of education brought more and more individuals into a widening
public aesthetic space, more rapidly domesticating the latest attempt to
shock the bourgeoisie.[11]

The triumph of art ideology, which left it dominant in high and mid-
dle-brow culture and deeply influential over popular culture, raised so-
cial contradictions to a point where the illusion of art as a transformative
social agency has become less and less supportable. What I want to ac-
count for in the following pages is the response to this situation by a
number of art-culture arguments that have had to face these contradic-
tions and the resolutions they have attempted. It is characteristic of the
contradictions and utopian illusions of art ideology that some of its vic-
tim sectors are among the most zealous in keeping it alive in its sunset
years. These include those self-defeating paradoxes, feminist aesthetics

and Marxist aesthetics. To begin, I want to look at the European avant-garde, a social phenomenon whose very existence embodies the crisis in aesthetic reasoning.

THE AVANT-GARDE CHALLENGES THE SYSTEM

> I am trying to say that a "liberationist aesthetic is a contradiction, an impossibility, a lie."
> —Michael Sahl[12]

The European avant-garde of the 1920s was one of a string of anti-classical aesthetic movements that began with the Romantics, seeking emancipation from the prison-house of eighteenth-century classical aesthetics. They aimed not only to overthrow the original theoretical base, but also to thwart the dominating social order for which the doctrine had become a principle cultural governor. Yet each of these anti-classical movements merely shifted the furniture of their prison, or enlarged its terrain.

There was a double action or dialectical contradiction in each of these movements. One thrust was to overthrow aesthetics as was then known, whether in the form of neo-classical principles or the traditions of the academy or the standing literary canon. This was the action Adorno had in mind in speaking of negative dialectics and negative aesthetics. But the other thrust was affirmative, as Herbert Marcuse noted, attempting to preserve and build on the utopian dimension in art and literature as a hoped-for alternative to the society of exchange value. Schiller's vision of the aesthetic as the basis of an education which would enlarge the moral capacities of humans is an early instance of this utopian mission, and generally taken as proof of the ennobling function of aesthetic reasoning. (But Martha Woodmansee's rereading of Schiller's *Aesthetic Letters*, finds a contempt for the general run of humanity, fueled by doubts about the efficacy of the French Revolution, forming parts of a rationale of ideal art that turns out to be a self-interested defense of his own position in the literary world.)[13] To anticipate the contradiction these anti-classical artist-thinkers were caught in—part of the pathos of the modernists—White German philosopher Marcuse observes how this affirmative or utopian motive in anti-classical art and literature is recouped by legitimated society as an endorsement of its order.

Their double-action resistance took the form of an increasingly "radical idealism," as Paul de Man describes it,[14] producing ever sharper denunciations of conventional middle-class living and its cultural appara-

tus, while postulating alternative utopian visions characterized by withdrawal into a life-plan of rarefied aesthetic experience. The inevitable dead-end position was reached by the movement of Aestheticism.[15] With Aestheticism the paradox became complete: the struggle against bourgeois control of imagination through the control of aesthetics resulted in aesthetic solipsism.

The stage was thus set for modernism and the avant-garde. The important distinction made by Peter Burger is useful in calibrating the frustrations imposed by the art ideology on the artists it was supposed to support. Where modernism attacked all previous traditions of art and literature (an anti-aesthetic gesture of a particular sort), the avant-garde of the 1920s attacked the institution of art itself. All of these successive anti-classical resistances to art formulas carried an implicit critique of aesthetics as such—a set of logical implications that the resisters usually chose not to focus and make a point of attack. When we come to the dadaists and surrealists, the attack on the institution of art becomes explicit.

Dadaism, the most radical movement within the European avant-garde, no longer criticizes schools that preceded it, but criticizes the institutionalization of art, and the course its development had taken in modern society:

> The concept "art as an institution" as used here refers to the productive and distributive apparatus and also to the ideas about art that prevail at a given time and that determine the reception of works. The avant-garde turns against both—the distribution apparatus on which the work of art depends, and the status of art in bourgeois society as defined by the concept of autonomy. Only after art in nineteenth-century Aestheticism has altogether detached itself from the praxis of life can the aesthetic develop "purely." But the other side of autonomy, art's lack of social impact, also becomes recognizable. The avant-gardist protest, whose aim it is to reintegrate art into the praxis of life, reveals the nexus between autonomy and the absence of any consequences.[16]

The classic example of dadaist anti-art is of course the Ready-Mades of Marcel Duchamps, including such objects of mass production as a bottle drier and most notoriously a urinal, entitled *Fountain* and signed fictitiously by R. Mutt. This "manifestation," as Burger describes it rather than as "work of art," made several statements at once. It exposed the arbitrariness of the aesthetic category: any object signed by an artist and placed in a gallery achieves the status of art. So much for the essentiality of art.[17] The Ready-Mades of Duchamps were making a similar point: not only the reputation of a work of art, but even its definition as art is an

artificial construct. Duchamps was at the same time attacking the mystique of the individual producer of art by choosing a mass-produced object. By focusing on the most everyday objects, Duchamps, like his fellow avant-gardists with their collages and montages, attempted to redirect the notion of art back to the practices of common experience.

These gestures, happenings, and manifestations, however striking as provocations, suffered, we know, the fatality of Euro-modernism, to be absorbed into the system they denounce. The system enlarges itself to embrace the urinal. As Harold Rosenberg says somewhere, "Art history is always waiting." It is possible to look back from a position outside aesthetic reasoning and view the introduction of ugliness in art (and with it the implicit rejection of the beautiful), of dissonance, fragmentation, non-narrativity, pastiche, etc., as evidences of a long history of attempts to escape the clutches of aesthetics.

Why did they fail? They failed—and this includes our contemporary neo-avant-garde, the postmodernists—because they break with one entrenched formulation of aesthetics only to launch into another more brutish, transgressive one. For Pierre Bourdieu, the "miraculous dialectical renewal, the countless acts of derision and desecration which modern art has perpetrated against art have always turned to the glory of art and the artist. . . . "[18] They may break with tradition, but they are unable to break with the art-culture alignment itself, or with its values and adjacent affiliations, enough to make their break effective.

The failure of high modernism and the avant-garde to clear their moorings is made plain in another history, with lessons for the future. Modernists and avant-gardists made forays outside the European context for artifacts that embodied the dream of escape from their cultural predicament—artifacts and images that mysteriously implied imaginative worlds vibrantly aloof to the bourgeois paradigm, or to "civilization," as they would like to say. But typically they made predatory raids on these exotic cultural treasuries while refusing to link these artifacts with their historical and political environments.[19] In their dealings with the non-Western world, the difference between modernism and the avant-garde is invisible. They remain Euro-colonizers, even though they play the game of being cultural outsiders in imitation of the peoples whose cultural works they appropriate. Valuing the artifacts of Africans and Polynesians for just those qualities that otherwise dictated their paganization in Western moral judgments, they attempted to masquerade an equivalent alienation. But their self-paganization amounted to little more than party masks, that they donned and took off at will. The crucial role of the primitivist

fever, or let us call it "jungle fever," in the invention of modernism was not imposed on Euro-modernist artists. Dadaists affected "savage" identities eagerly, "playing in the dark," as Toni Morrison would describe it.

The same consumption of the primitive Other is found in dada, German expressionism, and cubism. The photocollages of Hannah Hoch entitled *From an Ethnographical Museum*, that mixed images conventionally signifying European beauty with images of African art, attack conventional meaning-codes through dadaist irony; but they make their point through the inference of the African images as being synonymous with ugliness. The same is true of Picasso's use of African mask imagery in his path-breaking *Les Demoiselles d'Avignon* where it signifies the moral abandon appropriate to the brothel that is its setting. Picasso is said to have told Malraux that the African sculptures he saw at the Trocadero were "against everything," thus supporting his feeling that "I too am against everything. . . . everything is an enemy! Everything!"[20]

But Michael North has also found this Euro-modernist appropriation of non-White cultures heavily present in Anglo-American modernist writers like Joseph Conrad, Ezra Pound, T. S. Eliot, Gertrude Stein, Waldo Frank, William Carlos Williams, and many others. He shows the appropriation of Black dialect in modernist literature to play a similar role to that of the African mask in modernist visual art, concluding that "dialect became the prototype for the most radical representational strategies of English-language modernism."[21]

Presumably there were no African carvers in Europe to compete with the interpretations of their work by dadaists and other artistic adventurers. But there were such Black American writers as James Weldon Johnson, Zora Neale Hurston, Jean Toomer, Sterling Brown, Langston Hughes, and Claude McKay who were inventing Afro-modern literature by basing their work on the vernacular of their people at the same time that this speech was, as North demonstrates, a crucial element in the construction of Anglo-modernist writing. A revealing part of the story North tells is the denial of the identification as modernist to these Black writers by their White contemporaries, as well as the discouragement of the Black writers to use the same dialect forms that the White writers were capitalizing on: "Though they were often quite happy to predict great things for black writers in the future, for the present these folk materials and cultural creations would remain raw material for white writers to use."[22]

What North calls this "vampirish" relationship between White cultural producers and non-White subject matter has another dimension beyond the cultural sphere. They spurned the chance to consider joining

these cultures and peoples in their struggles against slavery and colonialism. What marks the limits of Euro-modernism here is its intensity in rebelling against Monopolated Light and Power, while ignoring its role as racialized imperialism or as patriarchy. Modernism wrote a master narrative for its own evolution which, given these limits, was necessarily tragic.

Europe's anti-classical dissidents failed to see, or to acknowledge in any serious way, the commonalities between their alienations and the suffering of societies exploited by Western capital. What they had in common with the colonized was the source of their discontents. It was the same social machinery that industrialized the mind of the West and alienated and marginalized its artists that also disrupted traditional societies abroad, through slavery and colonization. Imperialism was merely domestic exploitation exported. The ruthless manner in which colonized societies were herded, through taxation and other ruses, into a money economy, was only a replay of the sixteenth-century disenfranchisement of British yeoman farmers through the ruse of enclosures.[23] It was only a matter of time before the role of artist in Europe was "individualized," stripped of the protections of patronage or communal solidarity and thrown unprotected into the marketplace, just as self-sustaining farmers had been centuries earlier.

With only a few exceptions (like Louis Aragon), the cultural rebels of the West stood by and watched the mounting resistance of exploited populations—the Haitian revolution, the anti-slavery movement, the struggle against colonialism, cultural reconstructions of the type of the Harlem Renaissance, Negritude, and finally the Third World revolutions—while ignoring that these were also their struggles, if they were truly in opposition to industrial dehumanization. By accepting their membership within the palatial grounds of aestheticism, and standing on their professionalism, Euro-modernists as a group copped out through their all-purpose a-political escape clause. Maybe this defection should come as no surprise, since we have already seen, in the example of Arnold's "Culture and Anarchy" the abandonment by the Euro-modernists of the possibilities of the European working class, their racial brothers. The myth of an autonomous aesthetic sphere incapacitated them for such connections, at home or abroad.

This is a costly incapacity, since it shows their inability to grasp their entrapment from a position outside the dominating paradigm. Were they truly able to step outside the field of dominant power, they might have found modes of resistance more powerful and authentic than their ges-

tures of martyrdom. But their complicity with the cultural system that confined them is reflected in their failure to include more than a few women or any non-Westerners in the ranks of their exclusive, high modernist circle, at least not with sufficient conviction to enlarge the modernist canon. Does it not tell us something that of all the societies, circles, disciplines, professions among Western social organization, the ranks of the artistic modernists is the most exclusively White and male club of all? Not only does it tell us much about the seriousness of their reputed mission; it tells us much about the self-limitations they have imposed in their rush to embrace failure and fulfill their tragic vocation.

Part of the blindness of Euro-modernism and the avant-garde was the illusion that their retreat into the aesthetic sphere established a real difference from their neighbors. The failure of modernists and avant-gardists to extricate themselves from aestheticism, or what they perceived as its stultifying limits grew from their deep indebtedness and commitment to a social order they proposed to despise. As Robert Stam points out, "The modernist desacrilization of art is an ambiguous one, for modernists like Jarry and Godard are deeply imbued with the very culture they so vehemently attack."[24] Palestinian American theorist Edward Said has reread the process of canon formation and the hallowed lines of descent in the high history of art by noting the confused roles played by affiliation and by filiation. Affiliation is explainable as the coherence of individuals on the basis of similar ideas and preoccupations. But where affiliation has been presented as the motive of selection, evaluation, and preservation of Eurocentric cultural hierarchies, in actual fact, the role of filiation, or shared class and ethnic heritage, has been the operative agency more often than the claims of affiliation can conceal. More than is ever admitted, the modernist perspective is an ethnic gaze. It was so strongly an ethnic gaze that it was not merely blind to linkages of affiliation with non-White populations, it generally saw such populations through lenses of contempt.[25] This history must include the active strains of reaction, racism, anti-Semitism, and fascism among some of the most celebrated modernists. The ultra-royalism of T. S. Eliot, the fascism of Ezra Pound, Wyndham Lewis, Celine, the sympathy for fascism of D. W. Griffith, Stravinsky, Schoenberg, Knut Hamsen, Webern, Heidegger, and Paul de Man must be counted among the signifiers of anti-humanist strains in the modernist camp. How are we to assess the meaning of these retrograde political positions within the utopian public sphere of Euro-mod aestheticism? We might begin by considering how these "betrayals" are dealt with by the Euro-American art-cultural community.

The critique of representation offers one argument for refusing to quarantine works with such anti-humanistic backgrounds; aesthetic reasoning offers another. In the politics of representation, the exclusion of one range of works from the ranks of engagable art on the grounds of its pernicious political background would encourage a serious misunderstanding. Such a segregation of "polluted" works of art and thought supports a digital notion of the political meaning of cultural activity. The works of fascists should not be quarantined because of the need to see all cultural production as part of the historical process, inevitably complicit with it. The aesthetic argument for refusing to quarantine these works is, by contrast, because as works of art they exist apart from or maybe above the calculations of social and political experience.

The contradictions posed by fascist artists and cultural thinkers for aestheticism involve, among others, the doctrine of the autonomy of art. If the art-work is self-referencing, then why does it matter what opinions were held by its inventors? But this posture throws into doubt the notion of art as an invariable social benefit. How can the work "do good" in and for society when its only meaning is in and for itself? (The question is merely rhetorical, not meant to solicit the verbose replies that aesthetic reasoning can doubtless provide.) One argument would remove all cultural work from privileged discourse, while the other would preserve such work within a realm of difference where usual standards need not apply, as when posthumous revelation shows that H. L. Mencken, say, privately embraced racist and anti-Semitic views, or that White historian of mythology Joseph Campbell similarly clung to prejudices that were the embarrassment of his colleagues.

The protective borders around aesthetic-proof material obscures the moral indeterminacy of cultural production and reception. Granting the marvelous capacity of human beings to produce works of enthralling complexity and beauty, only the veil of aesthetic mystique hides the fact that this capacity, like any other, can be used equally for all available human purposes and motivations, including the most immoral. And no indulgent allusions to "the darker side of human imagination" supports the privileged view of talent in cases where a prisoner like Jean Genet or Jack Henry Abbot is pardoned for his crimes in the sphere of everyday reality because of the eloquence of his prose.[26] As Richard Taruskin concludes, "This [artistic fascination with fascism] was a madness and an evil to which many more succumbed than we care to remember, and it touched upon questions of real artistic substance that most of us still prefer to bracket off from 'life,' and thereby hope to neutralize."[27] And even more conclusively: "The legacy of fascism is an inherent and, in the

West, largely unacknowledged, facet of the anti-democratic legacy of modernism."[28]

But the aesthetic community refuses to probe seriously into the cultural-historical meaning of these nefarious allegiances among cultural figures of high repute. The discourse around such figures and their political allegiances is small and marginal. The cultural community in other words responds to this kind of news with a cover-up, a brief flurry of localized debate and then a quick retreat behind the Palace walls for further self-contemplation. The sophisticated flippancies of aesthetic discourse affect a strategy of massive historical denial.

What is refused in this stratagem is the fact that some of the feature ideological convictions of the aesthetic, its elitism, the myth of the artist as "genius," the legend of the modernist artist working in superior isolation, the scorn of the masses, the quasi-aristocratic arrogance of the artistic persona, meld comfortably with fascist, racist, and anti-Semitic worldviews. It is important to recognize that there was nothing within the program of aesthetic philosophy that excludes fascism and racism from its definitions, as the concept of "democracy," for instance, takes pains to do.

David Carroll's study of right-wing extremism in prewar French literature brings him to these conclusions:

> [F]ascism should be treated as an extreme but logical development of a number of fundamental aesthetic concepts or cultural ideals: namely, the notion of the integrity of "Man" as a founding cultural principle and political goal; of the totalized, organic unity of the artwork as both an aesthetic and political ideal; and finally, of culture considered as the model for the positive form of political totalization. . . .
>
> One thing that is made vividly clear by a study of the work of nationalist extremist writers of the turn of the century and French fascist writers and intellectuals of the 1930s and 1940s is that their literary and aesthetic sensibilities and critical skills did not save them from, or act as alternatives to, political dogmatism. A sensitivity to art and literature did not prevent them from being insensitive and indifferent in the face of the worst forms of injustice, or in most cases from being biased, xenophobic, or racist and actively promoting hatred and violence against others. On the contrary, it was precisely their particular literary and aesthetic convictions and ideals that led them to and supported the anti-Semitic prejudices and extremist political positions they formulated and defended in their literary and critical texts as well as in their more directly political writings.[29]

The collapse of utopian modernist illusions in the debacle of World War II which has been seen as preparing the ground for postmodernism should rather be seen as the dead end of aestheticism as responsible in-

tellectual commitment. The historical failure of Euro-modernism coincides with the bankruptcy of the aesthetic. Nevertheless, misrecognizing this bankruptcy, we see repeated familiar cycles with ever-new avant-gardes withdrawing deeper into one-dimensional formalist panaceas, followed by eager critical apologists. Meanwhile, the spell of the art ideology conceals its reactionary drift through history. Its progressively quietist or right-wing impact is made confusing by the escalating radicalism of the art-cult's abrasive social personae. By the time we get to the culture war fought by U.S. politicians against the National Endowment of the Arts in 1985, we don't notice that Maplethorpe and Serrano are, in their social implications, almost as reactionary as the ultra-rightist senator, Jesse Helms.

THE PARADOX OF MARXIST AESTHETICS

If the notion of a "liberationist aesthetic" is a contradiction in terms, as Sahl persuasively contends, then the notion of a Marxist aesthetic is oxymoronic. Nevertheless, the history of Marxist aesthetics is long and dense, populated with exquisite dialectical analyses. No disrespect is intended by the abbreviated treatment of this issue here. Yet even at this length, the debate has something to offer. Each of the critical interrogators of the aesthetic that have appeared in recent years breaks out of the aesthetic contract at different exit points, motivated by different agendas. At this stage of debate and disencumbrance, the example of varied attempts to find freedom from aesthetic illusion are often mutually instructive. Why is it that Marxism, that most skeptical of European heresies, remains incapable of demystifying this grand rationale of bourgeois consciousness? And what can we learn from a recent effort to dispel this enchantment from within the Marxist intellectual tradition?

The facts are simple; what is not so simple is their possible interpretations. Marx and Engels left a number of fragmentary remarks on aesthetics without ever getting the chance to organize and defend them fully. Later Marxist philosophers and theoreticians voluminously elaborated these remarks or moved beyond them in order to extrapolate a viable Marxist position on aesthetics. A chapter "On Aesthetics" became obligatory in treatises by the most important Marxist figures, and many books have been written on the subject. This history may reflect on the character of European philosophy: given a "problem," no matter how germane or ill-founded in its premises, the temptation to find a "solution" becomes

an itch too seductive not to scratch. So the history of the development of Marxist aesthetics follows the path of the idea in Europe generally, as though the point was to make a contribution to philosophic discourse. Both begin with fragments of dubious and obscure significance and erect from these hieroglyphic relics a grand theory that tells more about their authors than the objects they contemplate.

Crudely, Marx and Engels view the aesthetic dimension of man as an exception to historical materialism. Where human history must otherwise be interpreted as a dialectical struggle between the labors of men and their material-historical circumstances, most potently located in their economic conditions, the same is not true for the object of aesthetic consideration. The work of art transcends its time and place with meanings that are universal and durable beyond their epochs, if not eternal. This means that the aesthetic is an exception to the base/superstructure model of the relation of ideas and culture to the mode of production. The superstructure, where we find religion, law, education, philosophy, exists, in the realm of ideology; and ideology, determined by the mode of production, is, in capitalist society, inhabited by false consciousness. But it is possible in the case of art for the work to stand outside and even in contradiction to the level of development of its age, because great art expresses the essential nature of humanity.

In support of this reasoning, Marx reproduces some of the truisms of aesthetic humanism. He is no exception to his historical epoch in opting for what Martin Bernal calls the Aryan Model of interpreting Egyptian influence on Greek civilization: "Egyptian mythology could never be the soil or the womb which would give birth to Greek art."[30] His more central argument from the *Introduction to the Critique of Political Economy*, is that Greek art transcends the unpropitious level of social political and economic development of the society that produced it:

> But the difficulty does not lie in understanding that the Greek art and epos are bound up with certain forms of social development. It rather lies in understanding why they still afford us aesthetic enjoyment and in certain respects prevail as the standard and model beyond attainment. . . . Why should the historical childhood of humanity, where it had obtained its most beautiful development, not exert an eternal charm as an age that will never return.[31]

Even from the narratives traced in the previous chapter, the very unexamined character of these sentiments should be obvious. But coming from Marx, they set up some arresting dilemmas. Such opinions are fair evidences of "the other Marx" that Marxist historians were eager to re-

discover in the 1960s, in the English language at least. A feature of this recovery was the translation of Marx's *Economical and Philosophical Manuscripts of 1844*. Here was revealed a less dogmatic, "scientific," materialist Marx, more humane and humanist, more open to idealism. If the need was for a socialism with a human face at a time when the cannibalistic demonism of Stalin was being disclosed, then this forgotten text of Marx's was understandably welcome. And it contains characteristically brilliant essayistic analyses of the dangers of alienation to the human spirit. The problem is that this other Marx, who could in flashes rival the philosophical wit of Kierkegaard or Nietzsche, is of relatively minor historical significance beside the "major" Marx whose dialectical materialism deconstructed the workings of capitalism and authorized revolutionary action against its abuses.

The tensions between these two Marxes can stand as a node of contradiction, particularly in the understanding of Marxist interpretation of ideology and the base/superstructure relation, that became a problem left to neo-Marxist thought to resolve. That discussion is of minor interest here. What is more relevant is the fate of the aesthetic in recent neo-Marxist theory. Whatever allowances made for Marx and Engels in subscribing to the ruling clichés of their day, they do not absolve contemporary neo-Marxists for their persistence in a theoretical enterprise which has since lost much of its authority and force. Marx and Engels did not have the resources of recent counteraesthetic debate, such as the already-mentioned developments in the sociology of knowledge and art, the resurgence of Third World nationalism and cultures, the Black aesthetic, a revived feminism, not to mention the tragic history of the avant-garde and the flagging fortunes of modernism to help them see beyond the boundaries of aesthetic/humanist self-deception. Curiously, neo-Marxist thought is itself one of the agencies sapping the vitality of aesthetic theory, at the same time as it also acts as a field in which the flagging claims of the aesthetic receive authoritative attention. How this can be is simply explained. It is fairly characteristic of this school of thought to reexamine the questionable claims of the aesthetic, and to pinpoint some of its more serious fallacies, its tendentious support of repressive propositions, often with the acuteness that dialectical analysis at its best can supply, only to conclude by making a plea for the salvaging of aesthetic ideology.

White sociologist Janet Wolff's book *The Sociology of Art* illustrates the tendency. Her survey of the various historical positions held regarding the aesthetic and society is marked by diligent, close, and perceptive argumentation from a position informed by Marxist and feminist insights.

And at its beginning, her book promises to make sense of the face-off between aesthetic and sociological interpretation. If she succeeded, she would be giving a boost to the sociology of art, which has been intimidated as a discipline by the insistence of aesthetic theory to be above and beyond the reaches of sociological analysis. Through her study, she compactly exposes the inconsistencies in the leading explanations of the essence of art. But at the end of her book, when she has effectively laid the groundwork for seeing the hollowness of aesthetic discourse itself, she concludes by promising to resolve the issue in a forthcoming book in which she will definitively isolate the essence of art, that Holy Grail of Western philosophy and tar baby upon which some of the finest minds of Europe have been snared.

Terry Eagleton has followed a similar script, and Fredric Jameson has contributed variants. Eagleton has written two books on the links between Marxism and the aesthetic. The hope for a liberating awakening between books is not realized. *Criticism and Ideology: A Study in Marxist Literary Theory* covers familiar ground in this tradition, with uncommon insight, supplementing White cultural philosopher Raymond Williams's important text, *Marxism and Literary Theory*, which it preceded by one year.

Eagleton ends his study with a surprising conclusion: "The 'aesthetic' is too valuable to be surrendered without a struggle to the bourgeois aestheticians, and too contaminated by that ideology to be appropriated as it is. It is, perhaps, in the provisional, strategic silence of those who refuse to speak 'morally' and 'aesthetically' that something of the true meaning of both terms is articulated."[32] This silence which is nevertheless articulate in revealing the truth is a very thin reed upon which to conclude a strenuous labor of analysis, a dubious principle of resistance, but one which demonstrates its own aestheticism by relying for conclusive resonance on the prose mechanisms of the dying fall of its sentence rhythm rather than the power of its argument. Once again, following the false light of aestheticism, a liberation-minded intellectual manages to snatch defeat from the jaws of victory.

Between this and his second effort to reconcile Marxism and aestheticism, Eagleton wrote *Literary Theory: An Introduction*.[33] Here, Eagleton clarified some of the intricate interpretive grids of the new critique, poststructuralism, Foucauldianism, and Lacanian analysis, drawing particularly revealing maps of the development of literature as an institution with ideological roots. Apart from the value of this study in itself, it should have served as excellent preparation for *The Ideology of the Aes-*

thetic. This large book is densely knowledgeable and erudite, weighing the most important questions and thinkers in the history of this seductive science from a Marxist perspective. In the intervening years since *Criticism and Ideology*, Eagleton sharpened his descriptions of the ideological dimensions of aestheticism. But the outcome of this later book is little different from the earlier one.

Eagleton writes about the aesthetic ultimately to defend it, mainly from radical and transformative thinkers who might, in his eyes, go too far. At the end he commends aesthetic reasoning to dialectical critique, abjuring what is false in it, while salvaging what is "too valuable" to lose. This book also ends on an elegiac note. "The discourses of reason, truth, freedom and subjectivity, as we have inherited them, indeed require profound transformation; but it is unlikely that a politics which does not take these traditional topics with full seriousness will prove resilient enough to oppose the arrogance of power."[34]

One irony of this closing strategy is the diminishment of the aesthetic, even while he supports it, as a local discourse, no longer to be appealed to for its universal revelations of the essence of man, but instead as a historically rich discourse of "traditional" topics "as we have inherited them." Those who do not regard themselves as beneficiaries of this inheritance, and maybe cannot be counted among the "we" of the conversation, instead of its victims, may not find the argument for maintaining the tradition compelling simply because it is "rich." In this guise, Marxism begins to look like a body of thought dependent on its inheritance as a tradition within Western philosophy and theory, and one which feels the necessity to preserve its host intellectual environment in order to preserve itself.

Eagleton is writing to defend a Europe-centered class analysis as a priority within liberationist thought. This defensive posture is present in his warning to those preoccupied with issues of race and gender, particularly in the socialist theory–impoverished United States, "that these particular forms of oppression can themselves only be finally undone in the context of an end to capitalist social relations."[35] Eagleton, it seems, has pondered the pending death of the aesthetic and its vulnerability to the suspicious glances of those who have been silenced by it, and has opted to "save" it from the mugging it will surely fall to, because it is part of a discourse that the Marxist tradition must be privileged to correct, lest in otherwise being challenged, institutionalized Marxist values will be put at risk.

But the real object of Eagleton's rescue mission may be less the aesthetic than the Euro-enlightenment. Eagleton seems to think that the aesthetic

was one of the most important, surely one of the most characteristic accomplishments of that intellectual history. By defending Euro-enlightenment against those who would go outside its perimeters and against some of its bad mental habits, Eagleton commends it largely as a tradition, redeemed by its brilliance and its formal elegance. And while the end of his discussion defends this tradition as worth preserving, he deals sparingly with some of the reasons raised for its abandonment.

Supposing the Euro-enlightenment were to be dialectically salvaged, Eagleton's inquiries point out very little of the old paradigm that needs to be discarded, or exchanged for a newer, more historically reflexive one. His text runs through the canon of the major aesthetic theorists, from Shaftesbury and Baumgarten, to Hume, Burke, Kant, Schiller, Schelling, Hegel, Schopenhauer, Kierkegaard, Marx, Nietzsche, Freud, Heidegger, Benjamin, and Adorno. There is no room in this discussion for a Detroit auto worker or Scottish insurance adjuster to get her opinions into the dialogue, any more than they could get into his canonical texts, as subjects. A moral universalism is advocated, but with surprisingly little suggestion of how it may be advanced through the further study of his canonical thinkers, and far less otherwise.

This defense of Euro-enlightenment seldom reckons how its important contributions to human thought can be preserved without continuing to revere uncritically the major architects of that movement, the formalist characteristics of their thought, or the social process by which that thought came about. What the supply of some critical thinking might deliver is offered by Supreme Court Justice Thurgood Marshall. Commenting on the celebration of the two hundredth anniversary of the U.S. Constitution in 1987, Marshall put into historical perspective the framers of that document, who were much-imbued with Euro-enlightenment thought, particularly a principle architect of that document, Thomas Jefferson, whom his contemporaries called "the Philosopher."

Marshall deplored "the tendency for the celebration to oversimplify, and overlook the many other events that have been instrumental to our achievement as a nation."[36] He caused a minor uproar by noting, "Nor do I find the wisdom, foresight, and sense of justice exhibited by the Framers particularly profound. To the contrary, the government they devised was defective from the start, requiring several amendments, a civil war, and momentous social transformation to attain the system of constitutional government, and its respect for the individual freedoms and human rights, we hold as fundamental today."[37] Marshall recovers the vacillations and compromises that preserved slavery in a form profitable to

these enlightened legislators of all regions. He cements the limits of the historical imagination of these men by noting how ill-prepared they were to imagine a Supreme Court that included a woman and a descendant of an African slave: " 'We the People' no longer enslave, but the credit does not belong to the Framers. It belongs to those who refused to acquiesce in outdated notions of 'liberty,' 'justice,' and 'equality,' and who strived to better them."[38] Marshall's thoughts on this issue apply equally as well to the Euro-enlightenment as a whole.

The attempts of neo-Marxists like Eagleton and Jameson to hold back the tide of upstart critiques with assurances that their versions of left ideology have these "new" interests well covered has recently been interrupted by decisive critiques of Marxist aesthetics from within its tradition. Serious evidence of this refreshed perspective appears in Tony Bennett's *Outside Literature*. Bennett is willing to confront the fact that Marxism, like any other school of thought, bears the signs of its social construction, "that Marxism's political vision has been profoundly—and often disastrously—affected by the influence of Romantic aesthetics on Marx's conception of communist society as a vehicle for the full realization of humanity."[39]

One of the debatable survivals of this legacy is the utopianism that continues to surface in Marxist aesthetics. A prominent source of this utopian ideal is Schiller's "On the Aesthetic Education of Man." Schiller's essay, one of the more seductive documents in the library of aesthetic discourse, takes a major step in taming instrumental Reason toward a more humane society through widespread propagation of aesthetic values and education. In envisioning a society idealized through its contact with aesthetic ideology, Schiller makes a Romantic venture toward aestheticizing reality.

But Martha Woodmansee's recent reexamination of Schiller's famous essay finds contradictions where others have routinely found only sweetness and light. Woodmansee first notes the paradox that "at the end of the *Letters*[40] aesthetic experience is portrayed as itself the locus of freedom. 'Freedom' has lost the distinctly political inflection given it at the beginning ... and come to denote the kind of freedom to dream that is the consolation of the subjects of even the most repressive regimes."[41] She then follows the trajectory of this aesthetic idealism against the background of Schiller's career and other writings. An important turning point in his writing sees him abandoning popular and emancipatory concepts of literature in favor of more rarefied goals. To strive for the ideal and the universal is to avoid the popular and accessible, the every-

day and, not incidentally, the political. This is the alteration we see in Schiller's thought at a crucial time where he seems to be turning his back on the French Revolution and abandoning his hopes for popular success as poet and playwright. His conversion to a depoliticized ideal of art and literature coincides with his acquisition of a wealthy patron, in keeping with Woodmansee's analysis of the materialist motive behind eighteenth-century German aesthetic discourse generally.

Woodmansee's study watches closely as Schiller "promotes as the sole instrument of human salvation poetry produced in studied indifference to the desires . . . of a buying public that is depicted as being so base that it is beneath a serious poet's consideration. Once liberated from dependence on this public, Schiller is free to develop this idea and, above all, to erase the signs of its provenance in his own struggle as a professional writer for the attention of that public. Composed in the courtly setting of Weimar in the form of letters to his noble patron, his aesthetic retains so few such signs that it has been possible even for students of aesthetics as materialist as Terry Eagleton to read it as fundamentally progressive— the product of 'the dismal collapse of revolutionary hopes.' Still, to more 'resisting' readers schooled in Schiller's 'occasional' writings, signs of the theory's provenance remain. . . . "[42]

Schiller's line of reasoning has been traced into Marx's ideas, even though a more direct influence may have come from Schlegel, who was one of Marx's professors. Michael Sprinker for one has followed this line of thought to the conclusion that Marx's social vision is essentially an aesthetic one. As a nineteenth-century German philosopher, Marx would have had a difficult time excluding aesthetic dimensions from his thinking, since this newest of the cardinal disciplines within European philosophy was becoming aggressively influential, even threatening the terrain of metaphysics.

But the utopianism of neo-Marxist theory looks little different from the contemporary public aesthetic sphere purged of its more obvious bourgeois trappings and projected into an idealized future society. As this vision keeps cropping up in the writings of White cultural theorist Fredric Jameson, one is tempted to ask, whose utopia? Eagleton, who retains links to the utopian Marxist ideal, is nevertheless unpersuaded by "Jameson's startling claim to discern a proleptic image of utopia in any human collectivity whatsoever, which would presumably encompass racist rallies."[43] The imperatives of hope, of refusal of despair, for those seeking constructive social change, cannot be denied. But the claims for a science of history that Jameson insistently makes, point out a narrow path to sal-

vation that, given the responsiveness of Marxist ideology to "oppositional groups" like women, gays, racial minorities, and national groups, may not be so inviting. Here we find another reason behind the reluctance of some neo-Marxists to abandon aesthetic discourse. It is a reluctance to surrender the universalism of the discourse, which neo-Marxist aesthetics plans to inherit, as part of its claim to "science."

This is one of the points where Tony Bennett's interventions from a self-critical Marxist position offer some promising escape routes out of aesthetic tradition. "For where is there a Marxist aesthetic which does not derive its distinctive characteristics from a set of operative concepts culled from some pre-Marxist body of aesthetic theory. . . . To announce a requiem for aesthetics in toto would, no doubt, be premature inasmuch as, although its theoretical credentials are thoroughly tattered, it still has an undeniable political use-value—but only for the right. . . . The time is long past, however, when the project of a Marxist aesthetic ought finally to have been laid to rest. . . . nothing whatever of any practical political consequences hinges on the establishment of an aesthetic by whatever means, biological, social or historical."[44] If we see the adventure into Marxist aesthetics as a rehearsal of its main, capitalist tradition from a slightly different angle, we may find some prophetic value in the way this venture comes to an end. In this the bizarre, almost grotesque spectacle of Marxism embracing aesthetic idealism serves a backhanded historical purpose. If diligently analytical Marxist philosophers, armed with all the reasons for invalidating this discourse, yet determined to save it, cannot bring off this salvage job, then probably no one else can.

SEARCHING FOR A FEMINIST AESTHETIC

> Behind male admiration of [female] beauty, however, lurks always the ribald laughter, the withering scorn, the barbaric obscenity with which strength greets weakness in an attempt to deaden the fear that it has itself fallen prey to impotence, death and nature.
> —Adorno and Horkheimer, *Dialectics of Enlightenment*[45]

Our opening question—can the aesthetic be redeemed?—soon becomes rhetorical, replaced by the more practical question, what can we learn from emerging social movements and their mix with the dying ideology of art that is useful for a liberating politics of representation? It seems possible to direct this question to feminist theory and to popular ethnic liberation simultaneously.

The search for a feminist aesthetic in the United States, where the revival of feminism profited, as in the older U.S. feminist tradition, from linkage with African American liberation struggles, at first followed the example and trajectory of the Black aesthetic. But the theoretical problems encountered, though tantalizing and productive of much sophisticated analysis, seem to have led into blind alleys. When White feminist Nina Baym tentatively asserted in a much-quoted sentence, "I cannot avoid the belief that 'purely' literary criteria, as they have been employed to identify the best American works, have inevitably had a bias in favor of things male . . . " in 1978,[46] the impact and resonance were different from Addison Gayle's assertion in 1971 that "Most Americans, black and white, accept the existence of a 'White Aesthetic' as naturally as they accept April 15th as the deadline for paying their income tax. . . ."[47]

Aestheticism had always been promoted more aggressively as a sign of class and cultural distinction than of gender identities, which were more often assumed paternalistically, or dismissed humorously. The discovery by some feminists that the aesthetic was masculinist did not suggest much difference from the masculinism of other institutions and conventions. There was work to be done, but what?

Aesthetic reasoning exploited gender in a way that concealed its violence, or very seldom directed its nastiest thrusts at women generically. Looking at women, bourgeois aestheticians concluded, in effect, they are inferior, but they are ours. They then went on to split the difference with Occidental womanhood. "Women" were to be treated as objects of pleasure and possession, subordinate reflectors of male glory, but they were on the other hand accorded the privilege of bearers of beauty, sensuality, and sometimes spirituality. Aestheticism as a historical phenomenon of the eighteenth and nineteenth centuries, as we have already noted, profited from a "feminization" of public life. Out of this split difference there was no need to construct women as the ugly other from which male beauty could be discovered (except in instances such as Winckelmann's homophilic preference for beautiful young men). Out of the split difference the art ideology made White female beauty synonymous with bourgeois status—ladyhood—flattering the bearers of this look with implied superiority to all other women. Along with the benefits of incorporation into aesthetic canons, as icons of beauty, etc., came the relief from the animalization and dehumanization within European mind directed toward women of color, such as that which was directed toward the African woman whose naked body and sexual organs were put on display under the show-name of the Hottentot Venus.[48] The aesthetic did not insult

middle-class White women culturally; except as objects of humor, it re-fused to notice the possibilities for women's culture. Feminist theory, again perhaps following the example of ethnic and national identity poli-tics, pursued the question of women's culture, encountering more prob-lems than a similar search among ethnic groups, which had already been mapped out in anthropological investigation. One begins to see how the realization of the maleness of the aesthetic might lead to the inquiry into female or feminist aesthetics, which in turn might easily lead to other questions that would appear more urgent. Is there a "woman's culture," and what is its composition? What is the female identity that might give distinctive character to a female aesthetic?

The exploitative impact of aestheticism on women has been felt less from theoretical principles than in its execution, as protector of the sex-ism of male-authored cultural and critical works. There may have seemed little theoretical matter in aesthetic discourse that barred it from appro-priation by women, once they modified structures such as the subject-ob-ject relationship. Two options invited, from this point. One was to reject the masculinist bias in aesthetic discourse and continue to search for the principles and strategies that would contribute to a feminist aesthetic. This project repeatedly ran into difficulty through the implications of "blind-fold tests." Given an unknown text, few could accurately name the gender of its producer. The other option was to accept the possibility of a gender-free, general aesthetics, but, recognizing its historically ex-ploitative character through the biases and practices of male theoreticians and gatekeepers, accept the aesthetic as a practical reality and attempt to cleanse it of the contaminants that interfered with fully expressive use by women.

These and related issues are analyzed in White theorist Rita Felski's *Beyond Feminist Aesthetics: Feminist Literature and Social Change.*[49] Felski outlines the difficulties of forming a feminist aesthetic. In the face of these difficulties, she poses the model of a feminist public sphere as con-stellation of diverse feminist discourses. Her vision of the functioning of these discourses recalls the theorizing about positionalities of Stuart Hall: "Rather than a uniform interpretive community, then, it is perhaps more appropriate to speak of coalitions of overlapping subcommuni-ties, which share a common interest in combating gender oppression but which are differentiated not only by class and race positions but often by institutional locations and professional allegiances, and which draw upon a varied range of discursive frameworks."[50]

By abandoning a feminist aesthetic in favor of this feminist public

sphere, Felski gains the advantage of a more deliberate pursuit of the ends that a feminist aesthetic promises, a sphere where the strains of a constrictive, masculinist paradigm are less distracting, and the terrain is cleared for a more relevant politics of cultural empowerment, which is the real issue. But this prospect seems only half intended by Felski, whose priority is to get the discussion beyond feminist aesthetics, but not beyond the aesthetic as such.

But Felski's proposition differs little in impact from the pursuit of a feminist aesthetic that, in some versions, is pursued with more radical, disruptive intent. Despite these radical intentions, it is hard to see how a feminist aesthetic, once formulated, could avoid paralysis as another sub-aesthetic, a sisterly branch of the main thing, and from that position liable to reproduce some of the inequities and repressions of the center. In the spirit of "they've got an aesthetic, so it's only fair that we have one, too" one can already see a pattern of academic proliferation of articles and books dealing with the feminist aesthetic of this author or that novel, the number of them spinning into a vortex of ever more deeply remote formalist speculation. The product of such work has only the slightest political bearing. Borrowing a phrase from Toni Morrison, we might call it revisionary "canon fodder."

In Felski's alternative position, aesthetic discourse is left like a Trojan horse dropped in a feminist public sphere which offers little empowerment beyond the present situation. The effect is less ruptive than moderating, as is further shown in Felski's argument against too sharp an isolation of the political, ideological dimension of aesthetic discourse: "[A]ny attempt to assert the necessary identity of political and aesthetic value in the context of a theory of feminist aesthetics runs into obvious problems, given the impossibility of revoking the relative autonomy of literature and art in modernity as embodied, for instance, in the capacity of readers to experience pleasure from texts they do not necessarily concur with on political grounds or texts whose ideological stance may not be immediately obvious."[51]

This position abdicates radical critique of the aesthetic in response to its ambiguity, yielding to it all terrains connected with pleasure, which, as I read her, confirms the autonomy of art—a sweeping and dubious concession. The phrase "in modernity" apparently rules out the evidence of people in unmodern circumstances taking pleasure in cultural activity that may be clearly outside the aesthetic. The position is reminiscent of Eagleton's "yes/but"—yes, let us have radical critique, but don't take it too far—indicating a defense of the aesthetic which necessarily works as

rationalization of the dominant symbolic order. Felski's excursion, then, gives us one picture of the difficulty for feminist theory to break with the masculinist theoretical precedent.

The link between feminism and aestheticism is of course far more complex than I have suggested. The most potent interrogation of the aesthetic from a feminist standpoint has to be sought beyond Felski's investigation. For as she accurately points out, "feminist literature and criticism has offered the most sustained recent challenge to the idealist mythology of literature as a self-contained and transcendental sphere."[52] The fuller effect of that critique may be gathered by looking at a parallel challenge from feminism in the area of cinema. There may possibly be no single text of feminist literary theory as influential in its sphere as Laura Mulvey's "Narrative and Visual Pleasure" has been in feminist cinema theory.

Mulvey characterizes movie spectatorship as dominated by the male gaze. She locates the manipulation of cinematic codes to produce pleasurable rewards for the male viewing position through two agencies. One is the scopophilic pleasure, the pleasure of looking, as afforded the male gaze directed toward the female as erotic object. The other agency is the enhancement of the process of ego-identification within cinematic codes, as in the idolization of the movie hero by young boys.

The resonance of Mulvey's article arises partly from the infectiousness of cinema as an instrument of the symbolic domination of women, more graphic than comparable evidence drawn from literature. The unequal distribution of power in the subject-object relation to the disadvantage of women is demonstrated on the cinema screen, where the analysis returns to the ocular orientation that influenced the construction of the subject-object configuration in the first place. Mulvey offers instances in cinema supporting John Berger's reading of Western oil paintings locating gender functions there as woman-as-image and man as the-bearer-of-the-look.[53]

Mulvey's discussion of visual pleasure is weighted with considerable psychoanalytic baggage from Freud and Lacan which has provoked rejections of her logic of phallocentrism.[54] But these skirmishes remain outside her main and most important point, the predominant construction of knowledge and pleasure in Western cinema toward the needs and satisfactions of the male gaze. The gain in explanatory power of Mulvey's argument arises from her further exposure of the bias toward masculinism in the subject-object relation. In indicting the gaze of cinema as male-dominated, Mulvey's analysis implicitly but powerfully indicts the aes-

thetic gaze itself as masculinist. So it is understandable that a feminist reexamination of Mulvey's thesis by Mary Devereaux picks up this point and carries it to its logical conclusion, that "feminism relies on an alternative European view of art. In this, feminism constitutes part of a larger movement away from 'autonomous' aesthetics. . . . In adopting a politics of art, feminist theory confronts Anglo-American aesthetics head-on. It replaces reverence for art with skepticism. It asks that we be willing to rethink what we value and the reasons we value it."[55]

It is worth repeating that feminist theory and woman-centered critique form an intellectual environment in which the disenchantment with aestheticism gains great force. At the same time, despite Devereaux's claim, this rethinking seldom confronts Anglo-American aesthetics "head-on." For she immediately adds in a by-now-familiar maneuver, "In suggesting that this challenge deserves serious attention, I might be understood to claim that all traditional aesthetics is useless, that the accomplishments of the last century are a chimera. That is not my intent."[56] The more cautious approach she then goes on to advance, a piecemeal and case-by-case reexamination of the claims of the aesthetic versus a feminist politics of art, must be read as a deference to the rules of the Palace. Those in pursuit of a feminist aesthetic tend to engage in a project of rehabilitation before they interrogate the established paradigm as a disabling doctrine. So they pursue a course that leads them back into the cognitive dilemma they are trying to escape.

Meanwhile, the most potent head-on challenges to the aesthetic have come from feminists who did not start out analyzing issues of feminist aesthetics, but whose researches into the politics of representation took them into areas where the art ideology was no longer persuasive. We have seen how Mulvey makes a damaging revelation about the aesthetic while pursuing another object. Similar, forceful challenges to the aesthetic have been lodged by Laura Kipnis and Susan Kappeler starting from regions outside feminist aesthetic theory. Their analyses are more productive because they ask better questions than, why can't women have an aesthetic too? The seductions of aestheticism are such that a writer has a better chance of backing into productive disillusionment than setting out within the dogma from the start.

Kipnis observes the contribution of the aesthetic to cultural imperialism in instances where the political urgency is immediate.[57] The specific occasion of her critique is a book by Sir Hugh Thomas which argues that "Tragically, the Cuban revolution cannot offer a single notable novelist, a famous poet, a penetrating essayist, nor even a fresh contribution to

Marxist analysis."[58] In unraveling this tendentious argument, Kipnis surgically cuts to the complicity of the aesthetic with modes of domination. She disallows aestheticism in any strategy hoping to curtail political and cultural oppression: "Various camps have made the decentered subject a political program. This paper proposes a post-aesthetic as its counterpart."[59]

Susan Kappeler's challenge to aestheticism takes off from a rethinking of pornography and feminism. Kappeler begins by noting a major shift in the definition of pornography—another moment in the crisis of contemporary knowledge. Where pornography had previously been distinguished in the United States by its exploitation of obscenity, as defined by community standards, Kappeler notes with satisfaction the ruling of one court which adheres to a new yardstick, that pornography is offensive as a violation of women's civil rights.

Kappeler perceives the issue of pornography as one answerable to a cultural theory of representation. The impact of pornography, she insists, is in the real world and not merely in the realm of fiction and fantasy. Her aim is to narrow the distance between these realms so that we may see the injury of pornography on real women in the real world. Soon into her dissection of pornography, Kappeler turns to the subject-object relation where women are the object and men the subject.

What emerges is an analysis parallel to the deconstruction of the male gaze in cinema by Laura Mulvey: the role of voyeurism and scopophilia in the context of pornography. The position of pornography as a "fringe" activity, which Kappeler disputes, forces the radicalization of her critique. Virtually every argument against the dominated representation of women articulated by feminist theory—the rejection of "the systematic degradation of women, the wholesale cultural objectification women, the usurpation of women's subjectivity by the male gender"[60]—in other spheres recurs in her discussion as characteristic of pornography.

From the angle of pornographic critique, Kappeler scrutinizes the protection given to certain kinds of material by the sanctions of aestheticism. The exceptionalism of the claim of "art" for materials otherwise readable as pornography leads Kappeler into a full-scale critique of aesthetic reason: "The pornographer finds shelter behind his cultured brother, the artist. . . . What is needed is an explicit juxtaposition of aesthetic disinterestedness, or the irresponsibility of the text on the one hand, and the blatant sexual interest of desire on the other. Instead, art and literature are treated as sanctuaries—worlds apart—where we play

according to other rules, valid in those worlds, where the subject is the subject of the text and has no dimension in the real world."[61]

Kappeler's wider range of discussion interprets contemporary society as a pornographic culture (much as we shall see Griffith's *Birth of a Nation* displaying the psychology of a "rape culture"). Interestingly, Kappeler does not tighten her focus on the issue of censorship, viewing it as "a little internal quibble between sections of the bourgeois community."[62] Her widened scope, uncordoned by the barriers of aesthetic and cultural discipline, repositions the contest within the arena of the politics of representation, where it becomes part of a wider struggle for the reconstruction of modern society.

One challenge facing the interrogators of the grand narrative of Euro-humanism is the asymmetry among the interrogators themselves. The disenchantment of some of its critics reaches degrees where, by comparison, others remain mired in the seductions of the tradition. One explanation may be the different burdens felt by different marginalized populations. Some feminist critiques of aestheticism work mainly to redeem the aesthetic for the empowerment of women. This posture is addressed in Kappeler's rebuttal of Deirdre English's position that material called pornographic may have some valid use and interest for women: "At the root of the position taken by English is indeed a shared culture—a cultural understanding of knowledge, a cultural understanding of art—which prevents her from directing the logic of feminism at that cultural understanding itself."[63]

Something of the same disproportion can be seen between (White) feminist aesthetic formulations and the position of Black women cultural producers. Feminist aesthetic theory has followed the example of Euro-humanism, associating ideas filiatively as much as affiliatively. It is a discourse that remains bonded to the motive principles of the Father insofar as it seeks to acquire the inheritance of intellectual valorization, including the profits of entelechy, duplexing, and repressed qualifiers. Many Black feminists have pointed out the usage of "feminist" and "feminism" to refer to middle-class White women, functioning under the same privilege that Archie Bunker demanded, declaring that White people don't have to go around saying they are White. If the discursive inequity in repressing the qualifiers of White feminism is problematic for the construction of a feminism for women of color and a solidarity among all feminists, that same logic places in question the formation of a White middle-class feminist aesthetic as a feminist aesthetic as such. How can

we read Mary Devereaux's assurances—"In drawing our attention to culture in the broadest sense, feminist theorists rely on an alternative, European view of art"—other than as a reaffirmation of affiliative bonds with White male theorists while marginalizing the positions of non-White theorists?

The danger of a Black Aesthetic becoming a supplementary ethno-aesthetic, or "minority aesthetics" as domesticated subcategory of the "main thing" is realized in the statement of one feminist theorist: "Feminist aesthetics, black aesthetics, ethno-aesthetics, Indian (that is, Native American) aesthetics, are instances of new terminology that seek to redefine the parameters of the aesthetic based on artworks by women and artists of color. Such extensions may be perceived as threatening to the traditions of a white male aesthetic—to be summarily ignored or dismissed—or may be perceived as a welcome and long overdue improvement."[64] With this example in mind, we can see how the apparently progressive notion of multiple aesthetics only perpetuates a system where some institutionalized thought systems are allowed to go unmarked as general, even universal concepts, while branches are allowed as intellectual colonies, whose fates are determined by the "mother idea."

The failure to take the situation of women of color into structural consideration in efforts to think a feminist aesthetic is critical. It involves a blindness alluded to by Laura Kipnis when she cites the aesthetic "as a dominant instance in the ideological complexes that reproduce both racial oppression and women's oppression." Kipnis is clear that these burdens are not equal: "The problem for women is to be the privileged bearers of the aesthetic, the problems for non-White races is to be excluded from the aesthetic."[65] And even here entelechial usage has Kipnis repeating the awkward separation between "women" (meaning White women) and non-White races, leaving the women of these races in limbo.

The burden of serving as bearer of the aesthetic gaze has fallen to *White* women. This gentle imprisonment has been further made bearable by the location of non-White women as their inferiors, their aesthetic others. Women of color have felt the exaltation of the beauty of White women in art and advertising as a weapon crudely used against them in a context where, women's value being constructed largely on the basis of looks, such an unequal celebration is enormously costly to them in real, psychic, economic, and social loss. Were the project of formulating a (White) feminist aesthetic extended to include the significance of the experience of women of color, that project would necessarily be tremendously altered, if not abandoned. For the formulators find coherence for their nascent

doctrines only by repeating the same colonialisms and exploitations that characterize the aesthetic. A feminist aesthetic becomes a middle-woman exploiter much as Euro-modernists and avant-gardists before them have functioned as middle-man cultural exploiters of non-White populations and cultures.

The difficulty of this dilemma is seen once we ask what is omitted from a developing "feminist aesthetic" that might be altered to consider women who are not White. One might cite, for one thing, the imperatives that compelled the construction of a Black aesthetic. While the Black aesthetic is seldom any longer invoked as a guiding principle, the general sentiment motivating that idea remains much alive in the vision of leading Black women writers and filmmakers. In a book of interviews with many important Black women writers, Ntosake Shange says, "We do not have to refer continually to European art as the standard. That's absolutely absurd and racist, and I won't participate in that utter lie. My work is one of the few ways I can preserve the elements of our culture that need to be remembered and absolutely revered."[66] Similar sentiments are expressed by Toni Morrison, Alice Walker, and several other writers interviewed in the volume. It is among the opinions one has come to view as almost consensual among important Black women writers.

All the issues so far discussed in relation to feminism and aesthetics are highlighted in the case of the Hottentot Venus. In this episode of European cultural consumption of the Other we can see dimensions of aesthetics as foreign policy, as racism, as pornography, as the privileging of the male gaze as well as others not yet observed. We can also get another perspective on the insufficiencies of the White feminist search for an aesthetic when it fails to take race into account.

The Hottentot Venus or Saartje Baartman became an object of popular display in several circus-like public exhibitions because of her protruding buttocks but also became an object of scientific curiosity for the supposed abnormality of the Hottentot "apron" on her genitalia. The first exhibition took place in London in 1810, during the formative years of aesthetic theory. Her significance in Western conventional imagination is hinted in Gilman's paraphrase of the opinion of Buffon: "the antithesis of European sexual mores and beauty is embodied in the black, and the essential black, the lowest rung on the great chain of being, is the Hottentot."[67] She was later displayed in Paris, and died in 1815 at the age of twenty-five, with her body put through painstaking autopsies and her genitalia placed on public display. The voyeurism of Hottentotitis continued with other "Venuses" in 1829 and thereafter.[68]

In Sander L. Gilman's well-noted and fascinating account, the history of the Hottentot Venus uncovers several rather extraordinary ideological associations developed by the learned class in nineteenth-century Europe. One of these connections was the association of Blacks, particularly Black women, with sexual concupiscence, to the extent that mere inclusion of a Black servant in the background of a painting such as Manet's *Olympia* iconographically denoted the idea of lascivious desire. To this idea was linked the notion of women's genitalia as being "primitive," more primitive than the male, an idea shared by Darwin, Freud, and Havelock Ellis, and most primitive in the Black female.[69] These stigmata, prominent buttocks and "primitive" genitalia, also became deciphered as marks of the congenital prostitute in the science of the day, most prominently in the somatic determinism of Lombroso: "The perception of the prostitute in the late nineteenth century thus merged with the perception of the black."[70] The survival of this mental shorthand through the nineteenth century into twentieth-century modernism is reflected, as Gilman notes, in Picasso's 1901 version of *Olympia* where some of the hidden signifiers of Manet's painting become explicit: "Picasso saw the sexualized female as the visual analogue of the black."[71] Gilman's recognition of these thematics in *Les Demoiselles d'Avignon* of 1907 and Picasso's imagery therein bring us back full circle to an earlier discussion.

The nineteenth-century chain of reasoning made visible in the discourse around the Hottentot Venus recapitulates the mind-set of Euro-humanism when encountering the racial Other. First there is the search for difference, such as the formation of genitalia, as sign of the superiority of European typology. Then differences are stretched out to extremes, polarized as opposite ends of a scale, one end holding icons of Europeanness, or Whiteness, and representing beauty, the other containing images of non-Europeanness or non-Whiteness, usually Blackness, and representing ugliness, deformity, and pathology. The inexorable chain of Euro-enlightenment logic then proceeds to associate the beautiful image as the ideal type of the normal and the ugly image the embodiment of abnormality. Following this logic of correspondences, the reasoning then goes on to associate the normal with high morality and to make a link between the "ugly" and its abnormality with moral perversion, often signified as sexual promiscuity.

The dilemmas for White feminist aestheticism embedded in the history brutally summarized here are formidable. White feminists cannot help but be provoked by this most sensational example of the sexual objectification of women's bodies. And the criminalization of some women's

body types as inherently prostitutional belongs in the dark pages of Western "science" used as a weapon against the weak, and in this case the White female. But how must White feminism address the special denigration of Black women in this history? Can they see how the benefits from the presentable and supposedly reasonable discourse of aesthetics have been routinely waived when it comes to women of color?

This resistance to cultural domination, combined with defiance of masculinism and patriarchy as reproduced in Black men, or other men, raises problems for assimilation by a White feminist aesthetic. Broadly speaking, White feminist cultural theory has attempted incorporation of the gender-liberating elements in Black women's artwork and left the cultural-liberating elements alone. In the effort to resocialize the terrain once dominated by the White/male aesthetic, the challenge of this non-Western cultural resistance for a feminist aesthetic has been met by a notable silence. If White feminist thought on aesthetics were to be liberative, it would have to include the cultural exploitation of women of color in its analyses, but more than that, it would have to incorporate the whole issue of cultural exploitation as well as, and apart from, gender exploitation. It is an embarrassment much like the differing history of White and Black women in the Southern United States during the reign of slavery. Ultimately, this line of reasoning runs into the facts of cultural difference, which finally invalidate the aesthetic itself. In sum, the limitations of (White) feminist aesthetic theory is generally repetitive of the self-privileging Euro-humanism from which aesthetics sprang originally.[72]

And yet, feminist cultural theory might learn much from the conceptual positioning of women artists of color. For this discourse is sensitive to the danger of single-factor gender perspectives. Can we not suppose that the weight of lived experience versus general theory like the aesthetic is heavier among women of color? The rejection of the autonomy of art and the immersion in issues of the real world figures more prominently in the outlook of these artists and intellectuals, if anything, than they do in "general feminism." The wider mix of issues absorbed in the projects of women artists of color—economics, caste, class, nationalisms, spirituality, and religion—forms a ground from which the delusions of the art-cult are less compelling than for their Euro-modernist counterparts.

From this denser matrix, Black women cultural producers, like Barbara Christian for example, and other women of color, have exercised theoretical restraint, perceiving the danger of drawing a purely intellectual closure around issues that are dealt with more effectively in a holistic way.[73]

Out of this theoretical restraint, Black women cultural intellectuals have not seen the need to reject the aesthetic as such, however much their work and thought explicitly and implicitly contravene its debilitating influences. I was given some insight into the reluctance to sever that cord when I appeared on a panel with bell hooks, African American critic and theorist. Hooks spoke about the artistry and inventiveness of her grandmother, the "aesthetic" sense she demonstrated in artfully decorating her home and its environs. My talk was about the injuries of the aesthetic construct. In the dialogue that followed where bell hooks insisted that her grandmother's personal style was fully aesthetic, I saw once again an impulse among intellectuals of color to pump life into that dying authority so it could confer its deathbed blessings on their work and the work of their communities.

But generally, for feminists, Black or White, to move toward another aesthetic is to hitch their wagons to a dying star. What looks like a more promising direction comes out of a reversal of Rita Felski's program. Felski proposes to bypass a feminist aesthetic in order to achieve feminist cultural goals in feminist public spheres. This seems a politically attractive option. Even more attractive would be to see these goals pursued for the humanization of women, socially and politically, in any sphere. Felski's concept nevertheless has the advantage of drawing into the discussion a more widely embracing arc of issues and experiences of women of all colors. But where Felski would leave the aesthetic intact and "general," that is, genderless, I would recommend abandoning it altogether, in the conviction that the cultural-humanist goals of feminism might best be achieved without aestheticist baggage. Whatever is "lost" by the abandonment of aestheticism would be more than regained in the wider pursuit of cultural liberation.

CHAPTER V

■

The Rebirth of the Aesthetic in Cinema

For obscure reasons, narrative works considered landmarks in American culture as distinctive innovations or successes within their genres have often importantly involved the portrayal of African Americans. *The Jazz Singer*, the "first" sound movie, featured Al Jolson as a burnt-cork minstrel singer. The televised *Roots* had such a massive reception as to be credited with ensuring the future of the mini-series as a genre. Other historical hits that come to mind are Disney's *Song of the South*, which is believed to hold decisive historical attention for innovations in technicolor, feature-length animation, and the combined use of human and cartoon characters (repeated in that sequel breakthrough animation *Who Killed Roger Rabbit*, which merely included Blacks as near-invisible subtext); and *Gone with the Wind*, which made history as a technicolor historical epic. In the novel, *Uncle Tom's Cabin* surely made history as popular best-seller, if not for formal ingenuity. Might it be that some affinity exists between breakthrough productions and national allegories in which the definition of national character simultaneously involves a co-defining anti-type?

This description would certainly apply to D. W. Griffith's *The Birth of a Nation*, one of the most popular turning-point films of all time. *Birth* represents two historical landmarks, as an incomparable racial assault and as a founding breakthrough for subsequent filmmaking techniques. The impact of Griffith's movie on the art-culture system can be summarized by quoting Lewis Jacobs's observation that it "foreshadowed the best that was to come in cinema technique, earned for the screen its right to the status of art, and demonstrated with finality that the movie was one of the most potent social agencies in America,"[1] and, I might add, the modern world. Of these three achievements, the last can stand elaboration. Griffith's movie accomplished the reinvention of mass culture. Mass media had, of course, been in existence for well over a century by the

time Griffith's movie appeared. And the growing popularity of the movies had for a decade demonstrated many of the ingredients of mass culture. But the blockbuster presentation and scale of Griffith's entertainment was the first to make a single fictional creation an instant object of compelling national and international attention for all classes at the same socio-historical moment. It became the center of the first media event of a type that complements the definition of mass culture.

The outcry against the film's racism was also massive. Up to this point, as has been frequently observed, progressive social reformers, alarmed by the spell movies were holding over the lower classes, attempted to restrict their influence and, failing that, to control them through censorship, moral suasion, or ideological framing.[2] As a Victorian moralist with pretensions of educating the public through films, Griffith had become a favorite of these reformers. But *The Birth of a Nation* caused a split in this harmony. Many of these reformers came from backgrounds that had nurtured abolitionist principles. They were joined by the recently formed National Association for the Advancement of Colored People (NAACP) in seeking the banning of the film, bringing court suits against it, organizing pickets and boycotts against it, and in forcing Griffith to reedit and modify some of its most virulent racist passages.

The massive protests led by African American activists against *Birth*, including pickets organized by Boston's Monroe Trotter so vocal that he and several supporters were jailed, was probably the first mass campaign against media misrepresentation made by that group in its history. It may in fact have been the first such mass protest in anyone's history. That they made so determined, and partly successful, a struggle does them honor. Their resistance has been seldom matched by later Black activists in intensity, nor hardly surpassed in sophistication.

For the most part, the anti-racist attack on the film has been confined to its racial and historical deformities as acts of serious social consequences. These attacks have not included discussions of artistic issues. Perhaps its advocates have chosen not to dignify this line of discussion. If a movie makes a major, injurious racial assault on a population, what more need be said about it? Moreover, its African American social critics might well have felt disenfranchised from discussions of art, as an arena in which their views had been isolated as "minor" and inconsequential.

As frequent victims of racist representations Black activists have tended toward a reactive stance toward the arts and media, seeking redress in a "positive image" to counterbalance negative ones. By this narrow focus, anti-racist discourse on media has been severely handicapped

in its capacity to define problems and propose solutions. Their critiques focus on isolated characterizations and depictions within the given work. They bypass considerations of narrative, formalist devices, motifs, and most important of all, meaning. They remain conspicuous victims of the notion of media transparency, that the filmic or fictional narrative is to be taken as a mirror of lived experience. They overlook the possibilities for exercising theories of representation consistent with their liberative goals. But the conditions of possibility now exist to move toward a considered politics of representation, one more cogent than positive imagism.

A more central question for this study is why cinema scholars and aestheticians have kept the racial issue at arms length from their explorations of the film's technique, refusing to synthesize these two discussions. One explanation is an anxiety of influence. Because cinema studies has chartered its historical claim from the starting point of Griffith's movie— almost a myth of origin—there is an inclination not to burden this grand originating moment with the discourse on race relations in the United States. As a probationary branch of the aesthetic, cinema studies can be legitimated only through the exercise of the fundamental act of the aesthetic, the establishment of its discourse as autonomous. Were the discussion of the social implications of Griffith's racist movie to intrude to the fullest impact possible, then the discipline of film studies might lose its status, might enact its own "undisciplining."

Because of the collision of these issues on a rather massive scale in the critical space around *The Birth of a Nation*, it poses a dramatic confrontation on the issue of the validity of the aesthetic vis-à-vis other interpretive paradigms. My argument is that the aesthetic celebration of Griffith's blockbuster movie is another scene where the ideological determination of aesthetic discourse is at work. And that the aesthetic not only conceals its alliance with ideological motivations, as it always must, but that in the specific instance of Griffith's movie it works to suppress important social meanings which become clearer seen within the framework of the politics of media representation.

HOW THE SOUTH WAS LOST

Apologist film scholars for *The Birth of a Nation* take a passive attitude to the film's racism, usually tempering its force on one of four grounds. Some accept Griffith's denial of racist intent. Some specify the "unconsciousness" of Griffith's racism. Others argue that Griffith's portrait of

the Reconstruction era and the role of Black people in it is essentially ac-
curate. The added comment sometimes offered—that Blacks had made
considerable social progress of which Griffith was unaware—implies that
Blacks of the Reconstruction era may have been just as savage and back-
ward as Griffith portrayed them—stands in uneasy relation to a fourth
defense frequently made: that Griffith's posture toward Blacks, and its
easy acceptance by mass audiences, attests to the conventional racist
thought of those times.

In satisfying itself with these pro forma arguments, the discourse of
film studies in the United States makes its own compromise with racist
ideology. As its discussions proceed, it becomes conventional to repeat
these critical positions without interrogating their relation to each other
or to the film as a whole. It is as though its many celebrated rhetorical
achievements and its substantial defamation of Blacks were isolated is-
sues, discussable as of two separate films. Demonstrations of Griffith's
artistic mastery in particular scenes are never connected to their role in
denigrating Blacks. The reflex interpretation more importantly avoids
connection between the film's racist import and racism as a fact in
American life. In the instance of Griffith's national allegory, declared as
such in its title, the passive racism of film studies has drawn it to neglect
the meaning of this allegory and the role of racism in it, in striking con-
trast to the subtle social analysis given other national allegorical themes
like the Western or the gangster movie. Nor has film studies crossed its
self-constructed boundaries and examined the links between Griffith's
racial characterization, admittedly the most negative in U.S. film history,
and the wider theme of Hollywood negrophobia, arguably the most mas-
sive racist assault in the history of mass communications.[3]

Gerald Mast's *A Short History of the Movies*,[4] now in its fourth edition
since 1971, is fairly representative of the film's treatment in standard col-
lege texts. Mast's approach to the issues of racism and aesthetics is to con-
demn the film's bigotry, but in a way that mitigates its severity, then turn
from that subject as a troublesome intrusion and examine the film's ar-
tistic achievements as achievements in "human" expression.

Mast introduces the issue of racism indirectly, via reporting the re-
sponse of liberals in 1915: "The NAACP, the president of Harvard Uni-
versity, Jane Addams, and liberal politicians all damned the work for its
bigoted racist portrayal of the Negro." He then outlines his rhetorical
plan: "With all of the controversy over the film, it might be wise to look
at Griffith's handling of the black man a bit more closely before moving
on to the cinematic qualities of the film."

Mast's "close examination" reveals that two of the film's three villains are mulattoes, possessing qualities that Griffith had damned in White characters in early films: "That they were mulattoes indicates that Griffith's main target was not blacks but miscegenation." These qualifications carry sense if one assumes that racist discourse always invents novel vices to attribute to its targets. The distancing of Griffith's portrayal from ordinary racism by focusing on mulattoes and miscegenation loses force when Mast later acknowledges that Griffith saw Blacks, whom he wanted to keep separate, as inherently inferior to Whites.

Mast's final reflection on racial portrayal in the film concerns the notorious legislature scene where Black legislators with bare feet propped on desks swill liquor and carouse boisterously: "But Griffith's treatment of these blacks is not an isolated expression of racial prejudice; it is a part of his whole system of the evil of social change and disruption." The distinction implies that Griffith was drawing no particularist association between this behavior and blacks as blacks, or that he could not have been ravening among racist caricature and opposing social change and disruption at the same time. "And," Mast concludes, "cinematically this legislature scene is a visual marvel!"

The intrusive issue of race out of the way, Mast's exploration of the movie's cinematic qualities follows familiar lines, but produces a striking iteration of a quality observed as "human." "Though Griffith summarizes an entire historical era . . . his summarizing adopts a human focus." "Human values—love, sincerity, natural affection—triumph over social movements and social reformers." (One might ask whether Griffith's disdain for movements excluded the Klu Klux Klan, and whether Mast's formulation does not open an echo of disdain to fall back upon the previously mentioned social reformers who attacked the film.)

Further, "Griffith never deserts his human focus. . . . he cuts from the valiant human effort on the Union side to shots of a similar effort on the Confederate." "Griffith's attention to human dramatic detail dominates the film." "By capturing human emotions in concrete visual images, Griffith successfully renders human feeling. . . . " "*The Birth of a Nation* is part mammoth spectacle and part touching human drama." Mast concludes his discussion of the film on this exhaustively prepared note: "The film remains solid as human drama and cinematic achievement, flimsy as abstract social theory."

The studied innocence and lack of penetration within canonical film studies in this crucial instance is reflected in the defense of the film's racial portrayals by one of its founding heroes, James Agee. Himself a

Southerner, Agee more obviously than most defends Southern legend at the same time: "Griffith went to almost preposterous lengths to be fair to the Negroes as he understood them, and he understood them as a good type of Southerner does. . . . Griffith's absolute desire to be fair, and understandable, is written all over the picture; so are degrees of understanding, honesty and compassion far beyond the capacity of his accusers. So, of course, are the salient facts of the so-called Reconstruction years."[5] As part of the discursive etiquette of his times, Agee is speaking through a polite silence by leaving unsaid what is an unavoidable conclusion. If Griffith went to almost preposterous lengths to be fair to Negroes, then they were in actuality measurably worse than he depicted them, or not fully worth the lengths he went to in his portrayal. Through a less rigidly maintained discursive etiquette, film studies remains today politely silent about the issue of racism in U.S. film history.

Thornsten Veblen remarked about the film that he had never seen such concise misinformation. Concise misinformation is also impacted in Agee's summatory praise of the movie as "the one great epic, tragic film." The aesthetic masking of ideology is coined in this usage of "epic" and "tragic." They are, of course, generic designations linking the work to an ancient discussion of narrative art, to enshrined artifacts of the Western art-culture system. At the same time, no work can be appreciated as epic or tragic without acceptance or identification with its hero, its actions—in short, its ideological meaning. If the work is an epic, which means among other things that it elaborates a theme of national unity, then it goes without saying this unity must rest on the basis of White values, particularly the value of hatred of miscegenation. If it is an epic, it is an epic of White supremacy.

The cauterization of racist Black portrayal protects the film's reception as an epic, a grand spectacle on the theme of national unity. If racism is the issue, then racism can be denounced and mitigated through sophistic rationalizations. By segregating the issue of racism for bracketed attention, the real issue—White supremacy—is avoided. For it is only as a grand apology for White supremacy that the film fulfills the description of epic as grand articulation of national unity and consciousness.

"Epic" euphemistically masks a more cogent, less aesthetic, designation—myth. As propaganda, *Birth* accomplished the significant feat of transposing the national myth of the South into terms congruent with the mythology of White American nationalism. In Griffith's inscription, this myth rehearses Christian eschatology in national terms. Its basic narrative rhythm is Eden established, lost, restored. From the opening title,

the Edenic scene is laid, as well as its fundamental threat: "The introduc-tion of the African to American shores laid the seeds of national tragedy." This fundamental premise of Griffith's four-hour narrative is marvel-ously neglected in the commentaries, even those grappling with Griffith's attitude toward Blacks.[6] This is another place where the focus on stereo-typic images, and their negativity at the expense of narrative meaning is costly.

The Arcadian visit of the Stonemans to the Camerons near the begin-ning at once establishes the Edenic wholeness of the nation as reflected in these idealized families (not a poor White is to be found speaking in the film) and at the same time uses the delighted presence of the North-erners to confirm the plantation myth of a "naturally" ordered Southern civilization in which the Blacks are both happy and well-behaved.

The tragic flaw in this divinely chartered land is the belief of North-erners that Whites and Blacks can live together without Whites control-ling and containing the subdeveloped Black population. Stoneman's scheming, hissing "mulatto" mistress is given as much weight as any other image in explaining how the North and South came to blows by Northern misunderstanding of this principle. The Honorable Austin Stoneman is obviously modeled on Congressman Thaddeus Stevens, leader of the Radical Republicans in the U.S. Congress. He is depicted being manipulated through his passionate alliance with the scheming "leopardess" (so described in Thomas Dixon's novel about Stevens's affair with his Black housekeeper). He is the epical dark angel who, in his fall from grace precipitates wider disaster by imposing a harsh Black Recon-struction regime on the defenseless White South after the war.

The Christ-like martyrs in this mythic narrative are the soldiers who fall on the battlefield, Lincoln, little Flora Cameron, and the ravaged South. The Christ-like redeemers are "the Little Colonel" and his cohorts in the Klu Klux Klan that he is credited with organizing. (It is not always remembered that the KKK is a Christian secret society whose crosses on their robes and the crosses they burn testify to an apocryphal, fundamen-talist syncretism fusing the Bible with Scottish rites into American Chris-tian fascism.) The spectral image of a superimposed Christ blessing the newly united Ben Cameron and Elsie Stoneman on their way to a New Jerusalem, a "city on the hill,"[7] often derided as a gratuitous, non-realist intrusion on the text, is perfectly consistent with the mythic fabric of the whole tale.

As a national epic, Griffith's film asks the spectator in the White-sub-ject position to perceive the scene of essential national development as

the South instead of colonial New England or the westering frontier. It also asks that spectator to shift the core nationalizing experience from the land and the taming thereof to miscegenation, to Blacks, and the taming thereof. The issue of Black-White sexual relations, in fact, forms the spine of the text. If, in terms of action and excitement, the triple, parallel chase scene at the end is seen as the narrative climax, thematically the most potent and emotionally charged moment is the "Black" trooper Gus stalking the hapless Flora, "tiger-like," to her death-leap over a precipice in order to avoid a worse fate. This moment triggers the explosion into action of the racial resentments smouldering in the preceding scenes. The later sequence where Lynch, the upstart mulatto carpetbagger politician, salaciously entraps Lillian Gish as Elsie Stoneman serves to communitize the threat that by Gus's action alone might be taken as individual aberration.

CROSS-OVER VANITIES

The problematic of this classic film may be summed up like this: its great power in manipulating formal strategies has won it voluminous attention and respect as an aesthetic achievement. Its blatant racist portrayal of Blacks as threat to the national civilization has engendered another passionate discussion, in which the introduction of African Americans to the politics of representation in mass media can be historically traced. If, as I contend, the central theme of the work is the unification of national sentiment around the issue of miscegenation as threat to "civilization," then the neglect of this theme in the aesthetic dialogue amounts to a curious evasion of the question of meaning.

This indifference to meaning explains an extraordinary lapse in the worshipful exegesis of the film's formalist innovations. It goes unnoticed that virtually all of its formal achievements, its editing, the close-ups, iris shots, manipulation of crowds, camera movements, scenic set-ups, literary titles, etc., are deployed in the cause of aestheticizing and sentimentalizing his principals as White people. Gerald Mast's celebration of the "human" qualities of the film can be relocated as investing White American representations with ennobling virtues, articulating their personalities with individualizing, endearing details, and placing their dreams and visions within grand, confirming visual contexts. When such humanizing delineation is directed to non-White or politically variant characters, a frequent response from mainstream critics is to comment on this

"sentimentality." Mast's "humanist" aestheticism takes advantage, consciously or not, of the narrative equation of "human" with the White bourgeoisie. His usage very subtly excludes Black representation and expression from this "human" articulation. In fine scope, Mast encapsulates the hidden racial particularity of "humanist" discourse generally.

This is all the clearer when we see that the Blacks in the film are not involved in this aestheticization, but are consistently incorporated within a contra-aesthetic film language. This separate and unaesthetic representation of Blacks does more than provide grounds for complaint of stereotypic imagery. The divide between the aesthetic differential in portrayal of Whites and Blacks presents the "crack" through which the artistic overlay of the film can be penetrated and its meaning more fully clarified. Once penetrated, we can find a major illustration of the way an aesthetic cover not only shadows but conceals ideological meaning.

Cheryl Chisolm has spotted the crack in the surface look of the film in the discrepancy that its celebrated pictorial realism is crudely interrupted in the representation of Blacks, particularly by the convention of casting Black roles with White actors in burnt cork. She observes that this contributes a surreal dimension that, except for the general accommodation to distorted racial representation, should be seen as a striking and anomalous directorial intervention.[8] Opposed to the poetic realism Griffith employed to depict his White characters, for the Blacks he fashioned an anti- or subpoetic "realism," a different poetic altogether. Seeing this, we are better able to grapple with the murky grotesqueness of these humanoid figures dimly lit by the reverse of the fire that brightens his aureoled White figures. This alternative subpoetics is consistent with the manichean cultural symbolism Griffith marshalls throughout his film.

The contradictory and overdetermined use of White actors in blackface opens our perception to Griffith's personal stake in the making of the film. Fortunately, Richard Schickel, Griffith's most thorough biographer, has cleared new ground that should help shift interpretation beyond its bicameral myopia.

Two anecdotes from the largely self-made Griffith legend seem to augur the authorial elements behind the controversial labors of the film. In one, a Black elevator boy, on hearing Griffith sing, asserts that he should go on the stage—advice he followed into the theatrical career that preceded his movie-making achievements. In another, Griffith familiarly sits under a drinking table revelling in the Confederate derring-do tales of his father and other Southern veterans. To these should be added a third,

highlighted by Schickel. Griffith's first love came when he was smitten as a boy by "a slim, nut-brown maid with curling chestnut tresses" with whom he played a tag game in which, in one of his versions, he was never able to catch her, and in the other, he catches her after which she coyly tells him she let him do so.[9]

Griffith pursued this fantasy figure, whom he called his "first star," through a number of imaginative exertions. He wrote a short story about this girl, whose name he could not remember, called "It Never Happened." It included, according to Schickel, gossip about a father-daughter incest relation and suggestions of masturbatory fantasies about his dream girl.[10]

Griffith apparently suffered an extreme case of the romantic love concept where only desire unattained could keep its idealized inspiration in bloom. He could not, in Schickel's interpretation, find resolution of his lifelong division of women "between the virgin whom one somehow could not tag and the wanton who both titillated and appalled."[11] Much the ladies' man, Griffith ploughed through a number of aspiring and working actresses and admirers but found himself impotent or emotionally inhibited with a few women who captured his image of the ideal.

This femme ideal, imperiled by a beast-rapist with dishonor so deep as to make death a superior alternative, apparently served as the auteur of his film corpus, showing up not only in the guise of Flora in *Birth*. A villain-rapist in *War*, a play he wrote in 1907, prefigures not only Gus, but also menacing counterparts in *Hearts of the World, Broken Blossoms, America*, "to name only a few of his lustful sadists."[12]

So captivated by this dream motif was Griffith that he dragged it unfashionably into the 1920s and 1930s, and thereby doomed his comeback opportunities as a director. On this question Schickel sums up:

> But if it was not clear before, it became self-evident at this late date [1933]: with Griffith we are dealing not so much with racial prejudice, but rather with a deep and permanent sexual obsession. Indeed, the thought recurs that blackness was almost incidental to the obsession, a convenient visual aid in symbolizing the ugliest and most rapacious of male impulses, but not perhaps to be taken personally by blacks. As he had proved in so many films after *Birth*, color was not entirely necessary to the working out of his great, sordid theme, that theme that thrilled him to the deepest, darkest (and entirely unacknowledged) recesses of his being. In any event, he could no more abandon it in his work than he could abandon the pursuit of underage girls in life. It is saddening and infuriating, for one is hard-pressed to think of any other major figure, in films or for that matter in any of the arts, who so single-mindedly

kept circling back on this particular pathology. And to find him still in thrall to it when he needed to prove that he could move on to other matters is particularly distressing.[13]

Searching for the etiology of Griffith's psychic dilemma, Schickel considers the uncertain grasp he had on his parents' love, particularly his war-adventuring father. First of all, Griffith had no model of interaction with women other than his father's remoteness toward them. More pressingly, Griffith's obsession formation seems to have transferred his father's obsession with macho courage to a culturally more elevated theme, a staple of the Confederate mythic code, the ideal, unattainable symbol of womanhood and the valor necessary to protect it.

Should we be surprised that Thomas Dixon, the former preacher turned racist novelist who wrote the book and play later adapted as *The Birth of a Nation*, held a kindred obsession with the same virginal child-woman auteur who dominated Griffith's imaginative life? Except that as interpreted by historian Joel Williamson, Dixon's psyche was locked into a more classically Oedipal absorption with his mother. Dixon's consciousness was torn by the suffering he imagined his mother endured as a thirteen-year-old bride. The decisive trauma occurred during the final collapse of his mother's health, she deliriously mumbling references to her untimely marriage while he, a boy of twelve, overwhelmed by the medical and emotional responsibilities of caring for her, blamed her illnesses on this early marriage.

Dixon's writing of *The Leopard's Spots*, his first Klu Klux Klan novel, is portrayed by Williamson as an effort at psychic self-cure. As such, "it was a brilliant, disingenuous performance in which, in brief, Southern White maidenhood substituted for his mother, the black beast rapist was a surrogate for her never named violater, and the violater in the person of the black beast was horribly punished."[14]

Griffith's racism was unconscious, but then all racism, as a group psychosis, is unconscious, at least of its motivating sources. His negrophobia differed from Dixon's mainly in forming a smaller part in his total life program—his later gestures of amends and less vicious depictions of Blacks have been rightly dismissed as paltry in terms of offsetting the damage of *Birth*, but they do establish his lack of continual need to resort to the Negro-beast image. Griffith's obsession and Dixon's, so much alike despite their Oedipal variations, reached for nourishment into a largely unconscious or self-deceiving collective cultural symbolism.[15] If myth, as according to Lévi-Strauss, is a mechanism for resolving the contradictions of group experience and knowledge, then ideological rationales

must similarly bear the strain of masking and concealing alternate and incongruous perceptions.

Griffith's modus operandi as an instinctive auteur improviser, for whom Black people did not really exist, offers the most fascinating glimpse of this cultural symbolism at work. His stated reason for rejecting Black actors in favor of Whites in burnt cork was that he did not find any qualified Negro performers in the Los Angeles area, and further, he wanted to cast from his own company. These were familiar, Hollywood excuses, but they obviously papered over other needs. He was casting a private/cultural psychic drama in which the subtextual identifiability of Whiteness beneath the surface bestiality of Black was a libidinal requirement. As Silas Lynch, the half-caste upstart importuning Lillian Gish, who was one of Griffith's idealized romantic attachments, he cast his chief assistant and man of all work, one described as "sensitive to Griffith's every whim." The newcomer Gish was given her major role because "one day while we were rehearsing the scene where the colored man picks up the Northern girl gorilla-fashion, my hair, which was very blond, fell far below my waist and Griffith, seeing the contrast in the two figures, assigned me to play Elsie Stoneman."[16]

IF DAT WAS DEN, DIS MUST BE NOW

The spectacular oddness of the Blacks in Griffith's Civil War drama arises from his deployment of the theatrical and psychic license of the blackface minstrel show in the middle of an otherwise realist-poetic rhetorical mode. The minstrel show's expectation to produce comedy and laughter obscures our recognition that Griffith used its crucial masking mechanism for similar but more hard-nosed purposes. By having his foregrounded Black characters played by Whites in blackface, he made gains from the same emotional dynamics that made White minstrel audiences love to see their fellows in burnt cork. Under the mask of racial and moral darkness, hidden desires could be exercised and indulged in public performance, be glamorized and applauded. With the violence supplied by Thomas Dixon's narratives, Griffith carried the minstrel trope one step further. Using as spiritual ballast a Victorian religious morality so distraught as to endorse the racial religiosity of the KKK, Griffith fashioned a drama of the id where he could reenact the deflowering of Nordic nymphets, those virgins who most completely embodied the tribal idea

one must live and die for, and then experience the chastisement of this deepest of imaginative sins in the lynching of a Black alter ego who performed the desired sacrilege for his vicarious satisfaction.

By its extraordinary fusion of the two basic racial rituals of the post-bellum South—the minstrel show and the lynching—the movie exposed the essential kinship between them. Some of the fantastic gratification White men got from witnessing a lynching came from purgation of their incestuous guilt by identifying their inadmissible desires with the immolated Black victim. The minstrel mechanism, we can see, is one instance where the ideological masking of alternative or competing knowledge and information requires an actual, material mask. It is ideological masking elevated to a ritual level.

What name should be given this psycho-social phenomenon? Negro-fetishism? That term might easily be confused with anthropological characterizations of African traditional religions. A more descriptive name would be "negrophilia," understanding its complex fusion of desire and aversion, projection and concealment. Negrophilia is most lavishly put on display in the minstrel show. Contemporary witnesses testify to the essential good-naturedness and friendliness toward the Negro that was present in the minstrel tent. The carnival gaiety and circus atmosphere surrounding lynchings is also richly documented.

The heart of negrophilia is unbared in that curious erotic ritual where a White male heightens sexual pleasure from witnessing his wife having intercourse with a Black man—sometimes while he has sex with another partner. His pleasure derives from identifying with the erotic experience and maybe performance of the Black surrogate. His wife, if cooperative, says and does with the surrogate partner whatever most erotically arouses her legitimate mate. The surrogate is essentially being coitally or otherwise masturbated for her husband's satisfaction. Freudian analysis offers the accurate designation for this psychological maneuver as "displacement."

This displacement is powerful enough for the White male in this ritual to focus on his own satisfaction so prominently that he mentally obliterates the surrogate and his response or enjoyment of his wife from reality. Or rather, he appropriates it for his own. The mental migration is more thorough than mere identification. That would imply a sharing of his wife's sexuality with the Black partner. His wife is not contaminated by carnal contract with a tabooed partner. He was the partner. The Black man entangled with his mate is merely an erotic objet d'art, an aphrodis-

iac, a "marital convenience." Fetishism is most definitely involved inasmuch as in fetishism the obsessive object is not worshiped for itself but for transcendental values it is believed to represent.[17]

This radical displacement, including the obliteration of the actual presence of the Black partner in order to obtain the satisfying use of his fantastical image, is necessary to recognize since it explains several otherwise curious displacements in the fantastic perception of Blacks in racialist representation, not excluding Hollywood movies. A relevant displacement of this secondary kind is Griffith's insistence that he meant no insult to the Negro race in his portrayal of them in his epic. We can read this assertion as meaning that he never thought about actual Negroes, so caught up was he with them as auxiliary, fetish instruments for his private reveries.

The point of exploring Griffith's personal, erotic obsessions is to document his real but hidden purpose as he and Dixon manipulate White cultural symbolism while laying the foundation of popular, classical cinema. The vast popularity of his blockbuster movie argues that he was lucky enough (and surprised by his success, too) to have found autobiographical impulses that coalesced with transindividual symbolic needs, not only among his contemporaries but also among successive generations of American cineastes.

The minstrel show and the lynching formed twin theaters of this American symbolic order as seen from its underbelly. Both forms of ritual entertainment were extremely popular in the North, the minstrel show without rivalry. The inventive contribution of Dixon and even more of Griffith was to disassemble and reorganize the symbolic values of these familiar, conventional rituals into a grand mythic design in which they were discoverable afresh. These symbolic values were redistributed within the fabric of a pseudo-historical pageant in which their necessary truth-value was reconfirmed through narrative agencies such as suspenseful action moving inevitably toward a stirring climax. On a small scale the lynching of Gus and his castration (the last deleted from the film in most versions), clearly a White actor in blackface, skillfully fused these two apparent contrary rituals. On the larger scale, the ingenuity of the epic-mythical design lies in the recombination of the minstrel-lynching sign system, the Southern plantation myth, and the familiar fable of White Southern degradation under Reconstruction with more broadly national iconographies in the framework of a national epic allegory.

In order to do this, Griffith not only Biblicized his story, he also activated in it the racist European concept of the Great Chain of Being, ex-

tending from the playful puppies and birds that validate the domestic Eden of the White Southern home and hearth; to the Negroes most like those loveable pets when given the protection of White stewardship, but animalized as tiger/gorilla/serpent-like when unleashed by misguided leadership; through the decent and pure White Southern gentry who invent the Klan; right up to the Nordicized Christ who blesses their triumph at the end.

Sergei Eisenstein forcefully analyzed his own cinematic rhetoric and particularly his editing principles as dialectical, as opposed to Griffith's innovations, which had profoundly influenced him. By contrast to Eisenstein's dialectics the strategy of Griffith's rhetorical organization is manichean. Manichean dualism provides the key to much of Griffith's cinema rhetoric employed in the first half of the narrative, opposing peace to war, which prepares his viewer to accept the opposition of White to Black in the second half, as the historical complement or solution to the first. Moreover these innovations find a necessary, but little-noted complement in the subaesthetic devices of minstrelization and Black cinematic depersonalization. These devices as Griffith shaped them would also become part of the legacy he left to developing cinema.

And since Western cognitive grammar is oriented toward oppositional dualities, the play of this manicheanism in Griffith's "aesthetic" successfully masks its ideological bearings. The Eurocentric bias of aestheticism explains why this criticism has largely failed to recognize *Birth*'s epic quality as White supremacist myth, or the catharsis of its "tragedy" as pseudo-erotic release or exorcism on witnessing a well-orchestrated lynching of fetishized Black reality. So it is not surprising that this criticism has overlooked one of the film's intriguing distinctions. It is clearly the most powerful evocation of fascism among the classics of the cinemateque, not excluding *Triumph of the Will*. To embellish this impression of American fascism in this work, Griffith expressed mutual admiration with Italian fascists under Mussolini in 1924. After a lionized tour of Italy to consider the task of reconstructing the Italian film industry, Griffith found himself "mad about Mussolini," and projected a biography of Il Duce: "I believe that anything may happen as a result of this fascism. I should like to put into a film the remarkable spirit of the fascisti."[18]

Griffith's racism was largely unconscious, as has been often asserted. But what does that mean? The assertion is made as if to bracket Griffith's racist attitudes from further analyses. To say that his racism was unconscious is also to say that it was ideological, that he was little more racist than his historical times whose bigotry he was merely reflecting in his

films. The better observation is that he was no more racist than other Hollywood functionaries; had he not made this one symbolically hate-filled movie, he would never have called attention to his bigotry. But the notion that *Birth* merely reflected contemporary racial prejudice is also another way of bracketing the phenomenon of *Birth* from wider significance in our understanding of American culture and media.

Richard Schickel's description of Griffith's racism elaborates this bracketing perception, without, finally, dissolving the brackets. Throughout most of his life, Schickel observes, Griffith subscribed to a traditional Southern view of African Americans as "pre-moral children,"[19] of whom moral understanding was not to be expected: "This view of the blacks, which did not preclude (at least in theory) their coming after the passage of time to a true state of equality with whites was and remained until very recent time the conventional wisdom of 'enlightened' Southerners." Schickel makes use of a favored trope in the discussion of American racism, that of a mobile and advancing time boundary, "the very recent past," beyond which the pathologies of U.S. racist attitudes are framed as artifacts in a museum.

Historian Joel Williamson presents a sharper, more penetrating historical analysis of racial attitudes in the post–Civil War South that gives background to Griffith's views. According to Williamson, White perceptions of Blacks after the Civil War fell among three predominant positions. The Conservative view, the central, most entrenched one, sought to conserve the Negro by defining and protecting his place as an inferior in society. The Liberal view, held by a minority, felt that the Negro's capacity to rise to a position closer to that of Whites had not been tested and was open to social experimentation that might validate an optimistic outlook for the future of Negro uplift.[20] This is where Schickel places Griffith, mistakenly, in his expression in *Birth*. The opposite extreme of the Conservative position was asserted by the racial Radicals who flourished from 1889 until 1915. Radicalism was alarmed by a vision of a "new" Negro released from the wise controls of slavery into a freedom beyond his moral capacity, and rapidly retrogressing toward his natural state of savagery and bestiality. The economic crises of the rural South during those years, according to Williamson, weakened the claims of White Southern manhood in the role of breadwinner, hence that role shifted to defender of White womanhood from the threat of unsupervised Negroes roving through the Southern countryside. The Radicals saw no future for the Negro in the United States and looked for his eventual elimination.

Race Radicalism went into decline about 1915, according to this analysis, because of the inadequacies of its alarmist vision—instead of degenerating and disappearing, Blacks were visibly advancing numerically and somewhat socially. Ironically, then, *The Birth of a Nation* stands as the swan song of Radicalism as a major, acceptable position, a Radicalism whose fervor Thomas Dixon, one of its most passionate ideologues, passed to his suddenly inspired convert, Griffith. The Southern Conservative center recovered ground lost to Radicals, freezing racial perception of Blacks at a level close to that drawn by the Radicals for the next half century.

One contribution of Williamson's analysis is to restore variety, dynamism, and historical mobility to racialist representations. From this standpoint, *Birth* like the sensational Radicalism that conceived it, reflects a virulent episode in Southern consciousness, more than an aberration, but less than a permanent fixture. On the level of representation occupied by cinema, at least, *The Birth of a Nation* brought the ensuing ideological conflict to a head. The singularly trenchant counterattack on the movie from Black libertarians and their White progressive allies represented an unprecedented new force of resistance which demonstrated an altered historical terrain in which racial Radicalism was removed further from the center and placed on the defensive.

Mainstream filmmaking in the United States never again fashioned a portrait of Blacks massed in menace against White society, or being mowed down in droves, in a style reserved for darker hordes of Indians in the westward trek, or Mexican banditos or federales, or for other non-Western pagans. Yet the struggle pictured by Williamson between a dominant, centralizing Conservatism working to maintain a fixed place for Blacks, inflected by the variant perceptions of child-like, aspiring wards of White civilization on the one hand and brute, menacing savages on the other was to be replayed on American screens for the half-century following Griffith's supremacist epic and longer. The attitudes nurtured by his movie and its parent movement left enduring legacies and shaped psychic postures which would recur as themes in later episodes of national symbolic thought.

It is transparent, looking back, that the doctrine of the neutrality of the aesthetic and later the Kantian assertion of its disinterestedness were essential maneuvers for establishing its identity and integrity as a distinctive and separate activity and a ground for autonomous rules and criteria. This maneuver was necessary on several counts, all of them lying within the crises and local circumstances of Occidental history. The more recent schools and movements of criticism that have attempted to modify

this central doctrine, arguing that the work cannot be interpreted and understood apart from its social, historical, and political contexts, have, sometimes laughably, failed to confront the fact that the serious inclusion of these contexts violate and invalidate the identifying claims of the aesthetic itself.

These very sound contextualist arguments work to mitigate the confusions of the aesthetic and, as I have argued, to abrogate its effect almost entirely in major regions of contemporary critical discussion. Nevertheless, vast accretions of social, political, and economic interests have accumulated around the aesthetic as an institutionalized discursive history, much of it around the site of the established art-culture system. These interests manage to keep the aesthetic in operation, very much like a politics against political clarity, a mystifying ideology of autonomous art. In denying the political resonance of cultural works, this discourse in effect throws protective skirts around all sorts of political ideologies and nostrums couched within the representational form of "art," not simply because it loves them, but because it must protect them in order to protect its own authority. *The Birth of a Nation* is an arresting case in point. The gamble taken by aesthetic discourse, which it is presently losing, is that serious attacks on the political representations it protects, when brought down to the common light of day for accounting, may also bring it down to the same arena, suddenly and embarrassingly denuded of its mystifying aura.

I have spoken of Griffith's epic as a radical and evil work. This raises a question that deserves a postscript. If one grants that *The Birth of a Nation* may be an evil work, one injurious to the social fabric and retarding the effort to articulate the human, then the grounds of discussion have shifted. Where before the tension arose between the film's aesthetic reception versus its social-historical interpretation, now we are looking at its aesthetic versus its moral interpretation.

Griffith's film confronts us with the possibility of a work being powerfully persuasive, affecting, and aesthetically rewarding, while at the same time saturated with noxious conceits and ideas: beautiful yet evil. Cinema has established this possibility more vocally than other forms. The subject of evil art does appear in literature, as in Thomas Mann's "Mario the Magician," and his Doctor Faustus. The dilemmas raised by this prospect nevertheless remain an isolated sidebar in aesthetic discourse. It should be clear by now that human skills, artistic or otherwise, can not only serve both negative and positive ends, but serve each just as easily as the other.

Canonical reception of films like *The Birth of a Nation* and *Triumph of the Will* foregrounds their formalist accomplishments while bracketing their intended meanings as vicious material whose poison is no longer active or transparent to the historical observer. This is not the same as the ancient and intelligent realization that a work may be artful and pernicious at the same time. Instead, it hedges these considerations by reflecting on them only when the work in question holds no immanent threat to the values of the art-culture formation directing the aesthetic at the given historical moment.

More revealing is the aestheticist response to a work it finds ideologically or morally threatening as "not art at all." This maneuver clearly betrays the intent to protect the definition of art as contribution to "civilization," meaning canonized art of course. The obscurantist confusion over evil art arose at the point when art was redefined beyond its traditional significance as skill or craft and embodied with idealized, transcendental qualities as an autonomous realm of human experience, replacing the declining hegemony of Christian religion. Hence the exaggerated claims for art, such as Keats's assertion that "Truth is beauty, beauty truth" can be recognized as propaganda for this radical reorganization of knowledge and experience.

Set beside the medieval order of knowledge which the new concept of art helped displace, the mystifications of the new paradigm allow us to surmise that it too is a gross superstition. Moreover, whatever was superstitious in medievalism from the point of view of an enlightened humanist view was not its concept of art but the religious hierarchy that concept sometimes served. This prepares the paradox that the new concept, relying on displaced mystery, may be more superstitious and backward, and certainly more unscientific, than the paradigm it subverted. It is this mystifying aura orchestrated by the art-culture system that has deterred the recognition of *The Birth of a Nation* as one of the most accomplished articulations of fascism, of twentieth-century evil.

The confluence noted earlier of major, "liberating" American narrative texts and deposits of what Toni Morrison calls Africanisms—configurations of the African presence in American fiction—appears at once more and less strange when exampled in *The Birth of a Nation*. The parasitical nature of American identity in relation to the apparition of Blackness should no longer evoke surprise. But what might intensify reflection is the silence maintained by criticism and theory when faced with this asymmetrical coupling of cultural symbolisms. This silence testifies to the location of this parasitic relationship at the crux, rather than the mar-

gin of American cultural practice. This location is further certified when we perceive the fateful confluence as one between the aesthetic and Euro-American racial consciousness.

In what sense, to be more specific, did Griffith rebirth the aesthetic in cinema? Not merely by installing unity, balance, decorum, or other such values that were available to and availed by Edwin S. Porter and other early directors of European descent. Nor was it in unleashing the technical facilities of close-ups, continuity editing, composition, iris shots, night photography, etc. For while this was a brilliant achievement, it was of the order of the discovery of one grammar of cinema. It is on the rhetorical level, where meaning is encountered, that we can watch the aesthetic being reborn in his film.

Like the aesthetic inaugurated by eighteenth-century European philosophers, Griffith's film aesthetic promises and delivers sentiments beyond considerations of craft—large, ennobling sentiments of a sensory/moral gestalt transcending any particular time and place or any given art-piece. But where the architects of aesthetic theory based their modular vision of beauty and perfection in ancient Greece, Griffith turned to the homier epiphany of racialized Christianity. We may remark that in both cases the inscription of higher aesthetic values was also an inscription of the Aryan self as civilized ideal.

Since Griffith brings us to this point of recognition, it is fair that he bring us to another. The values encoded by the aesthetic—beauty, moderation, disinterestedness, purity, vitality—which have undergone change at historic crossroads, are nevertheless always the values by which Occidental imagination conceives of itself in its highest forms. If Griffith gave a new birth to the aesthetic in cinema, it was necessarily as the apotheosis of Caucasian perfection.

This aspect of the aesthetic, its celebration of the collective self, might not be in itself alarming or objectionable. It must be clear that most if not all cultures cling to a hierarchy of values that confer identity, and perhaps also distinction. Where this celebratory commitment becomes problematical is in the constitution of the aesthetic as a supra-ethnic cognitive grid, as a universal configuration. So canonized, it became a mythic construct, assuredly of great force and power, but of the sort that requires massive repressions along with its massive assertions. In this, the aesthetic operates simultaneously and harmoniously with a kindred ideology, that of Western racial superiority.

The critical and theoretical apparatus of film studies has inherited this

unholy marriage of parasitic group fantasy as a double bind. It must persist in a willful critical blindness, which becomes more easily, casually willed as its blindness becomes conventional. Or, by perceiving the doubled social meanings of its monological aesthetic discourse, it must begin to rid itself of false consciousness. And the longer it delays taking this second course, the more violent will be the traumas inflicted on its self-definitions and core assumptions.

CHAPTER VI

∎

The Aesthetic, the Movie

Through the movies we get some idea of how the aesthetic permeated popular imagination. Nineteen fifteen was a banner year for the aestheticization of movies, witnessing not only *The Birth of a Nation*'s aestheticization of racism, but also Vachel Lindsay's prescient *The Art of the Moving Picture*. Seemingly, the art ideology had found a new and fertile field of influence. But the actual result of this enthusiastic alliance was as problematical as it must have seemed to contemporaries. What happened to the aesthetic in the movies might better be seen as a tri-part narrative in which the aesthetic and the master narrative of Western historical imagination meet each other on the grounds of the classical cinema of Hollywood's golden years. For our inquiry, it becomes a moot point whether through this passage the aesthetic wins because it loses, or loses because it wins, or simply declares victory and gets the hell out. More crucially, what can be gleaned from this encounter about the limits of aesthetic reasoning fades in significance beside what we learn for the critique of representation.

As a highly developed discourse and one of the grand narratives of capital knowledge, the aesthetic might itself be imagined as a movie, most likely a classical black and white production typical of Hollywood at the height of its development. The analogy draws some of its power from the way the cinema and its apparatus function as a material extension of the aesthetic. Both are biased toward visual knowledge, with the lens of the camera easily likened to the "eye" of the aesthetic gaze. Much analysis has demonstrated how the standardized techniques of moviemaking accommodated themselves to the prevailing cultural modes of perception in Western societies.[1] When depth photography entered the movies, it naturally drew comparison to vanishing point perspective in Renaissance painting. Even before this, by the example of Griffith and

the teachings of Lindsay, the mise-en-scène of movies was likened to the composition of Western painting.

A more important aspect of the politics of this wedding of aestheticism and movies was the way movies mechanized the subject-object relation of Western philosophy. Within this mechanical materialization, we can see how the aesthetic itself, like the movies in Laura Mulvey's ground-breaking analysis, is coded for the male spectator, whose race and class we already know. Which also means that good reception demands that the unpreferred observer assume an invented self-image as close as possible to this paragon spectator. We can get another look at this ideal spectator, at least in the mind of one Boston critic writing in 1875. This worthy argued that if America wanted culture it needed to encourage "the man of high aesthetic nature and cultivation" who "has an almost divine right to exercise and nourish his superior faculties in what most transcendent manner he can. Let the mediocre majority feed after him, even on the crumbs that fall from his table, if need be."[2] Both the apparatus and imagery are coded for this exemplary observer, by way of implanting this ideal spectator within actual ones, or inducing them to suture themselves into his subject position, producing the cultural alienation involved in eating the crumbs of his responses.

Aesthetic discourse and the movies try to convince the spectator that their representations monopolize credible possibilities. Both try to effect an "invisible editing" to deny that the "truths" of their symbolic expressions are selected, highly codified reproductions of the collective consciousness of one social group. Like a Hollywood movie, the aesthetic tries to persuade the viewer that there is only one kind of human beauty, and only one kind of dependable human worthiness.

Like the movies of this production code, the aesthetic functions as support of the master narrative of the Western historical imaginary, signifying the inevitable historical progress of the Western bourgeoisie. Beginning in historical medias res, the aesthetic also shadows the narrative paradigm of the classical movie. With careless attention to its origins (which we have already seen are dubious), the aesthetic, as hero of its own tale, sets out on a quest, encounters several obstacles which it overcomes, and moves through a triumphant climax to an ending which brings all issues to a tight formal closure around its knowledge category.

We might conceive of the hero of aesthetic knowledge to be the autocratic Euro-humanist subject, very often represented by a White male artistic "genius." The bio-pic of this heroic subjectivity follows its ideologi-

cal adventures overcoming the obstacles to its quest for dominance, stamping out infidel ideas and non-conformist modes of consciousness, like the march of History in Hegel's philosophical opera. The highly formalized closure of the aesthetic adventure presumes to encapsulate all relevant cultural meanings, including the resistant materials that temporarily block its progress, either in the form of natural reality or subjected peoples. In both venues, closure is circumscribed around characters as well as narrative-ideology. The closure of the aesthetic as movie functions as boundary between what is and is not "natural" and between what is and is not to be expected and admired.

The idea of formula studio movies from Hollywood as a "classical" expression is a joke with many ironic ripples. Movies became "classical" with the aid of artistic pretensions, but as far as aestheticism is concerned the result was something of a Frankenstein monster. The stage for this unholy wedding was set by middle-class reformers, many of them Progressives, who in the teens of the century, worked to uplift the raucous entertainment consumed mostly by the working class in nickelodeons and vaudeville houses. The demand that the purveyors of sensationalist movie distractions clean up their act or get out of business, backed by a new licensing system, was taken by these shrewd businessmen as an invitation to move their product upward, classwise. They took the new challenge as the command to forget the maid and court the daughter.

The heavily industrialized studio system that emerged from this act cleaning—a fierce, monopolistic competition in which only the strong survived—was part of an entertainment/information revolution. The most important link between the aesthetic and the movies is the widened field of operation movies gave to the art-culture system where aestheticism works the crowd. This refers to the steady shift in the kind of knowledge and experience people are exposed to since the European Middle Ages. One dimension is the drastic increase in the amount of time devoted to leisure and entertainment. Another radical change has been the proportion of information gained through representations, including those of mechanical reproduction, as compared to direct experience.

Of course, the movies had an explosive role in both these developments, bringing closer what Debord has called "the society of the spectacle."[3] If the aesthetic became a system of implanting an internalized control of perceptions and feelings in the interests of the high middle class, then the movies vastly extended the reach of this aestheticization of experience. By the 1940s when 90 million Americans went to the movies once

a week, movies had become the advanced guard of a rise in distractions and leisure-time activity that would have staggered a medieval peasant. This was the entertainment explosion that became the consumer culture of the late twentieth century. This unprecedented culture industry became, not incidentally, a formidable mechanism of social control through mass media, as opposed to administrative coercion.

Part of the joke on the aesthetic was that a form of sensory stimulation had emerged whose very power and scope swamped the elite pretenses of aesthetic discourse, absorbing some of its dogmas, but blithely ignoring others, mainly the injunction to be privatist. Instead of a cultural doctrine to confer distinction on its supporters, the movies formed an entertainment culture whose driving motive was to give people a chance to *belong*. Movies were a process of social reconstruction and elevation for many U.S. populations, an opportunity to shed old, despised identities, as if in a second, symbolic migration from margin to mainstream, for their producers as well as their watchers. The idea of a mainstream would itself have been postponed without Hollywood's fabrication of same. And some of its most virulent detractors charge the movies with a social homogenization very different from the supposed impact of aesthetic experience. Movies were, as one Lindsay supporter argued, a chance "to plant new conceptions of civic and national idealism." But the formalist focus of aestheticism, the cultivation of disinterestedness, were wasted on a populist medium which saw viewers routinely confuse actors with the roles they played.

Despite the efforts of Vachel Lindsay and his followers to educate the movies to the ideology of art, the stratagem did not work. Not that the movies could not be convincingly aestheticized, and therefore provide employment for thousands of film studies professors. The problem was that this aestheticization did not matter, was beside the point, in a way that aesthetic discussion had never been allowed to become irrelevant to "classical" literature, music, painting, etc. The proof of this irrelevance is the insignificant, class-bound impact of films made under the banner of art, avant-gardism, experimentalism—films driven by aesthetic theorizing—beside those that were "classical," immensely powerful and successful in organizing cultural imaginations in ways that the older art-culture system had never been able to do. It was the crucial fate of aestheticizers of movies such as Lindsay in 1915 to attempt to elevate movies to art at a time when the insiders of the Palace were taking refuge from mass and popular culture into their aptly named (with)drawing rooms. Lindsay's

main practical recommendation, for instance, was to bring the film into the museum. The typical success of artifying the movies was to bring some of them into the reserved space of the art-sphere.

The aesthetic as a movie is classical in style and ambition, but ultimately falls short of the classical as a genre. The only victory or happy ending available to the aesthetic in the movies was Pyrrhic. Aesthetics-the-movie finally lost much of its timely appeal. It did not dissolve so much as become swamped by new devices overtaking its success—advances in film technology, the growing role of special effects, and sensations such as mayhem and womanly flesh. The movie capitalists relied on whatever aesthetic knowledge they had absorbed along the way to satisfy the reformers and upscale their product. The declining influence of the movie's reformers since the 1950s parallels the overshadowing of aesthetics by cruder appeals. The role of art-ideology in movies was being repeated in other fields—as Judas goat for the rising business of producing the product-consuming personality. This stylization of individual self-perception within society may have been the greatest historical effect of aesthetic reasoning.[4] The art-cult leaves in its trail huge populations devoted to the consumption of life as the narcissistic adornment of ego, measured by personal achievements and the collection of ego-boosting experiences that, when added up before death, could be counted an artistic success. Hence the bumper sticker "The One With the Most Toys at the End Wins." Its limited successes have been swallowed in a way to disclose its relative impotence in the face of market forces. With this double bind, we reach a point where aesthetic reasoning begins to take the character of a minor irritant to cultural liberation, distracting resistance from the more serious menace.

EURO-ENLIGHTENMENT: THE SEQUEL

> Taste as defined by "high culture," once it is "overdone," is normally passed on to the rest of society as leftovers to be devoured and ruminated over by those who were not invited to the feast.
> —Julio García Espinosa, "For an Imperfect Cinema"[5]

The description of Hollywood movies from the 1920s through the 1950s as "classical" is a joke with many wrinkles. One of them is that in many ways the description is apt. An encyclopedic book on the subject enumerates relevant characteristics: "notions of decorum, proportion, formal harmony, respect for tradition, mimesis, self-effacing craftsmanship, and

cool control of the perceiver's response—canons which critics in any medium call 'classical.' "[6] The idea of the machine-tooled mass production of movies in the 1930s and 1940s as a "classical" production becomes less a joke or wild metaphor the more it is scrutinized. Or the sting of the joke falls elsewhere. Once we allow for inevitable historical differences, the development of classical cinema in the United States begins to look remarkably like an effort, conscious but perhaps more unconscious, to recreate the original formation of classicism within the new medium. Harold Innes and Marshall McLuhan point out that every new medium of communication tends to absorb the functions and powers of previous media. More powerful media also follow an impulse to recapitulate and renovate older cultural traditions in the newer forms.

The spectacle of Hollywood reintroducing classicism follows Marx's observation that history repeats itself, first as tragedy, the second time as farce. But in the construction of Hollywood, tragedy and farce collaborate. The history of Hollywood reads best as a "tragic farce." For it is possible that the repetition of classicism in the "farcical" mannerisms of Hollywood have had more profound social consequences than the articulation of classical ideology in the more serious, pretentious guises of the eighteenth century.

Theodor Adorno and Max Horkheimer long ago noted the irony of classical moviemaking as a sequel to Euro-enlightenment. They noted and lamented this curious affinity in the most articulate savaging of Hollywood to date: "Their [the movies] prearranged harmony is a mockery of what had to be striven after in the great bourgeois works of art." But from their own Marxist elitism, they saw clearly that "[t]he art historians and guardians of culture who complain of the extinction in the West of a basic style-determining power are wrong. The stereotyped appropriation of everything, even the inchoate, for the purpose of mechanical reproduction surpasses the rigor and general currency of any 'real style,' in the sense in which cultural cognoscenti celebrate the organic pre-capitalist past."[7]

What explains the abyss between the poised description of Hollywood's classicism by Bordwell and company in *The Classical Hollywood Cinema* on one hand and the fierce jeremiads of Adorno and Horkheimer on the other? To account for this divergence, and to register some notations of my own, I will retrace some of the developments by which U.S. motion pictures became classical and some of their consequences.[8]

One of the major outcomes of Hollywood's classicism was the transformation of the high-middle-class values of aestheticism to a mass pub-

lic. The massification of the aesthetic came about through several means. One was the popularization of high cultural forms and values through popular genres like realistic novels, plays, and short stories. Another was through the appropriation by high artists of the stories, themes, and motifs, the traditions and lore of the folk, for "serious" literature, music, and pictorial art. The dissemination of mass literacy, universal education systems and the "feminization" and democratization of culture in the nineteenth century made spaces where the distribution and control of the aesthetic percolated to popular culture. The introduction of bourgeois moralizing, via instruments like the Hays Office or the Catholic League of Decency, dictated aestheticization of the sort where moralizing literature followed conventional bourgeois literary style. "Provided," wrote Lary May, "film could teach Anglo-Saxon ideals to all peoples, it might draw the masses away from salons and vice, creating a model citizenry. Then the movies could function, as one reformer phrased it, like a 'grand social worker,' allowing the viewer to go home and 'sleep the sleep of the just.' "[9]

The great drama of the Euro-enlightenment and the global conquests that made it possible were replayed around the studios of West Los Angeles in a period after World War I when competition from other national film industries had faded, opening the way for the U.S. industry to establish the most compelling system of world representation ever fashioned, and providing the world with its first global vocabulary of structured feelings. This second conquest recapitulated all the great themes of the first, but from an "American" standpoint, reassimilating universal knowledge to the understanding of the autocratic subject, whose specular position the lowliest citizen could occupy for fifteen cents.

In the 1920s, literary origins for movies were highly regarded; by the 1940s at MGM under Selznick, literary classics, Shakespeare and the classic European novels, popped up so often that one could suspect an impulse to represent the entire library of Western classics on film. The upward aspirations of the movie moguls, their clamor for respectability, reached for the hand middle-class reformers extended down to them, but the embrace seldom extended beyond "middlebrow" literary values of the sort customarily pandered through the public school system. What was passed on through most of these revampings was bourgeois sentimentalism no longer compelling for serious artists who, through romanticism, realism, impressionism, and modernism, had moved on to other versions of aestheticism, despising what they viewed as the corruption of art in its massification.[10]

The middle-class reform of movies had less to do with aesthetics than with the reflex moralization of narrative. This fit in well with the design of Hollywood's classical narrative pattern. As in neo-Aristotelian poetics, the story line is expected to follow a linear progression through clearly delineated beginning, middle, and end. To this linear development we can add the contours of Hollywood's classical story. A hero sets out on a quest, either from his own choosing, or one that is thrust upon him. He encounters several obstacles on the way, many of them engineered by an evil adversary. Along his journey, he is accompanied by a sidekick and an eligible woman, a love interest, who may alternately be the object of the quest, or the cause of the dilemma, the disturber of the peace that the hero's actions will restore. The greatest obstacle occurs at the climactic moment when the hero engages the adversary in single combat and over-comes him. All loose ends are neatly tied up at the end, the community healed, the money restored, the boy gets the girl, and society is again whole.

Bordwell and colleagues point to the magazine short story as a domi-nant influence on the narrative of classical movies. But the Hollywood practice was too anxious to overlook any means to its fantasizing ends. Drama should also be counted as a contributing influence, as indicated by the early, self-conscious description of movies as "photoplays." This narrative cosmology owes less to rational interpretation of empirical re-ality, even as found in magazine fiction, than to the worlds of neo-Pla-tonic and early Renaissance romance, especially their principle of cosmic resolution. The moralizing, ideological nature of the triumphant closure is illustrated in Shakespeare: "Comedy villains are normally dealt with in one of two ways at the conclusion of the action. Their plots foiled, they either repent like Orlando's brother and are rewarded by being accepted as redeemed members of the comic society or, like Don John in *Much Ado about Nothing*, they remain unregenerate. In the latter case, they must ex-pect to be punished and violently cast out."[11] Closure in both narrative genres signifies the contours of the society's cultural symbolism at one of its principal and well-guarded borders between what is or is not mor-ally meaningful.

The obligatory happy ending of classical movies suggests the decline in moral imagination in the socialization of movies for the masses. The imperative of the happy ending, meaning one where the cultural-norm hero triumphs, is demanded both by the market force of audience appeal and by ideology. In its contemporary form, then, the classical narrative is a kind of secular comedy. Tragedy, it becomes clear, is the appropriate

vehicle for the representations of older classical narratives, particularly those dominated by religious ethos. In ancient Greek and Christian drama the death of the hero at the end did not denote cultural or social failure, since the significance of the hero was dwarfed by the embracing significance of his death within the subject position of the gods or God. The death of the tragic hero was a form of sacrifice to the compact between the cosmic deities and the community of believers. But in the petit bourgeois humanism of Hollywood classical movies, the hero is constructed as more purely a value in himself, and his triumph is secular and material, though often couched as a simultaneous preservation of the natural order.

The massification of art in the movies, despite scorn from the Art-world, fulfills the mechanization and commodification promised in the bourgeois origins of classical aesthetics. The venom of Horkheimer and Adorno's critique of Hollywood arises partly from their writing just after World War II, in the height of the classical movie era and the recognition of the fascist apocalypse as one by-product of Euro-enlightenment. Where Adorno and Horkheimer, and also Walter Benjamin, saw the danger in the culture industry's capacity for producing the mass psychology of fascism, from a later perspective we might reflect on the imposition of a master narrative and a chosen-people ideology.

Through the powerful means at its disposal, classical cinema worked to recreate the entelechial version of humanity as White and male that had become one of the cardinal effects of the humanist revolution. Not only did the narrative favor this ideal hero and his destiny as if the chosen of the narrative gods, but camera angles, key lighting, image composition, the star system, musical accents all worked to establish his superiority as self-evident and his triumph as inevitable. More important for cultural politics, classical Hollywood movies encoded the relative inferiority of all other versions of the human along a celluloid chain of honorable to unhonorable being. In the process, Hollywood movies orchestrated an arsenal of negative ethnic and racial stereotypes that reappeared with machine-like consistency. The regime of Hollywood representation in its most powerful moment was in fact marked by the same contradictions that characterize the Euro-enlightenment, claiming the universal application of its avowed principles of rationality, humanism, and democracy but insisting those values could be located only in the normative Occidental. The containment of the expressive possibilities of Black life, for instance, formed the exact counterpart of the maintenance of slavery by apologists of enlightenment like Jefferson. Hence, in classical Hollywood

cinema, stereotyping became classical, i.e., conveying "notions of decorum, proportion, formal harmony, respect for tradition, mimesis, self-effacing craftsmanship, and cool control of the perceiver's response—canons which critics in any medium call 'classical.' "[12] The popular knowledge of the imperialist era of the early twentieth century inherited the empire-building tendencies of the Euro-enlightenment project.

The contributions of new knowledge by the upstart, popular medium were slim, earning the contempt of intellectuals, but the application of received, enlightened knowledge on the popular level, supported by batteries of research "experts," was revolutionary. History was retold from a Euro-American point of view. More important, the reformation of normative human character once again proposed a transcendental sphere of knowledge and existence, a model form of being, this time magnified, lit, musicked, framed, and composed so that the transcendence of the idea was matched by the transcendence of the image on the screen. This image, being normative, was necessarily non-ethnic, ethnicity being one of the values transcended. Like the enlightened conquerors of earlier centuries, this second conquest exercised the power of renaming the world, and many of its people. In the brusque manner in which Austrian custom officials, unless bribed, would Germanify Jewish names according to first impressions, hence Weiss, Schwartz, Gross, Klein, so the moguls of Hollywood would rename their starlings, often shedding the work of the Austrian gatekeepers.

Similarly, Hollywood reconstituted a hierarchy of cultural values, establishing an Anglo-American ideal at the center in place of the old European norm, and one that became increasingly "American" and less Anglo as the years passed, while placing other ethnicities and races in ratio to this heliocentric symbolic network. An active reordering system revisioned Euro-ethnic groups at first as aliens evolving into acceptable variants of the norm, modeling a Whitening process in the movies by going through a probationary period as supporting players, until they became mainstream.

The latter-day humanism of Hollywood movies bears curious continuities and breaks from its Euro-enlightenment past. As Sylvia Wynter observed in the sixteenth-century humanist revolution, narrative served as the vehicle for the construction of new concepts of the human. But where the humanism of the Renaissance held on to much of the idealism of its theological past, the principle value of the neo-humanism of Hollywood entertainments is that it is lucky to be a human being, period.

This value is articulated most clearly in fantasy and sci-fi movies

where alien or mythical beings enter the human sphere and fall in love with it, preferring it to either eternity or super-human conditions. These moves teach us what humanity means through the examples of time-space travelers and mutants willing to give up their special powers for a world where admittedly Earthlings kill each other in horrible wars and pollute their own environment, etc., but also where they can experience love, sex, and the pleasures of hamburgers. The reach of this vision promises a refreshing universalism by co-defining the human over and against e.t.'s and mutants. But the familiar limits of Euro-humanism show up in the repeated norms. The mermaid never falls in love with a woman. American consumer habits are framed as cute. And the most persuasive, authoritative apologist for the human condition, despite its flaws, is always a White male.

THE MASTER NARRATIVE

> The distance between subject and object, a presupposition of abstraction, is grounded in the distance from the thing itself which the master achieves through the mastered.
> —Horkheimer and Adorno,
> *Dialectics of Enlightenment*[13]

> [The master narrative is] whatever ideological script is being imposed by the people in authority on everyone else.
> —Toni Morrison, in *A World of Ideas*,
> a film with Bill Moyers

> What is a Church and What a Theatre?
> —William Blake

Sylvia Wynter suggests that every new historical paradigm of consciousness introduces a new rhetoric. The present order of knowledge, now undergoing its crisis, might be equated with the Euro-enlightenment of the eighteenth century. The new order of things of that foundational period as described by Foucault was the first to construct knowledge on the assumption of the priority of natural being, with the human locatable as a natural phenomenon, rather than as element of a theogenic mode of being. For Wynter the novel became the appropriate rhetorical mode through which this naturalistic humanism would express its codes of regularity.

What is helpful in this interpretation is the link between a ruling sym-

bolic network and its cognitive assumptions on the one hand and the will-to-narrate on the other. It is difficult to think of a society whose cosmic orientation escapes narrative encoding (narrative being an irresistible, implicit by-product of language?). The novel is a persuasive choice as the narrative form that best signals the coming dominance of the secular humanism of Europe's middle classes. But the function of narrative as the preferred form of dominant symbolic systems demands that "narrative" be understood to cover more ground than literary genres such as "novel," even though the novel might surely be taken as historical sign of a glacial rift in narrative discourse. If the novel became the classical narrative of eighteenth- and nineteenth-century secular humanist worldview, that role was taken over by the movies in the twentieth century. In the present era, the link Wynter proposes between a society's dominant outlook and its essentialized narrative outlook is illustrated by the Hollywood classical movie as the fabulous embodiment of the master narrative.

Every society, we assume, has its favorite mode of storytelling, indeed, its favorite, most characteristic story. The influence of this pivotal tale or tale type exerts its force, even in variants that observe its rule even as they try to escape it. The Western master narrative as recapitulated by Hayden White is substantially a mode of perceiving and writing history: "The master narratives from among which Western man may choose are those of Greek fatalism, Christian redemptionism, bourgeois progressivism, and Marxist utopianism. Each of these ways of constructing human history is still a possible option for contemporary Western society insofar as the modes of production of which these narratives are symbolic projections (slave, feudal, capitalist, and socialist) are still present, dominant or emergent in Western society."[14] It must be clear that the contemporary master narrative of the inevitable triumph of Western bourgeois progress far outstrips White's other variants in symbolic force and currency.

From this we can see that the master narrative is to history and the shaping of history what the classical narrative pattern is to short stories, novels, plays, and movies, an order of knowledge made canonical through authority and repetition. "Narrative" carries an even wider connotation in its cosmological function, suggested by Toni Morrison's perception of it as "ideological script." The master narrative is not so much a narrative as a pressure within the society to conceptualize itself in narrative terms, whether through myth, fairy tale, history, or modern fiction, as well as a pressure for that narration to be co-terminous with the symbolic order and its ideology. It operates as a dynamic principle, of quasi-organic

make-up, always changing, always contested, yet always determined by the dominant social will and the dominant social need.

Hayden White's title *The Content of the Form* aptly suggests the resolution of an important issue, the inseparability of form from meaning—even though aestheticism would have it otherwise—and also gives us a valuable motivation for looking at master and classical narrative simultaneously. It addresses the situation where a filmmaker's attempt to break with dominant ideology is snared by the tar baby of sedimented signifiers of "classical" narrative structure. Starting with resistant intentions, using the forms of mastery, you may likely reproduce the master ideology. At the same time, a reservation needs to be flagged about the lack of final symmetry between classical narrative pattern and master text of history in order to respect the principle of the reversibility of forms and the meanings attached to those forms. However powerfully a traditionally recognized form may evoke the cosmology of one social group, it would be essentialist and a-historical to deny the polysemic potential of all signs, linguistic or otherwise. Others, even enemies, can find ways to use all signifying practices against their originators. A distinction needs to be made between form as aesthetic meaning and form as social-political meaning. The first description typically tries to conceal the second. In Monopolated movies, the master narrative is usually given form through the patterns of classical narrative. For the critique of representation, the shrewdest course might be to see the one as the content of the form of the other. This holds even when it means accepting an ambiguity between narrative as story and the meta-narrative idea, which is no story at all, but the principle of symbolization by which a society dominates its being-for-itself and attempts to define its complementary non-being.

The master narrative reformats representation, knowledge, and meaning according to its cognitive coding, whether it is conspicuously present or apparently absent. Nearly all the genres of Hollywood films reinscribe the master narrative in varied settings and genres—the Western, the gangster story, the detective story, the musical, costume dramas, historical epics, science fiction, war films, spy films. . . . The ubiquitous presence of mastery in virtually all genres and settings is the mate of the image of the master-hero as modern man, asserting his dominance over nature.

The master narrative, then, is entelechy framed within a story line, dominant ideology dramatized. The master narrative is the social prophecy that attempts to find self-fulfillment in everyday and long-term social developments. Wherever a pause or resting point in the flow of human

experience occurs, the master narrative presents itself as a semiotic closure to give meaning to events just passed. Mastered narration, were it to function optimally, would coincide with everyday experience, since the powerful ideological effect of mastered textuality is to persuade the individual social being that she is living in and through this seemingly inevitable story with its ready-made explanations of cause and effect, of the reasonableness of things as they are. "Mass man" is not a fiction of social psychologists to the extent that many people can be seen to be Narrative-identified.

"Master narrative" unlocks semiotic windows in a number of directions, some of them unintentionally subversive, among them Hegel's formulation of "the master-bondsman relationship" (elided by the substitute "grand narrative"). Accepting these openings to further elaboration of the politics of representation, we may read the term not only as master in master copy of a reproductive system like taped music, but also in the more original sense of patriarchal master as opposed to mistress or maiden, where gender domination is rationalized; master as opposed to "man" or servant, legitimizing class relations; and master over slave, aestheticizing the signs of racial and colonial domination.

Richard Dyer similarly describes the personae of the hero of the colonial text:

> His ability to resolve [the disturbance of equilibrium] is part of his whiteness, just as whiteness is identified in . . . the narrative of personal growth that any colonial text with pretensions also has. The Empire provided a narrative space for the realization of manhood, both as action and maturation. The colonial landscape is expansive, enabling the hero to roam and giving us the entertainment of action; it is unexplored, giving him the task of discovery and us the pleasure of mystery; it is uncivilized, needing taming, providing the spectacle of power; it is difficult and dangerous, testing his machismo, providing us with suspense. In other words, the colonial landscape provides the occasion for the realization of white male virtues, which are not qualities of being but doing—acting, discovering, taming, conquering. At the same time, colonialism, as a social, political and economic system, even in fictions, also carries with it challenges of responsibility, of the establishment and maintenance of order, of the application of reason and authority to situations. These, too, are qualities of white manhood that are realized in the process of the colonial text. . . . [15]

In mastered storytelling, particularly in classical U.S. movies, the hero is chosen by the Narrative for a destiny which coincides with a dimly hidden historical allegory of a people chosen or covenanted to rule. The

"star effect" where supporting actors can be seen deferring to the constructed charisma of major actors, even when temporarily cast as insignificant figures, personalizes the authority of imperial destiny. The halo of deference shone upon this central figure by his fawning menage, including maiden, servant, often coded as sidekick, or doting hangers-on, models a hierarchy of relations for the social instruction of the audience.

The cultural-norm hero as the agent of the greater narrative in fact functions as the persona of authority. His is the charisma of dramatic focus granted him by the film and its technologies of lighting, framing, and point of view, conjuring his presence and actions as awesome or irresistible. As agent to the master text, this hero is himself a servant, giving service to the text's symbolic order. It is this industrially orchestrated authority that makes him inevitably attractive to the focal maiden, inevitably daunting to rebellious subalterns, and inevitably unstoppable by the villains who oppose him. It is this authority that makes the successful pass as the girl, that delivers the winning blow to the rival or antagonist, that guides the skill with which he alone figures out the shrewdest stratagem to overcome danger.

The principle that undergirds the master hero with authority is the same that monopolizes subjectivity for the empowered. Only the master text can create, place, and foster human subjectivity. It constitutes the subject and the essential values recognized by that subjectivity, what is knowledge and what is not, what is literature and what trash, what music and what noise, what is beautiful and what is junk. (When philosophers like Foucault announce the death of the human subject, they are really announcing the immanent demise of the force of the master narrative and its ability to define the human.) By the same token, it is the authority vested in mastered narration that gives the normative hero the prerogatives of majority voice, despite his actual minority status, most conspicuously in "native" settings—a majority of accumulated and jealously guarded subjectivity or selfhood.

SHADOW AND ACT

> Your name is Friday. My name is Master.
> —Robinson Crusoe

One ingenuity of the mastered system of representation is its subversion of alternate outlets for narrative empowerment. The master-text movie functions on a patriarchal principle, locating a psychological and

social place for every individual and for every emotional response with the design of allowing each viewer to accept the spectacle as imaginably her story. For those who opt out of emotional identification with the patron-hero, or who tire of the intense psychic demands of that role, other options and emotional locations are made tempting. But even in these the presence of the patron-hero is felt, even when he is absent. At crucial moments when he is off screen, it is as if the film is waiting for his return.

American film comedy offers a pastoral inversion of the master narrative that deepens the impression of its power, even when absent. The comic hero parodies the authority of the classical hero. The quest befalls the comic hero unwillingly. His ineptitude is the mirror-reverse of the normative hero's prowess. He is the strong hero's alter ego, made out of commoner stuff, cowardly where he might have been brave, confused instead of resourceful, unlucky where he might have been lucky. The misadventures of the comic hero, resolved at the end through a reversal of luck, not skill, invoke and then exorcise the absence of mastery, the anomaly of incompetence, the terror of male impotence. Such comedy relies on the memory of Narrative mastery secreted in the audience, who are invited to internalize its blessings and observe with indulgence the antics of clowns lacking its aplomb. Classical movie comedy carnivalizes the tropes of the more dignified comedy of heroic triumph. This economy of signs explains the dominance of the comic mode in Black representations in Hollywood movies and U.S. television. But the representational system ignores the possibilities of, say, comedies featuring Latinas, Black women, or women in general, since their mythical incompetence and archetypal lack of mastery (or simply "lack," as it was once fashionable to pronounce) leave their experiences immune to carnivalization except as comic vehicles for cross-dressing male parodies.

The Narrative justifies institutionalized dominance and also claims another privilege—the rightful dominance of the chosen narrative as the one healthy genre of expression over other streams of signifying. Competing discourses are patronized and trivialized beforehand. Narration alien to mastered discourse is dismissed as unmanly ("master" being a highly gendered term), whether coming from women or not. The nineteenth-century derogatives that burst out over the emergence of women writing and gaining an audience ("Those damnable, scribbling women . . . ") expressed a patriarchal propriety over discourse, threatened, as the Palace would have it, by inferior claims to the truth. Similarly the writing of U.S. African Americans has been subjected to the mechanical accusation of inadequacy as literature by virtue of its character as "protest" or

"propaganda," or as "sociology," effectively setting its subordinate place as "enslaved discourse" as opposed to the reputed discourse of "freedom." The denigration of still other cultural productions as "effete" or "decadent" once marginalized much work as "homosexual" whatever the sexual preferences of the producers. Patriarchal critical discourse thus prearticulates and precodes unmastered expression as subdiscursive.

Not satisfied with this preemption of unauthorized voices, mastered discourse frames its own versions of the histories of the subjected. We might call these histories "cover narratives," after the practice of powerful recording studios to issue "cover" recordings performed by celebrities to steal the thunder and audiences of lesser-known performers. Or we might read them as "cover stories" like the alibis of gangsters and spies. A cover story recodes an insurgent narrative, just as heroes of resistance are recoded as villains. Cover narratives also cast a wider net over a whole field of potential heresies, precoding their formation, like "pourquoi stories" such as Eve being made from Adam's rib or taking first bite from the forbidden fruit.

The job of controlling "minority" voices is echoed in the Hollywood convention of the "master shot," a production technique in classical cinema. The master shot was usually a long shot without cuts, taking in the whole scene. The action would then be repeated for closer shots at different specific angles. The purpose of the master shot, which contained all the information of the scene, was to provide the editor with enough footage to complete the continuity or sense of any sequence inadequately captured in the closer shots. Many directors resisted master shots because producers sometimes used them to recut the scene to a different meaning from the one the director intended. In a figurative sense, the master shot acts to protect the interests and meaning of mastery against alternate readings.

If this representational system worked at its optimum, virtually every mainstream text would perform as a subtext to the Narrative. In the classical movie, all characters other than the norm-hero are minor characters, expressive of minority in terms of cosmological significance, as he embodies majority wisdom. Patriarchally, they are parented by him, the greater wisdom of following his leadership being slowly modeled for these characters and the audience through the pedagogical exemplum of the story. ML&P's system of representation preempts possible rebellious development of these minor roles by anticipating and premastering their potentially disruptive energies. It establishes their "place" for them, hoping to tame any whiff of subversion. Some of these subgenres are the

maiden's tale—in the movies usually called women's pictures—the slave tale, and the servant's tale. In each of these, the presence or absence of the norm-hero's influence is felt.

In the master text movie, the role of the woman is sharply constricted as a function of the story. She may be the victim whose murder must be solved or avenged; or perhaps, as treasured beauty, she may be the prize of the quest (*Star Wars*) or the sidekick on the quest (*The Forty-Nine Steps*), often endangered at the climax and needing to be saved. Her ineptitude from which she must be saved becomes one of the obstacles the classical hero must overcome. This same ineptitude confirms her femininity, warranted in her helplessness.

The maiden's tale is the system's self-protective anticipation of rebuttals to its super-masculine monotony. It is an elaborated breakout of the woman's role in the conventional spectacle, a side-bar blown up to feature dimensions. The operative principle of these films is by now well known, almost a subset of the moral code of the Hollywood classical era: in the maiden's attempts to break dependence on the patron hero there can be only two outcomes. Either she recognizes her innate incompleteness and returns to the patronage of the male hero and achieves a happy ending (*Alice's Restaurant*) or she persists in her independent struggle and fails tragically (*Mildred Pierce*).

The hand of the master-classical text, of the content of its form, reaches over the representation of the disempowered so pervasively that liberatory narratives, approaching conventional formal structure, run the danger of being absorbed as its reaffirmation. A movie like *Thelma and Louise*, for instance, does not have the option of a fatal ending for its two women rebel heroes without that ending being perceived as submission to mastery.

The maiden's tale as classical movie is a self-fulfilling prophecy, justifying her lack of subjectivity in the basic, male-centered story, her dependency, and minority status, while granting some fascination with her "difference" and her importance as armless icon of the society's domestic sentiments. So described, the likelihood of a maiden's tale movie focusing on a Latina or Black woman as central character, for instance, is remote. Women of this description can hardly satisfy the function of cultural jewel for the ideologically mastered audience. Whatever interest these subjects might hold in the exclusive humanism of the system is subsumed under the curiosity and fear directed toward difference, in which case the males of those "other" cultures better serve the tradition.

The Narrative's slave text—which is actually the reverse of the antislave and ex-slave narrative of resisters like Frederick Douglass or Harriet

Jacobs—is best understood as a justifying appendix of imperial history. Such a text serves the dominant story of "man" by enacting on the narrational/fictive level the same justification of domination that racialism and racism provide for the rationales of slavery and colonialism. As with *The Birth of a Nation*, the more important question is not whether such texts are racist in intent but whether and how, routinely reproduced, they support the claims of White supremacy.

The plantation tradition and its darky slaves only too happy to please their masters presents an inversion of the master's story. Here there is no inevitable, triumphant progress through history, but instead a man, usually, swamped and nearly overcome by troubles. The Black hero is frequently close to crack-up. In the infrequent case where there is closing triumph, it is in a quest that the hero did not deliberately choose, but accepted unwillingly, as in *In the Heat of the Night* or *Intruder in the Dust*. In this subtextual version of the monocultural myth, the Black hero faces and suffers through or overcomes a number of life-crises only in order to acknowledge defeat at the story's end. This defeat is seldom total, however, and seldom ends in death, which is a resolution more likely favored in master-textual films where the Black sidekick dies sacrificially for the white hero (as Canada Lee dramatically dies in *Body and Soul*). More typically, the defeat is one of higher aspirations in which a form of tragiethnic catharsis is reached where, in musical comedies, the hero learns to be content with his mundane lot, and in non-musical fictions he learns the value of less ambitious strivings more suitable to the station of his tribe. The regularity we find is not only the official story of the Other, with obvious parallels in the characterization of non-Whites generally— think of Dr. Assiz in *A Passage to India*—but it is also a narrative made to do slavish service to the master text.

The slave tale being a justification of domination, it is not surprising that it incorporates manichean signifiers. The organizing principle of this manicheanism is the politically measured difference between the "good nigger" and the "bad nigger." Fundamentally, the representation of Black men in Hollywood movies revolves around the question, what do we have to fear from such men? and the determination to supply reassuring answers, in whatever genre. The iconography of this dramatic question is elaborated largely through a primitive Afro-Christianity (signified by choral Spirituals) as opposed to an even less civilized paganism, which in its most antithetical form is imaged as evil voodoo (invoked by drums). This stereotypology, developed as a kind of cafe skit dualism, finally gained status as Negro folklore through constant repetition and

is prototypically reproduced in *Green Pastures* and *Cabin in the Sky*, which features the contest between the good praying woman, Petunia, and the hot, wicked woman, Georgia Brown, for the soul of Joe, with the contest being further waged between The Lord's General and Lucifer Jr. Even these mythic potentates are underlings. They express a second-order manicheanism. Manicheanism in the slave text echoes that of the master text, but laterally. What is at stake is never cosmic order or even communal peace but local, individual triumph—a rise perhaps toward a level of existence more approvable by Whites. The narrative thrust which puts the hero in motion is likely to be trivial and accidental, never a chosen quest, and the outcome inconsequential. Rather, the Black male protagonist is more often in flight, a picaro, a running man. Frequently the manichean conflict is within himself, between his culturally backward, anti-social self and that higher ego that aligns him with subservient domesticity. The contest is close, but the tale is frequently cautionary; his defeat, his lost struggle reaffirming the Narrative by negative example.

We have already seen how the entelechial reach over language and meaning prejudices the rebel's dissent even before it is uttered. Through its subgenres of minority representation, the master narrative attempts the same entelechial dominance over the counterstories the rebel would tell. The mastered story assumes the space categorized as "just good entertainment," leaving the countertales of the marginalized looking like tendentious, ill-tempered special pleading. Once the high ground of normative experience is staked out, it is left to the marginalized to carry the burden of representing gender or race and whatever discomfort these themes carry.

THE CASE OF THE MISSING SERVANT

None but negers are sarvants.
—a white maid speaking in 1807, quoted in
The Wages of Whiteness[16]

The master narrative is structured like a honeycomb, reproducing its entelechial design in the smallest cell. Expecting this predictability, one posits a triad of maiden, slave, and servant subgenres in Hollywood classical movies to correspond to the needs of the signifying system to order the perceptions of gender, race-colonialism, and class. But "the servant's tale" presents some curious problems, mainly by its absence. In the traditional Narrative, characters abound who might be perceived as ser-

vants in the sense of serving the master-hero, mainly as sidekicks and assistants. But their function as markers of class differences and relationships is unstable. Often the sidekick is someone wealthier or more powerfully placed than the hero, sometimes he is the hero's producer or manager, yielding to the lead's "star effect," or out of respect for the hero's innate prowess, like Edward Everett Horton in Fred Astaire movies.

Servants as maids and butlers, etc., are more populous in classical movies than in real life, but it is difficult to find their roles expanded to feature-length treatment, except where, as in *My Man Godfrey* or *Has Anybody Seen My Gal?*, they are really patron-heroes masquerading as servants. Clearly the servant identity is hidden, made invisible in mainstream cinema in a way that makes its feature treatment implausible. If the story is about a person who works as a servant, the core of the tale is never about the job and the relation with "superiors" but about life apart from the job. The sympathetic servant's tale, as feature, barely exists even in class-conscious European representations, largely because of the force of Marxist socialism in exposing the exploitative nature of class relations, just as the *Uncle Tom* movie has become less viable in the United States since the Black consciousness movement was fired by the speeches of Malcolm X.

But there are reasons for the failure to develop servants' tales in the United States. David Roediger's *The Wages of Whiteness* points out that the word "servant" was largely banished from American English by White workers in their anxiety to distinguish themselves from slaves, the terms "slave" and "servant" having been used interchangeably in the colonial past. One New England maid declared in 1807, "I am Mr _____'s help. I'd have you know, man, that I am no sarvant; none but negers are sarvants." And Francis Trollope noted, "It is more than petty treason to the republic to call a free citizen a servant."[17]

In this radical renaming against common English usage (another instance of Whitening) we see the formation of some peculiarly potent grand narratives in the North American imaginary. A basic feature of the American dream is the myth that class is not a vital factor in the make-up and performance of U.S. society. The common man, if White, was held to be equal to any other man in the social category that made the greatest difference, the category of race.

This stratification by race produced a redefinition of labor in classical movies. A major innovation in classical movies since the early 1930s was the introduction of the common-man hero played by actors who would come to dominate the star system: John Wayne, James Stewart, Clark

Gable, Spencer Tracy, Gary Cooper, Henry Fonda, James Cagney, et al. These icons departed from the more traditional gentleman-hero type, the Anglo aristocrat characterized by John Barrymore or Ronald Coleman.[18] The roles these stars played were obviously those of workers, non-proprietal cowboys, trappers, oil rig workers, reporters, salesmen, enlisted soldiers, sailors, frontiersmen, truck drivers, and seldom as professionals, except maybe lawyers when a crime plot demanded this role. They are never aristocrats, like "the Little Colonel" in *The Birth of a Nation*.

But they are workers in a mythically servantless society. Their labor is mythologized to emphasize a freedom defined by the petit bourgeois populism of Hollywood ideology. They are decidedly independent workers. If sailors they may own their own small boat, if cowboys, ready to drift rather than accept humiliating conditions, if reporters defying their editors to the point of dismissal. Their independence evokes the values historically appropriated for the category White worker as opposed to its antithesis, Black servant. These values, such as the subscription to the Protestant work ethic, capacity to delay gratification, initiative and willingness to innovate, resourcefulness, determined dedication to the job at hand, etc., were often celebrated in classical movies, but just as often they were treated with breezy whimsy. The patron hero managed to possess the Protestant virtues and a cavalier indifference to them at the same time, as charming riverboat gambler, stagecoach robber, free-lance cowboy-gunman. The movies succeeded to the extent that these heroes evoked both the honor of contributing to social progress and libidinal relief from the pressure of that mission, both the acclaim of acquisitive individualism and the dismissal of its anal mindset. Ultimately, the demarcation of the common-man hero from his antithesis, the Black servant, rested less on his justification as sacrificing worker than on preordained attributes, his possession of "grace" mystically bestowed on his Whiteness.

The extraordinary maneuver of U.S. social structure, made necessary by specific labor demands, the absence of a landed aristocracy, the "frontier," and other factors, was to revise the local British-European focus on class and class domination toward the symbolics of race. The psychological wage gained from securing White identity can be seen as a key to the American dream, which did not exist in the eighteenth century, took its shape in the nineteenth century as a formula for assimilating European immigrants, but got its fullest elaboration in classical movies of the 1930s and 1940s. Put these scripts together, namely the contours of the master narrative hero, the servantless character of the American dream, the

special role of the slave narrative to supply an explanation of superiority-inferiority, and the rise of the common-man star-actor gives a different look to some familiar terrain. The elevation of the populist hero in classical movies and U.S. symbolic hierarchies was made possible by disenfranchising and interning Blacks and other minorities. A very exciting adventure in liberation and democratization was paid for with fierce repressions. The status of White women in the United States also benefited from this deemphasis of class and the advance of racialism, vastly increasing the number of women who could be respected and therefore improving the condition of "women" generally (like the woman quoted above, refusing the term "servant").

The American dream is another of the extended products of Euro-enlightenment where the transcendent condition is premised on its co-definition with non-White invalidity. The "dream" does not exist to the exclusion of people of color; its existence depends on their degradation to a lower, ineligible status. A corollary of this social fiction is the use of race to function as class. Thus, virtually all images of African Americans in classical movies are readable as servants in this fabricated U.S. sense, while none of the White representations are readable as such. This principle can be felt curiously even in contemporary movies involving Blacks and Whites who are supposedly equal, say detectives. Even when the Black character is a superior of the White, there is a presumption of servitude. On the one hand, the White actor may carry more star power. On the other, we can suspect the survival of the legacy of "master consciousness" in filmmakers and spectators.

Classical Hollywood movies of the 1930s and 1940s, then, through their reformulation of the master hero, further democratized and North Americanized Euro-enlightenment values, though the new regime was, strictly like the old one, a heavily racialized democracy. This transformation of classical European values helped Monopolated Light and Power to achieve the most potent stroke of dominant cinema, the illusion that the workers within the industrialized system were not workers at all but independent aspirants to the success of liberated men, beneficiaries of the American miracle. If this system of industrialized spectacle blinded them to their possible solidarity against economic and political exploitation, classical cinema, as industrial culture, granted them their most generous palliative, the psychic rewards of identification with a system that kept them in their place. The servant's tale is an enigmatic, absent presence in classical movies while the master hero, the agent of authority, is

actually the servant of the ideology of mastery and the class that manipulates it.

In U.S. movies the Narrative worked out an equation that is at once fantastic and by now familiar. The innovation of the common-man hero in mass entertainment worked through an unequal exchange. The lineaments of the old, traditional gentleman hero could be dispensed with *because* of the assurance of honor for the common-man hero like James Cagney, Jimmy Stewart, or Clark Gable algebraically derived from the low style of a Step 'n Fetchit, Rochester Anderson, or Willie Best in the same movies. Just as in Toomer's poem, the Southern belle's beauty is composed of the lynch victim's agony, the luster of these Golden Age movie idols is in part derived from the obscurity of their counterparts, the honorless Black porter and his company.

Many reasons have been given for the disappearance of the great movie heroes of the past. To these should be added the dimming of the transcendental Whitening once conferred on them by the master narrative and its simultaneous, parasitical portraiture of non-Whites in these black and white fantasies. The shifting personas of some major stars reflect the dwindling aura of imperial innocence. The much-lamented disappearance of the great luminaries of Hollywood's Golden Years is due in part to the effects of postwar human rights movements. When Spencer Tracy fights racism in *Bad Day at Black Rock* the old charisma lingers, but he is preceding through a narrative that helps to destroy the path that made that charisma possible. Gregory Peck is an interesting transitional figure moving toward the anti-heroes to come. In his various "I'm no bigot" roles, the narcissistic innocence of stars in art deco movies cracks and shatters, opening chasms in the profiles of a chosen-people history.

In many ways, watching the operations of the master text in the conventions of classical movies is a form of child's play, a primer introduction to the more consequential work of the Narrative as a mode of thought. In this wider field, the master text presides over the interpretation of the most important questions of social self-knowledge, using as guidelines its general understanding of concepts such as civilization, history, law, religion, philosophy, and of course art. Given the powerful hold of such assumptions, variations and oppositions within their boundaries are often credited with more significance than they deserve. Within the broader critique of representation, for example, the "anti-imperialist" significations in Conrad's "Heart of Darkness" shrink to trivial epiphenomena. Debate and contestation proceed continuously inside the Palace,

and to be sure, the features and issues of these contests are reflections of changes, both within and without. Nor should the meanings of these debates be dismissed. But they remain closed dialogues in the sense that their effect is always to preserve a protected ground of knowledge and power.

From outside these grounds, questions about the social function of Hollywood take on a different perspective. It is a truism of cinema history, for instance, that classical cinema experienced a decline in the 1950s, under the pressure of a liberalization of its signifying codes. But when we look at the recent history of Hollywood films through the lens of the master narrative, the changes have been superficial. Despite the existentialist skepticism of film noir, the rise of anti-heroes, the framing of movie villains as politicians or corporation executives, the characteristic product of this "post" classical era is one of liberal sentiments comfortably couched within a system of conventional regularity.[19] It has been pointed out, for instance, that anti-war sentiments are self-consciously positioned in movies like *Apocalypse Now* or *The Deer Hunter*, while the most affective emotional commitments are to the aestheticization of war and the sentimentalization of the historical master text.

The question whether Hollywood accurately reflects U.S. social reality, is ahead of and more progressive than general social consensus, or more conservatively trails behind the social climate becomes less relevant when viewed in relation to Hollywood's umbilical connection to the master narrative. Given the commanding presence of the Narrative, the question is altered. There can be no debating that the body of representation controlled by the master text seriously misrepresents the national experience. Statistics are unnecessary to see that certain populations and their symbolic interests are Capitalized, young White men, particularly, while others, like women of color, are virtually disappeared. Another framing of the question is appropriate. Assuming that the master narrative of the cinema reflects the dominant text of the society's imaginary, then the question becomes, does Hollywood lead or follow the unfolding articulation of this ideological fiction? And even this question turns out to be almost trivial in the light of the powerful role played by this wing of the U.S. "explanation industry."[20]

The supposed decline of classical cinema matters little beside the persistence of the classical narrative pattern, conjoined with master-narrative ideology. One illustration of this persistence is the way the *Star Wars* trilogy, appearing long after the reputed death of classical movies echoes *The Birth of a Nation*, a forerunner of the tradition, in the content of its

form.[21] The stories of these two movie epics bear remarkable parallels. Both have patron-heroes, the Little Colonel and Luke Skywalker. And both these heroes are fighting to preserve civilization as they know it from extinction after defeat in a massive war, rallying the remnants of Euro-humanist faith against further onslaught from soulless, conquering forces. The Jedi Knights, then, are virtually recreations of the Knights of the Klu Klux Klan, beleaguered in a futuristic counterpart to the post–Civil War Reconstruction. Both heroes have sidekick-servant supporters, the robots of Luke Skywalker replace the sassy but loyal Negro servants who fight for the Colonel and his family.

The ethnocentrism of *Star Wars* is displaced and diffused into a paranoid animosity toward vaguely Third World villains. A precious White woman is threatened by the sexual advances of non-White heavies in both narratives. And when, in *Return of the Jedi*, we learn that Princess Leia is Luke's sister, a further kinship to Flora, the Little Colonel's sister, falls into place. In both movies, the principal antagonist in support of the vengeful forces of domination repents his apostasy at the end, Darth Vader and Austin Stoneman. A curious lapse into blood ideology occurs in *Return of the Jedi* when Luke is informed that the authoritative "Force" of the Jedi Knights, the counterpart of the renegade Christianity of the KKK, can be transmitted only by genetic inheritance, a circumstance that critic Pauline Kael noted as "very un-American."[22]

Star Wars bears numerous other echoes of Griffith's blockbuster; on the formal level there is a striking parallel cutting among three battle scenes, toward the end, as in *The Birth of a Nation*. If the iconography of race and gender have been modified in the more recent film, what is reflected is the response to powerful voices of resistance in the current struggle over representation. After protests that Blacks were startlingly absent from the vision of the future in the first film of the trilogy, the *Star Wars* series added Billy Dee Williams as a shady but charming hustler in the next film and then upgraded him to a subaltern military commander in the next. And responding to feminist surveillance, Princess Leia is far less helpless in each succeeding film, carrying her share of the violent battles, and killing her rape-minded tormentor Jabba the Hutt herself. (All of which can be seen as Hollywood reading these protests as demands for inclusion from new viewer markets.) But what we witness in these modifications is the migration of the maiden's tale and the slave tale into more politically correct terrains where their apologies for subordination are less blatant, the better to keep the ideological script of the master narrative essentially unrevised. The new and improved race and gender rep-

resentations in the *Star Wars* trilogy are consistent with the updated servility in Hollywood movies generally. The shift from classical to post-classical movies from Hollywood leaves some fundamental intellectual commitments untouched, just as the shift from neo-classicism to Romanticism in European art-cult theory only implied a shift in emphasis within aestheticism, not its abandonment. Rather than ask whether Hollywood is more progressive or reactionary than the public it serves, we might better inquire into the cozy dialogue between its classical-master symbolics and the general symbolic order.

In the context of cinema history, the aesthetic finally looks like a B movie, assiduously but not convincingly trying to create the illusion of reality, with ever dimming results. Aestheticism will probably never be dismissable as a source of confusion and aggression, since it by now has become the intellectualization of Western cultural symbolics, organized to exert cultural power. But we may divide our attention from this point on between aesthetic reasoning and some of the more explicit centers of cultural influence that it serves. That means it is time to turn our attention more fully to the critique of representation.

PART II

CHAPTER VII

■

The Ironies of Majority-Minority Discourse

> I look in my pocket; I have seventy cents. Possibly I can buy a beer. A quart of ale specifically. Then I will have twenty cents with which to annoy and seduce my fingers when they wearily search for gainful employment. I have no idea at this moment what that seventy cents will mean to my neighbor around the corner, a poor Puerto Rican man I have seen hopefully watching my plastic garbage can. But I am certain it cannot mean the same thing. Say to David Rockefeller, 'I have money,' and he will think you mean something entirely different. That is, if you also dress the part. He would not for a moment think, 'Seventy cents.' But then, neither would many New York painters.
> —LeRoi Jones, *Home: Social Essays*[1]

> Irony might not only have been a kind of displaced revenge on the part of the oppressed colonized seduced by the west, but would have also allowed the francophone North African writer to take his own distance on the language by inverting it, destroying it and presenting new structures to the point where the French reader would feel a stranger in his own language.
> —Abdelkebir Khatabi, *Le Roman maghrebin*[2]

We have been well trained to accept as a basic knowledge of civilization that the aesthetic experience is a universal part of human nature. Many will, therefore, resist the idea of that concept being a vain, manipulative fetishism. The short answer to their question, what would you put in its place? is *everything*. Minus aestheticism, the world of human culture can subside back into its mottled, indeterminate multiplicity. The richness of invention and interpretation possible in a world no longer constricted by Euro-bourgeois taste norms should be immediately ap-

pealing. But to sit back and celebrate openness for its own sake might be short-sighted.

The internal logic of this study is to push further along lines of thought that promise liberation. Many chapters of cultural history, infested with aesthetic reasoning, remain to be rewritten. The social texts that share their histories with aestheticism—slogans of ML&P—need reexamination. Some would want to set out immediately to construct new, alternative criteria of cultural production and assessment. These are all practical initiatives. But the acceleration of the critique of representation is more pressing. In the process of demystifying aestheticism, this critique has demonstrated itself to be its most potent opposition. The tide has shifted against aestheticism in recent decades, putting it on the defensive against diverse and competent counterstrategies of interpretation. The core of this resistance is neither Marxism, feminism, the Black Aesthetic, the new historicism, cine-structuralism, nor poststructuralist theory. That core is the growing understanding of the politics of representation, to which all these disciplines have contributed.

The critique of representation, then, is a developing logic of interpretation that advances beyond aesthetic reasoning through its greater rigor and discipline, its resistance to obscurantism and mystique, its diligence in attempting safeguards against cultural bias. It is worth repeating that the critique of representation must have no built-in solicitude for the powerful or the weak, the left or the right, the female or the male. However, by attempting to put every sector's cards on the table, placed on a more level playing field (to bump game metaphors), the critique opens ways for more honest, therefore less elitist judgments than the heavily compromised discourses cultivated by the Euro-art conventions.

A good place to reenter the critique of representation is with the figure-ground illustration, the vase and the faces, that was discussed in the first chapter. While this pictograph clearly dramatizes a system of relations that is by no means inevitable or desirable, it nevertheless illustrates certain elements of power and value relations as institutionalized in Western thought. In the interest of resistance we may contemplate another order of relations, knowing that failure to recognize the rules of the game set up by the game-keepers, at least at the outset, may likely mean loss, defeat, further subjection by those rules. In this space, then, we may be reminded of certain elements of Monopolated discourse, of the master narrative, its manicheanism, its parasitic construction of Self through objectifying a co-defining, marginalized, "invisible" Other, its exploiting of the power to frame knowledge to its own advantage, its need to repress

contradictory information and views, its reliance on binary oppositions, the artificiality of its identity boundaries, which must nevertheless be heavily defended.

The politics of representation tries to clarify the struggle to control meaning implied in every expression. All statements are potentially ironic, since they cannot claim identity with all possible truth. The struggle begins with the basic effort to establish an intended meaning over the infinite range of non-sense. It continues in the labor needed to distinguish one set of meaning from other similar or "friendly" possibilities, as in revision or proofreading of a text for clarity or readability. Such demands on communication take on their political character where a set of meanings supports one brace of social interests over another. Just as we envision communication needing two parties at minimum, a sender and receiver, a politique can be implied wherever a minimum of two parties are engaged in an exchange, as soon as we grant that there are differences or potential differences between them.

The muted conversation or non-conversation mirrored in the figure-ground illustration also suggests important features of the unequal exchange of communication between the more and the less powerful members of a society. The weight and character of values in this communication differ enough that we can see them, at the point of communication dissonance, as reflecting different codings of reality. In search of an accessible strategy for reading these failed or inharmonious conversations where the validity of the less privileged is at stake, and respecting their vantage point, I propose to speak of this clash of paradigms as a species of irony, the discursive irony of the relations of domination.

The ironies of discourse are abundant and fairly obvious. By "irony" I mean a situation where two or more interpretations of the same statement are possible. When the language you confront is foreign, there is likely to be no communication at all. The betrayal involved in translation is a voluminous illustration of the ironies of discourse, so much so that I leave its lessons to be self-explanatory. The situation gets more interesting at the point where people use the same words but take different meanings from them. The "false friends" encountered when learning a foreign language exemplify this meaningful difference. One communication is immersed in one discourse or network of meaning clues, and the other in another. Such "ironic" confusions can be simple or complex, rooted in language, culture, or ideology. Shaw's *Pygmalion* and its musical version *My Fair Lady* draw much of their humor from irony as the absurd tension between class discourses. The ironies bedeviling cultural dis-

courses find amusing illustration in Laura Bohannan's essay "Hamlet and the Tiv."[3]

During her anthropological research among the Tiv of Nigeria, Laura Bohannan, almost on a dare, introduced the elders of "her" village to Shakespeare's *Hamlet*. She began, convinced that "human nature is pretty much the same the whole world over" and that "the general plot and motivation of the great tragedies would always be clear, everywhere."[4] But the elders soon interjected their own interpretations. They began by asserting the rightness of Hamlet's uncle marrying his mother after his father died, which was the proper thing to do, for after all, in Tiv, as in many West African societies, "the younger brother marries the elder brother's widow and becomes the father of his children."[5] The next challenge was the idea of a ghost walking and speaking, "for these people do not believe in the survival after death of any individual part of the personality. 'What is a ghost? An omen?' "[6] Among the many other hurdles to interpretation, it was impossible to make these listeners believe in Hamlet being mad by any means other than witchcraft exerted by "beings-that-lurk-in-the-forest." There was shocked scandal at Hamlet's behavior toward Gertrude: "a man should never scold his mother."[7]

The elders soon become impatient with the incredible parts of the story and start retelling it the way it ought to be according to their perceptions, even before Bohannan finished her version: "I began to get cross. 'If you don't like the story, I'll stop.' " An ironic turn occurs when the elders assure her, "But people are the same everywhere; therefore there are always witches. . . . " *Their* version rolls on: "[Laertes] killed his sister by witchcraft, drowning her so he could secretly sell her body to the witches."[8] The account ends, " 'Sometime,' concluded the old man, gathering his ragged toga about him, 'you must tell us more stories of your country. We, who are elders, will instruct you in their true meaning, so that when you return to your own land your elders will see that you have not been sitting in the bush, but among those who know things and who have taught you wisdom.' "[9]

The lessons of this tale are those we never really learn, the point behind the many jokes and extraordinary tales of cultural misunderstanding. The traveler has not asked for water; the words he spoke really mean he wants to marry the chief's daughter, and is prepared to fight her principal suitor to the death for the honor. The first lesson in Bohannan's variation on this anthropological genre is, of course, the suspicious nature of "universality." We can also get some insight into the way each culture embodies a predisposition toward stories it is culturally prepared

for, while either ignoring or rewriting those that diverge from its familiarity. The two story-paradigms are at odds in a way fertile in the production of ironies. But the elders control the framing of the interpretive contest. She is in their village as a learner, and they impose their superior knowledge and wisdom upon her. To say they control the framing is the same as noting that they assume the subject position, and make their cultural understandings the focus of the gaze. The ironies of discourse are present from the first inescapable moment of difference. But they become political with the slightest inequality of the power to frame meaning and name reality.

Allen Tate provides an established, traditional concept of irony. He sees it as "that arrangement of experience, either premeditated by art or accidentally appearing in the affairs of men, which permits the spectator an insight superior to that of the actor."[10] The notion of symbolic conflict where one party wins and another loses surfaces in the idea of "superior insight." This definition already betrays the political dimension of irony that only needs to be aggravated slightly to serve as an asset in the political interpretation of difference. The ironies of discourse become more deliberately political when the measure of difference between the two fields of meaning is one of power. This is where LeRoi Jones's (Amiri Baraka's) observation of the gulf between himself and multimillionaire David Rockefeller over the significance of the words "seventy-five cents" edges into the political. I look to the interpretation of ironies of discourse in order to more sharply grasp the repressive as well as emancipatory elements in expression.

Tate's definition is refreshingly honest compared to a more liberal identification of irony with expressive "freedom." The boundaries set up by Hugh Danziel Duncan reflect a liberal humanist frame of reference, softening the edge of Tate's conception: "Irony exists in one type of social bond, the bond of open, free, and informed discussion as a means to truth."[11] Duncan is more comfortable with irony as a form of expression implying equality between the two speakers. The ironist in this situation "believes in critical intelligence created in free discourse among men who believe that such discourse creates and sustains social bonds." Despite Duncan's characterization of irony as open, his version in fact presupposes a terrain where closure is sharply drawn around participants who are included in the dialogue as peers. The limits of Duncan's humanist ratio are made plain when he adds, "When there are wide gaps between social classes, or when status groups become strange and mysterious to each other, irony fails."[12]

The recognition that irony is inherently dialectical moves us to a more modern, less classical idea of its character. But this recognition does not lower its potential for reading adversarial iconographies. Richard H. Brown, following Kenneth Burke, has suggested "dialectical irony" as an alternative to positivistic sociological theory.[13] Brown's move toward a more "postmodern" sociological methodology in which all positions, including the interpreter's, are viewed as specific and limited doubtless carries some of the liberatory agency he finds in it. Though his search is for a "radical irony," it falls short of the radical by retaining some restricting legacies of the traditional Western discourse on irony, such as the celebration of reflective distance. He does not entirely fend off the observation of Hayden White that "as the basis of a world view, Irony tends to dissolve all belief in the possibility of positive political action."[14] Brown's advocacy of an interventionist dialectical irony evokes the freedom that he finds in the ontology of "art," thereby reducing its radical possibilities. The distance he urges as part of an ironic positioning devolves eventually into a Kantian aesthetic disinterestedness.

Liberal interpretations of irony like Duncan's associate it with a rhetoric of openness. Yet the limits of this freedom soon become transparent when applied to the discursive situation of the severely dispossessed. Brown's version of ironic interpretation evokes an openness only slightly less prohibitive. His "postmodern" irony deploys another liberal trope, that irony approximates the "condition of art." But irony, like art, depends on framing and closure. The function of closure can be seen in a battle of wits where the first speaker tries to cut the dialogue at an embarrassing point for his victim. But the victim may likely reopen the play of meanings in order to close at another, victorious point. To piggy-back on an expression of Ralph Ellison, "change the yoke [frame] and you change the joke [game]." The polite curtain thrown over discourses of danger and violence by Duncan and Brown is stripped away by Walter Benjamin: "There is no document of civilization which is not at the same time a document of barbarism."[15] Benjamin's aphorism focuses the essential ground from which discursive irony blossoms, and simultaneously enlightens that moment of grotesque exchange where, for Duncan, irony fails. As John Brenkman elaborates Benjamin's gnomic phrasing, "The preserved and validated monuments of Western culture are not only the achieved expression of meanings and values and a resource of potential means of expression for civilization; they also carry the imprint of the violence and forced labor which has made their creation possible."[16]

Brenkman's paraphrase well serves Benjamin's meaning, but it also

handily serves mine were one to read "preserved and validated monuments" as discourses, the monologues of the Palace. It is at this nexus of violence and violent suppression that dialectical irony takes on the character of discursive irony. This dimension of the ironic is understandably neglected to protect the "Noble Lie" in Plato's words, that preserves the supposed higher values of Palatial wisdom from erosion.[17]

Divergence of meaning on this level implies more than differences among citizens who share contracts preserving civil order. It extends to differences between discourses and paradigmatic assumptions, that carry possibilities of humorous or aesthetic reconciliation among the individuals who are to some degree their prisoners. Liberal humanist discussions focus on the soft end of irony, neglecting its force as a function of discursive violence, the other face of brutal, physical violence.

The need then is not to become an ironist mediating between competing positions or meanings, however helpful it might be to remind all partisans that their views are finite and contingent.[18] A more radical practice would be to analyze the ironies sedimented in unequally weighted discourses to better understand the semiotic manipulations of power, and the rhetorical strategies available to the disempowered to improve the odds.

The exchange between unequal discourses is always already ironic. The one most crucial advantage of dominant discourse is its ability to establish the frame of the dialogue (knowledge), according to the golden rule, which says, them with the gold make the rules. Nevertheless, because of an inescapable false consciousness within official representation, the Noble Lie, namely that the persuasiveness of its arguments has nothing to do with the weaponry at its disposal, the state terror that sustains it, or the acts of barbarism that installed it, routinely speaks with a surplus of hollow grammar which from a disenchanted distance is inherently ironic, as well as distorted, incomplete, reversible, bloated, and waiting for deflation. The language of power is never free from lying, and the nobility of this lie is in the eye of the beholder.

But this violence is dialectical as well, and mimetic too. As Khatibi implies, a fundamental irony arises when the colonized or "post-colonial," writes in the language of the colonizer. Even in the pronouns, this ironic situation becomes apparent. What does "man" signify in the colonizer's language, or more glaringly, "one." How to say "one" when one is the other? Fats Waller plays on this irony when he sings, "One never knows, *do* one?" compounding the ricochet of meanings by including the deliberate fracture of grammar from the point of view of Black idiom in the

same phrase that he mimes the affected speech of the Palace. How can "one" be included in the colonizer's "we" if that one is not allowed to speak in the councils of power?

Discursive irony occurs in the verbal interactions between the more and the less powerful, to the extent that both view their opposites as an Other. The irony occurs through the clash of cultural symbolisms, the war around meaning that takes place when they speak to each other. When the alienation between the two participants is one of class, "various different classes will use one and the same language. As a result, differently oriented accents intersect in every ideological sign. Sign becomes an arena of class struggle."[19] Irony, a surplus or discord of meaning, arises here as the intersection of differently oriented accents. In this usage—the one I favor—irony arises when a statement implies more, less, or something different when expressed or interpreted by participants located in different, opposing socio-political discourses.[20]

The discursive irony of the relations of domination rests on unequal semiotic and psychic exchange. We can scrutinize this irony in isolated speech situations, say in the appearance of a caricatured Black character in a Hollywood movie. But its ultimate foundation lies in the speech situation itself, in the unequal distribution of power and therefore knowledge and communicative force. It is through this imbalance that the speech, the very meaning of the representation of the one is registered as more significant and more psychically rewarding to attention than that of the Other. "The Other," in fact, can be taken as a register of communication, as a different musical key, the minor chords, the definition of the ungrammatical, a comical dialect in a serious drama.

Discursive irony robs the marginalized of the chance to speak with the same force and legitimacy as the centered. Pretending service to aesthetic enlightenment, discursive irony maneuvers the semiotic theft where meaning is stolen from the victimized and bestowed, unearned, on the victimizer, or the ideologically privileged. By the operations of discursive irony, the liberators among the legitimate become the terrorists among the oppressed. In discursive irony, the meaning of the Other, whether privileged or denied, threatens to become caricatural, and no matter how deliberately articulated, carries an unintentional and unshakable shadow presence like an unvoiced subtext.

The varieties of irony elude compilation within a grammar pretending to scientific precision. I want, nevertheless, to codify a few of the most crucial, recurring situations. Some of these interpretive frames, as I

choose to call them, are readable from the side of the strategically empowered. By name, three of these are Despotic irony, Ethiopicist irony, and Radical Ethiopicism. From the side of the less empowered stand the interpretive frames of Cyclopism, Aesopianism, and Achebianism, or radical resistance. In due time all of these will be fully explained and demonstrated. In the remainder of this chapter, I look at Despotic irony, Ethiopicist irony, Cyclopism, and Aesopianism.

These frames are of course not intended as a comprehensive categorization of all ironic possibilities—far from it. The list could be extended or revised. Nor do they ascribe essential characteristics to any communicators or institutions in society. Different individuals or parties may adopt one or another of these positions. As well, the relative crudeness of analysis allowed by these framings is soon evidenced. A given text might use different frames at different points. And how to assign an interpretive frame to a particular text may be highly debatable. However these modes of observation are rooted in familiar circumstances related to domination. It is axiomatic, for instance, that three recurring responses to a dominant social force are assimilation, negotiation, and confrontational resistance. It would be surprising if these typical responses, more or less embedded in the situation of domination itself, were not paralleled by modes of self-representation organized by the unprivileged. And with all their limitations these interpretive frames bring aid to the task of giving definition and explanatory point to some of the pivotal junctures in the critique of representation.

The most absolutist form of irony that the powerful direct to those they subordinate under the most totalitarian conditions might be called Despotic. The speaker calls attention to himself as a being superior to this despised alien: "Look at this thing which is a no thing compared to myself, which is a pre-eminent something." As an example of Despotic irony we might recall the practice of slave-owners in the United States giving their slaves such mock-heroic names as Cicero, Cato, Caesar, and the like. There is no need to explicate the irony involved. The distance between the slave's condition and that of his ancient and honored namesake, however, should be noted as suggesting some of the distance between the slave and the owner who has the power to so ironically name him. This slave-namer, to paraphrase Tate's definition, permits himself and his witnesses an insight superior to that of the slave so named.

The great body of Despotic representation in cinema lies in the legions of Sambos, the Coons, the Mexican greasers and spicks, and other de-

graded caricatures of classical Hollywood movies. These are paralleled by stereotypic characterizations in literature, vaudeville, radio, advertising, and popular humor. Marlon Riggs's documentary film *Ethnic Notions* chronicles imagery saturated with Despotic irony, thousands of wide-grinning Sambo houseboy statuettes to grace Southern gentry lawns, a zillion variations of watermelon cartoons, etc. One measure of Despotic representations is that their victims have difficulty recognizing themselves or their humanity in them.

Two characteristics of Despotic irony can be noted briefly. Despotic irony is rigorously manichean. The ironist sees the disparity between himself and his object as rooted in a binary order with himself located at the higher plane of existence and his object a token of the lower plane. Then, because the distinction drawn rests on this cosmology of divided planes of existence, the ironist, like most speakers from the Crystal Palace, characteristically denies the existence of irony or the intent to ironize. He claims merely to be expressing values reflective of the natural order. But often this disavowal must be read with a wink to the spectator included in the joke by having an insight superior to its object.

We might locate the Despotic ironic position illustratively in the institution of slavery in the United States, for one reason because it is well known and for another because the dynamic of racial domination established there holds continuities, though in historically altered form, with the present. During the era of slavery, the Despotic form of representation of the Other rested on a foundation of a stratified society of rather ancient type. Later, a new more modern foundation, that of functionally differentiated society, replaced the old order. Nevertheless the types and cognitive categories of the old order continue to persist as a kind of racialist fundamentalism.

Even during slavery the Despotic position was contested by a more liberal perspective. This posture has become increasingly influential as modernization and reform movements have eroded or outdated the totalitarianism of Despotic representation. Within this more liberal and indirect notion of social governance, the tenets of aestheticism come into fuller play, particularly those fusions of aesthetics and philosophies of history that read modern life and its functionally differentiated form of society as the fountain of alienation, and hope to find in the realm of the aesthetic a space of disengagement from this alienation. The many issues of intricate self-identification in the modernized social setting metastasize toward convoluted, ambivalent identification with outcast peoples.

"In the eighteenth and nineteenth centuries, conceptions of an autonomous aesthetic and philosophies of history repeatedly converge under the correct impression that their most fundamental and essential objective, to think the 'other' of modern civilization, is identical."[21] The great betrayal of this liberal mode of dominant ideology, reflected in artists, critics, and philosophers alike has been in the appropriation of the non-Western Other, whether seen as savage, native, exotic, anthropological curiosity, as an object manipulable in its effort to think the *alter* of their own alienation without regard to the falsification of this Other or the indefinite postponement of this surrogate's political empowerment in the process.

Where the Despotic subject represents this Other as Caliban, the Ethiopicist subject portrays it at best as Ariel. This liberal mode of Other representation is called Ethiopicist, recalling the tradition of nineteenth-century minstrels to give themselves such names as "Ethiopian Delineators" or "Ethiopian Serenaders." (I need to reassure my Ethiopian friends that the term has nothing whatsoever to do with the Ethiopia of actuality.) The liberalism of minstrelsy must be understood as relative. The minstrel show of the last century formed a composite of images, including some of the most Despotic. At the same time, historians of minstrelsy see its practitioners as sometimes liberal sympathizers with oppressed Blacks. Its racial imagery was presented in a frame that mitigated the most totalitarian bite. Its liberalism stands in contrast to its most purely Despotic counterpart in the representation of the Other, the ritual drama of exorcism through lynching.

If the nineteenth-century minstrel show was, by today's standards, of suspect liberalism, it nevertheless typifies a principle characteristic of the ironic gaze that persists in the liberalized regimes of later eras—the miming of a speculative self through the mask of an alien. Where the Despotic ironist is motivated by a desire to exorcise all resemblance between himself and his manichean double, the modern Ethiopicist performer makes an exaggerated demonstration of his/her liberalism, and at the same time effects to shame, titillate, or shock the more fundamentalist sectors of society by assuming the mask of the alien.

This frame of representation is also sedimented with recurring ironies, most of them ritually denied. One irony is that the figure represented seldom bears much resemblance to the alien, at least in comparison to the presentation or representation the alien might make. And yet, the figure never discloses the self of the masker—which is the point of masks. An-

other irony is that those whose identities have been appropriated are expected to be grateful, both for the effete reformism sometimes implied in these portrayals and for the portrayals themselves, beside the alternative of non-representation as invisible beings.

The mask of the Ethiopicist often assumes a politically correct liberal reformism, half expressed, if at all, in a posture of laterism—things will get better later, your day is coming—addressed to the claims of the appropriated, among them the chance to represent themselves. The appropriators ignore their role in postponing the self-representation of the appropriated. They make light of the energies and resources that might be transferred from Ethiopicism to self-representation. More, the Ethiopicist performer adopts the mask of the repressed mainly to address the dominant majority, not the minority. However a subtext of patient stoicism is frequently included which the repressed might read as a message to themselves but which also serves to restate conventional wisdom that the majority needs for consolation.

The Ethiopicist modality merely plays around, provocatively, with the Despotic counters of dominant representation, using the image of the other as a form of convoluted special pleading for sectors momentarily squeezed by the regimens of modernity. The image of the outcast is often adopted precisely because of its unacceptability, for its value as transgression of bourgeois serenity. In many of these efforts to shock a complacent public, the features of the dispossessed, the Black, the female, the homophile, are distorted in monstrous or abject forms that discount the interests of the represented. There is a modernist tradition of this sort of ventriloquism—the Cubist quotation of African masks, the literary masking of Gertrude Stein's *Melanctha*, Orson Welles's staging of *MacBeth* in a Haitian background, Genet's *The Blacks*. Toni Morrison has analyzed several Ethiopicist exercises in American fiction in her critical study *Playing in the Dark*.[22]

Despite its ingenuity in fashioning novel euphemisms, Ethiopicism routinely presents the Other subordinated to the master text of protected White destiny. Faced with the possibility of joining the outcasts in radical rebellion against a system that represses both, the Ethiopicist artist invariably retreats to a comfortable distance within the protected zone. Subscribing to the master narrative, Ethiopicist portrayals inscribe the ironies of pastoralism where a nether class is seen expressing itself carnivalesquely but never in a way that seriously challenges the right to rule of the oversociety.[23] The Ethiopicist performer and her preferred audience generally views the possibilities of the repressed through a more pessi-

mistic lens than they, from a different posture with its own economies of hope and ideology, view their own future.

There are also some pivotal frames of representation available to the repressed, each bearing its own ironic relation to domination. One of these might be called Cyclopean after the moment when Cyclops, who has been both wounded and verbally tricked by Odysseus, calls to the gods, screaming that "Nobody has blinded me!" This position, which is rarely adopted in its purity, nevertheless holds some inverse affinity to the Despotic frame. It is reflected in the "minority" or subordinated creators who identify so ardently with the values and forms of their colonizers that they are ironically unable to recognize their contribution to their own subordination. They hold as valid expressions those that mimic the genres and traditions of their masters, and value no praise except that which comes from them.

Writers who more understandably succumbed to the lures of Cyclopism in the nineteenth century, sometimes described as "literary pets," also have their contemporary counterparts. They are often found among those who insist on being perceived as "writers and film-directors, not Black writers or women film directors."[24] On the surface, their role in the critique of representation might be viewed as minor, merely adding canon fodder to the bulk of received ideas. Actually, they provide comforting evidence to the Crystal Palace that its standards are fair. They are likely to be gussied up and trotted out as star pupils of the zeitgeist. The Cyclopean performer also provides models for the neo-conservative Cyclopean consumer of culture, and helps to further confuse the minority spectator tempted to internalize the reigning spectacle. Because of the ambiguities of language and biography, hardly any writers or artists come to mind who fulfill the description of Cyclopean producers. Outside the arts, a good example would be the ideology and social practice of Supreme Court Justice Clarence Thomas.

A more complex mode of addressing the ironies of discourse is the Aesopian, where the performer addresses the challenges of "minority discourse." My use of the term begins with its generic sense of a speaker from a repressed community who inscribes one text for general (majority) consumption and another more subversive level of signification to be appreciated within the "freemasonry" of the subcultural group. The cycle of Brer Rabbit stories offers a familiar body of Aesopian expression in U.S. culture.

More broadly, the Aesopian mode is the zone in which minority speakers approach the power of dominant discourse from a position of nego-

tiation. The speaker in this position attempts to master a language and thematic understandable by the majority while also speaking to affirm the values and interests of the in-house group. The question immediately confronting this position is, which of two masters does the text most effectively serve? In Aesopian utterance, texts are precariously balanced so their ironies or registrations of difference in meaning typically fall on both sides of the discursive barrier between power and the lack of power, but may be finely calculated in retrospect (or later historical reconsideration) to have served one better than the other. More typically a final flat judgment seldom fits, since the meanings remain mixed, and more important, the contexts where meaning is registered are often incompatible. For example, in the minority, a certain ironic restitution of the power to speak is accomplished merely by the completion, publication, or exhibition of the text. But how does this compute in the struggle over meaning beside the reinforcement of canonical knowledge the Aesopian text might confer upon received tradition?

Paradoxically, both "Ethiopicist" and "Aesopian" are terms derived from the same root, "Ethiopia," Aesop being the Greek transcription of the famed storyteller they called "the Ethiopian." But the kind of irony implied in each name carries a different tonality, the first mocking the Other and the second defending the Self. Yet the two modes share an entrenchment in doubleness. They both rely on masking, the one masking itself as the Other, the second adopting masks in order to represent something of its true Self.

The temptation to deride the Aesopian performer out of hand as half-hearted or self-divided should be resisted. Almost by definition, every communicator outside the Palace but within range of its networks is positioned at the crossroads of the Aesopian mode (not excluding this text). While we may celebrate more exclusively resistant texts and strategies, the impact of work done from an Aesopian standpoint has, in dialectical relation to more insistently transgressive work, historically brought results toward cultural democracy.

The frames of representation demonstrating the most resistant postures among the ironies of discourse must be put aside to later discussion. Needless to say, among the strategies deployed there, frequently the values of the Palace are reversed through rhetorical strategies of recoding or reframing, or by posing their irrelevance through potent expression that lies altogether outside its cognitive map. But here, we need to consider further the essential relation within these ironies, the twin-ness of the relevant positions, and the way they sometimes act as doubles.

DOPPELGANGER DISCOURSES

> If I was a Negro, I'd probably think like them.
> If you were a Negro, nobody would care what you think.
> —Willem Dafoe and Gene Hackman as FBI agents
> in *Mississippi Burning*

> It is a question of taking what's theirs that is rich and transposing it into our own situation, or into the situation we wish to make for them.
> —Marcel Griaule[25]

> I came to realize the obvious: the subject of the dream is the dreamer. The fabrication of an Africanist persona is reflexive; an extraordinary meditation on the self; a powerful exploration of the fears and desires that reside in the writerly conscious. It is an astonishing revelation of longing, of terror, of perplexity, of shame, of magnanimity. It requires hard work not to see this.
> —Toni Morrison, *Playing in the Dark*[26]

Understanding its need to engorge all reference, and assimilate it to itself, we can appreciate the impulse in Palace discourse to colonize into subgenres any well-defined alternatives that might offer competition. The implicit irony that exists between this totalizing and peripheral discourse makes inevitable a kind of semiotic duet. As said before, the same combatant carries doubled identity in either discourse, captioned either as terrorist or liberator. The two discourses, moreover, often demonstrate the behavior of fictional doubles.

Doubling functions not only on the level of characterization. The premise of discursive irony implies that all discourse between majority and minority perspectives is doppelganger discourse. The doppelganger motif that spellbound nineteenth-century fiction readers may have played a role in the development of a modernist consciousness. It has been well argued that the doppelganger narrative reflects a Romanticist determination to fracture classical notions of human personality. Whatever older notions of the human character we might recover, that types were determined by "humours" or other agents, material or spiritual, most of them saw the human personality as a unified entity. Doppelganger fiction rose to create uncertainty and doubt in areas that had gone unquestioned.

We should remember that the "double-walker" stories of that era in-

cluded some where two distinct human beings in separate bodies carried out a kind of co-existence, often with one echoing the evil that the other projected as good. Edgar Allen Poe's short story "William Wilson" is of this type, as is *Confessions of a Justified Sinner*. But another form of this narrative saw the two personalities trapped within the same body, as in *Doctor Jekyll and Mr. Hyde*. *The Picture of Dorian Gray* is innovative in making an object, the painting, the receptacle of the *other* personality. The motif as enacted by two separate persons was marshaled for spiritual and moralizing effects, with the duo embodying a manichean split in the universe. But where the two personalities inhabit the same body, the resonance was more psychological and challenging to moral certainties. Nineteenth-century tales of doubled beings foreshadowed Freudian probings for the unconscious. But these stories also anticipate the anti-essentialist arguments that have arisen to complicate twentieth-century ideas of identity. It seems unsurprising, then, that Oscar Wilde's *The Picture of Dorian Gray* obviously reads like an allegory of the homosexual underground in Victorian England, with Gray's nocturnal forays into wicked parts of town for wicked deeds probably alluding to the sin that does not bear naming. But a similar interpretation seems to be gaining ground when applied to Stevenson's fable of Jekyll and Hyde.

The connection of the doppelganger motif with the ironies of majority-minority discourse becomes more believable the further it is pursued. Doppelganger as a motif was a genre of underground resistance to the monolithic identity of Victorian and Imperial Europe. It introduced a nineteenth-century "politics of difference" among Westerners divided by issues of gender and psychological outlook that also applied to outcasts of race. W. E. B. DuBois's famous description of the ambivalence haunting the African American personality easily reads like a blurb for a doppelganger novel: "two souls, two thoughts, two unreconciled strivings; two warring ideals in one dark body, whose dogged strength alone keeps it from being torn asunder."[27] This connection is elaborated in James Weldon Johnson's novel, *The Autobiography of an Ex-Colored Man*, where the central character leads a double life performed with the guilt-ridden anxiety of an underground man, not split between daytime probity and nighttime sin and crime, like Hyde-Jekyll, but sometimes living as a Black man and sometimes passing for White. As though to bring these two literary traditions together with a wink, Johnson draws a character who looks very much like Dorian Gray on an imagined sojourn in the United States and Paris, acting as the patron of the title character. The

manicheanism of good and evil that animates so much archetypal Western mythology takes on a complete second life in depictions of race, wearing a doppelganger design. So it is not surprising that racial contradictions in Western narratives often evoke the mechanisms and sentiments of double-walking. The central doubling link in the critique of representation has to be that between the Western master narrative and all those other scenarios of possible truth that would compare with it or overturn it.

Doubling gains interest when viewed as a function of whole narratives rather than of characters within stories. In such texts we may find dominant and dominated discourses articulated together in symbiotic relation, in such a way as to either confirm or refute the privileged symbolic order. Such texts are in fact doublet discourses, and of particular interest as dramatizations of the politics of representation. Two such texts are the films *Imitation of Life* (1934), which will be looked at here, and *The Cotton Club* (1982), which will be discussed later.

Imitation of Life, adapted from Fanny Hurst's novel, is a "woman's picture" with a difference. The Black female icon, pivotal in this film, figures in the typical women's picture of the classical era as shadow-sign validating the White heroine's womanhood. A poster showing a White female star with a Black maidservant in the background might be taken as the logo of the genre. For the Black women cast in minor roles in these pictures, in *Mildred Pierce, Jezebel*, or the women's-picture sequences of *Gone with the Wind*, for instance, the requirements are simple. Their uniformed dedication to household tranquillity ensures the freedom of their mistresses for the higher duties of the nineteenth-century cult of true womanhood, to provide emotional nurturance for their families and to maintain themselves as exemplars of inspiration and idealism, of the civilized graces and nobler callings—to be at once active agents of these values and their passive, fetishized embodiments.

The women's picture functions in relation to the master narrative as the elaboration of the maiden's role; the other, co-gendered side of that heroic text. The underlying question of the women's picture or the maiden's tale is, what will happen when the values embodied in her as vessel of true womanhood are put at risk, as when she is abandoned by her mate (*Stella Dallas*), rids herself of a worthless husband and sets out on her own (*Mildred Pierce*), demands a more independent life than patriarchal isolation (*Jezebel*), or is widowed (*Imitation of Life, Places in the Heart*)?

Bea Pullman in *Imitation* is a young widow who must find a living for

herself and her daughter, Jessie. Into their precarious existence comes Delilah, a Black woman who attaches herself to them as her family to serve, so that she may put a roof over her daughter, Peola. Of the various sub-subspecies of the master narrative, the Black women's picture is one that scarcely exists. A combined fragment of the maiden's tale and the slave-servant's story, its role as function of more politically central narratives is regarded as too axiomatic by master narrativity to demand independent development, hence the huge vacuum of representations of Black women in classical movies. Her presence is useful only as a background reflection of a persona who is herself not really central to the grand scheme of things. She is a shadow of a shadow.

Imitation of Life continues to fascinate as an instance where this role is expanded to the nearest approximation of a "Black women's picture" that Hollywood achieved, at least in the classical era. As star of the vehicle, Claudette Colbert is drawn as the idealized feminine presence of classical movies. Narrative, lighting, screen-positioning, ensure a protective aura around her worthiness and eventual triumph. Yet all along it is the subplot revolving around Delilah that commands real interest, and the story as a whole would scarcely exist without it.

The doubling of characters is in fact squared. The symmetry is complete in that both the White mother and her daughter are provided with their African American female alter egos. In this way the contradictions of race and of contrasting racial discourses as seen from the Crystal Palace are more richly orchestrated. Delilah naively provides the raw material for Bea's commercial success—a secret family recipe for magnificent pancakes that Bea mass markets with the utopian ease of the American dream, movie-style—with a rapid montage telescoping the steps to success. But the more important part of Delilah's story is her problem with her daughter Peola, the archetypal tragic mulatta of classical cinema, too White-looking to accept the servants' quarters of Black social positioning, yet saddled with an obviously Black mother who clumsily gives away her attempts to pass for White.

The trials of Delilah fall within the ironic code of Ethiopicism, almost as textbook illustration. Delilah and Peola are minstrel names for Black women. ("Delilah" obviously echoes that other great American icon of pancake virtuosity, Aunt Jemimah.) Naturally, Delilah's image must grace the merchandise package, and when told to smile for the photo, finally reproduces the perfect minstrel grin. She is even too obeisant to stop smiling until told to do so. Straight from the minstrel repertory of Black imagery is her fusion of simple-minded superstition—she swears

by her rabbit's foot—and her stoical, primitive Christianity, as well as her single life's desire for a grand Negro funeral, which is finally delivered as the gigantic production number of the movie.

But these static and traditional stereotypes operate within a grander scheme of ironic signification. The meandering movements of this domestic-business saga finally organize themselves around the theme of motherhood. In this women's movie as in many, the pathos of womanhood is embedded in the pathos of mothering. The refined tribulations of Bea's motherhood are shadowed and deep-reliefed by the darker, more subterranean tragedies of Delilah's ordeal as single parent.

Delilah's tragedy is rooted in the tragic "mulattaism" of her daughter. Between Delilah and Peola a sequence of ironic differences is drawn, arising from the secondary manicheanism that forms part of the mastered representation of colonized peoples. This level of difference operates as an explanatory subsystem of the high-profile difference between Whiteness and Otherness. This subtheme dances around the tension between those who accept their subservient position under White dominance and those who resist it—between Delilah who counsels her daughter to "Meet your cross halfway" and Peola who continually insists "I can't stand it!"

The theme of the "tragic mulatto" built around Peola is one where doppelganger discourses of the segregation era find a biological-cultural nesting ground. The surviving plantation myth would have it that the "White side" of the personality asserts the noble desire for freedom against a "Black side" inclined to slide back into passivity or primitivism. In the "mistress narrative" of *Imitation*, Peola's desire for a life of opportunity, free of social humiliation, is framed as a desire to be White. The other pull, toward the race loyalty her Mammy pleads for, bears the weight of Delilah's genial submission to the myth of White supremacy. Students from both races increasingly find Peola's desire to "pass for White" sympathetic, given the options, in both the 1934 version and the 1959 version directed by Douglas Sirk. But both sides of this schismatic proposition, Peola's or Delilah's, are drawn to articulate the narcissistic needs of Ethiopicist programming.

The other ambiguous sign aroused by Peola's plight as tragic mulatta is her sexuality. The popularity of the tragic mulatto theme springs from its capacity to produce unsanctioned desires at the same time that it safely disperses the accompanying fears. Unlike the stereotype of the Mammy fatally committed to nurturing others that Delilah fits perfectly, the tragic mulatta is portrayed as nubile, intent on achieving a self of her own creation, and dangerously available. "If, as feminists have argued,"

writes Jane Gaines, "women's sexuality evokes an unconscious terror in men, then black women's sexuality represents a special threat to White patriarchy; the possibility of its eruption stands for the aspirations of the black race as a whole."[28]

As noted, Peola's foreshadowing of many Black American aspirations is displaced in the narrative as an anxiety to pass. The additional threat of her sexuality is simultaneously expressed and repressed. Its expression in the 1934 version is mainly through visual codes. Peola becomes the movie's "single subversive element, a character in search of a movie," writes Donald Bogle.[29] Nor is it merely an irony of distorted notions of racial aesthetics that "with eyes light and liquid and almost haunted," Freddie Washington as Peola was the film's most sensuously powerful presence.[30] Her portrayal appears detached from the rest of the film by its need to restrain the implications of her sexual energy, even while contemplating it.

Peola's unquenchable desire demands an additional reading to further explain the perennial popularity of this film theme, among women particularly, both Black and White. Peola's fretful search for an independent self in contrast to Delilah's maternal other-directedness expresses a moment in contemporary feminist consciousness. Apart from standing distortedly for the aspirations of the black race as a whole, Peola may also stand for the search among liberating women for a self-definition outside the biologically determined contours of motherhood as prescribed by the master text and religiously affirmed by Delilah.

As a double-tiered exposition of the trials of motherhood, *Imitation of Life* does not sidestep questions of womanhood that, in a more radical frame, might evoke feminist considerations. Nor can the question whether this oblique reference is intentional be easily settled. Upstairs, we do in fact see Bea simultaneously juggling the urgent demands of running a large business, dealing with the problems of single-parenting and negotiating a romantic relationship: not far removed from the scene where contemporary feminist thought must work itself out.

As for the downstairs segment of this narrative we can see it functioning in a way that clarifies the Ethiopicist code of ironic discourse. Like the posture of Despotic irony, the Ethiopicist code exploits a distorted picture of the out-group for the symbolic benefit of the in-group. But it differs from Despotic irony in taking greater pains to impersonate the outsider and also in developing its ironies in more gentle, liberal, sympathetic terms. *Imitation of Life*, then, is a classic text of Ethiopicist irony in delineating the relations of Mammy to Maiden (it doesn't matter that the

maiden is a widow), in this subordinate branch of the master text. To focus on one phase of this representational paradigm, we might look at Delilah as Mammy, deployed to background Bea as Mother.

The architectonics of the Mammy stereotype are not always seen within a mythical economy of family, racial, and sexual organization. For instance, there is the Mammy's preferential treatment of her mistress's children over her own. This unequal exchange is powerfully evoked in Black women's fictions such as Toni Morrison's *The Bluest Eye*. But in Ethiopicist narratives this unequal exchange lies embedded in the primary identification of the Mammy with "her" adopted White family (cf. *The Birth of a Nation*). This unearned devotion is allegorized in *Imitation* when Delilah first enters Bea's house seeking refuge, voluntarily frees Bea from cooking chores so she can attend to little Jessie and only after she has gained a foothold brings little Peola in from outdoors where she has left her waiting. There is also the Mammy's eternal sexlessness, which is not merely the ironic mirror opposite of the desirable eligibility of the White Maiden, but is rather a direct and voluntary sacrifice to it.

This motif is played out repetitively in *Gone with the Wind* and other maiden melodramas where the Mammy sasses or cajoles the maiden toward eligible males, matrimony, and maternity under the aegis of patriarchy. Delilah follows this tradition, continually proposing that Bea take a husband, and drawing on her rabbit's foot power to bring this about. Just as Delilah refuses partnership or 20 percent of the business founded on her formula and a home of her own ("Mizz Pullman, please don't send me away!"), she also refuses her own mating prospects in order to advance Bea's. The Mammy's potential sexuality is given up as an offering, a tribute to the sexual and reproductive vitality of her higher surrogate ego.

Where the individual stereotypic traits of the Mammy figure add up is as alternative drone body to the maiden's, who is thus flattered in compensation for her eventual subordination to the master. In *Imitation*, Delilah's maternal other-centeredness, her identification with her adoptive family, being White-identified the way some women are male-identified, is so thorough that we are made to watch her die for these central others. Technically, she dies out of heartbreak over Peola's denial of her. She also dies in order to bring Peola to her knees at her funeral and back into the preordained social track laid out for her. (As infidel to the mastered system, Peola must be brought low.) But actually she dies for the Pullman household and its extensions in the White audience. Her deathbed pathos is played out for them as a downstairs reverberation, on a lower but

seismically powerful frequency, of the sacrificial pains endured in the cult of true womanhood and enacted upstairs in more elegant, poetic circumstances. Delilah's sacrifice of her life is the counterpoint of Bea's maternalistic sacrifice of immediate happiness with her fiance Stephen. Bea sends Stephen away indefinitely for Jessie's sake ("Go back to your islands"), to give Jessie time to forget her schoolgirl crush on him. In the economy of the master narrative, much of the heavy suffering is left for the servants to do, vicariously enriching and ennobling the masters. Delilah's death is a ritually enacted sacrifice to the Pullmans, the audience and to the text of true womanhood, which is also a subtext of White male rule.

The Mammy's tale, which is never encoded by the master tradition as a narrative in its own right, in this movie is developed as the more compelling part of a double story where it nevertheless plays a sustaining, "supporting" role in the drama of desire and aversion, transgression and punishment. This doubled play of racial and sexual motivations produces a dynamic more broadly evidenced in American than in European fiction. In U.S. fictions, the alienated substratum of Black female representation acts as a safety net of symbolic valuation, ensuring that the White heroine, however temporarily tragic, need seldom fall so low as an Emma Bovary, a Camille, or an Anna Karenina.

The threat of this downstairs drama as well as the lure of its exploitation is contained by the strict closure around the representation of Black women in U.S. narratives. The desire-aversion nexus in *Imitation of Life* exposes a functional symmetry between the mastered representation of Black women and Black men. In these representations the underlying subtextual question is, how can we enjoy from a protected distance the contemplation of the imagined sexual and personal power of the Black woman, while remaining reassured that this power can be controlled in our service and interests?

As one measure of this narratively repressed power we might image a countertextual portrayal in which the proverbial endurance, resourcefulness, and emotional depth of a "Delilah" was embodied in the same figure that also held the beauty, desirableness, and questing search for independent selfhood of a "Peola," and recognize such a portrait as the kind that is disallowed by the discursive boundaries placed around Black female figuration by White male and female authors. (That such figuration might stand closer to reality is suggested by the statistic that, from less favorable circumstances, Black women manage earning power close to that of White women in the United States.)

Another, postdated irony of Hurst's White/Black woman melodrama, more against the grain than textually authorized, arises from a historic rereading. The double-tiered trials of womanhood and motherhood, readable for feminist significance, may also be read as recording double feminist tracks. The movie might read metaphorically, embodying the situation between White and Black feminists in this country. The reservation of the paradigm of "true womanhood" for middle-class White women in nineteenth-century U.S. culture has its parallel in the construction of contemporary feminism as a normatively White middle-class development. In both instances the heroic suffering in the basement of the Crystal Palace by Black women is absorbed as confirmation of the self-representation of White women as noble sufferers, while the real but distorted aspirations of a Peola or a Delilah for an independent reading of their experience are refused expression. It is also possible that the current vogue for Black women writers, and for films from their novels, partly reflects the pleasure of these texts received from this double-tiered spectator position. Or from another angle, we might ask whether Anglo-feminism does not also maintain an "Ethiopicist" code in the reception of Black women's work.[31]

What the text of *Imitation of Life* authorizes for our inspection is a depiction of Black women from an Ethiopicist positioning where nearly all the ironies of difference fall to the disadvantage of Black women. If we read the possibilities of Black women as one discourse caught up in a doppelganger relationship with a maiden's tale discourse of White American women, the tale has dimensions of a horror movie. We might call it *Black Woman in the Attic*. The discourse of the principles in this quartet of doubled characters has its dreams highlighted and glamorized, caressed, while the discourse of their shadow-women must deny itself the right to speak, to maintain dignity, to avow loyalty to itself, must, prophetically, die for its mistress narrative. There can be no doubt that such a tale is an invention of the master narrative, to serve its masculinist as well as racist interests. But through the device of conjuring amity among these representations of women, to the extent that White women and Black women, feminist or not, enjoy this menu of sentiment unexamined, this doubling of narratives works.

CHAPTER VIII

■

The Ironies of Aesopianism

> I've got one mind for my Cap'n to see
> and one mind for what I know is me.
> —Black folk song
>
> A huge ditch was dug across the white cemetery
> and a big ditch was opened across the black graveyard.
> —Zora Neale Hurston, *Their Eyes Were Watching God*

In analyzing the colonial situation, Fanon exacerbates the manicheanism he finds there. Granted that the colonizers see their world rigidly split between civilized and backward, etc. It is also true that Fanon, like other radicals, tends to offer rigid either/or choices in the way the colonized may address the dominating society. Either the colonized internalizes the values of the colonizer (Cyclopeanism), or she rejects them outright in radical, revolutionary resistance. Any in-between possibilities are likely to be despised, per the radical 1960s, as weak-hearted liberalism. "You are either part of the solution or part of the problem" is an inspiring, illuminating slogan. But we should also recognize that it is a manichean position, even if a countermanicheanism.

But to operate effectively within our present crisis of knowledge requires more candor about the "gray areas" that the successes of decolonization and deconstruction have ironically multiplied. In recent decades, the nature of dominance, particularly cultural dominance, has shown itself to be more complicated than believed before. Consider the familiar liberation-minded catechism: to learn the oppressor's language is to imbibe his culture, and to imbibe his culture is to submit to cultural inferiority. Jean Genet writes in a vein that may be considered a Hegelian determinism of domination: "It is perhaps a new source of anguish for the Black man to realize that if he writes a masterpiece, it is in his en-

emy's language, his enemy's treasury which is enriched by the additional jewel he has so furiously and lovingly carved."[1]

Even the most totalizing forms of speech, the most Despotic or resistant, are subject to the limits of language, its answerability, its indeterminacy, ambiguity, its reversability. Speech acts have their real consequences, like a judge's death sentence, but all speech remains effective within a symbolic mode of representation that has a different function than action. The judge's sentence can be countermanded. The execution cannot. Radical filmmakers recognize this fact when they acknowledge that their films are not revolutionary—they do not and cannot make revolution. However uncompromising the discursive irony of a Despotic or resistant statement, it will always remain ironic, subject to the polysemic character of language.

Fear of the oppressor's language can approach a magical, regressive view of language where words contain within them the power and essence of the thing they describe. At its lowest level of perception, this prejudice finds difficulty in believing that a foreigner's language holds equivalent content and significance as one's own. Despite solid linguistic evidence, the notion persists that the language of some people is inferior to that of others, and in the primitivist mode of thinking that some languages are "just mumbo jumbo."

The magical understanding of language is akin to the literalism with which some viewers identify an actor with the role being played. This literalism, which produces the fallacy known in the field of communications as "the hypodermic effect"—the belief that an image projected to an audience enters that audience's consciousness like a hypodermic needle injection into the mainstream of its mind—is one of the deficits of "positive image" interpretation.[2]

Ngũgĩ wa Thiong'o's *Decolonizing the Mind* makes a sophisticated and compelling demonstration of the way European languages have been used as instruments of imperial control.[3] But it is also worth pointing out that the languages themselves are not the colonizers; the colonizers are the political-ideological frames of reference that impose these languages for imperious effects. Language is only one front of a struggle that has many vectors, in which language is implicated. The target of resistance need not merely be English or French so much as the ideological machinery and the symbolic-cultural regime that uses these languages, like other instruments, such as the educational system, the system of knowledge, the art-culture system, and its enabling doctrine, aestheticism, to extend its dominance. Uncompromising hostility to a power-connected

language may be less fruitful than an understanding of the semiotic arbitrariness of language, the social construction of its significance and the principle of power/knowledge that underlies the aggressive deployments of that language.

Thus, the interpretive frame of Aesopian irony occupies an unheroic space, short of absolute expression. Aesopianism is rooted in the inescapable ambiguity of language itself, its polysemism, its symbolic relation to material reality. "Meaning is always negotiated in the semiotic process, never simply imposed inexorably from above by an omnipotent author through an absolute code."[4] It is because of this answerability of language, together with the differences of power invested in each speaker, that cultural productions always possess a political dimension.

So the recognition of Aesopian strategies in a narrative only indicates the beginning of interpretive work, not grounds for a final dismissal. Of all the interpretive frames under examination here, Aesopianism is the one closest to capsule embodiment of the features of the ironies of discourse. In fact, like other objects contested by competing meaning-making systems, Aesopian strategies can arouse sharp divisions. I can recall, for instance, being reproached in some forums for not including reference to European thinkers in my admittedly hostile interrogations of aestheticism (even though I had in fact made reference to several), and also being criticized by differently minded auditors for having given such writers any "play" at all.

But how do we isolate Aesopianism among the many effects produced by the ambiguity of language? Recognizing the split-level architecture of the dominated communications process, and its double standards, the less powerful develop forms of expression which are readable one way through the values of the dominated sector and another way by the marginalized. This approaches the conventional definition of Aesopianism in folklore studies, where it is regularly applied to signifying folk tales like the Aesop fables themselves, the Brer Rabbit or Anancy tales, or the story of the tortoise and the birds in Chinua Achebe's *Things Fall Apart*.

Aesopianism is related to that double-voiced form of African American double entendre called signifyin'.[5] Yet signifyin' carries limits not borne by Aesopian speech. The signifyin' mask carries the risk of faking humility and then losing the sense of where the mask ends and the real self begins. We might also remember that the Grandfather's advice in *Invisible Man*, to "agree 'em to death and destruction" boomerangs on the tale's hero, as an empty-gun strategy.[6] And in *Nothing but a Man* (1964) the historical limits of signifying are marked when Duff rejects his fel-

low Black workers' advice to pretend to go along with the regime of insult and subservience demanded by White Southern racists, insisting that the times no longer demand such ruses.

In recent years, the meaning of "signifyin' " has been extended beyond the scope of African American vernacular expression to a paradigm embracing wider stretches of Black and resistant communication. My use of Aesopianism effects a similar widening of application. Both terms are now expanded to accommodate the most ambitious uses of language in the most ambitious texts. But the range of reference embraced by Aesopianism seems wider than that covered by signifyin', extending beyond either oral or literary tricksterism. Neither spiteful, hidden backtalk, coded messages of resistance (like the use of the song "Steal Away" as a signal for a planned escape), nor even the oblique transmission of a wisdom that the listener may not yet be morally or intellectually ready for—prime motivations for signifyin'—exhaust the possibilities of Aesopian speech. Aesopianism includes linguistic tricksterism but may also involve open, sincere, unmasked appeal to different audiences.

Aesopianism can be unintentional. Frederick Douglass pointed out how the tone of the songs sung by U.S. slaves was frequently misinterpreted by the slave-owning class, the songs' sadness or joy often being confused. Such confusion can result less from concealment than from the ironies of discourse themselves. Other times, storytellers will include references familiar to one audience and others familiar to another audience. Kafka's stories are ambiguously Jewish or universalist, whichever interpretive frame the reader brings to them.[7] The effort to control the meanings available to two or more distinct, and perhaps rival audiences in the same text is a hazardous game. Its players leave themselves open to accusations of cultural and political treachery, "sleeping with the enemy." Explanatory information presented for an outsider audience is sometimes resented by insiders as fawning upon the oppressors. A more realistic understanding of the situation of the minority producer might remove the need for simplistic equations. African writers often include material in their works that Western readers are not likely to be familiar with enough to understand, sometimes explaining for that audience, sometimes not, each striking a different balance.

The emergent narrator is under pressure to avoid the rhetorical frames of petition and negotiation, recalling humiliating subservience of the past, in favor of a stance of confrontation. "To whom is the work addressed" reflects the wary search for political authenticity, under the too-simple assumption that texts addressed to the dominant group are nec-

essarily conciliatory—"prim and decorous ambassadors who went a-beg-
ging to white America" was the way Richard Wright wrote of this trans-
gression.[8] This formula takes direction of address as equal to direction of
empowerment but overlooks the non-hypodermic capacities of language.
There are in fact valid, liberatory uses for addressing the dominant
Other: to offset stereotypes, to enlarge cultural capital and therefore so-
cial power, to renegotiate terms of interaction and exchange, to secure
new coalitions and alliances, to provoke advantageous divisions among
the majority, to deflate majority pomposity, to satirize majority claims to
preordained superiority, to delegitimize oppressive majority values, or
cross-pollinate its linguistic "purity," or in other ways to decolonize the
public space. Equally there are contexts where narrators frame their com-
munications to perform one or the other of these functions and also ex-
press meanings to their embattled interpretive community in the same
text.

Aesopianism demands negotiated reading of texts from populations
tired of negotiating, and eager to give restorative orders. The patience
to particularize, to respect certain features of a cultural object while re-
jecting others, is not always handy. This is a characteristic frustration of
the minority situation. But we can deny the plurality of meaning, from
angle to angle, and among different historical positions only at high cost
to the project of rewriting knowledge. And the tradition of signifyin'
among African Americans in slavery, sometimes encoded in works jus-
tifiably considered masterful expression, demonstrates an understanding
of parody, of the multiple capacity of language, of irony in a way that
explodes the argument that Aesopian irony is too complicated for the less
advantaged to comprehend or use.

The political force and direction of Aesopian texts varies from lu-
bricious assimilation, approaching Cyclopean self-abnegation, to deter-
mined but masked resistance. On top of other complications, every rhe-
torical posture associated with Aesopianism, as with other discursive
frames, carries the potential of being faked.[9] All of the entelechial distor-
tions cultivated by Monopolated Light and Power can serve as distrac-
tions for the Aesopian narrator. One danger is that this narrator may out-
run the sophistication of his native interpretive community. This is often
the fate of James Weldon Johnson's *Autobiography of an Ex-Colored Man*
(1912). This brilliant and ironic tale adopts the point of view of a mar-
ginally Black man who passes for White, makes incisive observations
about both sides of the color line, temporarily adopts the heroic goals of
Black liberation then slides finally into the easier path of invisible assimi-

lation. Many young Black readers miss the cautionary point of this man's selling of his birthright "for a mess of pottage." Not understanding the ruse of the novel's original, anonymous publication, they confuse the hero's racial disloyalty as the views of James Weldon Johnson, whose life and commitments were very much different.[10] The ironies of Aesopianism include all the hazards of minority leadership, not only the danger of being misunderstood, but also the temptation to be co-opted by the Palace. There is Strong Aesopianism, firm in its resistance, and there is Weak Aesopianism. Weak Aesopianism, expressed by "mockingbird" writers and artists, is drawn to the temptation of Aesopian cosmopolitanism, alienation from the defensiveness, the compensatory inflation, moralistic fundamentalism, literalism, and the appeals of positive image that often show up in emergent populations. Weak Aesopianism in its cosmopolitan mode is drawn to the criteria, the values, the "aesthetics" of the Palace, accepting the Cyclopean notion that these values are "universal." The attachment to aesthetic reasoning and to the mythology and mystique of the Western artist are further allurements for the tar baby of alienated Aesopianism.[11]

A major set of issues gathers around the apparent kinship between Aesopian and Ethiopicist modes of representation. The bias of aesthetic discourse leads to a conflation of the two, which tends to muzzle the ironies of discourse, to subvert the particular ironic positioning of minority representation, or to redefine its self-determining strategies as deficiencies. These discursive frames in fact have much in common beyond their names ("Aesop" being the Greek for "the Ethiopian"), beginning with their acknowledgment of doubleness, their traffic with Otherness, their co-habitation in a space that tolerates the idea of exchange. As much as has been said about the tug-of-war of competing discourses, or the discursive Otherness of many populations facing each other, we can never afford to forget Bakhtin's recognition of the role of positive exchanges between "others," that we learn from those unlike ourselves, that Otherness keeps our worlds fresh and alive, that the Other is always opportunity for spiritual and cultural growth, and that many exchanges across cultural/linguistic barriers profit from this positive dimension of Otherness.

This reasoning needs to address some other considerations. The assertion of mutuality, of I/Thou in human exchange is a marvelous idea; but to offer this ideal as model for reality is to impose a liberal universalism whose actual consequence is constructing a Trojan horse for the enemies of redistributive justice. The crucial, ironic difference between Ethiopicist and Aesopian expression often gets muddied in the language of

Euro-art conventions and generalizations about representation. The conflation of Ethiopicist and minority perspectives is an essential feature of liberal multiculturalism. It has been suggested, for instance, that all narrative storytelling is a kind of Ethiopicism, except for the most narrowly autobiographical, since the author, whether from majority or minority, heavily or weakly empowered, is always representing personalities that are in many ways other to her experience. Henry Louis Gates, Jr. reflects this position by suggesting that all writers are "cultural impersonators." This argument wants to collapse the peculiar features of Ethiopicist representation as a constituent element of imaginative discourse. In all of these cases, refusing to recognize the difference between Aesopian and Ethiopicist modes, as in the rhetoric of multiculturalism, the crucial omission is the discrepancy of power.

The Ethiopicist and Aesopian positions are not different faces of the same coin. There is a theoretical drift that likes to argue that the oppressor and the oppressed "need" each other. This half-truth reveals its emptiness when real historical change threatens. These two parties "need" each other like a murder needs a perpetrator and a victim; they need each other only to maintain the very different roles, one clearly sociopathic, the other not necessarily, that go to compose the crime. The "need" is in each case very different. The victim has a "need" only insofar as he or she is only to be a victim; otherwise, the victim has a real need not to be a victim, a much differently grounded need than the perpetrator's need to be a perpetrator. One of the burdens of representation carried by the downpressed is the Monopolated impulse to restrict their identity to victimage and their victimage to pathology.

The difference between Ethiopicist and Aesopian frames remains impermeable so long as inequities of power hold a decisive meaning in the contacts among social groups. Narratively, to deny this difference is to argue that fictional doubles—Dr. Jekyll and Mr. Hyde, the two Dorian Grays, Bea and Delilah in *Imitation of Life*, etc.—are identical to each other. This difference is so fundamental that to disavow it is to deny the politics of representation.

THE HOST AND THE REPLICANT

One of the more important narratives illuminating the ironies of discourse through the use of fictional doubles is Mark Twain's novel *Pudd'nhead Wilson*. Roxy, a slave woman, switches her light-skinned in-

fant with the master's look-a-like baby in order to spare her child the miseries of bondage. Her son, raised in freedom and privilege, grows up to be a con-man, a scoundrel, and a thief. The legitimate heir grows up in slavery as a dull-witted, uninterested, and uninteresting individual. Twain brilliantly introduces the changeling motif into the debates around race, genes, environment, culture, social perception, and prejudices. His novel provides an important link between the doppelganger theme in nineteenth-century romantic literature and the repressed theme of doubling as a haunt of racialist discourse. (Twain was one author who developed the motif in both the romance-romantic tradition and the racial one; his novel *The Prince and the Pauper* offers a more conventional treatment of the theme.) But Twain's mystery-romance strangely misses promising opportunities to make his theme resonate. As a writer watchful of opportunities to demonstrate the human folly arising from attaching false values to appearances—as in *The Prince and the Pauper*—Twain's *Pudd'nhead Wilson* curiously muffles the splendid opportunities of its premise. This one of Twain's novels might in fact fit the description Ralph Ellison made of White American novelists since Twain was guilty of moral evasions around this central, national issue of race, as compared to the more courageous address to this issue in Twain's *The Adventures of Huckleberry Finn*. The kind of moral evasion Ellison describes is due, in part, to the repression of political for aesthetic salience characteristic of the art-cultural system since that time.

An important dimension of *Pudd'nhead Wilson* arises from its location within Ethiopicist irony. But this identity cannot rely simply on Twain's identification as a "White" writer. The identification of an author as either majority or minority is, finally, part of the work and its interpretation. This is the best solution to some of the questions around the troubling but key issue of authenticity.

Henry Louis Gates, Jr.'s article " 'Authenticity,' or the Lesson of Little Tree" incisively deconstructs certain notions of authorship. Building on the model of the blindfold test, Gates cites interesting cases of literary misidentification that contradict the notion of racial, ethnic, or gender identity in literature. One of the most bizarre instances is the novel *Education of Little Tree*, about an adopted Native American boy, assumed to have been written by a Native American author. The book, which sold over 600,000 copies and won awards, turned out later to have been written by "A Ku Klux Klan terrorist, right-wing radio announcer, home-grown American fascist and anti-Semite, rabble-rousing demagogue and. . . ."[12]

Gates's essay targets the Black Aesthetic and other attempts to con-

struct alternative or minority literary foundations. The lesson he would have us learn is the irrational hunger that easily creeps into minority efforts to authenticate their values in an era of hyper-anxious indentity politics. But this lesson can be turned around with even greater effect when addressed to the institutionalized center. The interrogation of authenticity is a part of Gates's project of deessentializing race. It is curious that in efforts to deessentialize race, Gates and others turn routinely to Blackness. The observation is seldom made that it is Whiteness that has all along been defined on the basis of a purity that can be threatened by one drop of non-White genetic material.[13] Gates's critical practice has been described as deconstructing the already decentered.[14] Likewise, the concern for authenticity, and for its related authority, has a longer and more fantastical history among the gatekeepers of culture and identity. Lois Maillol Jones, the African American painter, tells of entering her works into exhibitions under the name of a White friend when, during the segregation era, they had been rejected because of her "race."

Gates's intervention can be read another way. The fall of authenticity as a tool of interpretation throws the role of judgment away from aesthetic reasoning (consider the role of "authentication" in the sale of paintings) and toward a more socially based analysis. The central thrust of Gates's analysis leaves us solidly on the grounds where literary identity is socially constructed, is, in other words dependent on discursive formations. The identity of an author linked to a work, whether accurate or not, becomes part of the symbolic compact between the work and its reception, just as much as any part of its text. *Gulliver's Travels* is another book entirely if we take it to have been written by a Chinese scholar or by an Italian poet. *The Education of Little Tree* changed its meaning as soon as its trickster authorship was found out, but the bases of interpretation on which these meanings rest do not alter, except through other historical changes.

More precisely, the identity of a work is impacted by the cultural frame of the author's supposed background plus that culture's repertory of symbolic knowledge, as seen in that culture and by outsiders. The identification of a work as by an ancient Greek author is a framing that conditions and controls its reception, so much so that this framing almost acts as a character or a collaborating author. The deconstruction of "authenticity" is both valid and productive. But the use of these insights is what matters. Authenticity, closely interrogated, turns out to be a myth, woven around each cultural object. Yet because that myth functions as

part of the object, as, I maintain, one of its co-authors, we must learn to read the narrative and its myth of origin simultaneously, and politically. But given the assumption that Mark Twain really wrote *Pudd'nhead Wilson* and that Clemens/Twain (whose pen name reinforce the notion of doubled identity) was White, as that term is defined, then the novel can be read as an Ethiopicist text. If we applied another hypothetical interpretive frame to our reading of the novel, imagining it to have been written by a Black writer, the character of the novel would become even more difficult to explain—not impossible to imagine, but producing many more semantic puzzles to unravel. In this instance, the Ethiopicist/Aesopian difference might be partly located in the relative absence of what Toni Morrison calls the African presence in Twain's novel, even though the significance of that presence is putatively that novel's most powerful theme. *Pudd'nhead Wilson* is remarkably uninterested in group differences in a way that might be understandable for a majority writer but would be extraordinary for a minority writer, carrying the burden of representation.[15]

This difference falls into clearer focus in a text that approaches similar questions of doubling and racial identity. Charles W. Chesnutt's novel, *The Marrow of Tradition*, was published in 1901, seven years after *Pudd'nhead Wilson*. Chesnutt's novel is easily seen as an Aesopian text. The author was clear that his audience was mainly White and Northern, but he also showed concern to honor the interests of a Black interpretive position, enough to risk the irritation of his primary market. Located at this nervous intersection, Chesnutt advances our analysis by reflecting upon its discursive ironies, and by dramatizing them through fictional and discursive doubles no less engaging than Twain's.

Chesnutt's story reaches its climax in the harsh revelations of a race riot, like *Invisible Man*. But unlike Ellison's novel, the racial microcosm of Chesnutt's small North Carolina city is elaborated through the histories, complications, and destinies of families, framed in domestic melodrama. The "marrow" of the title reverberates the issue of blood production and transmission. The most fateful blood connection of the narrative, is an unspeakable one. Janet Miller and Olivia Carteret are look-a-like half-sisters, though one is Black and the other White. Olivia is the White daughter of Sam and Elizabeth Murkel; Janet is the daughter of Sam and Julia, his Black housekeeper, whom he bedded and secretly married after his first wife died.

One of the major threads of Chesnutt's story involves racial doubling

and masking that both echoes and departs from Twain's example. Doubling as masking, as doppelganger intrigue, is introduced into the story through Tom Delamere, young playboy of an honored family, and Sandy, Tom's old, trusted, and loyal family Black servant. For amusement, Tom perfects imitations of Sandy's gestures and movements, carrying this charade to the point of wearing burnt cork and old clothes. In a desperate need for money, Tom disguises himself as Sandy, robs the treasure chest of his aunt and unintentionally causes her death. Sandy is arrested for murder, suspected of a worse crime against White womanhood, and becomes the object of a lynching hysteria, that with the added incitements of the family newspapers, evolves into widespread mayhem.

On the scaffold of these story lines, Chesnutt illustrates a number of coded, subrosa societal behaviors. The wealth withheld and stolen from a Black family, by means of the repressed documents, helps run the newspaper that promotes racial oppression. The honor of Whites with genteel status relies on the dishonor of Black people for validation. The social imagery of Blacks as dishonored beings is maintained like a ready reserve of social power that needy Whites, in a crisis, can cash in on for their profit.

Tom's masquerade as his family servant in order to commit his crimes is one of those powerful metaphors that prompted Freud to seek insight into human psychology through imaginative literature. Chesnutt's parabolic fiction offers striking amendments to the well-observed parasitism of White supremacy. His narrative proposes that the definers in such a society almost certainly carry a replication of that Other self within their personalities. In Chesnutt's fictional world this would mean that every White man would necessarily carry through his life a fictive Black man within his own psyche as co-habitant of his being. This is not startling, being the reverse of the colonized's internalization of the colonizer recognized by Fanon and Memmi.[16] But of course the colonizer internalizes the colonized as well, though he must take pains to deny it. The psychological mechanism involved carries obvious parallels with gender construction. Societies in which men shape their identities in terms of their unwomanliness produce men in whom the fear of harboring womanly characteristics must always be guarded against. It is the fear itself that provides hosts to the "woman" in such men. Then both the fear and the "woman" inside these men must be denied.[17]

This other internalization gives us a slightly different take on the frames of discursive irony. In Despotic irony, internalization of the subordinated Other must be frantically repressed—a kind of authoritarian

egoism that has its gender counterpart as macho masculinity. The drive toward Ethiopicist performances in majority narrators might more clearly be seen as unsettling interrogations of the authoritarian cultural/racial assumptions of their societies, just as cross-dressing playfully questions its sexual certitudes, and the doppelganger motif questions its ideal of an authorized, unified self. We might be right to regard these three forms of signifying as kindred, though not identical forms of performative masking.

The replicant of the Other carried by the host personality shares only incidental resemblance to real, living people. The replicant is a mythic other self, or selves—fictional beings authored by their host. Their characteristics and values vary with each host. Depending on the psychic needs of their hosts, internalized replicants may be evil or benign, angelic or mischievous, morally puritanical or licentious. Tom Delamere is drawn by Chesnutt as a man whose primary feeling for Sandy is contempt for his servile foolishness. But Chesnutt reinforces Delamere's internalization of Sandy by showing Delamere, on a carnival occasion, wearing Sandy's clothes and doing a cakewalk in Sandy's body-language well enough to fool Sandy's closest acquaintances.

It seems likely that Chesnutt was consciously signifyin' on these contradictions. When Tom Delamere mounts burnt cork in order to imitate Sandy, Chesnutt is of course ironizing minstrelsy. But he may also be slyly ironizing the Ethiopicist storyteller. It is just imaginable that in drawing Tom's misappropriation of Sandy's identity, he may be alluding to another misappropriation, the theft or denial by Tom Sawyer of the freedom of Nigger Jim in *The Adventures of Huckleberry Finn.*

Chesnutt seems perfectly aware of the ironies of discourse which are, after all, crucial to the narrative structure of his tale. Sandy, a bit drunk, sees Tom Delamere disguised as himself, walking ahead of him in the dark: "Ef dat's me in front, den I mus' be my own ha'nt; an' whichever one of us is de ha'nt, de yuther must be dead an' don' know it."[18] Chesnutt portrays Sandy through the lens of minstrelsy, whether to ease harsh portrayals of White society for his White readers, or to satirize Black people of a class and outlook that offended Chesnutt's own social self-image. But more interesting is Chesnutt's minstrelizing of the doppelganger tradition in high, romantic literature as in the anecdote of Goethe walking through the woods and dramatically meeting—himself!—ironizing that tradition by underscoring the racial dimension this motif always unwittingly harbored. Chesnutt's conscious, parodic use of this theme is made clear by a reference to the most famous doppelganger of his day. Evidence

turns up of Sandy's innocence and he is released, but "Sandy, having thus escaped from the Mr. Hyde of the mob, now received the benediction of its Dr. Jekyll."[19] To take the modern myth of Jekyll-Hyde into a racialized context could be Chesnutt's oblique way of saying, "the monstrous identity you project upon us is really another side of you." As he explains at another point, "Suspicion was at once directed toward the negroes, as it always is when unexplained crime is committed in a Southern community."[20]

When Tom Delamere's grandfather understands the crime and identifies Tom as the murderer, the White town fathers suppress this guilt as ideologically too costly. The innocence of "the negro"—for Chesnutt makes clear that any Black scapegoat will do—must be suppressed, just as the earned inheritance of Black people, in the form of posthumous wills, legitimating marriage licenses, or promises of forty acres and a mule, must also be suppressed. For the zero sum logic is that the easier it is to believe a Black person must be responsible for a social evil, the harder it is to believe a White person responsible. The formula then becomes: the system of White supremacy and its beneficiaries have an interest in Black people faring poorly and being made to look bad, if only to confirm a regimen of representation from which the racially privileged members of the society can benefit, each at the expense of his or her fetishized, imaginary racial double. Ellison's famous observation—"Thus on the moral level I propose that we view the whole of American life as a drama acted out upon the body of a Negro giant, who, lying trussed up like Gulliver, forms the stage and the scene upon which and within which the action unfolds"[21]—may be thought of as the accumulated form of these internalized replicants infiltrating the U.S. psyche.

Doppelgangerism in its racialized context has much to do with Aesopianism, as made to order for this split-voiced mode of expression. But doubling also holds a fundamental significance for the formative development of the African American narrative, as of many traditions of the downpressed, as the themes of commitment or betrayal, loyalty or "passing" assert themselves as necessities. The sense of being reinvented as the subhuman other of a powerful social discourse was inescapable for these emergent authors. But racial doppelgangerism shows some significant differences from the early literary model. Racial doubles are projections by their criminal authors outside themselves and upon others, as scapegoats. This is very different from the narrative lessons indicated by Jekyll/Hyde and the rest. The direction of moral inquiry is in fact reversed. Where the racial doppelganger is the product of the ancient wish

to blame the crime or shortcoming on the stranger, the more modern imagination warns that the transgressor may be ourselves. And writers like James Weldon Johnson, Chesnutt, and to a lesser extent, Twain, expand the lessons of the Romantic doppelganger theme for an even more modernist exposure of the old-fashioned mechanism of sacrificing the Other.

The critique of representation finds further grounds for allegorization: the personality of each member of a society has been partly shaped, authored, by its dominant group fictions, its cultural symbolisms. But each social being is also co-author to some degree of the corporate fiction he or she inhabits. The "authorship" of individual members of a society produces its narratives in collaboration with its "symbolic compact."[22] A good deal of social satisfaction arises in the pleasure of co-creating these narratives, which also serve to confirm or adjust the script by which lived experience will be pursued and interpreted—this is where gossip becomes a player in cultural reproduction. Every citizen, therefore, is not only co-author, by training and socialization, of the group master narrative, but also co-author of the images of the significant Others invented as dummy roles of that narrative. Tom Delamere and Charles Stuart (a wife murderer who won much national sympathy in a celebrated Boston case by blaming the crime on a fictitious Black assailant) are narrators of homicidal fictions that they count on their social fellows to co-sign as collaborating authors. This makes all socialized individuals more or less ambitious authors of their society's pursuits of meaning; and writers and storytellers like Chesnutt then become authors in a once-removed mode, writing about social "authors" in this more primary sense.[23] By exploring the racial doppelganger, Chesnutt brought unwelcome exposure to the symbolic compact that held nineteenth-century Southern "tradition" together. His was a story that *untold* the collective narrative co-authored by society and White Southern writers together.

The notion of fiction writers as authors commenting on their characters also viewed as authors, themselves constructing social fictions in collaboration with other "narrators" of society may be verbally cumbersome, but it also pushes up some solutions to issues of interpretation. The idea shares some link to the dialogism of Bakhtin, which extends both to the author of a novel and the multivocal postures taken by characters in that novel. Here, the prospect of authors commenting on character-authors makes possible a *relatively* simple way of speaking about a curious homonym between authors and characters in the ironies of discourse. Just as we speak of writers taking the positions I have called Despotic,

Cyclopean, and the rest, these terms apply equally well to some of the behaviors and attitudes of fictional characters. The source of this "homonym" where we use "author" in two different senses lies in the fact that the ironies of discourse are not only a feature of fiction, they are reflections of the political fabric of lived experience.

Chesnutt created a tragic narration, not tragic in the fate of any individuals but in the hopeless destruction of human possibilities in the U.S. South and the lack of any source of hope for a likely resolution to a national dilemma. His countermelodrama was ruled by this calculation and by the determination to draw an allegory through which sensible people might work to bring about a future where some hopeful resolution could be imagined. So he plays out many of the most pressing issues of the racial dilemma, through fictional hypotheses, insinuations, or authorial asides. But he does so with the awareness that the same circumstances that deny a hopeful solution also limit the possibilities of direct discussion of the problem—that he, as author, must take an Aesopian approach as the only way of gaining an audience at a time when the audience for novels was overwhelmingly White. (Chesnutt comments on the risks of a more militant literary approach in his day through the radical Black-authored editorial that is put aside and then later used to whip up the mob against Black people.)

This authorial situation helps explain Chesnutt's exploitation of some caricatural effects. Chesnutt's tactic throughout is one of concession, withdrawal, then oblique subversion. One conspicuous trade-off in this tricksterish maneuvering is the portrayal of pathetic, Cyclopean Black characters in the traditions of the plantation darky, frequently leaning on the conventions and dialect of the minstrel show. His Aesopianism takes the course of giving a stereotype-dependent White audience some of the coon show it habitually craves. But these lackey-minded servants must further be counted as recodings of the usual Despotic representations, and cunning revisions at that.

Chesnutt nods to the truism that this menial behavior has been conditioned by the constraints and brutalities of slavery and its aftermath, but more tellingly, his stereotyped Toms and race traitors act as ironic doubles to the roles of mastery. Sandy's refusal to accept any help in his plight as a man accused of murder lest such help reflect negatively on the social reputation of his masters makes a mockery of the code of honor celebrated by the Euro-ruling class of the last century: "Fer I wuz raise' by a Delamere, suh, an' deir principles spread ter de niggers 'round 'em, suh; an' ef I has ter die for somethin' I did n' do,—I kin die, suh, like a

gent'eman!" This speech, which may remotely echo the sacrificial gesture of Sidney Carton in *A Tale of Two Cities*, needs to be read as though coming from an Ishmael Reed novel to appreciate the satire involved, and the direction of that satire toward this fatuous, irrelevant code of honor. We cannot miss how wildly misplaced this loyalty is. There seems to be some proportional relation between the toadyism of these servants and the dishonesty of the ruling class they serve. Chesnutt stirs up the old notion that the quality of a man's servants is a reflection of the man himself. We are reminded of Hegel's idea that the bondsman is more fortunate than the master since the bondsman has a positive role model to look up to, where the master has none to find in the bondsman.

In short, Chesnutt presents minstrelized portraits of several Black characters in his story, but they revoice their usual significance in a fictional scheme where their behavior carnivalizes the honor of the nineteenth-century Southern gentleman and the cult of true Southern womanhood as well. These portraits demonstrate the absurdity of the Cyclopean position at the same time that they lampoon the pretenses of its beneficiaries.

But the same maneuver of masked submission to literary tradition, married to subversion, applies to Chesnutt's display of melodramatic effects, considered to be his novel's chief artistic weakness. Straight realism would not have offered him the masks or the materials that he needed to sabotage Southern honor. Melodrama, as a given of the dominant literary regime, better suited him as a vehicle. But this did not prevent Chesnutt from using it in an Aesopian way, serving the Northern White audience the literary conventions it expected, but in a way that coolly parodied that genre.

Just as the doppelganger motif approaches broad farce when Sandy goes into his "effn' dats my ha'nt den who is I" routine, Chesnutt must have realized that the insertion of Black people into domestic melodrama alters the tone and resonance of the genre. It could not have escaped him that the social-psychological frame of nineteenth-century melodrama makes sense only with the values of the Euro-American ruling class squarely installed at the center of its workings, as the cult of true womanhood applied only to upper-middle-class "ladies." All these values come into play in the scenario where Janet and William Miller save the child of Janet's White half-sister, moments after their own child has been killed in the riot, and with grand displays of noblesse oblige. I think Chesnutt understood, as in the nature of discursive irony, that a Black woman of refinement and sensibility acting with noble generosity toward

a former oppressor is a gesture whose point might be rejected by a White audience of 1901. The ruling literary conventions of his time posed Chesnutt between minstrelsy and melodrama, with a transparent indication which one was reserved as his "place." Given these dim conditions of possibility, Chesnutt's writing moved both to employ and to undermine these genres and their assumptions at the same time.

The futility of such efforts to overthrow the order of explanation *in his time* seems echoed by the hollow noblesse oblige gestures of Janet and William Miller. For this hollowness is merely more polished than Sandy's absurd sacrificial posture. And yet, Chesnutt, in his authorial bind, may have identified with Janet's declaration of independence: "I throw back your father's name, your father's wealth, your sisterly recognition. I want none of them,—they are bought too dear!" If this is not to be read as Chesnutt's declaration—since he soon gave up novel writing as pointless in that era—it is at least one position from which the genre of melodrama and its ideological assumptions might be scrutinized.

HANGIN' WITH THE HOMEBOYS

There stand, then, several interesting grounds on which to compare Twain's Ethiopicism in *Pudd'nhead Wilson* and Chesnutt's Aesopianisms in *The Marrow of Tradition*, and we can touch on a few of them here. One is Twain's tight-lipped approach to the prickly issue of race compared to the more venturesome efforts of Chesnutt. Shelley Fisher Fishkin recalls a revealing passage that Twain cut from the manuscript of *Pudd'nhead Wilson*, which she cites as evidence that Twain was not advancing the theory that " 'the one drop of black blood in [Tom's] veins' was responsible for his failure as human being."[24] Tom, remember, is the feckless son of Roxy, the slave woman who switched him in cradle with the family heir.

> In his [Tom's] broodings in the solitudes, he searched himself for the reason of certain things, & in toil & pain he worked out the answers:
> Why was he a coward? It was the nigger in him. The nigger blood? Yes, the nigger blood degraded from original courage to cowardice by decades & generations of insult & outrage inflicted in circumstances which forbade reprisals, & made mute & meek endurance acceptance the only refuge & defense.
> Whence came that in him which was high, & whence that which was base? That which was high came from either blood, & was the monopoly of neither color; but that which was base was the white blood in him debased by the brutalizing effects of a long-descended long-drawn heredity of slave-owning, with the habit of abuse which the possession of

irresponsible power always creates & perpetuates, by a law of human nature. So he argued.[25]

This passage certainly established, as Fishkin argues in her fascinating book, the likelihood that Twain held or at least entertained radically egalitarian ideas, based on reasoning from nurture rather than nature (but this passage also carries an unscientific notion of genetically inheriting cultural attitudes). More striking is the fact that Twain *repressed* this argument from his novel, not only in this form, where, coming through the indirect address of Tom's self-scrutiny, it might be viewed as unconvincing character portrayal, but anywhere else in his text, leaving the final version open to the interpretation that one drop of Black blood might indeed make a scoundrel. This compares sharply with the several passages where Chesnutt puts strong, incisive views on the line. Coming at issues similar to those in Twain's repressed passage, but with a twist from the politics of representation, Chesnutt presents Dr. Miller's reflections:

> The qualities which in a white man would win the applause of the world would in a negro be taken as the mark of savagery. So thoroughly diseased was public opinion in matters of race that the negro who died for the common rights of humanity might look for no meed of admiration or glory. At such a time, in the white man's eyes, a negro's courage would be mere desperation; his love of liberty a mere animal dislike of restraint. Every finer human instinct would be interpreted in terms of savagery. Or, if forced to admire, they would none the less repress. They would applaud his courage while they stretched his neck, or carried off the fragments of his mangled body as souvenirs, in much the same way that savages preserve the scalps or eat the hearts of their enemies.[26]

Twain's silence beside Chesnutt's bluntness suggests differences in their positions within the ironies of discourse. Twain obviously did not want to risk challenging what the discursive freight would bear at that time, beyond the effort he made public in his novel. In *Pudd'nhead Wilson* Twain mobilizes the changeling motif but does not exploit its rich doubling possibilities, especially where their racial applications are conspicuous, nearly as much as he exploits ironic doublings to make class and social commentary in *The Prince and the Pauper*. Racial doubling sits like a loaded cannon that never gets fired. Chesnutt, by contrast, spoke in certain passages from a radical, outlawed discourse that fundamentally challenged the legitimacy of the social order. Both writers, further, blunted their sharper points through genre devices. Inexplicably, Twain introduces a pair of Italian twins who fall into his narrative like fugitives

from another literary planet. More, the moral issues resonant in his story are muted at the climactic point by a crime/detective scenario dealing with the introduction of fingerprints as criminal evidence. This move parallels the irrelevant folderol of Tom Sawyer's pranks played with Jim's freedom toward the end of *Huckleberry Finn*. At certain moments, when the weight of moral examination gets heavy, Twain retreats into boyish, fiction-making toys, much like the special effects of flippant Hollywood spectaculars. In his turn, Chesnutt carried momentous questions through his hide-and-seek games with genre expectations almost to their maximum signifying power.

At any rate, Chesnutt paid dearly for the radical side of his Aesopian mask. William Dean Howells, his literary sponsor, himself judged that Chesnutt "stands up for his own people with a courage that has more justice than mercy in it. The book is in fact, bitter, bitter. There is no reason in history why it should not be so, if wrong is to be repaid with hate, and yet it would be better if it were not so bitter."[27] And Paul Elmer More, a literary architect of humanism in his day said, "Chesnutt had done what he could to humiliate the whites" adding that he saw the final chapter "utterly revolting."[28] After this reception and the poor sales of his novel, Chesnutt, unlike his Ethiopicist counterpart, felt forced to withdraw from literature.

None of these demonstrations make irrefutable distinctions between Aesopian and Ethiopicist texts. Rightfully so, as long as "blindfold tests" are able to find readers who can confuse texts coming from Palace or subaltern quarters. But some issues may be worth further thought. I would urge that while Ethiopicism and Aesopianism are the grounds on which the least settled identities can be located, where most mobile interchange takes place, there is nevertheless something enduring in the discursive *position* from which texts acquire their identities as either one or the other. That, unremarkably, the situation of speaking from outside the grounds of authorized social communication imposes constraints different from those pressed on authorized artists who wish to cross the tracks; that Aesopianism is a bit like "passing" upward at least in terms of genred expectations, and Ethiopicism is more like passing "downward" through an adjacent terrain, and one marked as traditionally, significantly *Other*.

The affinity between Twain and Chesnutt's representational strategies bring us back to the knotty question of mimicry. The temptation for the pariah class to "pass" is different from the harboring of doppelganger replicants of the racial Other. Interestingly, for the issue of the African presence in American literature, Mark Twain's biography offers some fas-

cinating moments of internalizing the Other. Twain was exceptionally fond of African American spirituals, but not only of listening to them. On special occasions he would sing them. On one occasion at a formal dinner party at his home in Hartford, Twain broke into song. "He swayed gently as he stood; his voice was low and soft, a whisper of wind in the trees; his eyes were closed and he smiled strangely."[29] Apparently the songs took Twain into a trance from which he did not easily escape. This moment is recalled in a book *Was Huck Black?* that argues impressively that many of his sources for Huck's characterization and language and therefore the perspective of Twain's path-breaking novel came from his admiration and study of the speech and attitudes of Black individuals he encountered. But further, on at least one occasion, Twain stunned his guests by making a credible imitation of Black dance.

> And, in a crowning act of confident alienation from his guests he twisted his body into the likeness of a crippled uncle or a Negro at a hoe-down and danced strange dances for them. . . . [W]ith most sober and smileless face, he twisted his angular body into all the strange contortions known to the dancing darkies of the South.[30]

Being a man of great mimetic skill and imaginative daring, Twain was able to playfully bring the replicant Other in his psyche into public view. We might conclude that Twain was, in the phrase of Toni Morrison, "playing in the dark." And it is necessary to repeat that this replicant need not always be of monstrous character; for Twain, the singer of Black spirituals, this replicant in him was in touch with spiritual tones and values of a special and honorable sort.[31] Might this not be one more place where the discrepant power among people of different social status makes a mockery of actions nobly intended? I raise this question in connection with Twain's "break dancing"—so described by Fishkin—only because it might have struck Chesnutt that way. Let us imagine that Chesnutt heard of this remarkable behavior by the nation's most famous author of that time. Chesnutt could have heard of it from Howells, his literary sponsor, who was there that night, or from other sources. At any rate, there is a striking resemblance between Twain's trance-like exhibition of another being inside himself and Tom's masquerade of Sandy in *The Marrow of Tradition*. Twain's dance, described as that of a "crippled uncle," parallels the dance of Tom impersonating the aged Sandy. The notion of twisted body and strangeness is carried over into the description of Tom's mimicry of Sandy, spoken of as "grotesque contortions" and also as a "buck dance."

We should remember that the historic progression in this field of so-cial-symbolic mimicry was that Whites put on blackface to imitate ar-resting, exotic Black behavior, and when Black entertainers came along, they were forced to put burnt cork on already Black faces before they were allowed to perform on public stages. The Ethiopicist appropriation of a repressed social group might set the style of portrayal for that group, since it is very likely that its class will get first crack at such portrayals, with wider reception than self-portrayers can command.[32] Then when members of the repressed group get a chance to portray themselves, they are likely to recreate the acceptable personas that "tradition" has left them, with a mixture of self-celebration and resentment.

This is what may have happened in the transaction between Twain's and Chesnutt's novels. I repeat that Tom Delamere masking as Sandy in order to commit a crime might form an intertextual commentary on Tom Sawyer's playful games with Jim's freedom in *The Adventures of Huckleberry Finn*. It may also be relevant to the more direct comparison I am making between *Pudd'nhead Wilson* and *The Marrow of Tradition* that Twain's Black character who is passing for White for ignoble ends and Chesnutt's White character who feigns a Black identity for his low schemes are both named *Tom*. The crippled-uncle dance of Twain's recalls the original dance from which minstrelsy was appropriated, that of a crippled Black man named Jim Crow.[33]

A final word about Chesnutt's predicament as a writer for whom Ae-sopianism was a forced condition: Chesnutt was very conscious of the "who do you write for?" question. He spoke wistfully of "the kind of stuff I could write if I were not all the time oppressed by the fear that this line or this sentiment would offend somebody's prejudice, jar on some-body's American-trained sense of propriety. . . . " Like other Aesopian cul-tural producers there was one hedge to the bind of writing for a restric-tive audience, and for writing about a social situation in which he could see no immediate hope for improvement. Chesnutt saw the possibility of writing for a future in which he might be better understood and his thoughts more easily connected to fertile discussions. The Aesopian writer in Chesnutt's position had available another doubled mode of ex-pression: to speak to the present at the same time that she speaks to the future.

CHAPTER IX

■

Radical Ethiopicism

For when it comes to conscience, we know that in this world each of us, black and white alike, must become the keeper of his own.
—Ralph Ellison, *Shadow and Act*[1]

The interpretive frames we have examined—Despotic, Aesopian, and the rest—have little interest in themselves. They are, like the abstraction "power," meaningless until awakened by particular desires, concrete situations, or narrative issues. Nevertheless, single narratives may reveal more of their meanings when interpreted through these ironies of discourse. Different narratives stand a chance of co-illumination as they interact within these frames. Of the various levels of perception, one of the most important is the one allowing us to contemplate the "rules of the game"—the politics of interpretation. But this analysis cannot go forward without the question coming up, is *radical*, unexploitive Ethiopicism possible?

Ethiopicist portrayal is statistically significant, since with the imbalance of power/knowledge the world's majority populations are mostly known through the lens of a centralized minority. In recent decades, 80 percent of the films distributed and screened in the world were made in the United States. Such a number ought to give some bite to the notion of hegemony. That figure also helps us see how one local master narrative can become the lingua franca for movies generally. Most of the images seen on the world screen portray either a minority reflecting itself or reflecting others from its viewpoint.

We would have to imagine a radical Ethiopicism, even if one never existed. It would be politically necessary. To deny the possibility of a radical Ethiopicism would be to curtail some of the possibilities of language, and

of human imagination. It would dim the hope of peaceful co-existence under different flags and different ways of being human. If radical Ethiopicism turned out to be an illusion, a utopian fantasy or a series of empty rhetorical gestures, the prospect of an unprofitable separatism, of unyielding, fanatical fundamentalism would loom more heavily. The hope would fade that the critique of representation, responsibly pursued, might yield a guide through the traps and seductions of cultural production than the one aesthetic reasoning has given us. There is no point in developing a politics of representation if its findings have no chance of leading to a just peace between different meaning-making groups. If radical Ethiopicism is impossible, the chances for cultural democracy are sharply limited.

This issue is complicated because satisfying Ethiopicisms are few and hard to come by. The restorative or reformist initiatives advanced by members of the power majority through history have often turned out to have been self-serving, biased, and distortive. Hypocritical liberalisms and radicalisms are easily found. Racist abolitionists, imperialist socialists, sexist male feminists—all have become familiar figures in the social-historical landscape.

Ethiopicism finds one of its greatest handicaps in its origin as alternative to Despotic irony, therefore too easily casting itself as reforming liberator, judging itself, perhaps accurately but reductively as better than the baseline of Despotism to which it compares itself. Where Despotic perception grants no human value to the outsiders, the Ethiopicist makes an effort and finds some grounds for human consideration, and begins to congratulate itself. A transition of this sort took place in Hollywood's representation of African Americans, shifting from the rigidly Despotic regime of darky stereotypes in the 1930s to the "Negro interest" wave of films provoked by the liberalizing influences of World War II.

The first emotion is pity. Where the Despotic narrator demonstrates no sympathetic identification, the Ethiopicist storyteller shows that he has feelings for the pariah class. The Ethiopicist approaches the Other through that most humane of measures: how would I feel if I were her? Of course the imagery that usually comes out of such an approach is the projection of one's own feelings onto the Other in the context of the pitiable. *Home of the Brave* (1949), one of the "Negro interest" films, found its object of pity in a Black soldier who reacts oversensitively to a racial slur and throws himself into a serious case of derangement. The film was adapted from a play by Arthur Laurents in which the leading character was originally a Jewish soldier.

Here is an instance where adaption provides grounds for a "commutation test" through which we can sharpen our interpretive focus. The story feels more at home if we imagine the central figure as a Jew than as a Black. This is one more instance where the immigrant experience of many Hollywood decision makers is advanced as normative source of values and, with more generosity than insight, applied to another population that, by that immigrant generation's light, ought to be grateful for the relative securities of a U.S. residency, and ought, in the improving social horizon of 1949, focus less on slights, real or imagined, and more on harmony with one's neighbors.

The problem with pity—if it has not been fully exposed by *Imitation of Life*—is its complementary dehumanization. In an era of feminist revival, we get several opportunities to see this form of Ethiopicist subrepresentation. It often takes the form of representations of women as victims in narratives that despite their intentions manage to further disempower women characters and deprive them of agency, full subjectivity, and therefore of humanity. This has been a characteristic of some of the portraits of women in Spike Lee's movies. Nola Darling, despite given considerable agency early on in *She's Gotta Have It*, specifically in her insistence on openly juggling sexual liasons with three men, is in a climactic moment portrayed as an almost willing abettor to her own brutal sexual exploitation, approaching rape. Another climactic moment in *School Daze* shows Jane, a fraternity groupie, being passed on as a sexual trophy from one frat man to another. The point about the victimization of college women is made through a representational victimization. Such projections of pity often reproduce the debasements of the maiden's tale or the slave narrative, only slightly disturbed by the sympathetic intentions of the narrator. We find it difficult, as Frederick Douglass observed, to feel respect for the person we pity.

By now some of the persistent features of the Ethiopicist mode are familiar: ambivalent relation to the master narrative; the self-reflexive portraiture of the Other; the instrumentalization of sympathy; the reluctant acknowledgment of subjectivity in the outsider; the proffering of "solutions" via the dominant success formula; the attraction to exotic character types; the recognition of worth among the downpressed through the gaze of a majority figure. To these we can add the persistent denial of family and community background for the minority character. Of the many major roles played by Sidney Poitier, a major icon in Ethiopicist movies, *A Raisin in the Sun*, written by insider playwright Lorraine Hansberry, comes to mind as a rare instance where he has a family that matters.

We are left with the alternative of evaluating Ethiopicist portrayals by the presence or absence of these techniques of unequal representation. Another possibility is to examine likely candidates for successful or radical Ethiopicist representation and consider their achievements and limitations. This I propose to do with four Hollywood films dealing with African Americans: *Nothing but a Man, Ragtime, The Cotton Club,* and *Brother from Another Planet.*

The first question is, what do we mean by "radical"? I can think of three possible ways such films might be considered radical. One would be the suggestion of radical political or social resolutions to the problem of race in the United States. Another form of radicalism would be a serious revision or reversal of the paradigm of disempowerment kept alive in the media. A third is a strong revaluation of African American culture or history.

Revisions of history offer fertile grounds for searching for radical identification with the Black experience by non-Black film directors. A number of films including *Glory* and *A Soldier's Story* open new perspectives onto people of African descent in U.S. history, here military history, highlighting the participation of Black soldiers in U.S. wars. But most such films fall far short of radicalism in their direction of focal attention on a centralizing White character (*Glory*), or their tacit reintroduction of the master narrative (*A Soldier's Story*), or other motions of residual dominance. *A Soldier's Story* and *Glory* make two of a series of films where a reappreciation of Blacks in U.S. history have been attempted since the 1960s, some of them dogmatic history lessons, some of them stilted biopics, very few of them free of genre formulas, and many of them striking a daring posture on the race relations of the past, at a safe remove from the more controversial present.

Nothing but a Man (1964) by Michael Roemer made a radical departure from conventional Hollywood treatments of African Americans on several grounds. It gives no support for the master narrative. Set in the U.S. South at the dawn of the civil rights period, it follows Duff, a railroad gang worker who stops in a town and meets the Minister's daughter, falls in love, and decides to challenge the obstacles of an apartheid society in order to marry her and settle down. The White townsmen live up to expectations as hardened rednecks, and there is no hint of easy, heroic solutions. At the same time, the film settles for closure with Duff trying to make amends for past mistakes of his own, which is far different from the options available for Black characters per the slave narrative, where they must either prove loyal to the system and be rewarded or defy it and be made an example.

While there are allusions to the historical changes simmering through the Black South in 1964, the film's restrained notation of these political currents is too modest to be thought of as radical. There are subtle cultural signifiers that merit respect as innovative for the period. Some of the background music from Martha and the Vandellas and the Motown sound color the story with soulful intonations; a church scene is convincingly enacted with almost documentary accuracy, in contrast to the hamming up such scenes usually get in Hollywood. Most of the film is successfully set in realistic, almost neo-realist mode, and this may present its greatest claim to have overcome the reflex distortions of Ethiopicist representations. The film must therefore be credited with quietly overturning the cinematic traditions of Black representation in Hollywood at the time, and in a way balanced and poised enough to avoid the companion error of going overboard (the way, say, Black exploitation movies of the 1970s do).

Nothing but a Man has won many admirers among educated Black viewers for its sensitivity to issues of Black social experience, its exploration of some of the dilemmas of masculinity among Blacks as well as the appreciative role of Duff's mate (played by Abbey Lincoln), in understanding those dilemmas, which seems to go to the heart of the internal problems of that community, and for that reason, I think, the film has been admired particularly by many Black women. Yet the same design that gives the film sensitive insights into Black social dilemmas might be read by some viewers as verging on sociological clichés. But very finely attuned performances and adroit cinematography and music blunt the suggestion of textbook analysis. More than that, *Nothing but a Man* achieves that rarest of commodities in the movie projection of Black people: intimacy.

Ragtime (1981), directed by Polish filmmaker Milos Forman, is a very different kind of film than *Nothing but a Man*, extravagantly allegorical where the earlier film was seated within the unexceptional. Studded with vignettes of historical characters around the early years of this century, it centers on Coalhouse Walker, a ragtime piano player who becomes enraged by the willful mutilation of his new automobile. With amazing purpose, dignity, and planning, Walker and his friends carry out a miniature guerrilla campaign against the firemen who destroyed his car, then take siege in the Pierpont Morgan library for a shoot-out showdown. A settlement is arranged with the chief of police, then violated as Walker is shot and killed as he emerges to surrender.

Coalhouse Walker's defiant stand against the New York Police Department has been dismissed as a historical improbability (there are little-

known historical precedents for some of his actions, though not all of them in combination). Donald Bogle found objectionable the insinuation of contemporary attitudes upon a picture of the past. Ishmael Reed vehemently protested the film's portrait of African American men, arguing that Walker is made to appear irresponsible, jeopardizing his family's life and welfare for an ego trip about an automobile.

These are narrowly cast critiques. *Ragtime* is an extremely ambitious, far-reaching movie whose multiple layers cannot be read any way except as a national allegory of the most sweeping kind. Its several plot lines include the celebrated murder of celebrity architect Stanford White, the escapades of Houdini, the repressions of Victorian Puritanism, giving way under the relaxations of new attitudes rising through popular entertainment, vividly suggested by the birth of the motion picture industry and most vividly imparted by the Black cultural input of ragtime. Somewhere in its entrails, as in the novel by E. L. Doctorow, there may lie a profound, or shallow emblem of "America" at a crucial, revealing moment of national development. The movie takes the shape of an anti-epic, following the trajectory of a nation's maldevelopment. In which case, Coalhouse Walker as its heroic anti-hero (in the sense that he stands against everything the "nation" actually is) may be seen as a prototypical Ethiopicist icon, since his usefulness to the epic theme is as the most singular affront that might be directed to the Despotic energies in U.S. society. Coalhouse defies the master narrative and he pays with his life; this much is true to the Rebellious Slave narrative. But the closure of his destiny is not remorseful in the manner of Brutus Jones in *The Emperor Jones*; rather Walker gains agency by choosing his destiny while looking toward an emancipated future, like Josh, the doomed rebel in *The Marrow of Tradition*. Apart from the minor flaws of *Ragtime*'s portrayal of Blacks, its exploitation of Black life as harbinger of alternative vision in U.S. society is far from subversive of Black culture, particularly Black popular culture, imaged as oasis of sanity and generosity. What remains is an exploitation, though a warm, friendly one.[2] On the grounds of political progressivism, or resistance to racism and domination, one would have to regard *Ragtime* as more upstanding than many Aesopian projections, and more sensible and progressive than most Black exploitation movies.

Ragtime uses the past to comment on the present, but more, it uses the present to revise our understanding of the past. How successfully it does this is a question seldom asked. By contrast, *Brother from Another Planet* (1984), directed by John Sayles, uses the future to comment on the present. Immediately our search for radical Ethiopicism should recognize

the different radicalisms that may intersect with Black representation. Radicalism in *Ragtime* evokes at least a different period feel, of the Haymarket riots and bomb-throwing anarchists, of Sacco and Vanzetti. The radicalism of *Brother* is decidedly post-1960s, of transgressive music, widespread anti-establishment cynicism, dreadlocks, and countercultural life-styles. Which only goes to demonstrate once again that different Ethiopicist radicalisms will ask different benefits from the genie of iconic Blackness.

The interplanetary "Brother" of Sayles's film is in flight from slave-catchers hot in pursuit. Among his striking characteristics are his muteness and his ability to heal his wounds instantly and to solve electronic and mechanical problems by touch. He has an exceptional ability to experience other people's pain, even by touching objects once close to them. While in flight from the interstellar slave-patrollers, the Brother acts as a fast-learning innocent abroad, provoking ironic reflections on contemporary civilization in New York city. He also exercises a healing influence on the community people around him (his refuge is Harlem). Recognizing the human wreckage of the drug trade, he traces the flow to a major organizer and kills him. When the space cops finally catch up to him, a number of other Black interstellar fugitives mysteriously come to his rescue.

Brother is heavily committed to both cultural and political radicalism. Harlem (where Sayles lived during the 1970s) is a refuge from the ravages of rampant Whiteness, poorer but distinctly more civilized and humane. The flow of daily life, the gestations of oral tradition, the multiple trickster schemes involved in urban survival in New York City are all celebrated both for themselves and as instruments of resistance from an oppression that appears to be more cultural and psychic than simply economic. What *Brother* shares with the other films in this search for radical brotherhood is that the defining principle of the United States, its character, divisions, and disunity, is found less in economic/class struggle than through the ruptures of racial division.

The impact of *Brother from Another Planet* is something like a clever, irreverent tee shirt logo; it does not shrink from politically correct positions. There are, nevertheless, points at which residual signifiers bleed through its fabric to remind us of old, sedimented mythologies. Some careful African American observers noted that even in the film's vision of the future and of outer space, Black people seemed to be inscribed as equatable only with slavery, as though extending into the sci-fi future the old, Southern slavocracy concept of a "peculiar endowment" in Black

people for that condition. Moreover, the Brother is somewhat animalized by having only three toes. Further, his speechlessness, while making possible many interesting alternative communications, recalls the dumbness imposed as a condition of slavery and exoticized inferiority. Black people are projected as morally less flawed than Whites, but through a rather social Darwinian notion that they are less rationalistic, more intuitive, more right-brained, etc. The narrative perhaps accidentally stumbles into a discourse of "model minority" immigrants by allowing comparisons between the Brother's skills and those of other Harlemites.[3]

Francis Ford Coppola's *The Cotton Club*, as an Ethiopicist portrayal of Black people in a Hollywood musical might be considered revolutionary, or at least progressive, depending on the baseline of measurement. A text that employs doubling on as large a scale as *Imitation of Life*, it views Black Americans from an entirely different sentiment. Where the earlier film used doubling in order to say, "Aren't we lucky we're not Black and shouldn't we be more grateful for our non-Black blessings," the later film seems to say, "Wouldn't it be great if we were lucky enough to be Black," while reflecting on the same historical period, the late 1920s and early 1930s. Like some other films of its period, it takes on a revision of Blacks in U.S. history from the changed perspectives introduced by the 1960s. So once again we get glimpses of Black people going into action for the good cause, fighting back physically. This correction of the myth of Black passivity bears kinship with the revision of women characters who now go into action to save themselves from perils instead of waiting to be rescued.

The historical Cotton Club in Harlem in the 1920s and 1930s may have been the ground zero of one of the most explosive germinations of popular cultural talent in the twentieth century, comparable perhaps to the Moulin Rouge, or to British music halls generally. The talent was Black and the clientele was White, jaunting uptown for a taste of the Other. The movie that Francis Ford Coppola directed about this historical moment disappointed Black intellectuals because it thrust Richard Gere as a White trumpet player into the center of the narrative along with several White gangsters who, historically, were the owners of the club. Once again, granting this criticism, are there features of the film that might redeem its radical potential?

We must ask ourselves whether the sacrifice of Black centrality is compensated by the national allegory woven by the film, in which African Americans are key players. Since the film was so quickly dismissed (White press and audiences were disappointed because there was not

enough of Richard Gere, and because what there was of him was not glamorous enough), its vigorously doubled structure was barely noticed. The story line follows two showbiz families, one White, one Black, each with two brothers pulled toward the magnet of big-time New York entertainment. One of the brothers from each pair is given a love interest, making two couples, Dixie and Vera as the White pair and Sandman and Lila as the Black couple.

The evenly paired characters cross paths through an interwoven narrative in which almost every scene has its symmetrical double. As a White jazz musician, and therefore a kind of Ethiopicist, Dixie tries his best to play with the Black musicians. Meanwhile, Lila seeks to cross over into the White world as a fair-skinned singer. Dixie and his girl, Vera, dance a tango where, frustrated about their relationship, he smacks her up, then down, in step to the music, so to speak. This is in contrast to a scene where Sandman takes his frustrated desire for Lila onto a tap-dancing floor, with her and a community of tappers of all ages for a joyous, cathartic group tap-out. Dixie's brother becomes a rogue gangster whom Dixie abandons before he is shot and killed. Sandman and his brother fight, split, then come together in a duo dance routine which they end with a kiss, on the lips.

The affair of the Black couple is troubled by racism but is not nearly so clouded as is the Dixie-Vera affair by Dutch Schultz's "savage" gangster violence. Dutch feigns reconciliation with a mob competitor at a party then butchers him most gruesomely in front of his guests. One alternate scene to this display of sadistic violence is set up when Sandman becomes enraged by the racist harassment of a bouncer at the Cotton Club, to the point of seeking hired revenge from Bumpy. The Harlem gangster tells him to get even with his feet, by transcendentally perfecting his art. This metaphor is extended when Sandman, in the middle of a dance routine, kicks a gun out of Dutch's hand, aimed at Dixie. There follows a scene of striking mythic ambition. A sharply structured sequence where Dutch is finally gunned down in a men's room is intercut with Sandman tapping upon a pyramid of wooden steps at an increasingly furious pace, sparks flying from his metallic taps which generate the staccato rap of a machine gun. The metaphor is novel: Sandman is dancing Dutch Schultz to death.

Through this tautly choreographed, Black/White art deco duet, the narrative puts into play the arresting opposition: White gangsterism as symbolic of mainstream U.S. American rapacity and greed opposed to African American art as a vehicle for finding creative resolutions through

healing and love. The few signifiers of this doppelganger discourse leave it to the spectator to recover historical echoes: slavery versus the Spirituals; the Robber Barons versus the Blues; prohibition, urban corruption, and gangsterism versus the Harlem renaissance with its innovative city blues and jazz, its reconstructions of the musical revue and musical comedy and, not least, tap dancing.

For all its liberalism, *The Cotton Club* understandably accepts the proposition that to tell the story of a society or community it is effective to give centrality to its most powerful or influential figures. This accounts for the large place given to White personalities in a story whose heart has always been the historical gathering of Black American talent. Such recentering is both commercial and ideological. It reflects a majoritarian position, placing lower priority on the need to redistribute power/knowledge. It is not a position that a minority narrator, interested in rewriting cultural knowledge, is likely to adopt. Emergent narrators have little problem producing national and global allegorical narratives in which the silenced population is effectively center-stage while powerful exploiters are marginalized—to name a few: *Beloved, Ceddo, Things Fall Apart, Cane, Daughters of the Dust*.

By now we must recognize the double pressure on the majority narrator projecting images of a minority. Along with the demands of feminism, this storyteller must face the interpretive critiques of awakened minorities (who can put a hurt on the box office), as well as balance the appetites and expectations of a majority audience well trained to resist change. We should also give recognition to the historical pressure on majority narrators to address Blackness as allegory within the present crisis of knowledge. Their right to do so is unquestionable.

Moreover, these radical Ethiopicist film directors, however successful in capturing another culture, could be seen as redressing the moral evasion that Ralph Ellison found to characterize American literature of Hemingway and Steinbeck and most others since Twain: that perhaps the 1960s had persuaded them to adopt what Ellison described as "this conception of the Negro as a symbol of Man. . . . "[4] Nevertheless, in allegory lies distortion. Lived African American experience is nothing like the giant Negro of Ellison's vision, or quite like the mythic figures of *Ragtime, The Cotton Club*, and *Brother from Another Planet* (but there is less of this distortion in *Nothing but a Man*, as its title asserts).

The need remains for a continued negotiation between radical Ethiopicist and other expressive positions. We need to recognize an abstract symmetry between minstrelsy and passing, between Dixie's desire as a

musician for the rewards of Blackness and Lila's hunger as a singer for the rewards of Whiteness. But while their transgressive quests occupy the same historical space, there is no reason to pretend that that is a unified, or even peaceful space. Their common frustration suggests possibilities of exchange at the crossroads, where ideas of coalition, reconciliation, and mutuality are laid out as a fantasy preparation for the real thing. Radical Ethiopicism must be seen as an endemic condition of the crisis of knowledge which has brought it into existence. It must occupy a space of co-existence with other signifiers, a space where remote connections go unacknowledged, where positions remain divided by different histories, interests, economies of scale, ambitions, different connections with the art-culture system, and different hierarchies of value.

Still other perspectives on radical Ethiopicism are generated in the documentary film *In Darkest Hollywood: Cinema and Apartheid* by Peter Davis and Daniel Riesenfeld. Its authors examine the reflections of apartheid and anti-apartheid struggles in films made in Hollywood and in South Africa. Right off, it is necessary to say that this film seems eminently successful in accomplishing a radical Ethiopicism. Before a screening of the film, which I had not seen, I asked a critical-minded group of American teachers of all levels to consider: 1) which spectator position or audience the film was coded for; 2) whether the narration was a heavy-handed "voice of God" or a less manipulative one; 3) and if the "point of voice," that is the tonal quality of the narration, whether White or Black, male or female, trained broadcast or natural-sounding amateur voice, imparted a particular quality to the film. The Black teachers in the group unanimously agreed that the film was securely and precisely intended for *them* as auditors, while not excluding its address to other spectators. It turned out also that there is no off-camera narration in the film, the verbal commentary being carried entirely by interviewees. The first and most prominent of these is Lewis Nkosi, celebrated Black South African novelist, followed by others who reflect a Black South African majority, and the population whose voices had been most severely repressed by apartheid.

While avoiding the hazards of Ethiopicism, this film at the same time provides multiple glimpses of its problematics. The presence of Despotic irony aimed at the Black majority by the European minority—a necessary condition for the appearance of Ethiopicism—holds some eerie parallels to the history of racial representation in the United States. The Dutch Afrikaners dutifully had their own versions of *The Birth of a Nation*. A fundamental genre of early South African cinema was the Boer trekkers

against the natives, which, one commentator points out, appeared even before the Cowboys-and-Indians genre in U.S. movies. "The mythologies of natives and White conquerors are virtually interchangeable," notes Lewis Nkosi. The duplication of the master narrative trope of wagons circled in defense against a savage horde ensures us that categories such as Despotic discourse, while not essential, are nevertheless not capricious.

The title of *In Darkest Hollywood* suggests that cinema in South Africa reverberates Hollywood's history of racial imagery, combined with the Western myth of Africa as the "Dark continent." Beyond this doppelganger connection between Hollywood and South African cinema, this film provokes awareness that the doppelganger link between minority and majority discourse is dialogical, and therefore saturated with ambiguities that demand negotiated readings in order to approach resolution. From the testimony of Nkosi and his Black contemporaries, the gangster image of classical Hollywood films encouraged a posture of urban alienation that helped modernize Black self-consciousness. This of course was not a result of Ethiopicist presentation as much as an instance of self-liberating reading of mainstream iconography by a population not included in the original audience concept.[5]

More strictly Ethiopicist was the South African production of *Jim Comes to Jo'burg* in the late 1940s in another of the many developments that suggest parallel connection between the portrayal of Blacks in South Africa and the United States. This film went further than any before toward treating South Africa's majority Black population with genteel affection, and was widely viewed and admired by the Black moviegoers who got a chance to see it. Rather familiarly, the idealistic White producers of this film did not count on the hostile reaction of more commercial movie interests that wanted to block its distribution. In response, these interests created their own all-Black cast film, *Zonk!*, which returned Black imagery safely back into the paths of minstrelsy.

The generous impulse behind *Jim Comes to Jo'burg* was part of an international postwar liberalization of movie imagery that included Hollywood's "Negro interest" films of 1949 and 1950, like *Pinky, Home of the Brave*, and *Intruders of the Dust* and social problem films like *Gentlemen's Agreement*, as well as Italian neo-realism. One of the most acute discussions of the "Negro interest" movies was Ralph Ellison's essay "Shadow and Act." His conclusion that "when it comes to conscience, we know that in this world each of us, black and white alike, must become the keeper of his own"[6] applies equally well to the Ethiopicists who made *Jim*, as represented in *In Darkest Hollywood* by Erica Rutherford. Lewis

Nkosi reflects on Rutherford and her companions many years later: "Despite Erica Rutherford's sincerity, it will surprise many readers that nowhere does she question the fact that her film unit never attempted to involve blacks except in roles in front of the camera. There was never any question, for instance, of blacks scripting anything, even when the stories to be filmed involved black lives."[7]

Rutherford recalls a story that illustrates a prototypical discursive irony. Attracted by the colorful singing and rhythmic movements of some Black South Africans when loading a very heavy crate, her crew decided to include a like shot in their film using an empty crate. As an afterthought in the editing room, they asked an African in the projection room what the song means and were told it is all about "what bastards the white men are for making them work so hard for so little money." For Nkosi, "The moral of the story of the empty crate is that it was never enough to say, as Rutherford tells it in her autobiography, that 'we decided we could make better films *for* black Africans than those presently on the market, which depicted a lot of violence.' What Rutherford and her company ought to have done was to make Africans creative collaborators on both sides of the camera in the telling of their own stories."[8] This seems to be one of the most reliable lessons to be reaped from any study of Ethiopicism, in cinema at least.

Nkosi's extended reflections on this issue are relevant to the dilemmas of the Ethiopicist space:

> Not only in scriptwriting but in a whole lot of areas where blacks have been excluded until the recent past—as camera operators, laboratory technicians, executive managers—their inclusion in the process of filmmaking must be evident. That is one way of ensuring that part of the truth can be told in the new postapartheid struggle for justice. These days we are told often enough that it does not matter ultimately who tells the story, that "authenticity" is an uncertain commodity, that validation of our experience cannot be guaranteed by the politics of self-presentation. But most black South Africans remain skeptical, because it is those who hitherto have wielded power and influence who are now most eloquent in propounding such theories.[9]

A familiar pattern arises in *In Darkest Hollywood* of idealistic, liberative gestures that turn out, in hindsight, years later not to have been so liberating. Yet, these efforts made *some* kind of contribution, usually less revolutionary, or sometimes differently revolutionary, than the filmmakers supposed. Of course, this can be said for all films and mass-produced narratives. But it is particularly true of Ethiopicist works that they are

caught in a gray area between an oppressive present and an idealistic future, not only when they first appear, but also within drastic reassessments of later historical perspectives. We can pass quickly over the dilemma of such Ethiopicist narrators being damned if they do and damned if they don't, a side effect of massive global injustice. More important is the tension between partial, relative reforms and the colder, absolute assessment in terms of cultural democracy. On the one hand, it is the curse of the underprivileged that their well-being must continually be subjected to relativistic criteria, and postponed justice. Erica Rutherford echoes this realism: "We started saying, why doesn't somebody make a really good film about Africans, with African actors—a full length entertainment film. We certainly thought that if we could create a black film industry, that they [the blacks] would *gradually* take over, with their own identity."[10] However we measure this posture, it has to be remembered that the Ethiopicist's dilemma is conditioned by the Despotic frame of reference created by an imperialist social order. We need to remember too that this social order also impacts on the Aesopian narrator, who, as we have seen in the case of Charles W. Chesnutt, is also forced to compromise and to seek fulfillment of imaginative intuitions in an indefinite future. Yet the judgment that the bottle is half *empty* has as one merit the conceptualization of what a full bottle might look like—something that usually does not preoccupy the Ethiopicist as much as it might.

In Darkest Hollywood helps us see these issues clearer. The relativist position falls short of *radical* rupture with the offending tradition, whatever its other achievements, and usually reproduces some of the features of that tradition, inadvertently or in conscious compromise. Lewis Nkosi has identified one consistent feature present when radical Ethiopicism is achieved: collaboration with members of the represented group. This collaboration helps explain the fairly successful radical Ethiopicism of such films mentioned in *In Darkest Africa* as *Come Back Africa*, directed by Lionel Rosogin, with heavy input from Black South African writers such as Bloke Modisane, Can Themba, and Lewis Nkosi. Rosogin also took the risk of violating apartheid laws by going into the segregated Black communities himself. Yet another example of decisive collaboration is *Mapantsula*, co-written and co-directed by Oliver Schmitz (White) and Thomas Mogotlane (Black).

Beyond the "involvement" issue, and other questions like the revision of history, the empowering of characters, the supply of family background, the denial of the slave narrative, etc., success at radical Ethiopicism is ultimately a matter of placing an equal or higher priority on equity with

the minority represented than on the pressures of commercial success, political security, or the satisfactions of an artistic, individualist ego-ideal. Not mysteriously, the discordant ironies of wayward Ethiopicist mimicry quickly dissolve in the presence of such a rare commitment. The relatively weaker lure of these ideal priorities may explain why radical Ethiopicism may be more easily found in documentaries, like *In Darkest Hollywood*, than in feature films, and among feature films, in low-budget narratives closer to documentary realism like *Come Back Africa* and *Nothing but a Man* than in more fantastical movies, where ancient tribal mythologies tend to creep back onto the screen.

FROM PRIMITIVISM TO MULTICULTURALISM

Estimating the radical possibilities of Ethiopicist representation entails the need to avoid demonizing this form of expression, to recognize its all-too-human origins. Nothing in Ethiopicism is peculiar to any group or historical situation, which is to say that this form of cultural practice might be expected to turn up wherever one social group maintains privilege over others, through cultural legitimation or capitalization. But further, Ethiopicism needs to be historicized more than the other interpretive frames. For while the dogmatism of Despotic irony or the abjectness of Cyclopism may be permanent features of the domination cycle, Ethiopicism has a recent history that must be accounted for.

The defining marks of Ethiopicist representation show it to be an aspect of aesthetic modernism. The authors of *No Man's Land: The Place of the Woman Writer in the Twentieth Century* have established a novel thesis about the character of literary modernism.[11] They contend that modernism in literature was largely a response by male writers to the fearful rise of women in competition with their labors. They see the battle of the sexes that had traditionally gone on in literary texts to have intensified in the twentieth century and particularly around the time of World War I as a result of the escalating number and power of women authors. They demonstrate in multiple volumes that the modernist impulse itself was largely determined by an anxiety of gender in which the possibility that authorship was not essentially a masculine calling turned out to be extraordinarily debilitating among Western male writers, but also stimulating of novel creative efforts and results.

A different scenario explains the influence of Ethiopicism on Euro-modernism. Ethiopicist representation is a historical phenomenon, its his-

tory is co-terminous with the encounter of Europeans with non-European populations through exploration, conquest, and colonization. As such, it is a by-product of several narratives of modernity. From the beginning, Euro-modernism was a product of aesthetic and literary discourse, arising out of the seventeenth-century debates between "the ancients" and "the moderns," or more specifically whether the achievements of the classical world were a pinnacle that could never be recovered but only emulated as opposed to the view that those achievements had been and would continue to be surpassed.

The concept of modernity carried notions of contingency, crisis, and displacement from tradition. Euro-modernism cannot escape its history, since it is born out of its own reinvention of the idea of history (if Habermas is to be believed, out of Hegel's idea of history) as a process of change and transformation separating itself from older notions of stability and uniform order. But if tradition served as the Other to the modern, there were also other counteridentities of its self-fashioning. Habermas notes, "The discovery of the 'new world,' the Renaissance, and the Reformation—these three monumental events around the year 1500 constituted the epochal threshold between modern times and the middle ages."[12]

The first of these monumental events, the encounter with formerly unknown peoples, while hardly unsuspected as an influence on the thought of the Renaissance and the Euro-enlightenment, per the example of Montaigne's essay on "savages"—one of the first Ethiopicist portraits, and a duly liberal one at that—has only randomly been understood as a contributing source of modernism. This is a history that so far has not been consolidated.[13] But a central chapter of it would be constructed around the formative couplet primitive/modern. The developing discourse of the modern needed the notion of the primitive and reinvented it to suit its purposes. (Adorno and Horkheimer argue convincingly that Homer's Odysseus develops a primitivist-colonialist narrative around his encounter with Cyclops.)

If modernity existed within contingent, historical time, experienced as a pressured moment in which life could be accomplished between the past and the always-immanent future, then the primitive was needed as the contrary experience of time as a never-changing cycle. We can here supplement Hegel's thought from another passage where he speaks of the category that needs to be rationalized before losing its shame: "At this point, let us forget Africa, not to mention it again. For Africa is no historical part of the world."[14] In Hegel's historical dialectic, the primitive was the Other to the articulation through art and aesthetic reasoning of

the rational force of human progress. We have earlier seen that this bipolarity played a part in the development of aesthetic knowledge vis-à-vis Oriental, African, and Amerindian peoples.

But another version of the European dialogue on primitive/modern is shown through Habermas's readings of Nietzsche. Nietzsche needs the aesthetic concept and the concept of the primitive just as much as Hegel, but with their functions turned on their heads. Where Hegel proposed that "with the new mythology art will take the place of philosophy, because aesthetic intuition is 'the highest act of reason,' "[15] Nietzsche on the other hand "continues the Romantic purification of the aesthetic phenomenon from all theoretical and practical associations. In the aesthetic experience, the Dionysian reality is shut off by a 'chasm of forgetfulness' against the world of theoretical knowledge and moral action, against the everyday."[16]

In these two positions, one enshrining reason against "the primitive," the other saluting the "primitive" as an outlet from the prison of rationality, in fact adopting the mask of the primitive, we have the key ingredients of the monologue of Euro-modernism, particularly cultural Euro-modernism, and its notions of the non-Western world. An elliptical calendar of moments might be constructed of important historical "speeches" in this monologue from Montaigne on "Savages," to Shakespeare's *The Tempest* in which the controlling emotion might be wonder and novelty, to *Robinson Crusoe* where the dialogue narrows on the greed of acquisitive capitalism and colonialism, passing through Baudelaire's various colonial lusts, to Conrad's "Heart of Darkness" and its nihilistic perception of imperialism, pausing at the Cubist appropriation of African sculpture, then moving through Surrealism and onward.

We might locate these various tendencies among the possibilities of Despotic and Ethiopicist irony, but the historical analysis demands going beyond those broad categories. Maria Torgovnick's study of primitivist ideology in the West clarifies its obscurantism and myopic mythology,[17] but takes pains to acknowledge elements of progressivism, liberalism, generosity in primitivist thought, as well as stereotypical xenophobia. But this acknowledgment resembles the apology for aesthetic reasoning as in many respects a socially improving structure of feeling. This takes primitivists at their face value, as they represent themselves, and places perhaps too high a value on their good intentions.

The challenge is to see Euro-modernism as both a complex affair and one with finite, cultural boundaries. The complexity of modernism vis-à-vis non-European Others includes its scope from little-acknowledged

fascist impulses to leftist notions of progress. There is also the difficulty of bracketing the narrative of historical progress as a foregone conclusion of modernist development. It is not simply a matter of "good" modernists versus "bad" modernists; of the contrast between the revoiced Robinson Crusoe movie, *Man Friday* of 1976 starring Richard Roundtree, which satirizes Crusoe and celebrates Friday and his mellow, civilized compatriots as compared to the bad old version of Defoe's novel; or of the contrast between the celebratory portrait of Black men fighting in the U.S. Civil War in the movie *Glory* and D. W. Griffith's alienating portrait of that same generation in *The Birth of a Nation*. It is also a question of seeing how both liberal and reactionary modernisms have fashioned themselves cannibalistically from an imperialist historical development where, on the one hand, the differences between Despotic and Ethiopicist representation are extremely significant in certain local contexts and on the other where these are mere epiphenomena of a larger context in which the burden of the practices of representation remains exploitation.

This matter of context has increased in importance since the claiming of voice by the formerly colonized. Euro-modernism vis-à-vis the non-Western has a different history than Euro-modernism vis-à-vis writing women (per *No Man's Land*). The impact of other cultures on Euro-modernist consciousness was formative and influential at an earlier historical point, say from 1500 on, than the challenge posed by women writers to male writers. The challenge of gender rivalry may have reached a high point of influence on modernism during and following World War I, while it was more pointedly after World War II that the retorts to the master narrative from people of color posed a challenge that no longer contributed to modernist self-definition, but began to erode it. The refusal of the role of primitive by vast populations of the world following World War II (as engineered by the Black Aesthetic, for instance) disrupted the primitive/modern narrative, and uncoupled a fundamental Euro-modernist identity formation. This uncoupling was surely one source of the end of modernity and the beginning of an imagined postmodernity.

In this analysis, we can find a very sound use for the postmodern idea. That idea has at least the salutary force of recognizing that "modernity" was always in part a characterization of certain behaviors more than a final identification of the present and the endless future. In short, postmodernism confirms the finiteness and limits of modernity. What needs to be added was that Euro-modernism was always limited by its exclusion of the non-Western world as ground for subjectivity or base for truth claims about the world. What is postmodern now was always beyond

modernism during the period of its high influence, which is to say that there was always a position of credibility and value outside of Euro-modern reference, though generally denied.

Ethiopicist representation, then, is but one complex, ambivalent, multifaceted development in a history inflected by domination and, in more recent times, by resistance. So regarded, can we fail to notice the rise of Ethiopicism along with the rise of expectations among marginalized Europeans with different motives and different readings of their advantages, and the rise of radical Ethiopicism with the decline of imperialism and the growth of resistance among the underrepresented? Are not the wider social and historical movements that make a *Ragtime* or a *Glory* possible more profound than the question whether their authors are really free of colonial mentalities, etc.? The more important focus is on the co-development of a power/knowledge complex involving Euro-modernism, aestheticism, and Ethiopicism as mutually reinforcing elements of an art-culture system that still works dutifully to maintain cultural and media inequity.

The force of this framework is illustrated by what may look like a trivial instance. Ethiopicism persists as a characteristic of what might be called the discourse of the Other,[18] in the "enlightened" assumption that the centered bearers of knowledge have a right (as heirs of the civilizing mission) to speak both as subject and for the objectified. So that when Habermas persists in describing what he calls "the discovery of the 'new world,' " it is not only the new world that needs to be placed in ambiguity. To continue to see those in the new world as the "discovered" is to maintain the fiction of a centered European subject position, licensed to gaze at the strangers, but not to be gazed upon in return. The persisting narrative of Columbus's discovery of the Americas reflects a framing device suitable for the production of Despotic reference at worst or radical Ethiopicism at best. The whole enterprise of interrogating the aesthetic, the Euro-centrism of "modernism," and the relative blindnesses of Ethiopicism has to do with the liberation of human consciousness from these obstacles to clearer understanding of world culture.

The small acknowledgments of the presence of others in the world as muscled into perception by militant liberation movements, and given the form of multiculturalism, matter very little when attempted in neglect of this larger historical perspective. The issue of Ethiopicism turned up, for instance, in the intense debate around *Miss Saigon*, when the Asian-American theatrical community protested the filling of the lead role with a European actor. Our investigation of radical Ethiopicism reassured us

that the right of everybody to portray anybody should surely be a guarantee of any wholesome set of cultural practices. But at the same time, this self-deceiving, localized version of multiculturalism must be made to confront the fact that the privileged, one-sided presentation of non-Europeans by Westerners has a history.

If there is any value in calculating the varieties and variegations of the frames of discursive irony as I have attempted, it is in opposition to the continued respect given to the principles of aesthetic calculation, but also against the priorities of the ruling art-culture system formed out of the same assumptions as aestheticism, but now comfortably perpetuated as indispensable institutions of "modern" living. Where we end up finally is with the realization that discourses are the fundamental, decisive units of comprehension, interpretation, and debate, not individual works or authors, at least where the hope of doing justice to the culturally dispossessed is concerned. These discourses might alternately be seen as narratives or as histories, and the big story of the last four centuries or so is the monopolization of history by one population. "The settler makes history and is conscious of making it."[19] It is in such large frames of interpretation, not in the fussier preoccupations where the art-culture system steers our attention, that the crucial questions of meaning are determined. It is from these frames of reference that the authenticity of texts, or even authors, derives, or even matters. Here, the good or ill will of an author, whether or not he is a radical or conservative Ethiopicist, dwindles in significance. This is not to say that the intimate experiences of individuals or groups are of no consequence. But when these local realities come within range of the art-cult and its boasted aesthetic authority, what matters is the vigilant watch over much larger narratives. Here, Fanon's argument is still valid: "On the level of underdeveloped humanity there is a kind of collective effort, a sort of common destiny. The news which interests the Third World does not deal with king Baudouin's marriage nor the scandals of the Italian ruling class."[20]

PART III

CHAPTER X

■

The Grammar of Resistance

No form of discursive irony is more important to this analytical framework than radical resistance. Without radical resistance, there would be no return of the repressed, no challenge to the canon, or the curriculum, no serious interruption to the monologue of European narcissism—no crisis of knowledge. For all the value of the Aesopian voice, its subtleties, complexities, and relative openness to multiple points of view, that voice might ring with an unsettling hollowness, suggestive of abnegation, lacking the presence of another voice and perspective in the neighborhood, less tentative, more promising of a full and complete humanity existing apart from the authorized possibilities and determined to fight for its prerogatives.

Without doubt, the insinuations of resistance form part of the exchange among the rivals and competitors for Power, and between Power and its victims, even when those insinuations go unvoiced. Power, paradoxically, longs to hear its rebuttal from its victims, and spends idle moments of reverie elaborately imagining them. But it is the terrible genius of radical resistance, when it finally breaks into speech, that it is full of unwanted surprises, carrying a menace not really anticipated in the daydreams of confrontation and debate entertained by the powerful.

Far from what is often imagined, radical resistance is much more complicated than just saying "no" to repression. Radical resistance comprises the highest consciousness of the politics of representation standing outside the privileged circle of expression. The goal of radical resistance must be to find effective forms of symbolic action promoting a more humane social order. This may be very different from hurling inflammatory language at the Palace walls. The rhetoric or resentment sometimes includes the simplistic reversal of the law of the authorities, or worse, the mere exchange of identities between oppressor and oppressed, without any reduction in the universe of abuse. "To turn their evil backwards is

to live," was one anagramatic formulation of this impulse.[1] But of course such a "radical" strategy ends by replicating the influence of the center, co-signing its alienations.

Radical resistance carries its own internal contradictions—confusing gestures reaching toward liberation but hampered by the fears and psychic burdens that distort the movement toward a more positive social order. Gross hyperbole often arises out of a fear of reproducing in oneself the blindness of Cyclopism or the moral ambiguities of Weak Aesopianism. That same fear may also lead to muzzling the name of the colonizer, as though that name, like a ghost, will haunt and control one's own thinking. Equally limiting is the politics of *ressentiment*, of spite, the dim politics of emotional venting, blind rage, or fantasies of extravagant, hostile conspiracies, or competitions in excess verbiage rampant among the alienated.

Beyond these simplistic reflex gestures and their momentary narcissistic satisfactions, radical resistance includes the understanding that what must be resisted, as well as offensive portrayals, is a regime of representation that has been centuries in the making. The logic of the present crisis demands a particular self-consciousness about its immanence, an awareness of its particular secret, which the dominant order wishes to keep hidden—that the future of that order is not guaranteed. That logic also insists on a double vision regarding representations, viewing them in terms of their specific historical moment, but at the same time as they function within a large-scale historical framework. Within this logic, the alerted reader will never allow herself to accept the idea that a discussion about racial representation in the Uncle Remus tales, for instance, or Charlie Chan, the Richard Pryor movie *The Toy*, or *The Emperor Jones, Imitation of Life, The Birth of a Nation, Amos 'n Andy, The Adventures of Huckleberry Finn*, a racialized item on the eleven o'clock news, racist Disney films like *Jungle Book* or *Aladdin*, or the liberal lesbian movie, *Fried Green Tomatoes*, is an isolated moment and not a fragment of a discursive sequence intimately related to the foundation of modern slavery and high colonialism as they flourished in the nineteenth century and the rationales for these systems laid down in the European Enlightenment of the eighteenth century.

The ironies of discourse set up a situation where knowledge is being continually recoded—where one narrative is continually challenged by a counternarrative. But this inescapable fact of language is given a new urgency in our present historical period. Received wisdom has come under assault since the 1950s on a scale unlike anything since the Euro-enlight-

enment. The present crisis of knowledge has sharpened these ironies into the needling debates of countless culture wars. Broadly speaking, the battle rages between dominant, old knowledge and resistant, new perspectives. (The usual provisos need be entered here: dominant knowledge is not monolithic; it is always contested from within as well as from without; and despite labels such as PC, new perspectives are also not monolithic.) At the heart of our contemporary search for reliable ways of knowing lies the fact that the systems of knowledge sponsored by the Palace have been used in monumental lies about those outside its confines, and those who have been lied to and lied about have abruptly made themselves heard through withering critiques. Since World War II a battery of contradictions loom before monological Euro-centered knowledge, accelerating toward a showdown. Indeed, the Japanese nationalism of World War II was as much a violent resistance to Western domination as was the non-violent anti-colonial movement of Ghandianism that began long before that Great War.

The history of global cultural resistance has yet to be written. But that resistance has grown in form and substance to give Monopolated Light and Power an unwanted, shadowy double; wherever we encounter dominant, centered Western ideology, we are now aware that there is, somewhere in the immediate environment, another story waiting to be told. One sure sign of this doubling of discourse is the proliferation of brilliant cultural alternatives, flaunting their pagan difference from authorized "civilized" mores: the spirituals, the blues, the calinda, rumba, folktales, ragtime, *cinema nuovo*, jazz, rhythm and blues, bossa nova, Soul, reggae, highlife, zouk, hip hop.

The intent of the many alternative narratives that now contest the authorized version is to revise or recode its interpretations of reality.

> Our father, who art in heaven
> The white man owe me eleven and give me seven;
> Thy kingdom come, they will be done,
> If I hadn't took that I wouldn't got none.[2]

This ditty from enslaved Africans in the United States parodies the biblical "Lord's Prayer" not merely to interrogate Christianity and the Western claim to authority over Christian knowledge, but also as rebuttal to Christian apologies for slavery. It insinuates a hidden knowledge, based in material, economic experience as opposed to the idealistic rationales of "civilized" discourse. If the delicate, modest poems of Phillis Wheatley, the African-born slave girl who became a gifted protégée of a New En-

gland family and author of chiseled neo-classical verse, give us an early example of Weak Aesopianism, this slave song exemplifies an early instance of radical resistance to authorized truth.

At its highest level of clarity, the radical understanding of the politics of representation is also the least ironic of the frames of interpretation. It is most open to the possibilities of multiple reflexivity, and is the least willing to endure distortion in the interest of self-aggrandizement. This is not to claim for this perspective a scientism such as that boasted for Marxist analysis. For all its awareness of the ironies of competing discourses, it is nevertheless also aware that its own utterances are implicated in an ironized universe of communication. It doesn't try to eliminate all contradictions from an imperfect world, but to reduce those contradictions that exacerbate social injustice. So it is predictable that radical resistance is paganized by the art-culture system.

The regular defenses of the cultural gatekeepers are most alert to the dangers coming from radical interventions. The assertions of radicalism are derided for their strangeness, their unfamiliarity within the conversational grid or grammar that functions as password. The gatekeepers find the methodologies of radical resistance to be pitifully underdeveloped beside their own, which through the services of entelechy have the advantage of erecting tar baby formalisms that leave the arrangements of knowledge-power undisturbed.

Monopolated Light and Power organizes an obstacle course before the threat of confrontation. Arguments outside its approved parameters are pre-defined as noise at worse, marginalia at best. Against the fiat of monologic information the assertion of identity by the out-caste personality is already contraband knowledge. Once such assertions of alternative identity are voiced aggressively enough to gain revisionary momentum, they are labeled "protest writing," or polemics. They violate the canonical rule of the aesthetic that expression be disinterested. The rhetorical equivalent of aesthetic disinterestedness in general discussion would be "objectivity." The privileging of form over content in aesthetic reasoning as another means of silencing the political, is rivaled in academic debate by what can be called intellectual formalism.

The narrator working in repressive circumstances and hoping to make a decisive intervention may do well to forget the negative forces arrayed against her, to forget everything except the effective expression of the idea at hand, if possible. On the other hand, that narrator may do badly to forget. The one incontrovertible fact of her imaginative activity is its

immersion in a media administration where her interests are disparaged by this host of already-waiting negations or minimalizations of her efforts. Without raising a police stick over behavior in such a situation, it remains clear that from the standpoint of representation, all things being equal, the work is most fertile that includes a simultaneous critique of domineering reference and an affirmation of alternate cultural possibility.

This is so for many reasons. Critique and affirmation are reinforced by each other, and better reinforced to the extent that the two drives harmoniously interconnect. A work purely devoted to negative resistance is hard to imagine. At such an extreme, the work would only confirm the adversarial discourse by reversing it point by point. Whether it wishes to or not, a radically resistant text must address the need to affirm as well as negate. The text that only negates runs the risk of defeatism, suggesting the absence of any vision to replace that of oppression, even of oppression resisted. And however momentarily satisfying it may feel to enjoy a cultural product that proceeds unaffected by the current struggle against canonical knowledge and values, that satisfaction is gained at considerable loss, as we shall make clear later. To focus exclusively on either the negative critique or the affirmative assertion is to miss the particular features of the current crisis and the prospect of making the most powerful intervention therein. In the critique of aesthetic knowledge, the works that make the most powerful interventions are those that offer the clearest light out of the established art-cultural regime *and* toward more humanizing perspectives.

ACHEBIAN FABLES

The collision of Euro-enlightenment thought with radical resistance from the colonized is allegorized in Chinua Achebe's novel *Things Fall Apart*. Achebe's novel originated as an expression of counterknowledge. The author was provoked into becoming a writer by his disgust with the clownish, Despotic portrait of his Nigerian homeland in Joyce Cary's novel *Mister Johnson*. Achebe has also admitted the negative stimulus of Conrad's novella "Heart of Darkness." The distance between Achebe's narrative and the European invention of Otherness in Cary's novel establishes a doubled discourse and a resonant clash of ironies.[3]

The sweep and force of Achebe's tale need not be reexperienced minutely for our purpose. The story takes a deliberate path through mo-

ments of village life that illuminate a culture whose logic and integrity cannot be denied, however different from or similar to Western ways. Achebe effectively reconfigures Cary's satire, replacing its buffoonery with high seriousness and dignity, its glib jokes with minute observation, its rash generalizations with complex, knowledgeable understanding. Achebe's fable explores the crucial years in the life of an East Nigerian villager, Okonkwo. Okonkwo's excessive zeal to fulfill the highest obligations of his village traditions simultaneously illuminates the vital authority of those traditions and the tragedy of an individual so placed in history that his compelling desire to compensate for inner doubts leads him to carry communal obligations to fatal excess. The crucial juncture comes at the point when British colonizers encroach upon his world, raising his personal contradictions to a boil. At this moment, he kills a British messenger, realizes that his people, losing their ancient assurance in the face of the encroaching world, will not back him up, and kills himself.

On the last page of this epic drama, the British District Commissioner, who has barely scratched the story's pages, reflects on the part of the tale he had witnessed as possible material for a book he is planning:

> As he walked back to the court he thought about that book. Every day brought him some new material. The story of this man who had killed a messenger and hanged himself would make interesting reading. One could almost write a whole chapter on him. Perhaps not a whole chapter but a reasonable paragraph, at any rate. There was so much else to include, and one must be firm in cutting out details. He had already chosen the title of the book, after much thought: *The Pacification of the Primitive Tribes of the Lower Niger.*

Here, Achebe puts into play many of the ironies of institutional/resistant discourse. First is the irony of proportion. Viewing the tale in terms of Western cultural capital, the colonizer deems a paragraph appropriate for a story the reader has just encountered in tragic and epic density. The difference—a paragraph, an epic—metaphorically calibrates the different weights and proportions the same experiences can carry in two alienated contexts. By inference, we must suppose that a reverse ratio might be applied for works regarded narcissistically in the canon: works that merit epic attention there might seem worth a slight paragraph elsewhere.

The reduction to near invisibility of difference viewed from the Eurocentric frame is masked by inevitable distortion. The discrepancy in scope is in effect a reduction in value, complexity, and significance granted to

non-canonical experience. This reduction is only partly explained as ethnocentricity. Also at work is the imperial morality which calculates actions of resistance as at best errors against historical inevitability, hence the trivialization by the master text of heroic resistance against its aggression as eccentric outbursts of the crazed, demonized, or foolish.

The ironies of Achebe's intervention carry many implications. More important however is Achebe's control of them to the advantage of his textual authority. He has reversed the proportions, reframing the operations of Monopolated Light and Power as provincially ignorant commentary on a momentous experience it is unwilling to comprehend. To see it another way, Achebe's ironical reversal decanters crystal knowledge by reframing it, not only as merely a finite stance among others but also as mischievous, minor, and peripheral to another vision where different values are honored.

Achebe's maneuver, which I will call Achebian irony, suggests the highest form of resistant consciousness and practice, the construction of an alternative vision combined with a demonstration of the limitations of received knowledge. Rhetorical reframing might be loosely compared to the cinematographic maneuver of zooming outward from a tightly shot scene to include a surrounding area, which may bring a different, surprising picture into the frame. A half-dressed woman serenely prepares her bath—a staple movie moment. The camera "outframes" and we see the outline of a shadowy male figure watching her. It outframes again and we discover another man watching the first. One more outframe and we see all the previous set-ups on a movie sound stage, like Chinese boxes.

This trite device emblemizes the filmmaker's control over the quantity and timing of information the viewer will share, and also the meaningful relation of one piece of information to another. It can also stand allegorically for the rhetorical maneuver of reframing. (This is a loose analogy, however, since in films and obviously in novels, plays, music, painting, and even non-fiction writing the altered meaning is achieved in other ways beside changes in camera focus distance.) In *Things Fall Apart* the focal position of narrator-spectator "inframes" or zooms in on the little, ethnocentric mind of the colonial officer at the end.

An unspecific embarrassment might be one response to this passage. The colonial officer's thinking, though crude, might approximate that of many uninitiated readers before they had experienced the full text. His thoughts are like a mirror for many of us. A shock of recognition of our-

selves, or former selves, in the mirror of our microframed perspective, awaits us. Of course, this strategy leaves open the possibility of denial that the reader was ever so narrow, and therefore leaves the reader more deeply embedded in the new, alternative world-perspective of Achebe's villagers.

Achebian irony is paradigmatic for the conflict between majority and minority discourse. Majority discourse, like the colonial officer's notes, is always/already "written," that is, claiming the authority of documented script. Minority discourse is always treated as "oral," even when written down. There may be some irony in the fact that the colonial officer's written reflections on a predominantly "oral" people are actually written by one of their descendants. But that misses the point implicit in Achebe's ironic construction. Though we may celebrate the validity and richness of cultural work produced from oral tradition, we should not slight the practice of Monopolated Light and Power in dealing with both the materials of oral tradition and the non-Western materials written from its inspiration as though they were oral in contradistinction to writing, that is, as forgettable. In the present formation of power-knowledge, there is writing and then there is writing, with one body of work safekept as literature and the other located in a more ephemeral place. Despite the investigations of thoughtful scholarship, the arrangements of power-knowledge continue to patrol the categories of literacy/orality for a kind of coded separation between information valuable to its traditions, i.e., valid, documentable, useful as evidence in the construction of knowledge, and information considered oral as in prehistorical, of dubious certainty, uncertifiable hearsay, not coming from reliable sources. The one may be sacrosanct, attached to a divine order, the other, pagan. This intuitive gatekeeping practice helps explain how information about unprivileged populations, women or "minorities," disappears so easily from scholarship, needing to be rediscovered generations later.

The Achebian gaze is one that evokes writing about writing, or writing upon writing. In the context of mediated knowledge and the power to control such knowledge, it is self-reflexive. The emergent storyteller is drawn to self-reflexivity by the way the native self is positioned in relation to the guarded center of imperial subjectivity. Emergent self-assertion in such a decentered space is necessarily self-reflexive. The emergent narrator is one-who-knows-she-knows at one remove from authorized knowledge. This is the positioning of a particular brand of modernism, in which the centered, subjective gaze of the colonizer becomes the con-

vention or tradition against which the emergent or decolonizing modern develops itself. The Achebian gaze is self-reflexive after first being other-reflexive. It creates a new ground for the decolonizing self in relation to an altered and ironized positioning of the imperial other. In discovering the self-reflexivity of its knowledge of self, the new, resistant position dissipates the transparency of Monopolated Light and Power and underscores *its* formerly hidden self-reflexivity. Authorized, Western knowledge is "modernized" through the Achebian gaze in a way that differs from its self-modernization.

The Achebian gaze raises the paganized narrative to the dominant structural position and reduces the master narrative to the marginalized position. The effect is something like seeing Gulliver in the land of the Lilliputians and then seeing him in the land of the giant Brobdingnagians. By seeing a narrative that we are accustomed to receive as gospel myth in this shrunken form, our moral imaginations are freed to entertain other reversals beside scale.[4] Historically, with the explosion of resistant expression in the 1950s and 1960s, the mimicry in which the dispossessed imitated the manners of the gentry, sometimes to Cyclopean excess, took an acrid turn. Per the self-reflexivity we have just discussed, the mimicry became self-conscious. That is, an awareness was heightened of the self-destruction involved in the interaction and imitation of the authoritarian other. Almost immediately there arose acid satirical portraits of such Cyclopean behavior (again, see Clay in *Dutchman*, for one) among the dispossessed, and at the same time derisive portraits of the colonizers became more frequent.

Almost as harbingers of the new manner for representing majority discourse, characters standing for dominant society became reduced to stick figures. In Genet's *The Blacks*, in Black Arts dramas in the United States and in a powerful folk drama from Mozambique, captured in a film by Ruy Guerra, *Mueda*, Europeans and White Americans are portrayed by Black actors wearing a circle of white chalk over their faces, achieving a curious ghost-like impersonality. In this guise, these figures never gained much more identity than "the colonial officer," or "the postman," "the farmer-boss," etc. While such practices might be reproached as reverse stereotyping, they have their tactical justifications. One rationale is the need to prevent privileged identities, already oversubscribed with meanings, to regain the central focus of attention. Another might be the usefulness of such devices for streamlining some observations about dominant knowledge.

Toni Morrison's novel *The Bluest Eye* opens with a replica of the Dick and Jane primer stories that puts a normative pretty (and White) face on the world of childhood experience:

SEE MOTHERMOTHERISVERYNICEMO
THERWILLYOUPLAYWITHJANEMOTH
ERLAUGHSLAUGHMOTHERLAUGHLA[5]

Snippets from this text recur throughout the novel, echoing with incremental irony beside the elaborated tale of Pecola's childhood tortured by racist aesthetics and her subsequent dehumanization. The official code of appearances suitable for childhood—the better to reproduce a middle-class culture and its claims to privilege, security, and control—takes on a bitter edge when placed alone and naked out of its neighborhood. In rap music, this technique might be called ironic sampling.

Doubtless the first noticeable impact of this kind of reframing is its force in defusing the master text and its fictional messengers. This is surely one of the effects of the White suburbanite who visits the Younger family in Lorraine Hansberry's play (and film) *A Raisin in the Sun* in order to bribe them away from his neighborhood, a risibly small, timorous, wimpy character to be standing for a community that wants to preserve its purity. But the Achebian gaze can carry more complex meanings too. In Ousmane Sembene's great epic film *Ceddo*, the Catholic missionary fantasizes a flash-forward to his own funeral, where the holiness of his life is celebrated by African converts to his religion. But the irony is double-edged: his mourners include "pagans" who clearly despise him; nevertheless, the European dress of the celebrants of this African-Catholic mass reminds us that this seventeenth-century dream was also somewhat prophetic.

Like this one, other instances of Achebian irony not only deflate the pretenses of the Palace, they are also instructive revisions or reflections of history. An instance in literature is Toni Morrison's novel *Beloved*. This work profoundly transforms the meaning of slavery in the United States in a way that demands the reperception of U.S. history and Western history in the modern era. In effect it exposes the monuments of barbarism concealed by monuments of civilization. If the character of U.S. slavery as she portrays it is compelling, then the received, official history of the United States is incredible.

One particular narrative moment deploys a powerful reframing strategy. The principle characters recall the traumatic experiences they have endured only in snatches, repressing the full force of humiliating recollec-

tion. One of these relates to Sethe, the central character. After the planta-
tion where she was enslaved was sold, the new master turned out to be a
strange person the slaves call Schoolteacher. Schoolteacher is a meticu-
lous projector in the sense depicted by Swift in *Gulliver's Travels*, an
ultra-rationalist who seeks to bring scientific exactitude to the business
of extracting profit from his slave-holdings. He holds classes for the
White boys of the neighborhood, instructing them in the science of slave-
mastering. One decisive afternoon he orders Sethe into the classroom
as an exhibit, lecturing his pupils about her properties as one would a
specimen in a biology class. Elaborating on her reproductive functions,
he orders the boys in the class to draw milk from her breasts in order to
examine her productive qualities. This denaturing experience inflicts a
life-lasting psychic injury.

This revaluation of privileged discourse depends on our reading the
character of Schoolteacher as an icon of the Euro-enlightenment, incor-
porating its rationalism with its blindness. Another analogy is to the sci-
entific barbarity of the concentration camps (an analogue Morrison has
alluded to in comments about her motives in writing the novel). If Nazism
may be viewed as an aberration of Enlightenment, then such rationalist
philosophical explorers as Thomas Jefferson, slave-owner and principal
architect of the U.S. Constitution, bring the contradictions of rationalism
and oppression closer to Euro-enlightenment's core. But Schoolteacher is
more than an allegory for Jefferson, whose discussions of slavery in *Notes
on the State of Virginia* might have been written by such a fictional char-
acter. Schoolteacher and his operations stand, in this narrative, where
the perspective of the enslaved is, for once, foregrounded, as analogue of
the Euro-enlightenment itself, several of whose most eminent savants
eloquently incorporated slavery and racism into their rationalization of
universal knowledge. By historical extension, Schoolteacher and his ped-
agogy also stand as analogues for the intellectual heirs of Euro-enlight-
enment who have yet to excavate the contradictions of Monopolated
Light and Power. In Morrison's text, the dehumanizations invented by the
privileged subject immersed in the "human sciences" is reframed in iso-
lation within the lyrical, personal revelation of a sentient humanity
whose existence it would deny or destroy.

One specific Achebian effect of note in Morrison's tale is the moment
when characters we have experienced in depth and come to care about
are viewed through the eyes of uncomprehending slave-catchers, School-
teacher among them. With the sudden shift of focus, it takes a moment
of acclimation to realize that the "crazy old nigger" who "was standing

in the woodpile with an axe" and "another one—a woman with a flower in her hat. Crazy, too probably, because she too was standing stock still" are the respected elder figures Stamp Paid and Baby Suggs. In this practice of reverse focusing, we get an illustration of how the dehumanizing assumptions of a historical Western gaze produces stereotypic oversimplifications—"one must be firm in cutting out details." (The effect is something like experiencing a grand opera in which one walk-by character is a minor chieftain raving about the disloyalty of his subjects— whom we finally recognize as King Lear.) Also implicated in this passage is the historical Western gaze and the way it represses the horror or revulsion its presence can produce.

Among other ironic reframings of centrist knowledge in African American writing, some involve scenes in which Black characters go to the movies. In these scenes the majoritarian meanings of these movies become convoluted absurdities, producing psychic damage in the minds of "minority" characters. One such moment is evoked in *The Bluest Eye*. Pecola's mother Pauline, rather stupified by her life as a domestic and her static marriage, finds relief in the movies:

> The onliest time I be happy seem like was when I was in the picture show. . . . White men taking such good care of they women, and they all dressed up in big clean houses with the bathtubs right in the same room with the toilet. Them pictures gave me a lot of pleasure, but it made coming home hard, and looking at Cholly hard. I don't know. I 'member one time I went to see Clark Gable and Jean Harlow. I fixed my hair up like I'd seen hers on a magazine. A part on the side, with one little curl on my forehead. It looked just like her. Well, almost just like. Anyway, I sat in that show with my hair done up that way and had a good time. I thought I'd see it through to the end again, and I got up to get some candy. I was sitting back in my seat, and I taken a big bite of that candy and it pulled a tooth right out of my mouth. I could have cried. I had good teeth, not a rotten one in my head. I don't believe I ever did get over that. There I was, five months pregnant, trying to look like Jean Harlow, and a front tooth gone. Everything went then. Look like I just didn't care no more after that. I let my hair go back, plaited it up, and settled down to just being ugly. I still went to the pictures, though, but the meanness got worse. I wanted my tooth back. Cholly poked fun at me, and we started fighting again.[6]

The narrator introduces Pauline's internal monologue with a comment on the effects of the movies on her: "Along with the idea of romantic love, she was introduced to another—physical beauty. Probably the two most destructive ideas in the history of human thought."

Another memorable moviehouse scene occurs in Richard Wright's *Native Son*. Watching *Trader Horn*, Bigger and his friends use the screen fantasies to feed the distorted consciousness they bring with them, but heightened by the false consciousness of movie-tone reality. They revel in the thought that rich White women are loose, that "reds" are evil bomb-throwers. When this film is followed by an ethnographic film about African village life, they leave in disgust at the remoteness of this scenario from their desired fantasy existence. The fantastic notions Bigger finds reinforced in the movie are among those that lead to his embroilment in the murder of two young women and later to his implication of "reds" in the crime. The movies mediate the false consciousness of Bigger and like-deprived youths, growing out of their inability to make sense of their restricted existence, producing illusory notions about the life of privilege.

The point is not whether the sentiments facilitated in such passages are true. Pauline's broken tooth may not fairly signify the retort of Reality to her Bovarist fantasies. Rich White women may in fact be looser than others. Romantic love and physical beauty, the first an invention of Western culture, the second an applied code of the aesthetic, may not be the two worst ideas in the history of human thought. These passages dramatize the discursive abuse of the disempowered. At the same time they impart a meaning to the false consciousness suffered by the victims of crystal knowledge and show that knowledge reframed as sponsor of ignorance and self-violation.

THE OTHER SLAVE NARRATIVE

The stories emerging in the current era give shape to the "hidden histories" nurtured in popular memory. They not only refute the classic system of representation. At the same time, they rewrite history and the concept of the human. Further, most of them, deliberately or not, invalidate the propagandistic doctrines of the aesthetic. For if the aesthetic that forms the institutional charter of the art-culture system were truly disinterested, universalistic, productive of the transcendent moment, then such works would not be obscured in the comers of cultural discourse, displaced by the current novelties of a class jealous of its earned privileges.

This new knowledge beside the old crystallizes an emerging modernism. The clash of these two regimes of symbolic identification recalls those encounters where an established paradigm of civilization is over-

thrown by an insistent new vision. There is something of a turnabout in this revolution, since it arises mainly from those societies and peoples who were the up-ended victims of a previous world revolution, that of expansive Euro-capitalism. In the encounter between these two hierarchies of values, those of the former colonizers are being recoded and reframed as bearers of superstition. This is particularly apparent with the High Fetishism of the art world, as a feeble structure of cultured defense in which even its constituents display increasing difficulty to maintain their belief or support. This revolution in perception is dramatized in a conceptually innovative film by Cuban director Sergio Giral.

The Other Francisco is built around the conflict between two regimes of truth, one elitist, the other popular. Giral performs an archaeological analysis of Cuban slavery, taking as his starting point a celebrated nineteenth-century romantic novel, *Francisco*, by the Cuban novelist, Anselmo Suarez y Romero. In the novel the story of the slaves on one plantation is aestheticized, its imagery shaped by an Ethiopicist gaze. The tale makes an affirmation of freedom, but it is a romantic freedom, expressing the liberal anti-slavery sentiment that the author would wish for himself, and so imposes on his imagined slaves.

Giral presents a soft-focused reenactment of the novel's sentimental view of slavery. But then he interrupts this version of the master narrative with another, sharply different version of the same story. The film opens with the romanticized version, on the tribulations of two slave lovers, Francisco and Dorotea. Dorotea is pursued by Ricardo, a plantation owner whose sexual advances she rebuffs until he threatens the life of Francisco. With a dissolve, the spectator is in the midst of a salon where the novelist Anselmo Suarez y Romero is reading from his novel *Francisco*. The cine-narrative device is very much like zooming out from a scene to show the context of its fabrication, not a movie set but a literary salon where the novelists and his patrons are gathered. These are all historical figures. It is the cosmopolitan literary salon of Domingo del Monte, who hosted the literary circle that produced the first Cuban novelists. Also present is Richard Madden, a British emissary sent to inquire into the condition of the slave trade under a British-Spanish treaty agreement.

A narrator announces a different analysis of events in a voice lacking all aesthetic distance and brusquely breaking the illusions of controlled spectatorship in the manner of Bertholt Brecht. The narration breaks down the varied interests involved in Cuban slave society at that historical moment. The landed aristocracy is opposed to independence from Spain for fear that it would bring an end to slavery. They fear this pros-

pect not only economically, but also because Blacks outnumber Whites on the island. Madden represents British interests, supporting a free trade doctrine and is thus opposed to slavery. His calculation is that imported British machinery at the sugar mills would demand even more labor than emancipated ex-slaves could supply. Somewhat between these two positions, Del Monte upholds a cosmopolitan, reformist desire for gradual emancipation. This view fairly captures that of Romero, who urges it with more romantic and humanitarian fervor in his novel.

After the opening sequence and the shift to its salon framing, a narrator's voice-over declares, "This Negro was Francisco." The narrator then goes on to ask, "Or did the novel have within it another Francisco whom Anselmo Suarez y Romero never got around to showing us?" Over a freeze-frame of Francisco bedecked in a coachman's uniform, the film title appears, one of the most appropriate, effective uses of delayed titles. Thereafter unravel two competing versions of history, a doubled narrative, one romanticized, the other closer to documentary, critiquing the first through a meditation on the probable historical life of a "real" Francisco.

In the novelist's version, the lovers meet in an idyllic, sylvan setting, shot in the gauze focus of classical Hollywood movies, looking more like an idealized studio setting than any sight from the profit-grinding machinery of slavery. The lovers make all the protestations and genteel gestures of Western romantic love. Dorotea, in a white dress, confesses the sacrifice of her honor she has made to save Francisco's life and declares they must never see each other again. Whereupon, after she leaves, Francisco beats the ground with his fists and later hangs himself. Romero adds, "The mulatta was consumed little by little till many years later she died."

The narrator once again intervenes and points out the divergence between the novel's portrayal of the treatment of slave women and their actual experience. That experience is depicted as deglamorized sexual brutalization. A woman is raped by an overseer. Pregnant women are forced to work in the fields and to cut cane. A pregnant woman hides in the fields and prepares an abortion-inducing potion.

A stunning stroke of narrative intervention is inserted at one point, bringing the British diplomat, the novelist, and Del Monte to the dinner party of the fictional slave-owner. Madden then interviews some of the novel's characters, the overseer particularly, as well as the novelist and Del Monte, probing the economic motivations of slavery neglected in the novel.

At this point slave resistance is introduced into the revised version of

the story—one of the histories hidden by Romero's prettification. Giral points out, "At the time that Suarez Romero was writing the novel, there was a movement of slave conspiracies and uprisings throughout the land. It is extremely significant that Suarez Romero at no time as much as alludes to these uprisings, though as a slave-holder himself he must certainly have been aware of them."[7] According to Giral's calculations from his personal study of slavery in Cuba, the number of runaway slaves living in palenques, or fugitive slave communities, may have approached 50 percent of the slave population.

To correct this omission, the most acute revision of the novel is the introduction of an escaped field hand, Crispin, who after capture and punishment leads a rebellion of the slaves against the plantation. After some intrigue, the slaves rise up and free themselves from shackles, burn the fields, and ransack the house, killing the overseer and his slave-helpers. They mount a carnival of self-emancipation, momentarily in possession of the symbols of mastery, affluence, and security. Some slaves flee to the mountains, some, frightened or trusting, remain behind. The plantation patrol arrives and kills the slaves who remained behind, including Francisco, whose years as a house servant had made him placid and apathetic. The narrator asks if slaves would have committed suicide, for love particularly, in the presence of other means of rebellion. The film closes on images of escaped slaves running through the forest and looking down from the mountains upon the Cuban valleys below.

The Other Francisco is remarkable, as Michael Chanan once pointed out, because where others have talked about deconstructive cinema, Giral has effectively done it.[8] It discovers cracks in the novel's apparently smooth surface and penetrates them, opening up tissues of significant material concealed by the master text. It uses Achebian strategies to unmask the evasions of Ethiopicism in the received portrayal of Cuban slavery. The liberal Ethiopicist gaze prefers the recall of isolated, picturesque virtues, and sharply delineated individualities, among the masked population. (Once again we should think about those many favorite servant/ Mammy/Nanny memoirs the privileged use to shield themselves from the urgencies of class, politics, and history.) These virtues serve as pennants saluting the prospect of evolutionary reform, paced by widening education and refinement. Giral held a precise estimation of Romero's romantic Ethiopicism: "For the sake of presenting the slave as a human being, perceived and treated as such, he elevated him to the level and to the interests of the free white man. It's a very naive position."[9]

The development of both Aesopian and Achebian irony arises in the

context of competing histories. But there is a radical difference. Aesopian rhetoric employs double entendre to express in cryptic or oblique ways a sentiment of resistance abiding beneath the institutional view. Achebian irony turns the Aesopian tactic inside out, using craft to expose rather than insinuate, reversing the balance of overt and subversive meaning. It uplifts the veiled resistance of the Aesopian tale to major theme. It recasts and retells the official story that Aesopian rhetoric negotiates with, so that the contradictions of the Crystal Palace are exposed to public view.

THE CLOWN'S DISGUISE

We can also learn much about the strategies of reconfiguration from Hopi director Victor Masayesva's short video *Ritual Clowns* (1988). Using a variety of techniques, film, stock footage, animation, and stills, *Ritual Clowns* relates a part of the sacred cosmology of the Hopi nation. According to this ancestral mythology, the universe was a regally sufficient place before humans entered it. As the animation recreates the myth, humans entered the natural universe as its clowns, tumbling, falling, and running backward from the sky to the earth. As clowns, humans bring the enlivening, disruptive, comic-tragic elements into natural existence. The sacred ritual in which this identity is recognized is shown in old stiff photographs, recovered ethnographic footage and film of recent performances. The male dancers appear in outlandish, uncoordinated, and unconventional dress, and their dance is a pageant of orchestrated clumsiness, reenacting the original entry of founding clown-humans into the natural kingdom. The people come to recognize that the sun they had glorified,

> . . . rose for himself alone,
> for his own glory and not for
> The People.
> Then the clowns were called.
> Called and chosen to complete
> the people's purpose.
> In this way they completed life
> and became one with the people.
> [subtitled translation of Hopi narration]

The clowns are the humans who become one with the people or other animals. Another voice-over, the filmmaker's distinctly non-broadcast voice, apparently speaking without a script, offers further explanation: "You know. Nature was perfect. We came in and disturbed it. And this

is how ... the song represents our ambition." Over this explanation is screened one of several mandala-like symbols, with inserts of two separated filmed sequences, one of birds and another of clown dancers.

The ritual of the clowns is invoked "when we need punishment." Here another "mandala" symbol holds three simultaneous frames: one of high-altitude rockets being launched; one of restless urban crowds; and one of warfare, an amphibious assault. Another voice-over is heard, presumably that of a female anthropologist from the past commenting on the clown dances: "they are absolutely disgusting." And later: "Their dances are no place for a clean thinking person."

A clip of a Charlie Chaplin silent movie plays over the comment "What the people have done is pretty much defeated the whole clown ceremony." This comment following the interpolations of the anthropologists implies an erosion of the ceremony as a consequence of Western "rationalization" of cultural values. The costs of colonialism and Euro-modernization are reflected in the trivialization of sacred symbols as the clown shrivels into eccentric jester in the humanist cosmology.

The recreation of this myth in popular media, which called for the video artist to gain special dispensation from the elders of the Hopi nation, gets much of its power from the reframing of Western influences against which it reverberates. *Ritual Clowns* functions as one more reminder that archetypal narratives have not been charters of domination in an societies. Societies can function without them, all the more so if their priorities are placed on harmony rather than on apologies for conquest. Sacred value is here lodged in the natural universe, not in acquisitive individualism. The central conceit of Euro-humanism is reversed. Humanity does not dominate nature; it despoils and disfigures it with its incongruous presence. The master hero triumphing over history is replaced by the human figure as tragicomic anti-hero.

The Achebian framing of the anthropologists' pronouncements, the Chaplin quotation, and other Western references suggest the identity of Western man as super-clown within the clown-human order of things, bringing more of the disruption into human (clown) culture than the original clowns brought when they came tumbling backward into the universe. This reading gains force in a metaphoric moment two-thirds through the video. The narrator describes one of the functions of the clown ritual as "to show how much of a child he [the human] still is." The cut is to the garish architecture of Las Vegas, a monument to clown sensibility only half-understood by its erectors, a parody of the Crystal Palace. The camera picks up a preteen boy, his face painted clown fash-

ion, with added bulbous nose and New Year's Eve party hat. Sitting on the sidewalk outside a "palace" casino, he intones the pontifical pronouncements of Western metaphysics. In one extremely concentrated and amusing moment the magisterial, universalizing solemnity of Enlightenment philosophy is reframed as quintessential, clown chatter, the more so against the background concept of the overabundant sufficiency of the natural world, visible behind the Disneyesque casinos. The moment stands sharply and comically defined under and against Hopi wisdom. The order of knowledge is reversed, not out of perverse opposition, but to further clarify a profound meaning from world culture that otherwise remains obscured.

Are we to take the summation that "the people have pretty much defeated the whole clown ceremony" as elegy for human possibilities? Or is the interventionist video itself a movement of its recovery? If we read the video rightly, do we not see that the ceremony is not the actuality it signalizes, and that the defeat of the ceremony is, incongruously, a confirmation, with a vengeance, of its warning? Might we extend Espinosa's metaphor (explored in chapter 12) to see in the clowns' ritual a revelation of the human as "imperfection," but comically so, beside the illusory "perfection" of Euro-humanism? The videowork is too non-linear to provide "explanations" of this sort that only a clown would demand. The liberative function within the politics of representation is not to impose knowledge such as the Hopi myth/ritual on the concept of the human, but rather to ensure that no humanism be taken seriously that is not open to such contributions.

RESISTANCE AS METADISCOURSE

Works as diverse as *Things Fall Apart, Beloved, The Other Francisco*, and *Ritual Clowns*, diverse not only in their historical and cultural matrices but also in their different employment of tragic, comic, and satiric tonalities, reconfigure the Palace monologue. In their diversity they express little in common except resistance to bullying mischaracterization. We can profit from their example as rhetorical models. But their import extends beyond this formalist function. They are also markers of historical significance. We might add to their consideration the reframing and recoding in David Wong's play *M Butterfly*, which tells a very different story about the Western involvement in Asia than Puccini's opera. In Thomas Alea's film script *The Tempest*, Shakespeare's Caribbean fantasy is rewrit-

ten with the whole psychology of inferiority drawn from it under the name of Calibanism. As Alea tells the story, Caliban is a determined revolutionary against Prospero's colonization who attempts to enlist the more acculturated houseservant Ariel in his conspiracy of liberation. LeRoi Jones's *Dutchman* is yet another work that rescripts a Western classic narrative: in this case, the Flying Dutchman of Wagner's opera, doomed to search the seas endlessly until he can find a soul willing to sacrifice her fate for his liberation. Jones's play recovers in this myth a prototype of the aggressive individualism of Occidentalism searching for unwitting victims in the wider world.

The number of works involved in this rewriting of history is immense. To the token few discussed so far should be added the current reinterpretation and rephrasing of the Grimm brothers' fairy tales.[10] Research into the original folk tales reshaped by the brothers shows them to have come from the kitchens of peasant women, frequently fixed upon the injuries and abuses women were burdened with by the men in their houseworlds. The Grimm tales systematically transcoded the sentiments of these tales, routinely sanitizing and ennobling these legendary domestic abusers. Works are now appearing in which the original sentiment is restored to these "old wives' tales." As in many refigured narratives, the reconstructed version uncovers some expressions of heroic humanism erased as contradictory to the patriarchal script. In the light of this recovered knowledge, we can see in Alice Walker's novel *The Color Purple* a modernized fable of the sort distorted by the Brothers Grimm.

These stories are people's history in the sense that, if the broad public gets its history from stories, even non-fictional ones, these works, widely seen and respected in many quarters, prove successful in imposing provocative reincarnations upon our view of the present. History exists here like a presence that in another time might have been called spiritual—if not as a persona, then as a living, changing entity. It exists in these works as though it has been experienced and is still being experienced, without aesthetic distance, without the pageantry of colorful cultural reproduction. Their impact on the present pungently dismisses the thought of genrifying them as "historical" films, novels, or plays. Their historical vitality is such that the language of conventional criticism only deadens them, without claiming victory over their urgency. They thus demand and deserve new critical thought and language.

What these Achebian narrations contain more decisively than many other narratives is the content and strategy of critique embedded in their texts. At junctures of cultural crisis like the one from which these works

arise, the function of critique, which is always implicitly (but sometimes sheepishly) present in any artwork becomes a determining element. The role of liberative historical critique is carried by the allegorical meta-discourse conducted in these works of resistance and transformation, usually in a wider scope than in formal criticism, where the comparable bite and resonance is typically missing.

Formal, academic criticism is often intimidated by such works, since by the fiat of the aesthetic and the boundaries of the art-culture hegemony, such undisciplined interventions are contraband. While the function of renovative criticism, beyond locating the predications, framing, and control of discursive irony in cultural productions, is to "unpack" their wider implications and connect them with other revisionary histories. These conflicting motives are dramatized in the innovative museum exhibition called Exhibition-*ism* and staged at the Museum for African Art in New York City in 1994.[11] Techniques of framing interpretation of cultural objects in museum display were the subject and object of this show. One revealing stratagem was to juxtapose two "ironic" wall texts, one of the conventional sort, and another detailing the kind of information that the curator usually has at hand but leaves out as inelegant. So an object might be described with a title, its material, size, source, and perhaps some note about its cultural use. The self-reflexive alternative wall text added such information as where it was acquired, when it might have been judged a fake, who possibly carved it, how much was paid for it, what materials were added to it after acquisition. The two texts revealed the chasm between the aestheticized framing of the object and its presence as a historical, possibly political signifier. Similarly, narratives of resistance form a universe of alternative discourse at war with classical narrative, uncovering veiled perspectives and undercutting the symbolic logic of a film like *Imitation of Life* or Hollywood's many other unenlightened imitations of life.

CHAPTER XI

■

The Self-Authenticating Narrative

The recodification of knowledge gets us embroiled in sometimes painful ironies and contradictions. At the moment their efforts finally win some recognition under the banner of the aesthetic (like the dubious recognition of a "Black renaissance" in a special cover story in *Time* magazine in October 1994) some cultural narrators of emergent populations may become irritated to hear that that banner salutes a corrupt ideal. This news may be taken as an even more painful contradiction if their economic livelihood depends on their credibility within the art-culture system. Reframing knowledge always means disrupting social and personal histories that people are caught up in living at the moment. To turn to a familiar example, when the feminist movement vehemently challenged our understanding of gender relations in the early 1970s the irony was not sweetly received by some men, who had previously thought of themselves as model human beings, not as "sexist pigs."

There is a related resistance to reformatted knowledge and values in the hunger for positive image. As a sensible adjustment to an uncomfortable situation, members of a dominated population will tend to give some grudging respect to the agendas and rules of the occupying power. Sneak into the metropolitan society, go to school, and study hard; get a job as a busboy first, and you may work your way up to a managerial position; buy a house, a late model car, and send your kids to university. Indisputable wisdom. But the time comes, a crisis moment, when a searching reexamination of the agendas of the powerful becomes possible, and liberative. Some will seize that moment and some will nervously resist its possibilities.

The declaration of a Black aesthetic was such a moment—liberating for some and repugnant to others in the minority community. Several minority artists and writers were uncomfortable with the new direction in cultural thought. Those who adjusted to the Black aesthetic may in turn

be made unhappy by the challenge to abandon aesthetic rationales whole-sale. In most such situations, the argument for positive images reflects the position of social inertia. For many, positive image means positive according to the prevailing norm: protesters and demonstrators will be expected to wear correct shirts, ties, and jackets. (I do not rule out the pragmatic use of such symbolics as ways of controlling media represen-tations.) Others may set up an alternative value system, based on libera-tive principles, and fan a desire for the uplifting image based on that model. There can be a positive image ideology rooted in Cyclopism, and a positive image ideology rooted in resistance—the celebration of the po-litically correct.

The crucial lack in nearly all positive image scenarios is an apprecia-tion of history as a living, dialogical process. Here I am building on (and freely adapting) Patrick Taylor's argument in *The Narrative of Liberation*. Taylor draws a line between mythic narratives and narratives of libera-tion. Mythic narratives, like the Anancy and the Spider stories for example, dramatize and fix traditional knowledge, seek for enduring truths, cele-brate ancestral values. Narratives of liberation, by contrast, locate the in-dividual tale within the circulations of history, within concrete political frameworks that are frequently ignored by the mythic narration. In the mythic narrative, certain individuals, beings, and roles have stable posi-tions. The characters are archetypes. In the narrative of liberation, the characters, their actions, and their meanings are relational. History in the narrative of liberation is dialectical. Therefore our reading of narrative also needs to be dialectical.

We have seen how the "authentic" narrative loses its force when we discover that the identity of the author is of a different color, gender, or political ideology than we first believed. A kernel understanding of his-tory as dialogical construction is located in the mental shift we make when we learn of some very different source for a work we first admired, or hated. Our admiration is relational not only to the assumed identity of the author, but also to the shifting meanings the work might hold in different time periods and interpretive contexts.[1] One of the most fasci-nating instances of shifting historical interpretations is the wildly vary-ing interpretations of Caliban in different stagings of *The Tempest* over the centuries, varying from different animal- or fish-like characterizations to any number of ethnic and racial types.

History as changing, multivalent constructions that enable and em-power collective activism differs from those ideas of history that provoke the demand for positive images—history as myth, or history as saga of

heroic individuals. The impulse of positive imagism often produces the desire for compensatory heroism. The most-repeated aspiration of Black Hollywood male actors used to be to make a film of Toussaint L'Ouverture. The second favorite theme would have been Pushkin. But in opposition to the cultural dependency of this desire—mostly a reaction to majority misrepresentation—another form of narrative desire arises.

This other narrative hunger, which raises new challenges for radical resistance, is the desire for the self-authenticating narrative.[2] The interpretive frame of self-authentication is at work when the narrative is "free" of reference to majoritarian power, when the tale sings itself for itself and its hearers, uncontaminated by the potentially distortive need to rebut, reverse, or recode a hostile alternative. The foundation of its appeal lies in its achievement of a sense of wholeness. In its denial of the zero sum manicheanism of colonialist and anti-colonialist discourse, the narrative that validates itself autonomously, through its inner cultural resources gives the illusion of microcosmically approximating the condition of freedom from mental oppression for the individual or group. Is not even the resistant narrative indebted, even parasitically bonded, to the master text? If this is so, only the story that emerges uncluttered by debt of influence, even negative influence, any looming taint of *ressentiment*, can be freely self-authenticating. The spontaneous, indigenous cultural presence and ambience of the group may be allowed to stand in its own right, as something worthy of attention and recognition, with that recognition sought from the interpretive community of the author, or what Toni Cade Bambara calls its "authenticating audience."

The impulse toward self-authenticating narratives seemed to accelerate in the 1980s. Some radical or rebellious movements took a turn inward, toward self-identifying realms of myth, magic, ritual, fantasy, and collective memory. This development was all the more striking when it came from quarters noted for militance and confrontation such as "third cinema." *Tangos: The Exile of Gardel* was one of the most notable of the turnabout films. Its director, Fernando Solanas, had been one of the founders of "third cinema," a movement designed to use the camera as a filmic arm of Third World revolutions. "First cinema" in this analysis is the cinema of escape and evasion coming out of commercial Hollywood. "Second cinema" is the alternative of art movies, led by various waves of European films. In the 1980s, "third cinema" went into decline after having established a theoretical background to a historic rise of brilliant resistant films like *The Other Francisco, Lucia, Battle of Algiers, Soleil O, Burn* (by Gillo Pontecorvo; third cinema was never defined as exclusively

"third world"), the films of Ousmane Sembene, several wonderful films from Communist China (contra the anti-socialist propaganda line about boy-meets-tractor social realism), and many others. In China the death of Mao and the reforms of his successors influenced a change in story-telling policy that made possible films like *Horse Thief*, where political nuance, if present, was undetectable to Western observers. The appearance of such films from places once marked by radical intellectual resistance might have been a trial canary signaling the coming of Perestroika and the decline of international Leninist socialism. *Almacita Di Desolato, 1001 Camels, La Vielle Quimboise et le Majordome, Yeelen, She's Gotta Have It, Halfouine* are some of the films suggesting this departure from third cinema.

The attraction of the self-authenticating text was the promise of authenticity in the Sartrean-Fanonian sense of psychological wholeness, of unlamented being. Western psychology has given us a florid portrait of the colonized man as a psycho-cultural castrato, a eunuch, a shadow, an archetypal Caliban, fractionated by inferiority feelings, a black skin wearing a white mask. Was it not possible to overcome this mark of oppression by fashioning narratives where reminders of the occupiers were absent from the premises? The celebration of vernacular tradition feeds on this thirst for self-authentication. Was it not obvious that resistant texts were crafted by intellectuals educated in the shadow of the Palace, intimates of its philosophies and paradigms? A more natural mythic birth of self-authentication would spring from those who had nursed from independent, collective memories since birth. Vernacular forms such as the blues offer heroic examples. The illusion of utopian worlds before the coming of the European colonizers plays a larger role in this drive toward cultural integrity.

TOOTHSOME AND TOOTHLESS TIGRITUDES

Yeelen is the third feature film of Souleymane Cissé, of Mali, to intrigue international audiences. His two previous films, *Baara* (*The Porter*, 1978) and *Finye* (*The Wind*, 1982), were national allegories of corrupt neo-colonialist regimes stifling the labors of honest men and the idealism of young Malians. Following them, *Yeelen* was something of a surprise. For Cissé, the shift was unmistakably dictated by the political situation in Mali. Official pressure against these films mounted to the point where Cissé recognized, "If I wanted to stay in my country and enjoy a degree

of the freedom of expression, I had to lighten things a bit, or to make a different type of cinema. . . . I had to put my thesis at a deeper level. I made *Yeelen*, which to me is my most political film."[3]

Yeelen returns to a favored Cissé theme: conflict between the old and the new. But now that theme is worked out in the fabulous past, steeped in myth and traditional ritual. This time, the conflict is a father-son struggle to the death between Soma Diarra, a leader of the feared secret society of the Bambara, the Komo, and his son, Nianankoro, who attempts to use the sacred knowledge of the society for different purposes. The father believes the son has stolen the ritual and corrupted it, violating the holy compact that produces its power. The son respects the awesome authority of his father, but resists the father's use of ritual power to terrorize and abuse those weaker than himself. The son flees with part of the vital instrumentality of magical power. The father pursues relentlessly until the two meet in a combat to the death in which they are both vanquished in what looks something like a mushroom cloud explosion. *Yeelen* tells a story that some have seen as somewhat akin to the great West African epic, *Sunjata*. If anything, Cissé's film is more traditional than *Sunjata* since it is further removed from any explicit historical period, and unlike *Sunjata*, the beliefs and customs of the Bambara people at the center of the film show no outside influence, even of Islam.

One of the most popular recent African movies among African and international audiences (it won the Jury prize at Cannes in 1987), *Yeelen* unfolds among spectacularly beautiful scenes and images, magical feats and symbols. Much of the film's compelling aura comes from its mythic splendor and its symbolic license, which commanded critical attention as a kind of African version of magical realism. Hieroglyphic, graphic signs appear at the beginning of the film along with gnomic texts. A point of excitement in Mali is the film's depiction of the Komo ritual, a ritual of a society so secret in Mali that most Malians had never seen it, and one for which Cissé had to get permission from the society authorities to reproduce on the screen. When a number of African films (produced by Africans) are shown to young people in the United States, *Yeelen* is usually chosen as the one best liked.

But what can we make of Cissé's assertion that *Yeelen* is his most political film? Here, the issue of self-authentication is compactly raised. Without putting *Yeelen* on trial, or asking more of it than the high intellectual and imaginative pleasure it has given us, we must ask, is a narrative like *Yeelen* more political than explicitly confrontational works of resistance narrative?

One can imagine a profound political resonance in the film for Malian audiences. At its deeper level, the story evokes Bambara traditional culture as it has never been seen before on the screen. The film is an act of cultural validation of the first order. It contributes to the rewriting of African identity, supplanting the caricature of Africa from inanities like *Tarzan* to obscurations like *Out of Africa*. And at the allegorical distance of the narrative, the combat between the old and the new in Malian history could not be mistaken by Malian audiences as other than a meditation on the contemporary struggles of Mali as a political body, out of which a movement has recently emerged to end military and authoritarian regimes and institute a more democratic process.

But the question remains whether a narration that confines itself to the cultural history of its host population plays as effective a liberative role as one that addresses its political contingencies directly? It is a question with a history, of course. Through yet another framing of the question, that of Fanon's celebrated three stages, *Yeelen* might be seen as a retreat from his earlier films where his audience might be aroused to anti-imperialist battle, as by a fighting song, and back into the second stage in which the "native intellectual" remembers that he is a Black man and abstractly immerses himself in the culture of his people.

Cissé acknowledged that by the time of *Yeelen*, he had exhausted the possibility of making politicized films in his country, controlled by military dictatorship. And some of the films that declined politics and abandoned "third cinema" were made by directors in exile. Might the role of resistance resemble a psychological exile from everyday, routine experience, an analytical and intellectual alienation? Fanon writes of the native intellectual who, at one point in his prerevolutionary development, suddenly rediscovers his people: "[W]e find the native is disturbed; he decides to remember who he is."[4] Coming after their seasoning in the sophistications of the Palace and its academies, the phase that follows is like the ending of an exile from their culture: "Because they realize they are in danger of losing their lives and thus becoming lost to their people, these men, hot-headed and with anger in their hearts, relentlessly determine to renew contact once more with the oldest and most pre-colonial springs of life of their people."[5]

In Fanon's scenario, there then follows a third phase, when the native intellectual gives up his culturalism in order to write battle songs of popular and national revolution. This third phase is possibly a primary source of the "third cinema" concept, which tries to actualize Fanon's revolutionary program in the context of film culture. However, the haz-

ards of this struggle may involve their own forms of exile, both literal and figurative. The irruption of culturally contained, politically muted films within the space of "third cinema" in the 1980s may enact a rebound to an earlier stage of historical experience. This would be a return from the exile of political struggle in a postcolonial setting to a revived program of redemption through cultural tradition and affirmation.

If *Yeelen* is a self-authenticating document, what does that imply about its politics of representation? This question might evoke some of the same criticism made by Fanon of culturalist intellectuals, and also some different responses. The cultural movement targeted by Fanon's acerbic analysis was *negritude*, the cultural revivalist, largely francophone movement of writers that celebrated Blackness and African civilization. Negritude was different from the self-authenticating impulse since these writers were very consciously political in their work, often Pan-African nationalists, explicitly and vehemently anti-colonialist, and strongly resistant to Eurocentrism. Some of their work may be seen as motivated by the desire for positive imagery (but not always), and some of it has been critiqued for a reflex oppositionality. In fact, one of the best-remembered verbal assaults against negritude was a reproach for its lack of self-authentication. "Does a tiger declare its tigritude?" asked Wole Soyinka.

The tiger in this rhetorical question cleverly embodies the concept of self-authorization. Think for a moment. The being of a tiger. Can we suppose him (or her) to have an identity problem? Does the tiger identify himself as the Other of the animals he encounters in his habitat? Does he define himself as the Other of the eland he chases down for lunch? Or any other creature? Soyinka wants us to think of the tiger's psychological integrity, his unquestioned sense of himself, but also his power, which goes far to confirm his confidence. Does not negritude in proclaiming its pride in its Blackness highlight an insecurity that prompts its demonstrative outbursts? The argument has some powerful supports and some merit, though the analogy, like most, leaves some loose strings.[6]

The dilemma of self-authentication is that in seeking to escape the alienation of the margin, it also escapes history. By opting for an imaginative discourse free of the reference to the history in which Europeans invaded, enslaved, colonized, or commodified most of the world, the self-authenticating text disarms itself from important agencies within the political struggle of representation. If our notions of history are alert, we might question the totalism of the narrative that authenticates itself through cultural autonomy. It may do so within "art," or within "culture," but it cannot preserve that autonomy, even as a fiction, within his-

tory. The hope invested in history-free creativity ignores the long reach of power/knowledge. The work generated for a particular authenticating community cannot insulate itself against reinterpretation and misinterpretation in other venues. The vernacular work or vernacular-inspired work must claim its resonance in a communications marketplace, a "society of the spectacle" where power respects no innocence. We patronize such works if we absolve them of accountability to history.

What are we to make of the reception of such works, the clamor of applause in the suburbs of the Palace? Are they not heirloomed, museumed, and celebrated for that same authenticity that the resistant intellectual once sought there, one step behind the anthropologist? Is not that celebration and applause an ironic echo of the cry of discovery shouted by "the native intellectual" reimmersing himself in his once-abandoned culture, in Fanon's parable? Apart from its refusal of history, the vulnerable point of the self-authenticated work is its denial of irony. With his head in the sands of representation, the self-authenticating narrator cultivates illusions of transparent, unambiguous communication. It is like the gesture of a child who puts his hands across his eyes and believes that he cannot be seen.

We should not too quickly lose the values that self-sustaining works bring us. Despite the facility of Western capitalism in erasing any cultural formation that stands in its way, these works affirm, "I am still here." They archive and validate traditions, perceptions, and practices, and give them textuality and body. They bear witness that the peril of cultural extinction through homogenization has not prevailed. Were its mission achieved, the autonomous cultural project would realize one of the major goals of decolonization.

But the success of this kind of production remains precarious, sometimes surrendering hostages to capital-driven piracy. The self-authenticating document is liable to misappropriation within the claustrophobic framing of the folkloric. To make a work self-referential in the way of such texts is to invite the ethnographic gaze. The self-authenticator in fact does the job of the classical ethnographer for him, namely circumcise historical and political context from the field of knowledge. This operation makes the document more, not less exposed to hostile reinterpretation of its significance. In the United States, the blues as a celebrated, self-authenticating documentation might also stand as a warning of the greed of the appropriators.

Once again Achebe's novel *Things Fall Apart* gives a telling demonstration case. It is possible to imagine Achebe's tale as a self-authentication

THE MASK OF ART

text, and surely that is one of its driving motives. Delete the passage about the district commissioner and his intention to add material to his book. Withdraw a few small but important passages about the coming of colonialism. What would then be left is a tale of a self-sustaining culture, possibly approaching the myth of an African golden age before the coming of the Europeans. The story would be "mythic" but not "liberatory." The ethnographic dimension of the novel, already widely recognized, would become its dominating focus. As such, the work would be more routinely exoticized than it already is. To be sure, the work might seem to contain an oblique reproach to Western civilization: see how nice our lives were before you stepped into our Eden? Such an implied reading would rely on anthropological good will, a value that hardly penetrates to the innards of Western consciousness. The inclusion of the one paragraph about the district commissioner's perspective forestalls easy appropriation. Of course any text can be recoded or appropriated, but the irony of this gesture makes hostile appropriation uninviting.

The insertion of even minimal political signatures within an otherwise self-authenticating narrative of cultural revival signals resistance to misappropriation, much like an anti-copying device on a videotape or an anti-theft bar in an automobile. In the absence of such references, *Yeelen* is left open to self-serving readings of Western discourse. One of the risks taken by a self-authenticating film like *Yeelen* is to place itself where it can receive grateful respect from Western viewers for its artistry, its focus on "the human condition"—which has become a code-word in the Artworld for "not disturbing to the values of the reigning middle-class." Specifically, the film runs the risk of appeasing the gaze of primitivism. But it does maintain its dignity in the face of such an Ethiopicist fantasy. After one screening of the movie, a somewhat puzzled colleague asked me, "It's about an Oedipal conflict, isn't it?" I tried to explain how the Freudian notion of father-son conflict may be complicated in some African societies by the tutelary role of uncles and other kinship principles. But even more urgent in her question may have been the hope of aligning *Yeelen* within the canonical and familiar frames of ancient Greek narrative. As Patrick Taylor argues, "Liberating narrative, however, does not lose itself in an abstract universality, divorced from all temporality. Liberation is only meaningful as the realization of freedom in time, that is, as a lived universal."[7]

My own relative ignorance of Bambara culture is of a different order. There may be an art of not-knowing about another culture, not yet perfected by anthropologists, in which the observer guards against her

own construction of a bogus "authenticity." Such an art would include continual guard against formulae of perception like pop anthropology, fantasies of the exotic African, the trivialization of folkloric fascination, disingenuous vaporizing about "universal art," and a-historical and a-political reference of cultural specifics to an essentialized "human nature."

There is also a danger in seeing the political only in terms of engagement with Western dominance. But *Yeelen* is only relatively a-historical. It is clearly historicized as "before the Europeans" therefore focusing our attention on "internal" dilemmas that Western audiences are not used to observing attentively. There are certainly politics evidenced in the tale, Malian politics, and politics that can be learned by anyone willing to watch narrowly. The pivotal idea in *Yeelen* of stealing a powerful system of representation, not only from an older, oppressive generation but also as an alternative to a Despotic system is eminently political. Nor can one fault the filmmaker for making his statement in the oblique manner available to his political situation. His resort to indirection establishes the positioning of his film as a Strong Aesopian allegory vis-à-vis the political reference of Mali, and a Weak Aesopianism in the face of Western discourse.

THE MARK OF ZORA

Zora Neale Hurston saluted her novel *Their Eyes Were Watching God* because it is unpolitical, and therefore ideologically innocent. In her argument for such a literary ideal, she gives an aggressive defense of the self-authenticating narrative: "The Negro artist . . . conceives that a Negro can do nothing but weave something in his particular art form about the Race problem. . . . the effect of the whole has been to fix activities in a mold that precluded originality and denied creation in the arts."[8]

The barrage of criticism her novel received from Black men writers has been interpreted as rooted in mysogyny. An element of sexist ill will can never be ruled out. Zora's provocative personality must have been a sweaty challenge to male egos in her times. But it is too easy to dismiss the arguments made against *Their Eyes Were Watching God* and its author on the grounds of its politics of representation, specifically that its handling of discursive ironies was less than liberating. Hurston's novel has, since the revival of the feminist movement, moved toward the status of a canonized American classic. Within the terrain of its time, though, it

raised some arguable issues. Richard Wright, Alain Locke, and Sterling Brown interrogated the book *because* of the political neutrality that Hurston saw as one of its main attractions. Today we recognize that there is a considerable, developed reference to racism in the novel, set in Florida. But this reference functions in the margins of the novel's basic character as a love story.

The critiques by politically committed writers in a highly racialized period point to the dangers of self-authentication—that it is liable to folkloric reduction. The 1930s Black literary scene was influenced by a left, materialist ideology, reacting negatively to the primitivist gaze that influential White gatekeepers had directed to Black writers like Hurston during the Harlem renaissance of the 1920s. There is something of the demand for politically correct imagery in their critiques. At the same time, Hurston's education as an anthropologist is seldom given attention as an ideological location in her work. But the possibility of an ethnographic gaze, a doubled ethnographic gaze, one outsider, the other insider, is very much present in her novel. Hurston evidences the subtlest understanding of the ironies of discourse in her novel. Her text produces the double-visioned Aesopian phrasing of "A huge ditch was dug across the white cemetery and a big ditch was opened across the black graveyard." There was obviously among her critics the fear that the openness of her work to the outsider ethnographic gaze might also open it to Ethiopicist scrutiny, or more simply, that Hurston might minstrelize Black American experience. This was Richard Wright's point: "Miss Hurston voluntarily continues in her novel the tradition which was forced upon the Negro in the theater, that is, the minstrel technique that makes the 'white folks' laugh. . . . She exploits that phase of Negro life which is 'quaint,' the phase which evokes a piteous smile on the lips of the 'superior' race."[9]

The essay Hurston wrote a year later was a kind of manifesto of her creative aims and at once a consolidated retort to the critics of her cultural politics.[10] Hurston estimated the art and literature of the Negro American as insignificant because it suffered from obsessive concern with the race problem. Consequently, "what was produced was a self-conscious document lacking in drama, analysis, characterization and the universal oneness necessary to literature." Hurston quotes for support a White reviewer of an earlier novel of hers: "Here at last is a Negro story without bias. The characters live and move. The story is about Negroes but it could be anybody. It is the first time that a Negro story has been offered without special pleading. The characters in the story are seen in

relation to themselves and not in relation to the whites as has been the rule. To watch these people one would conclude that there were no white people in the world. The author is an artist that will go far."[11]

Pursued to its fullest, the self-authenticating narrative returns us plumply into the arms of the original tar baby of aesthetic contemplation. Self-authentication, which in Hurston's mind is important mainly as validation of individual talent, can claim "disinterest," just as aesthetic reasoning does. Its posture can be interpreted as "above" politics. However else we read the desire for the self-authenticating narration, its appeal remains suspiciously akin to the much-mystified condition of the work of art in the lexicon of aestheticism. It attracts the familiar rhetoric of approaching the condition of art, the claim to be autotelic, self-referencing—the self-authenticating work, like the poem in McLeish's formula, "should not mean, but be." The insistence on independence from ideology takes one step toward aesthetic self-deception.

Neither positive imagism nor self-authentication embraces the complexity or the contrariness of knowledge, which leaves them unhistorical. Imagine a text that satisfies either hunger transformed into a history text and you quickly see their limits: an uncritical, feel-good exposition of heroic or correct behavior on the one hand or a cultural narcissism bordering on chauvinism on the other. Lacking historical perspective, they turn their faces away from the condition of modernity.

What happened to Hurston's novel gives us some lessons about self-authenticated texts. But these are also lessons about history and the narrative of liberation. At least two discourses have arisen since the appearance of *Their Eyes Were Watching God* to enlarge and alter the novel's significance. One was the Black aesthetic movement, which orchestrated a reimmersion into the vernacular dimension of Black culture, much as Fanon's second phase outlines. Since the 1960s, her novel has been enjoying a culturalist moment. The reversal from Black insecurity to Black pride enabled readers to celebrate ethnographic aspects of her novel that some contemporaries deplored.

The larger discursive shift in the novel's reception has of course been its resonance and reinterpretation through the feminist movement. Even at the risk of distorting Hurston's original intentions feminist interpretations have opened the narrative to many-faceted readings through which the work's splendor shines with new brilliance.[12] At the same time these feminist readings have tended to celebrate the story's neutralization of socio-racial politics, along with Hurston, emphasizing its cultural self-authentication and its aestheticism as somehow a counter to a politi-

cal reading that is vaguely assumed to be masculinist.[13] These feminist readings seem willing to benefit from the appeal to a postnationalist, or postcolonialist phase of representation in which politics and the politics of representation are submerged. *Their Eyes Were Watching God* would then be joined to those films that withdraw from the struggles of third cinema.

It is safe to say that a text cannot be regarded as liberative by virtue of its self-referentiality alone. Its historical contribution is jeopardized if its cultural originality precludes an awareness of the power formations that work to control its meanings. However much we celebrate the documentation of human integrity in such texts, the discharge of their ironies into general discourse is not guaranteed to be progressive. Denial of the relevance of power is one way of inching toward Cyclopeanism.

Other lessons can be drawn from Hurston's conception of her novel and its varied receptions in different historical periods. For me, the most significant conclusions have to do with the salience of history seen as living process, as complex and changing as language, and the necessity of this conception of history as background to any sensitive reading of cultural works. It is ironic that the position of Hurston on "art and such" (the "and such" working as a hedge against pomposity) is opposed to the frame of reference through which her novel has made a stunning comeback since the 1970s. It is the very intensely political review of her novel that has given its depoliticized "art" a chance to shine forth, though with resonances that may have surprised her. Which is to say that the limitation of both positive imagism and self-authentication is an insufficient grasp of the critique of representation.

There is an appreciable hunger among postcolonial spectators for documents of exorcism, for works in which their people are just themselves, not reactors trapped in mimicry of others. But the fate of such documents within the politics of representation has repeatedly been transformation as museumed artifacts, like African sculptures, or disarmed symbols of nostalgia, like the blues of African Americans, or Dylan Thomas's tipsy prefatory exoticization of Amos Tutuola's novel *The Palm Wine Drinkard*. When the pursuit of the authentic and autonomous cultural experience dismisses the presence of a global system of knowledge operating under hierarchical controls, that pursuit becomes a form of whistling in the dark.

If we are more advanced in our reading of this issue since Zora Neale Hurston drew her position in 1938, it is because of challenges presented to the ideologies that exploit the self-authenticating cultural document

for their own benefit. The canonical reception of "art" and "literature" and the universality thereof, as well as the paradigm of an essentialized "human nature," have been reinterpreted within the politics of representation as colonizing instruments of a domineering art-culture system. These challenges to the overdeveloped world system of interpretation help make the world somewhat safer for an unhegemonic reception of *Yeelen*. Just as Cissé's film may contribute to possibilities for freer political discourse elsewhere.

Ummediated by defining boundaries and resistances to appropriation within the work, cultural identity can be "laundered" into cultural non-identity, and made tributary to another cultural tradition. A film or novel may have great power as an icon of cultural presence. But it has a better chance to control its identity by tying down within itself resistances to malappropriation.

CHAPTER XII

■

The Imperfect Narrative of Resistance

> I am not sure it is possible for a Negro to write well without making us aware he is a Negro. On the other hand, if being a Negro is the only subject, the writing is not important.
> —Louis Simpson, quoted in *The Black Aesthetic*[1]

> The values that keep the dominant set of criteria in power are simply ineffective in a framework where one no longer abides by them.
> —Trinh Minh-ha, *Woman, Native, Other*[2]

> I am outside
> history.
> I am inside history,
> it is hungrier
> than I thot.
>
> —Ishmael Reed[3]

Positive imagism and self-authentication reflect different angles on a crucial problem in the politics of representation—how to position oneself in the face of overwhelming, alienating power/knowledge. Beneath that question lies another: who are the "we" that is mounting this resistance and how do "we" conceive ourselves? Though very different, even diametrical alternatives, the two perspectives are alike in limiting themselves within a low-productive culturalism. The weakness of culturalism as defined here lies in buying into notions of culture organized by the canonical art-culture system, partly as articulated by Matthew Arnold and partly by classical anthropology. This is a view of culture divorced from history (except a kind of museum catalog, cultural history), and therefore from political analysis.

The limitation of these two culturalist perspectives are overcome in the

theoretical insights of Julio García Espinosa's essay "For an Imperfect Cinema."[4] Writing as a Cuban filmmaker and theorist, Espinosa fashioned an argument usually considered a part of third cinema theory, and as such, remains one of its most endurable products. If dominant cinema has managed to present itself as "perfect cinema—technically and artistically masterful," then there is no better choice for the resistant film activist than to cultivate an "imperfect cinema."[5]

Espinosa's case for a new concept of cinema rests on an anti-elitist critique of "art." Art as an isolated, impartial, uncommitted activity, as produced by individuals regarded as special and different, as an activity carrying its own, peculiar cognitive agency, is recognized by Espinosa as an irrelevance: "A new poetics of the cinema will, above all, be a 'partisan' and 'committed', art, a consciously and resolutely 'committed' cinema— that is to say, an 'imperfect' cinema."[6] Instead of the "perfection" claimed by high art, Espinosa advances popular art, by which he means cultural work practiced as a general, social activity, in which the collaboration between the work and the receiving audience/population is foregrounded.

For critiques of aestheticism, the example of jazz quickly rises as an example of cultural production amazingly vital and yet amazingly free of the rules and regularities of classicism. Not surprisingly, then, in an argument somewhat parallel to Espinosa's, one writer, Ted Gioia, discusses jazz as *The Imperfect Art*.[7] True, jazz embodies many of the features that mark the concept of Espinosa's imperfect cinema, its call-response relation to its audience, its commitment to improvisation and process rather than to calculation and product, its collective authorship, its irreverence toward tradition, its unabashed populism. Gioia senses the revolutionary potential in this configuration: "An aesthetics of jazz would almost be a type of non-aesthetics."[8] If Gioia inches back from the precipice of this discovery, retreating into bromides about the creative artist in an attempt to win a place for jazz musicians in this lineage, we need not follow him in these regressions.

In both these descriptions "imperfect" must be understood as ironical, that is, as depending on a double meaning, twinned with the concept of the perfect that those with the privileges of power/knowledge are eager to impose. The concept of "imperfect" culture acknowledges this power to define at the same time that it rejects the substance of the definitions. It exposes the irony that resistance will always embrace contraband meanings and values, and these meanings and their carriers will always be framed as unofficial, unorthodox, indiscrete, undisciplined, chaotic, methodologically incorrect, vulgar, or in a word, imperfect. Speaking in

an entirely different context, Fanon glimpsed the imperfection of the colonized populations: "In the Weltanschauung of a colonized people there is an impurity, a flaw that outlaws any ontological explanation."[9] This is the Fanon that sees the condition of the colonized as a pathology, not the later Fanon that sees it as a moment pregnant with change and transformation. In other words, Fanon and Gioia recognize the impurity of uncanonized people and their thought and culture, but with less of the irony that Espinosa brings to the models against which they are inevitably deemed lacking. The shallowness of "perfection" is perhaps more quickly grasped in Espinosa's example of the cinema of perfection, the slick, technically poised practice of the culture industry.[10] It is the perfection of an aestheticized cultural regime, of the Crystal Palace, and by isolating it from other possibilities Espinosa refreshes our eyes to the ordinary.

Imperfect narrative differs in fact from two kinds of "perfection." Hollywood has honed its product since the classical era to the point where a trained audience easily buys into its aesthetic contract, glibly scuttling any deviation from the standardized form of storytelling.[11] With millions at stake, Hollywood executives have once again resorted to a sure-fire formula for a screenplay, based on the book, *Screenplay* by Syd Field.[12] Following the how-to directions of this cinematic cookbook, Hollywood executives reportedly routinely turn to page 30 and page 60 of an expected 90-page script in order to find the crises/resolutions required to make a successful script. Screenwriters, in turn, when watching a movie, say they are often able to tell which page of the script they are watching, particularly when the story reflects pages 30 and 60. The 30–60–90 regimen of movie construction poses one form of oppressive perfection against which a liberative movement would have to contend, or bear the curse of amateurishness.

But there is another, older view of the perfect that carries its own, unproductive contract. The discourse of aesthetics in its start-up phase advanced the perfection of the work-in-itself as the ideal to which "true art" must aspire as opposed to the inspiration of pleasure in an audience. Writes Karl Philipp Moritz in 1785, "But if the actual purpose of your work was the pleasure you wished to effect rather than the perfection of the work itself, then the approval of your work by this or that person will for that very reason be suspect to me."[13] The "perfection" of aestheticism, Woodmansee makes clear, was a compensatory movement against the threat of mass literature and its hold on audiences, its appeal to the sensations of its readers. One can just barely hear Moritz making the claim

that would characterize many of his successors in aesthetic reasoning: that the popular success of a work may very well be grounds for disputing its artistic merit. Moritz, one of the founders of aestheticism, is also a major contributor to the development of what Martha Bayles has described as "perverse modernism."[14] The Romantic-modernist-avant-garde devotion to the perfection of the work as thing-in-itself usually went along with the celebration of personal failure and suffering as sign of integrity. In this commitment to failure, they relish an egoistic irony that is very different from the "imperfection" Espinosa salutes.

Bill Gunn, the widely gifted but neglected director of *Ganja and Hess*, who was also a playwright, novelist, screenwriter, painter, and actor, insisted "you must not succeed." But this injunction applied specifically to the imperfection demanded of the Black cultural narrator, not to the voluntary isolation of the high modernist. Because, paradoxically—and this is a point too seldom seen in Euro-left criticism—the repugnance of liberative works, in the eyes of the Palace, may lie in their immediate and often successful appeal to the popular. Which is why it is important to recognize that imperfect cinema does not reject the popular, in fact celebrates it as an arena of communication where the free exchange of ideas is more likely than in either the terrain of formulaic mass culture or the autotelic pursuit of "pure beauty." From this vantage point, we may better see how the movies of Spike Lee, for all of their sometimes financial success and popular appeal, may also express the power of imperfect cinema.

It is very certain that Espinosa, in promoting "imperfect cinema," is not validating shoddy technique, amateurish acting, bad writing, inferior production values, etc. It is equally certain that the phrase will continue to evoke such thoughts in many, perhaps the majority of those who encounter it—so firm is the grip of our trained, aestheticized reaction to films. This issue should be joined directly. There is a complete, double-tongued history of the development of "perfection" in overdeveloped cinema. Crucial to this progression has been the continual search for technical virtuosity, largely as a matter of "product definition," i.e., a way of elevating one studio, production team, or individual movie over others as a desirable commodity. The march of special effects that soon become standard practices, together with the streamlining of narrative patterns into the "classical" template, has produced an ever-changing canonized look and sound, calculated to make any alternative seem inept and flawed. Once the competition is viewed not as another studio, but another nation or class or race or gender or other political grouping, "prod-

uct definition" works to affirm a superior-inferior hierarchy marking variances from the norm as less desirable, shoddy, shady, suspect. The "slickness" of a Hollywood movie is an instrument of ideological domination and control. The capacity to spend excess millions on a movie production in order to maintain this slickness, as well as pay the stars who lend their charisma to it, is another feature of Monopolated Light and Power that helps it maintain its stranglehold on the appearance of rightness. The illusion of technical perfection in Hollywood movies always serves as advertisement for the economic system it represents as principal cultural agency.[15]

The combination of these carefully orchestrated illusions has managed over a century to implant the imagery of the Hollywood screen as an icon of desire, and the world off the screen as one, possibly, of revulsion. Consider N'Deye Touti, a character in Ousmane Sembene's novel *God's Bits of Wood*. N'Deye Touti is a pretty young African woman who has received more formal education than her neighbors, and constantly feels her difference. "She lived in a kind of separate world; the reading she did, the films she saw, made her part of a universe in which her own people had no place, and by the same token she no longer had a place in theirs."[16]

Along with her introduction to European education, N'Deye's mental construction had been altered, her consciousness aestheticized. The cinema is a principal agent of her transformation, the source of her dream of the romantic love of a Prince Charming. "And this, in turn, had made her recognize what she now called the 'lack of civilization' of her own people. In the books she had read, love was something that went with parties and costume balls, weekends in the country and trips in automobiles, yachting trips and vacations abroad, elegant anniversary presents and the fall showings at the great couturiers. Real life was there; not here, in this wretched corner, where she was confronted with beggars and cripples at every turning."[17]

The march of perfection relies on technical expertise and the charisma of privilege, but also on the ideology of purity versus corruption. It feeds the alienation of the young African infected by Eurocentric ideals. By the unequal exchange that flows with the rule of perfection, her world, the real world of her inhabitance, is rendered always/already imperfect. Happening on a documentary on a tribe of Pygmies, she is revolted. "She felt as if she were being hurled backward, and down to the level of these dwarfs, and had an insane desire to run out of the theatre, crying aloud, 'No, no! These are not the real Africans!' "[18] (This could very well be the same African documentary film that repels Bigger Thomas in *Native Son*.)

Cripples, beggars, dwarfs become the signifiers of the world imperfected by the unequal symbolic exchange of power/knowledge. They stand as the inscriptions of the disempowered habituated for us as stereotypes: they are lazy, ignorant, unduly emotional, ugly and deformed in appearance, dirty in their personal hygiene, improvident, pathological, sneaky, criminal-minded, diabolically superstitious, immoral, animalistic, sexually profligate, silly, childish, ill-tempered, pagan, illiterate, and backward. . . .

Espinosa's argument furthers the critique of aestheticism and the art-cult system. To accept the ironic imperfection of resistance may be the most decisive mental act for breaking the aesthetic contract. The difference between "perfect" and "imperfect" cinema fully dramatizes the ironies of discourse. Espinosa's trope engages an irony where the value-meaning of an imperfect work is always located outside the zone where the judgments of quality are made.

If cultural production outside the capitalized zone is categorically "imperfect," then resistant works from this area are imperfect on two grounds. First, by their origination in an unapproved cultural context, and second by their direct opposition to the values of "quality," through various reframing techniques. The burden of two codes of representation, one supported, the other opposed, must be carried by practitioners of imperfect culture. More important, the frame of knowledge emerging from resistance is inescapably incomplete, a work-in-progress, unavoidably "experimental," unsanctioned, lacking the grounding in approved tradition.

The dialogue of "imperfection" underscores the ironies of domination as well as subordination. The description of the "perfect" embodies the process I have been calling "entelechy," through which an object may be known by its highest, most ideal development as opposed to its premature or incomplete manifestation, as "man" is the entelechial fulfillment of "boy" in Aristotle's reasoning, or as, in the calculus of domination, "majority" is superior to "minority," Self to Other, Subject to Object, developed to underdeveloped, literate to vernacular, capitalized phenomena over lower-case experience, literature to writing, art to folk art or crafts. The point where the ironies raised by "perfect/imperfect" resonate most widely is in the framework of the narrative of mastery against the narrative of liberation.

Recall the double-image illustration of the simultaneous pretty woman and the unattractive old woman, "My Wife and My Mother-in-Law." The pretty young woman is favored by the master narrative. She only needs to be male to qualify as its norm-hero, but lacking that, her prettiness

makes her a fit object of that hero's desire and quest. The old lady is the young belle's alter ego, her co-defining Other. The perfections of the master narrative rely on the contrasting presence of imperfections, projected, as noted before, onto the maiden, the servant, the slave. In the schema of mastery, the presence of these incomplete types is necessary for the completion of the perfect story. Even more necessary, of course is the essence of corruption and imperfection, the villain who, were the narrative to be recoded, might also be viewed as a tempter of the maiden, servant and slave to rebel, and in some revisions, might even be understood to be the hero to these Others and their interests. (I hope it is clear by now that I am improvising on the foundation of Espinosa's germinal ideas.)

To develop "imperfect cinema" or narration as a concept means simply to work this irony into full consciousness. It is to recognize how imperfection has been essentialized as a characteristic of any undertaking not authorized by the social structure. Once again we must recall that the master narrative is deployed to control the interpretation of meaning in historical experience as well as in cultural works. With its reiterated theme of the inevitable progress and dominance of the Western bourgeoisie, its goal is always to locate perfection in the technical slickness of its self-image on the screen as an index of its relative perfection in the world.

Espinosa's figure of speech brings into daylight the hidden history whereby aestheticism has "imperfected" almost everything not favorably contributing to its self-image. We should understand that all cultural production outside of Occidental culture and mainstream Western popular culture is "imperfect." All popular culture, all cultural expression produced anywhere, as folklore or whatever, exists in the zone of imperfection. An occasional election occurs of an expressive form perceived as achieving classical status in another culture, say, Noh plays in Japan, Chinese opera, traditional African sculptures, conferring honorary perfectibility on these forms (much as respected persons of color visiting apartheid South Africa were conferred "honorary White" status). But otherwise, imperfection is ordained merely by these expressions being Other, by not being in a European language, or by not having Western stars, or using a different musical scale, the characters in their narratives not rounded to the requirements of Euro-bourgeois individualism, or presenting dances that elude description according to the movement vocabulary of ballet, or celebrating a different history than that shaped around the triumph of the West, thereby producing only an inept caricature of modernity, if at all, or honoring different gods. It is also clear that the construction of the perfect in aesthetic humanism was partner to the fabrication of Whiteness out of whiteness.

In emergent narration, impulses repressed by the classical tale but seeking to get out through its cracks, those contradictory meanings rippling beneath its apparently finished surface like a thirsty undertext, erupt into self-motivated expressiveness. The emergent narrative does an unholy dance with the mastered tale, negates it, ironizes and parodies it, and leaves it in a form that in Bakhtin's work would be described as grotesque. The servant domesticated in the servant's tale, the maiden seduced in the maiden's story and the slave tamed in the muted slave chronicle burst free with very different stories of their own, jarring the natural-appearing order and rupturing its illusion of competence and grace. Thus Bigger Thomas, the first-day chauffeur who in his class confusion, false consciousness, and racialized fear and rage kills his employer's daughter, is the unseemly other side of the genial Black-chauffeur story, *Driving Miss Daisy*.

Mastered cinema knits a suture between aestheticized narrative threads and possibilities of social thought and imagination. In contrast stand the films of reality-in-progress, where style and shape find appropriate balance with the messy process of history unfolding itself, possibly discovering enlightenments of the human condition along the way. Naturally, the makers of such films will hold unconventional ideas of enlightenment. But their choice of formal strategies open, instead of close, the opportunities of genuine dialogue. If "Hunting Is Not Those Heads On the Wall," as LeRoi Jones insists,[19] but instead signifies a cultural process unfolding to itself, then on the moving conveyor belt of cultural practice, intersecting with everyday social reality, there can be no solitary point where perfection can be grasped.

CODE-BREAKING

The notion of imperfect cinema becomes complex and troubling mainly through García Espinosa's naming as imperfect the cinema and culture of the disinherited. But this is also the source of its power since it brings most of the crucial issues to the surface, refuses fragmentation and postponement of the arguments, and clarifies the ensuing conflict. "[E]ither you tried to make an artistic cinema, estranged from a public which had the potential for substantially changing reality, and these films would be sent to the cinematheques and become part of an anthology of great films; or you made films which posed, let's say, the denunciation of a reality disguised by aesthetics, and which finally spoke to our exposed innards."[20] Either you accept the aesthetic contract, or you try to break it.

But Espinosa's ideas force us to confront another question: how does the imperfect tense of emergent narration involve resistance to aestheticization or to the aesthetic itself, and must this resistance be conscious or can it be implicit? The question is almost unanswerable in any neat way. Resistance to aestheticization may carry implicit resistance to the aesthetic-as-such for some interpreters, or remain implicit or partly conscious for others, while some may altogether reject the idea of severance from aesthetic discourse.

The question is raised by some interesting cases. Some premises of the aesthetic contract were deliberately violated by Richard Wright in his composition of his novel *Native Son*. After the reviews of his previous novel, *Uncle Tom's Children*, he realized, he wrote, "I had made an awfully naive mistake. I found that I had written a book which even bankers' daughters could read and weep over and feel good about. I swore to myself that if I ever wrote another book, no one would weep over it; that it would be so hard and deep that they would have to face it without the consolation of tears."[21] The execution of *Native Son* demonstrates this resolve at several turns, from the opening in which Bigger's poor family's flat is invaded by a rat that has to be killed with a skillet, to the ending where the reader's cathartic relief is denied by Bigger's insistence that "what I killed for must have been good."

Similarly, Alice Walker abandoned a good deal of literary convention in her novel, *The Temple of My Familiar*. Gone is anything resembling creative-writing-school prose. The novel predictably disarmed and disappointed reviewers by forgoing many of the pleasures usually evoked in the form. Generally, the book is misread as a novel, for, like *The Color Purple*, it is more accurately read as a philosophical fable, elucidating Walker's reconstruction of human history through the prism of her concept of "womanism," a vision alternative to masculinism, but more fully rooted in non-Western premises than feminism. In contrast to conventional aesthetic narration, Walker develops pleasure-enhancing strategies appropriate for her philosophical goals, specifically the narrative strategies and techniques of popular storytelling, approaching the formal characteristics of the fairy tale or fable. (For this, she picks up the utopian romance codes of the end of *The Color Purple*.) This narrative strategy dismisses the inevitable critique of political "interestedness." Her example reminds us that there are modes of storytelling, such as the Bible, in which the subservience of the tale to "higher," ex-aesthetic demands, openly acknowledged, are justified and accepted by the intended interpretive community.

The way a cultural work might engage the possibilities of productive imperfection is nearly inexhaustible. For a work to contribute to the expressive possibilities of imperfection, it need only organize resistance to cultural domination in general, and to the aesthetic in particular. (There is always the option of ignoring these pressures, as in self-authentication.) Thus imperfect cinema or art is not a formula, nor an alternate aesthetic, but rather an open-ended exploration of undominated ways of communicating.

The practice of unaestheticized construction helps account for the much-noted restrained cinema style of Ousmane Sembene, Africa's best-known film director. The minimalism of his cinematography reflects economic realism. But his style is also a response to cultural imperatives. Sembene's films are characterized by a largely stationary camera that frames its subjects from human eye level. It is almost as if the characters are walking into the orbit of the camera rather than the camera seeking them out. *Ceddo*, for instance, is shot in a way that emphasizes the horizontality of its environs. The connectedness of individuals in a community-based orientation is allowed to emerge. As Teshome Gabriel observes, the infrequent use of close-ups is part of a cinematic vision where the individual's actions are always foregrounded by their social implications.[22]

The narrative strategies of Wright, Morrison, and Walker, and the cinematographic strategies of Sembene forge alternative concepts of subjectivity. They carry force as fabling practices which have their counterparts in innumerable cultural works, including productions of resistant Western artists. These works break the aesthetic contract, whether deliberately, centrally and as a committed strategy, or provisionally, accidentally, or merely as a temporary tactic.

Possibly the most striking example of breaking the contract with aestheticism, because the most famous, is Maya Lin's Vietnam Memorial on the Mall in Washington, D.C. The long and often-told story of initial official resistance to the design (with vehement objections from Ross Perot), its eventual acceptance, its overwhelming popularity, and then the addition to it of a supplemental statue encapsulates the conflict between mastered and alternative representation.[23]

One of the design's early opponents, a Pentagon lawyer, called it "a black gash of shame and sorrow."[24] The monument really does work as a gash across conventional figuration of patriotic and memorial pomposity. Largely through omissions, our "conventional expectations for the work are destroyed, requiring us to bring to it something out of our individual

experiences that does not necessarily conform to conventional expectations."[25] Among these departures is the absence of a flag or other patriotic paraphenalia.

More, the structure makes no representation of the human form, and therefore no quasi-realistic portraits with which the norm-hero spectator position can identify. In place of these narrative values is the other, stunning, unadorned narration of the names of the men and women who died in the war.[26] This lack of realistic depiction of warriors resonates with Cynthia Ward's observation: "Realistic literary [and sculptural] conventions such as unity, credibility, character development and motivation have been—appropriately—called into question by readers who have found such prescriptive criteria constitutive of a normalizing, bourgeois white male subjectivity."[27] Sonja Foss notes, "Each name suggests individual features, actions, personalities, families and friends that defy their placement in a general, ideal class," such as a realistic statue would.[28]

"I didn't set out to conquer the earth, or overpower it . . . " says Lin.[29] Her resistance to the codes of mastery includes rejection of the phallic monument prototype, rearing erect and dominating over its viewer. The earth with which the structure gently co-exists may be read narrowly as the earth disturbed by the memorial's placement on the Washington Mall, but more widely the Earth besieged by conquest via master narratives. Lin said, "It's like opening up your hands. It's not so threatening. You're using the earth, asking people to come in."[30]

Read as a narrative, the memorial consistently refuses classical, mastering structure in a way that, by contrast, registers its "imperfection." As a narrative, the memorial is almost non-narrative, in the classical sense. Objectors to the design dislike it because they cannot, familiarly, understand its story. There is no clear beginning or end, because there is no middle, in the sense of a scale of rising action building suspense and then releasing it; no climax, not even in the form of a clash of adversaries (as some memorial statues depict, with the opponent fallen, perhaps, at the knees or shouldering the horse of the superior hero on horseback). There is no closure that resolves contradictions and restores the order of the status quo, just a few spaces left for names that might be added when records become more complete. It is a narrative without heroes—individuals singled out for distinguished attention or identification, as in the movies.

This "decolonizing text," as it has been called,[31] honors the bourgeois value of individualism to the letter, insisting on total individualization of the act of memorialization. At the same time, making this observance

of individualism total, or totally inclusive, at least insofar as U.S. casualties of the war are concerned,[32] explodes the flaw in the individualism of Euro-humanism—that it never seriously included all humans. The memorial counters Euro-individualism where a synecdoche is always operating, an entelechial substitution in which the privileged stand as representations for the "rest." It refuses the rhetoric of individualist Aristotelian tragedy, by denying catharsis, or the idea of noble sacrifice, therefore leaving exposed the generously enacted, unaestheticized brutality of war. There is only one story—the name and the signification, "he or she died or is missing in action"—but repeated in 58,000 variations.

The structure embodies the values of imperfect art by its openness to the visitor's participation, lacking which it is incomplete. It is "asking the people to come in." It leaves it to the spectator to fill in the details of the narrative of each person memorialized. The memorial is reflexive art since the mourner may see her own image mirrored in the polished, black stone, opposite the name of the military person memorialized. This openness of the memorial, and its accessibility to popular emotion have been co-signed by the personal items left at the wall as offerings, seemingly in as "pagan" a spirit as treasures left in a pharaoh's tomb.

The response of privilege to the Wall reminds us that as a discourse, the aesthetic is not a fixed set of doctrines but a self-adjusting structure of mobile perceptions, according to the evolving needs of its class supporters. Neither can we dismiss its need to reach out and claim for its own benefit any cultural work that makes a significant break with its intentions. With the Vietnam Memorial, once it was in place, the classes supported by the aesthetic, like the U.S. conductors of the war, cut their losses by declaring the effort a success.

This is pretty much what was attempted by the Congressional and official opponents to Lin's design when they insisted that it be supplemented by a flag and flagpole and a statue of American fighting men, which was completed and dedicated two years later, depicting three men in battle fatigues and carrying guns and ammunition, one Caucasian, one Hispanic, and one Black (need we ask which was in the center?). This maneuver holds two lessons for us. First, that it is always possible for a resistant work to be recouped by sufficiently powerful cultural editing. In some future time, the significance of Lin's design could theoretically be reversed to uphold the glory of war in general and the U.S. war in Vietnam in particular. But also the unconvincing multiculturalism of the warrior statue reflects the pressure the dominant cultural hierarchy must face from new vocal dissenters. Such pressures undoubtedly cause ad-

justments that the optimistic read as promises of a value-free, culture-free codification of the beautiful and the meaningful. In the absence of such a utopian solution, we might read this multicultural tribute to the U.S. soldiers of the war as a replication of Occidental aesthetic ideology, with concessions to two pseudo-ethno-aesthetics.

Lin's design may one day be reappropriated to mean the reverse of its original intentions, but the addition of *Three Fighting Men* has been so far largely ineffective. Observers note how visitors walk casually past it toward the thematic center of the piece. By insisting on its inclusion, the Congressional dissenters have constructed a topological allegory. The statue, as aesthetic-ideological counterstatement, makes a couplet with the memorial structure. Together, they present a graphic portrayal of two codes of signification competing against each other, one representing all the priorities of official aesthetics that the other defies. Together, they compose a tableau of ironic discourse. The official effort, like so many others, turns out to be a self-satirizing gesture. I have argued that a resistant cultural work gains in effectiveness by including in its reach some fragmentary, telltale presence from the myth it seeks to dispel. The Congressional supplementers "complete" Lin's original design in this direction by highlighting the iconology her design triumphs over. These supplementers in fact play precisely the role of the District Commissioner at the end of Achebe's novel, placing themselves within the self-derisive frames of Achebian irony.

DON'T LOVE ME BECAUSE I'M BEAUTIFUL

"Imperfect" is not a style, though in the art-cult environment that is just what many would first want to make it. The means of powerfully expressing the values of emergent art are almost as inexhaustible as the historical process. The resources of realism, and the "in your face" realism of some contemporary works, sustain effective expression outside the precincts patrolled for flawlessness. But so can the "blue note" of the blues, troublesome as it is for Western musical notation, or the ragged, "worried" line of the blues, or the same line as related to the deliberately uneven cadences of Langston Hughes's poems, the lower-case spelling of bell hooks's name, the quirky, adolescent misspellings of hip-hop titles like *Menace II Society*, the asymmetry of African art, the powerful "ugliness" of *Native Son*, which might recall that marvelous phrase of Paule

Marshall, the "beautiful ugly," as well as the concept of the reversible in traditional African architecture which assumes the impermanence of its structures, the discardability of some sculptures in this tradition, and despite contrary perceptions so can the invocation of the beautiful in Toni Morrison's novels. In much African American expression there is the whole resonance of "funk" that can be put to work to foil the traps of aestheticization. And in the immediacy and orality of the performative work, its perishable facticity will always contain something vulnerable beside the polish and finish of literary work or mechanically reproduced entertainment.

The films of Spike Lee "signify" on transgressive aestheticism. The formal shape of Lee's cinema violates many Hollywood codes of competence. At the same time, his work is popular in both senses—widely liked and appreciated, and directed to a non-elite authenticating community—which confounds the Euro-modernist notion (per Moritz, for example, or later, the negative aesthetics of Adorno) that a work of consequence must be a commercial failure.

The key innovation of Spike Lee's cinema is bringing the arts of the not-perfect within the citadel of commercial movies. Among his intriguing moves in this direction is the artistic heresy of being funny and entertaining in a vernacular tradition—"street"—without surrendering to the antics of minstrelsy. Lee's jazz-inspired, improvisational directing style is a departure from classical notions of cinema form. The disavowal of genres in most of his films—"I feel I make films that don't fall into any particular genre"[33]—contributes to a rhetoric of resistance (which may also be true in *School Daze* and *Malcolm X*, where he flirts with genres subversively). There is also his graffiti approach to iconography, his cartoon characters, and his neglect of bourgeois individualism in their development, for which he is routinely criticized from the tradition of mastery.[34] Likewise, Lee's films are often panned for their fractured story lines, his indifference to the classical stops of clear beginning, middle, and end. Usually, this critique invokes questions of form and "aesthetics" over social meaning, without considering that these breaks from classical form might be deliberate. Had similar criticisms prevailed in the formative period of jazz, that art form would never have come to development. His endings, particularly, stamp a signature of deliberate non-closure on all his movies, refusing the ideological closures of the master narrative. (It would be strange, though valid, to see reviewers decrying the fairy-tale endings of romantic comedies or the triumphant march over the bad

guy's corpse at the close of countless thrillers as egregiously ideological and blatant propaganda.) Lee shares this refusal of consoling closure with Toni Morrison, another very different narrator of emergent art.

Sylvia Wynter speaks of "breaking the contract" with the "unitary system of meaning" through narrative structures like *Do the Right Thing*, "whose performative acts of counter-meaning encoded both in its signifying practises as well as in its Black popular musical forms, can be properly evaluated only in the context of the challenge that it makes to the cultural Imaginary of our present order."[35] And it is in this regard, rather than the accumulation of characteristics, that we read the valid non-compliance of such a work, the way it remains toxic to the heraldic code. What makes this recognition challenging is that Lee's movies also make eager use of the devices and resources of the popular movie industry: high production values, well-trained and familiar actors (increasing in number over the years), if not stars, some exposed flesh and sex scenes— "As usual I gotta have a vicious sex scene"[36]—a focus on youth and youth culture, dynamic popular music, much comedy (which is too often considered out of sync with the posture of resistance).

The tension from these mixed predications arises from Lee's combination of two trajectories. Lee's early development as a Black independent film director, from the same tradition that produced Kathy Collins, Bill Gunn, and such L. A. Rebellion directors as Charles Burnett, Haile Gerima, Larry Clark, and Julie Dash is clearly the source of his techniques of cinematic resistance. His innovation was to go further than these other independents into the monopolated and commodified territory of popular entertainment. At the same time, Lee has so far remained an ideological rebel, unlike the many Black directors who followed his success in Hollywood by exploiting Black popular culture. The resulting "edge" to his earlier films has made them indigestible to the dominant movie industry, except as successful commercial ventures. They read as "imperfect" to this cinema system in ways that deny them the international prizes they might have won otherwise. (There was much talk at Cannes about *Do the Right Thing* as a probable winner of a major prize, but it did not happen, and the same is true of Lee's films at the Academy Awards.)

In *Do the Right Thing*, the Wall of Fame in Sal's pizza parlor reverses the social healing of the wall of the Vietnam Memorial. The way Sal responds to Buggin' Out's confrontation—"Sal, how come you ain't got no brothers up on the wall here?"—reverberates the issues of media as private property. "You want brothers up on the Wall of Fame, you open up your own business, then you can do what you wanna do. My pizzeria,

Italian-Americans up on the wall." Most of the Italian American celebri-
ties on the wall, by the way, are movie or entertainment stars—Sinatra,
Perry Como, Liza Minelli, Sylvester Stallone as Rocky. Buggin' Out's re-
tort echoes an argument often made by African Americans regarding
their underrepresentation or misrepresentation in Hollywood flicks—
that they deserve better treatment considering the disproportionately
large share of the audience they make: "Sal, that might be fine, you own
this, but rarely do I see any Italian Americans eating in here. All I've ever
seen is Black folks. So since we spend much money here, we do have some
say."

As for "playing music too loud," this action and its response em-
blemize contemporary culture wars. Sal racializes the confrontation:
"Turn that JUNGLE MUSIC off. We ain't in Africa." After smashing Ra-
him's radio with a baseball bat—two appropriately clashing symbols of
cultural pride—he says, "I just killed your fucking music!" and the place
explodes in public violence. The scene and the film are very much about
racial imagery and identity politics as played out in public space. The
racial deaths in Bensonhurst and Howard Beach had to do with Black
young men wandering into so-called "White" neighborhoods, looking
for gas because their gas had run out, or looking to buy an advertised
used car. The collision of cultural positions in public space over "trivial"
everyday actions perceived as invasions of culturally defined "turfs"
lends itself to examination in visual media like *Do the Right Thing*. The
markings of turf, cultural boundaries, and the way that turf is claimed
and patrolled is extended by Lee beyond ethnic neighborhoods to include
the boundary marking of media, symbol-making turf.

The cultural/political statement of *Do the Right Thing* may be less pro-
found than other films. It may fall short of various revolutionary agen-
das, too tame for Maoism, too male-centered for feminism. It was surely
too pro–Italian American and too limply Black for many Black viewers
and too pro-Black and anti–Italian American for many Italian American
viewers, intentionally, by the way: "This film is gonna make people pick
sides, especially Italians and Blacks. In my eyes, there are no winners in
this one."[37] Much of the criticism of the film is predicated on Black posi-
tive imagism and Italian American positive imagism. The internal limits
of this kind of cultural conflict put a chilling effect on any more complex
interpretations. The possibility of *Do the Right Thing* serving as an in-
structive sample of imperfect cinema—granting its flaws as a model po-
litical document—might rely on the unschematic and imperfect theoreti-
cal question, compared to what?

The issue is that an effective narrative of resistance may also be one that contains elements viewed as taboo in some doctrinaire versions of resistance: sensuality, humor, entertainment, excitement. "Negative aesthetics" as proposed by Theodor Adorno, and implicitly adopted by what has been called "perverse modernism," may be more (or less) than making one's statement in ways that negate the prevailing rationale of society. It can easily slip into the habit of mind that says any features successfully used by the dominant narrative system must be avoided. But slowly, theorists of oppositional cinema have begun to draw back from this ideological purity with the question, can we afford to surrender the pleasures of narration (and I would add humor, beauty, sensuality, even sentiment) to the tradition of mastery?[38]

Resistant cinema and narrative need not be joyless, nor (as I plan to argue more fully) must the rejection of aestheticism mean the denial of beauty. (Curiously, in the throes of the negative aesthetics and perverse modernism reigning in the art scene,[39] beauty has been banished and left to marginal regions of expression.) Though some detractors may reject Spike Lee's movies as example, the argument stands that popularity need not equate with selling out. The wide and deep acceptance of the Vietnam Memorial as an almost instantaneously exalted national shrine may be a more persuasive case in point:

> It has been traditionally believed that the concerns of art were not to be found in the sane but in the sick, not in the normal but in the abnormal, not in those who struggle but in those who weep, not in lucid minds but in neurotic ones. Imperfect cinema is changing this way of seeing the question. . . . [T]here is no need for suffering to be synonymous with artistic elegance. There is still a trend in modern art—undoubtedly related to Christian tradition—which identifies seriousness with suffering. . . . Imperfect cinema must put an end to this tradition. . . . Imperfect cinema can also be enjoyable, both for the maker and for its new audience. Those who struggle do not struggle on the edge of life, but in the midst of it. . . . Imperfect cinema can enjoy itself despite everything which conspires to negate enjoyment.[40]

NOT FREE AND NOT AT LAST

But real confusion is spread by chic resistance, cultural work that proposes an "aesthetic" of imperfection, attracted by the *frisson*, the "edge" that such characterization brings with it. These stylistic gambits are as old as the noble savagery that titillated Euro-romanticism and the primitivism that became a template for Euro-modernism. This simulation of

imperfection/resistance harbors a feeble Ethiopicism, miming the cultural identity of outsiders.

As formalist technique, the imperfect is open to any political persuasion. Cinema history is filled with instances of modernist code-breaking to serve various ideologies, from the self-reflexivity of *Citizen Kane* and *The Man Who Shot Liberty Valance* to the interruptions of illusionism through direct address to audiences in Woody Allen's *Annie Hall* or Donald Duck cartoons, or Spike Lee's commercials for Nike. Television also finds ways to market the comic possibilities of imperfection by airing outtakes, bloopers, and such subprofessional footage as home movies.

Rather than propose a litmus test of authentic resistance, we might consider the distinction: those whose opposition to the art-cult is readable as a tar baby relation to that system—i.e., those whose categories of crucial thought overlap with the boundaries and basic assumptions of that system, only disagreeing with it on a few issues. Beside these: those whose opposition to that system extends beyond dialogues on art to seriously different visions of society.

Picture this way of grasping the difference. There are those whose opposition to the art-cult is based on a single issue, versus more roundly based resistances. Then there may be those whose opposition to the art-culture system can be located in hostility to the way that system has operated over the last 50 or 100 years, like many postmodernists, compared to those for whom the roots of opposition go back further—for some, 200, 300, or even 500 years—each date implying a different historical basis of opposition. Then there is the perspective of Kenneth Coutts-Smith: "Only a certain type of analytical approach . . . whereby art is regarded primarily from the point of view of its social role, is capable of revealing an assumption so arrogant as to stagger the mind: the assumption that the whole existing body of world culture from the very dawn of human time must be conveniently understood and appreciated *in the light of the European visual experience of the last 500 years!*"[41]

Ultimately there can be no sure-fire proofs of authenticity. But we can use our common sense. We can recognize the antics of the art-cult well enough. We can recognize the attachment to the cult of the artist-genius, the dedication to increasingly bizarre levels of individualistic posturing, the elitism of the object transmitted through the aura of elitism, the exclusion of everyday people and their concerns, the unrelenting, though camouflaged Eurocentrism, the peremptory, arrogant assumption that only the few can speak the truth to another few. The question Espinosa puts to the would-be maker of imperfect cinema is, "What are you doing

to overcome the barrier of the 'cultured' elite audience which up to now has conditioned the form of your work?"[42] It is this movement toward the truly popular, toward everyday people in their everyday lives, unmediated by the gimmickry of mass communications, that identifies imperfect/resistant cinema.

We can expect an objection: the designation "imperfect" for the cultural production of the unprivileged concedes too much, has an odor of defeatism and capitulation, particularly when paired with the description of dominant culture as "perfect." Not even quote marks will ease this discomfort, for some. Some will argue that this is what the disadvantaged have heard all their lives, how imperfect they are. To hear this from another source claiming to be friendly, and with some academic authority, may be piling on more grief where enough is enough. To call the cultural labors of the outlanders "imperfect" smacks of blaming the victim. The irony of this renaming may go over the heads of the educationally dispossessed, the poor masses, who are not used to such sophisticated word play.

But imperfect cultural critique may be less a remote, intellectual conceit than a structuring of perceptions and criteria already built into the way the poor and the less powerful have familiarly addressed the world. "Imperfection," as a resource in ongoing cultural wars, is a fair transcription of the way things are. Far from being a sophisticated rhetorical gambit, imperfection as a strategy of cultural resistance may seem very familiar to the downpressed. The unequal distribution of power and wealth is a source of irony that seldom escapes those who hold the smaller share. They understand the point of Allen Tate's definition of irony in which "superior insight" is granted one party over another as one that often conforms to a hierarchy of social status.

Consider the persistence of trickster tales around the globe. By this evidence there is no lack of irony in popular and traditional cultures. African Americans enduring slavery, to take one such population, demonstrate the keenest understanding of the repertoire of ironic discourse. Almost by necessity, they mastered the arts of double entendre, oblique reference, Aesopian expression, and coded reference—without the aid of any academic intellectuals among them. They fashioned an oppositional cultural symbolism by elaborating a dense allegory recoding the Bible to their situation, as in the captivity of the Jews in Egypt. Their oral narratives are richly parodic. The cycle of the Brer Rabbit tales testifies to their capacity to generate—and understand—a narrative concept that on surface appears mythic, but is actually resistant and liberative.

And yet, it has been theorized that television works to erase the perception of subtleties, narrative complexity, irony, and shadings of character among generations who have grown up without the benefit of traditional storytelling. This alarming, plausible speculation points again to the capacity of capitalist development to derail unmediated culture. But if this is true, it suggests that the features of television that produce this one-dimensional effect, in the absence of playful ambiguity, irony, complexity, mark television as another institutional purveyor of "perfect" cultural production, and therefore ripe for critique from imperfection.

Rejecting the concept of "imperfection" because it may daunt or confuse the less powerful betrays the prejudices of positive imagism. But by now, we should recognize positivism in this vein as the nervous twitch of an acculturative/assimilationist psychology. Such remains the drift of this rationale, even when it is pursued aggressively, and even when it is voiced by abject victims of abused power who have for the moment lost hope in any other court of opinion.

Positive imagism holds to the hope of a deliverance by means of a perfection shared in fundamental ways with the hierarchy of received values. "Imperfection," on the other hand, holds the possibility of raising the concrete situation of the less powerful to a high level of consciousness, one based on a realistic assessment of history and the history of popular struggle. The imperfect narrative of freedom need not surrender to an indefinitely postponed "becoming," or to an apologetic embrace of permanent immanence. As a strategy conditioned by the present crisis of knowledge, it can open the way to different resolutions of this crisis, while building on the conviction that the regime of cultural authority located in Eurocentrism must come to an end.

CHAPTER XIII

■

Daughters of the Terreiros

The issues raised so far come to a head as a serial confrontation with the idea of an imperial Western civilization continually asserting its supremacy over less powerful margins. This interface has been restructured by the retorts of the formerly silenced to this self-flattering monologue. Given the newly found voice of these culturally out-of-doors communities, the exchange implies the morphing of the grand narrative of inevitable bourgeois advancement into a troubled dialogue, a Babel of ironies in which virtually every boast of the master text is shadowed by its dissenting doppelganger. One resistant narrative that stands athwart the imperial version of history and knowledge in a most memorable *debat* with its master text is *Daughters of the Dust*, a film by African American director Julie Dash, particularly as this text remodels our understanding of the settling of the New World.

The quincentennial commemoration of the voyage of Columbus set off explosive rebuttals of the official story of heroic exploration, noble conquest, and pioneering service to the advance of civilization. The rapine, pillage, torture, starvation, enslavement, genocide, and colonization that are the other, suppressed side of this myth of Columbus as light-bringer of civilization surfaced in the 1992 debates. *Daughters of the Dust* successfully contravenes the myth of Columbus, the chosen text of the master narrative of New World history, as well as the imagery of Shakespeare's *The Tempest*, as its classical dramatization. It does so, first of all by embodying the historical personality of the silenced victims of the Eurocentric pageant, viewing them on the grounds of their own social and cultural contexts. As a crossroads narrative, *Daughters* powerfully doubles and complicates the discourse of aestheticism, challenges the Eurocentric debasement of non-European, and African culture, questions the patriarchal paranoia of the master narrative and explores cosmologies that sug-

gest alternative forms of knowledge from which we might salvage possibilities outside the hegemony of aestheticism.

Dash's film emerges from the ranks of the Black independent cinema movement in the United States, specifically from what I have called the "L.A. Rebellion," a group of film directors trained at UCLA committed to a cinema of resistance against the misrepresentation of Black people on the commercial screen.[1] In an art-culture system that proclaims its democratic availability and open opportunity, the silencing of African American women is evidenced by the fact that this 1991 film is the first by a Black American woman to get widespread theatrical distribution. The struggle of these Black independents to get their films made against massive obstruction illustrates the culture industry's efficiency in repression as well as production. Meanwhile the films of the L.A. Rebellion command special attention for the way they make the politics of representation an issue in their narratives and iconographies.

The first word free-associated with Dash's film invariably refers to its "beauty." But from the outset, this mark of its beauty is circled with ambiguity. When the film won an award for cinematography at the 1991 Sundance Film Festival—an award that should be understood to embrace its costuming, art-direction, casting, and mise-en-scène—we might read a validation from the conventions of aestheticism. But the "beauty" of the film is also a point of contention, arising from different culturally political positions. The question is, does the film embody Western or contra-Western notions of beauty?

Daughters of the Dust is spendthrift with beauty, of seascapes and landscapes, of cultural ambiences, charismatic, symbolic objects, forms, choreographed movements, harmoniously arranged colors, but is most strikingly generous with the beauty of Black women. It has been accurately noted that the cinegraphic display of beautiful Black (and black) women in this film overwhelms any historical precedent in the depiction of Black women in painting, still photography, or any other visual medium. On this ground alone the film is remarkable. But is this beauty the sort that submits to the dominant canons of taste? Does it surrender to codes of the beautiful embodied in Venus de Milo or Madonna? Do we have to return to the illustrations given us by Petrus de Camper or Sir Kenneth Clark to understand that the beauty of the daughters of Africa in this film signifies the radical subversion of a familiar code of knowledge, standing it on its head so that what has been framed as beastly or monstrous or grotesque now more nearly resembles the divine? In *Daughters of the Dust*

this entelechial hierarchy of beauty is overthrown. And considering its historically exceptional portrayal of the beauty of black/Black women, the upending of conventional perceptions it achieves might be considered as revolutionary a recoding of a dominant tradition of imagining as any we might refer to.[2]

As if to assure us that the beauty of Julie Dash's construction is not the same as that of the art/culture system, this beauty became the target of mainstream movie critics. One likened the movie to a Laura Ashley fashion show, another to a TV commercial for "Obsession," the perfume. Complaints about the supposed anachronism of Black women of this period being able to attain such dress and grooming were commonplaces of the film's early reception—almost never lodged by non-White reviewers or spectators.

There was a kind of rage in these exceptions to the film's "accuracy." We have to penetrate the logic of these comments. There is, first of all, the convenient forgetting of the convention by which Euro-American identity is routinely glorified and prettified in movies, both in the decor of the character's lives and the physical attractiveness of the characters themselves. (It has been ungenerously argued that all the two dozen physically attractive inhabitants of the British Isles have been funneled into the movies.) This convention must be forgotten for the observer to object to the possibility of selective enhancement in the casting of *Daughters of the Dust*.

The caustic rejection of the costuming suggests that it is the beauty of the women themselves rather than the historical accuracy of their costumes that raises the heat. We are talking about an epistemological need, almost a cultural-historic hunger, for Black ugliness, the comforting associations with slums, poverty, abjection, self-contempt—for responsibly dependable Otherness.[3] Of course in this exchange within the politics of representation, ideas of beauty are inseparable from ideas of status, in a combination intermingling both race and class. We must take into account a coding of European knowledge where the representation of Black people above a certain level of security and poise is symbolically forbidden, as though violating a sumptuary law like those imposed by the New England Puritans. The difference would be that whereas finery offended the Puritans for going beyond a fit homely plainness in the eyes of God, the elegant portrayal of Black people goes beyond a comforting shabbiness in the eyes of transcendental Whiteness. To the extent that—have you noticed?—a demeanor of melancholy, stoical suffering, impoverishment, or abjection has become generic for the Palatial representation of

Blacks, the reverse of this demeanor, when it isn't minstrel happiness, is easily taken to be unaesthetic.

The core question has arisen before—is this work too beautiful to be effective in resisting cultural absorption? It is a question that has been raised about the exquisitely crafted novels of Toni Morrison. Is beauty too soft a weapon to be used in defense of the downpressed? Might not beauty pacify the spectator, tranquilizing where the greater need is to arouse, enrage, engage, and enlist? Is beauty to be understood as the spoils of the rich, powerful, complacent, better spurned by those who must make priorities of survival and resistance? Does the aspiration to beauty betray the internalization of "master's" values?

These questions demand a patience that must itself be placed under suspicion. Are these not just the kind of questions that aesthetic reasoning would impose on us? Are they not best avoided, or cut as short as possible? Let us leave these questions here, certain that partial answers to them will arise in the course of our pursuit of other, more central priorities.

The issue of "story" also arises around this film as it enters into dialogue and conflict with the expectations of the master narrative. The film opens on a boat carrying travelers to Ibo Landing. But immediately, as signaled by the difference of the beauties involved, we learn this is to be a different story than the official one. As Toni Cade Bambara notes:

> As this boat cuts through the green, thick waters, we see a woman standing near the prow. She wears a veiled hat and a long white dress.
>
> Embedded in the memory of millions is the European schoolmarm-adventuress-mercenary-disguised-as-missionary woman who helps sell the conquest of Africa as an heroic adventure. But this woman is not that woman. She's standing hipshot, chin cocked, one aim akimbo. The ebonics [African American body language, per Dr. Ernie Smith of University of California, Irvine] send the message that this is not Brenda Joyce/Maureen O'Sullivan/ Katherine Hepburn/Bo Derek/Jessica Lange/Meryl Streep/ Sigourney Weaver or any other White star venturing into Tarzan's heart of darkness to have a sultry affair with a pith-helmeted matinee idol, or with a scruffy, cigar-smoking cult figure, or with a male gorilla, in order to sell us imperialism as entertainment.
>
> In this film that hipshot posture says, Africans will not be seen scrambling in the dust for Bogie's tossed away stogie. Nor singing off-key as Hepburn plunks Anglican hymns on the piano. Nor fleeing a big, black, monstrous, white nightmare only to be crushed underfoot. Nor being upstaged by scenery in a travelogue cruise down the Congo, part of a cluster of images that invite but don't commit. Nor being a mute and static backdrop for White folks' actions in the foreground, helping to

make that passive/active metaphor of the international race-relations in-
dustry indelible. Nor being absent as cast members, ghosts merely in
back-projected ethnographic footage purchased from a documentarist
trained to go to people of color to study but not to learn from. Nor being
absent altogether so as to make Banana Republic colonial-nostalgia cloth-
ing for a price clean-kill innocent.[4]

Ibo Landing, where this boat is heading, is a location in the Sea Islands
off the coast of Georgia and South Carolina, places where, because of iso-
lation and the high proportion of African slaves to White slavery proprie-
tors, the retention of African cultural qualities is highest in the United
States. The time is 1902, roughly the year of W. E. B. DuBois's landmark
book, *The Souls of Black Folk*, focusing a crossroads moment in the history
of both Black and White Americans. Slavery had ended within living
memory, and Reconstruction had set mean obstacles against the realiza-
tion of Black freedom.

The passengers heading for Ibo Landing carry some of the clashing
worldviews that intersect during the coming drama. Viola, the Christian
convert and evangelical missionary scorns the African survivals and "su-
perstitions" of these islands that she has escaped from. Mr. Snead, the
photographer she brings to record this milestone day, occupies himself
and his passengers with the wonders of a kaleidoscope: "It's beauty, sim-
plicity and science, all rolled into one small tube." In Mr. Snead we can
recognize a convert to Enlightenment modernism. Yellow Mary, accom-
panied by her friend Trula, remains an apostate to both of these versions
of "civilization." Her travels to Cuba and Nova Scotia as wet nurse and
prostitute have deepened her skepticism of caretaker society and quick-
ened her hunger for the African-rooted values she once left behind.

These travelers arrive for a special day of farewell—more than half
the population of this small community aim to migrate to the North in
search of a better life. This day at Ibo Landing also marks a crossroads
between Afro-diasporic culture with its time-space continuum and the
rationalized, instrumentalized, desacralized orientation of competitive
individualism, or capitalism, with Christianity portrayed as a naive
handmaiden of the latter. And in terms of mundane, historic time, this
day at Ibo Landing in 1902, the turn of the century, evokes one of the
major transformative experiences of Black people in the United States,
the series of migrations from the post-slavery, rural, pastoral South to the
"modernity" of the urban, mechanized North.

At this crossroads, key life choices face these hopeful but anxious
searchers, some to be grasped as the glittering promise of the future. At

the center of this small world sits Nana Peazant, its matriarch, reluctant to see her "children" depart for fear they will cut adrift from their roots, which gave them the strength to survive the middle passage and slavery. What is in danger of being forgotten is the African spiritual tradition that gave them their sense of identity and empowered their survival through slavery. The archive of images, movements, and sounds organized in the film display several African retentions, as though remembering what has been forgotten—games, visual symbols, homely religious practices like arranging bottles on trees, some linguistic inheritances (the language of the film is mostly Gullah, a very Africanized dialect of English named after Angola, where many of the Africans held captive in these islands came from), methods of hair braiding and grooming, styles of child rearing, naming practices, and most important, belief, by some, in the African gods and spiritual forces and the importance of appealing to them.

In most societies, the connection between beauty and spirituality is felt as seamless, with the possible idea of "art" landing where it may. The aberration of "aesthetic" beauty is its steady divorce from spirituality within secular humanism. The spiritual residues of the Western notions of beauty remain only as fossils from historical and cultural experience, or genealogical fantasy, amputated memories of Christianity, borrowed conceits from ancient Greece, and appropriations from societies otherwise deemed inferior. Not surprisingly, *Daughters of the Dust* projects another idea of beauty, like most societies, linked to a defined spirituality, a lived sense of history and culture. The film is *about* these linkages, in fact, and the threat of their extinction. It is about the hazard of a people losing one form of identity and being given another one in which an alienating aesthetic and hostile connection to spirituality are imposed as the only ones worth having. So the text and texture of the film are manifestations of one such alternate cosmology in a form where narrative events are subordinate to this overarching purpose of cultural *recollection*.

One of many breaks from the master narrative of perfect cinema is the film's freedom from the focus on a single, central hero. Its multivocal design shares the role of narrator among four women, Nana Peazant, Eula, Yellow Mary, and Eula's Unborn Child, who according to many West African traditions, is to be considered an ancestor as well as future offspring. These voices grant intersubjectivity to these characters and empower them within and over the narrative. Their polyphony disrupts location within a privileged spectator position.[5] This quartet of unobtrusive but authoritative voices act as a communal chorus, expressing a stratum of perception closer to a mythic or spiritual register than the privat-

ized narrator of conventional cinema. What they narrate is not their personal, subjective feelings, the unimpeachable source of truth in Hollywood movies, but understandings of shared meanings and values.

Nevertheless, the addictions of classical cinema have conditioned many viewers to assume that "nothing happens" in *Daughters of the Dust*. But the notion of when "something happens" is a trained expectation. Notions of "something happening" change from texts dominated by Renaissance magic, like *The Tempest*, to texts informed by rationalistic economic individualism, as in *Robinson Crusoe*, or through ritual enlightenment, as is the case in Dash's film. Without the psychological causality of classical narrative, the story nevertheless flows with a very apparent sense of direction, imperfect only to those whose demands of "something happening" exclude cultural and spiritual enlightenment. In fact the plot moves steadily and inexorably toward a fundamental ideological confrontation that in its own way echoes the ongoing collision between Monopolated and emergent worldviews.

This moment of recognition is in fact planned by Nana Peazant:

> Bot wen dey come today fer kiss dese ol witha
> op cheek bye-bye, A'm gon hab sompin mo dan farewell
> waitin on em. (Pausing, then)
> Ya see, A been wok pon a plan

At a crucial moment, grounded in African American experience, when the clan has feasted and relaxed a bit, they are summoned and seen to move in slow motion toward a central point, gathered by Nana's urgent need. Once they gather beneath a giant tree, Nana puts in motion a ritual of mutual bonding. The meaning of this moment is only fully realized when we understand this ground, this dust, in which the clan assembles to be a *terreiro*.

Daughters of the Dust is a mythic narrative. Its signifying on more than one level is telegraphed in a press release where several of the key characters are associated with African *orixas*, or personalized spiritual forces. The press release, which can only have been written by the film's director, links five principal characters of the film to orixas: Yellow Mary to Yemanja; Nana Peazant to Oshun; Eli to Ogun; Eula to Oya-Yansa, and the Unborn Child to Elegba. But the film is less about these divine spirits, less a retelling of their mythic existence as, let us say, Cocteau's *Orphee* re-presents an ancient Greek myth, but more a story of mortals caught up in their historical dilemmas to which the roles and characters of the orixas lend another, powerful dimension of explanation and significance.[6]

The richly textured symbolic fabric of *Daughters of the Dust* gains clarity through the lens of the Nâgo culture of Brazil. Nâgo names the African population surviving slavery in Brazil, coming mainly from Yoruba society, particularly from the Bay of Benin, but also from several other nations and population groups. Nâgo identifies a population, a cultural orientation, a belief system heavily centered on the worship of ancestors, the will and determination for that population and its values to survive, and a spiritual way of life: Candomble.[7]

Interpreters of Nâgo worldview observe a parallel existence of reality on two connected planes, the worldly and the spiritual. What is doubtless the significant difference with Western perspective is this continual interpenetration and lack of separation between these two planes of existence. An obvious illustration arises from the link between the mortal characters in Dash's movie and the orixas, a link that cannot be explained away as the gods taking mortal form in order to get involved in the affairs of humans.

The interpenetration of the two planes of existence, and of multiple time frames, is figured in the presence of Eula's Unborn Child as a character. In many West African cosmologies, the ancestors whom it is the obligation and joy of the living to honor and celebrate, include the generations yet to come as well as those who have gone before. This cultural precept is given a gyno-centric spin in Nana Peazant's words: "The ancestors and the womb are one." The presence of the Unborn Child in the film, though unacknowledged by the others, addresses the connectedness of the reality levels. When the Unborn Child speaks with authority about identifications and events to materialize in the future, the narrative frame carries some of the dimensions of time travel in science fiction, but from very different explanations of causes.

According to Muniz Sodre and Juana Elbein Dos Santos, two authorities on African religion in Brazil, the *terreiro* is a point where the mundane and the sacred intersect. Some of the meanings of *Daughters of the Dust* become clearer in the light of this intimate knowledge. For Sodre, "The *terreiro* is a sacred territory that breaks with Western territorial claims. It is an openness that makes possible a contact between different levels of existence. In Candomble, communication with the gods is essentially ritual. In this context, man is not a social man, but a ritual man. Social man operates or is separated by rational bonds. Ritual men are organized by sacred bonds, expressed through territory, land, kinship relations and relations to ancestors."[8]

In my Portuguese dictionary, *terreiro* is defined as "yard, public place;

(Brazil) outdoor place where voodoo is practiced." But, as Juana Elbein Dos Santos insists, "*terreiro* is more than a piece of land. It is an institution, an alliance and a semantic pact."[9] Sodre elaborates: "Space is quantitative. *Terreiro* is space affected by human influence. In *terreiro* a space can be born, grow old, and die, and then be born again. The body itself can be seen as a *terreiro*. Politically, the *terreiro* is a Black territory in a space controlled by White men. . . . The *terreiro* is an Africa concentrated. The *terreiro* contains all the gods; it's an African digest."[10]

Nana's plan is to effect a number of transformations, exercising the corridors linking spiritual and natural worlds. One of these is to transform the dust, the space where the group is gathered, into *terreiro*. The symbolic harvest of this dust, which Eula memorializes in her climactic speech, is in the transformed scraps that make up Nana's "hand," bits and scraps of memories, a tress of her mother's hair, etc., tied up to a Christian Bible. The clan of kinfolks gather to greet Nana farewell and find themselves in the midst of a ritual—invited to kiss the "hand" that Nana proffers to them. The "hand" Nana asks her kinfolk to kiss instead of a farewell upon her cheek represents memory scraps of cultural empowerment salvaged from the "dust" of a hostile cultural environment.

This ceremonial moment of the kissing of Nana's "hand" may seem like "nothing happening" to those indifferent to ritual and spiritual meaning, although they have been trained to be satisfied with Prospero's magic resolutions in *The Tempest*. But within the context of *Daughters of the Dust*, the choices each character makes whether or not to honor this antique ritual load this moment with revelations of ideological commitments that are prophetic for this community and its coming generations. Typical of this significance is the moment Snead, the photographer, kisses the hand.

Throughout the day, Mr. Snead has experienced a kind of ethnographic fascination with this unusual community and its preservation of a culture assumed to be "lost." Mr. Snead functions as the outside observer's alter ego and friend, his reactions presenting a model for what our industrialized mental impressions might register were the audience inserted into the film's world. His photos remind us of those grand, stiff extended family portraits of proud Black people of almost a century ago, formal in their Sunday best. They also function like *tableau vivants* formally capturing an imagined history that, since we see the action both before and after the "stills," make up a chronicle of what this recorded experience might mean. Oddly enough, the *tableau vivants* in *Daughters of the Dust* operate technically very much as in *The Birth of a Nation*. Except

that the tableaux of Dash's films more intensely urge "Remember, re-member" to a population and audience Griffith was eager to forget.

As the day wears on, Mr. Snead's scientific curiosity and accumulating information produce in him a steady transformation from bemused voy-eurism to respect and admiration. He is "touched" by what he sees. An-other foundation of Nâgo culture is the belief that spiritual knowledge must be communicated directly and immediately in concrete experience, such as songs, dance, and ritual, as opposed to abstract communications of the sort that mark industrialized print literacy.

Nana's "hand" is an embodiment of herself and what she represents. In the crucial scene, kissing has the ritual significance of transference of power or allegiance, as in kissing the ring or hand of a pope or king. But it more immediately reflects the direct transmission of spiritual knowl-edge. One of the most salient instances of a significant touch in Candom-ble is the touch on the forehead of an initiate by a *mae de santos*, sending the initiate into a trance of possession.

Snead's kiss of the "hand" reflects his growing affinity for the life-world he has that day experienced. After Snead impulsively rushes for-ward and kisses the hand, he equally impulsively embraces Viola, his evangelistic, missionary companion, and kisses her on the lips. There-upon, Viola, who had all along vehemently rebelled against the ceremony ("It's not right! We're supposed to die and go to heaven! What you're do-ing is wrong!") suddenly rushes forward and kisses the "hand" herself. This sudden conversion may speak to the weakness of the syncretism through which many New World Africans converted to Christianity out of opportunism.

While Viola is suddenly reconverted, Haagar is adamant, breaking out of the gathering, decrying this "hoodoo *mess.*" Haagar is the eager "pio-neer" who most sharply resists Nana's influence. Her position reflects the abandonment of ancestral belief in favor of the acquisitive materialism fostered in a Sears Roebucks catalog. Her spiritual skepticism embod-ies an allegiance with dominant schemas of knowledge and pragmatic search after the main chance: "Old Used-To-Do-It-This-Way don't help none *today!*" At this crossroads point, Haagar's flight from the family circle indicates the path of some postcolonials toward Cyclopean coop-eration with Monopolated Light and Power.

There is an instructive pathos in Haagar's rejection of Nana's values. Haagar expresses the acquisitive sense of individualized property that holds one of the major challenges of the new system to the old. Her com-mitment to this new value system is suggested by the names she has

given her daughters, Myown and Iona. At a pivotal moment, when her young daughter jumps from a boat loaded with migrants, determined to remain behind with her Amerindian lover, Haagar screams after her, "Iona!" which becomes drawn out to "I-OWN-HUH," which finally becomes "I-OWN-HER!"[11]

The personal and group history that brings Haagar to her assimilationist ideology is better understood when we recall the significance of her name. The Biblical Hagar was the concubine of Abraham who gave him a son, Ishmael, when his wife Sarah could not. Cast out by Sarah in her jealousy, the Biblical Hagar became, for African captives, symbolic of the African mother in slavery whose lack of legitimate status passed on to her children, and robbed her of her claims to them. The possessiveness shown by Haagar in Julie Dash's film exposes the anxiety of motherhood emerging from the shadow of slavery, to fully claim the rights and status of mother to her children in a way that enslaved mothers only recently could not. This theme was given another, postslavery twist in the memorable chapter called "Haagar and her Children" in E. Franklin Frazier's landmark sociological study, *The Negro Family in the United States*.[12] There, Frazier analyzes the social dilemmas of the Black families that migrated to the impoverished quarters of Northern cities where the bonds of family soon unravel and Haagar loses her children to the anonymous appeals of the city just as she had once lost them to the "social death" of slavery.

Against this view of relationship and possession stands the contrary view of Nana. When Eli vents his torment that the disgrace of rape has happened to "my wife. I don't feel like she's mine anymore," Nana reminds him, "You can't give back what you never owned. Eula never belonged to you, she married you." Nana's statement might be taken as a liberationist attitude drawn from the slave experience, that having been property to other people, Africans should not adopt a similar, limiting condition for others—just the reverse of Haagar's desire to assimilate the conditions of ownership that, as a slave mother, would have been denied her.

The most powerful counterweight to Haagar's condemnation of the ritual is Eula's climactic speech, arising out of a moment of spiritual possession provoked by an embrace with Nana and Yellow Mary. Eula's words—"We're the daughters of those old dusty things Nana carries in her tin can"—are the most resonant verbalization of the title theme of abuse and transformation, transformation and continuity. Her verbal explosion is motivated first as a defense of Yellow Mary, whose contribution to the text elaborates another of the crossroads conditions faced by these

survivors. As a farer in the crossroads, Yellow Mary needs to be recalled as a manifestation of Yemanja, the goddess of the waters and mother of creation, her "child," depicted as a prostitute, a venturer into White civilization so disillusioned that she gives up nursing and her role as nurturer, saying, "I 'fix' the titty." Yellow Mary represents a transgressive variation on the White Mary of the immaculate conception. (As mother of creation, Yemanja has often been linked syncretically with the Virgin Mary.) She is treated as a pariah by many of the women of Ibo Landing because she is a "fallen woman" and because she is a "yellow" woman. Dash seems to be meditating a mythical-historical narrative in which the original cosmology of the *orixas* is being refigured for a new historical crisis period.

Not only Yellow Mary but all the characters voyaging to Ibo Landing at the opening of the day show the marks of adaptation to modernity. Many in that community hunger for this new, post-African world. The movie shuttles between the options of industrial society and traditional African culture. The inspirational story of the Africans brought in chains to Ibo Landing who took one look and then walked across the waters back toward Iboland is followed by the comment, "All then peoples drowned." In conceptual terms the historical crisis faced by the Ibo Landing community, as symbol of the diasporan African community, is between an attempt to live by the example of the African world as a kind of imagined ancestral essence before the trauma of Europe on the one hand or by the light of the lessons and transformations imposed by the middle passage on the other.

So the invoking of the *orixas* takes place in a context where African people are in perpetual crisis and the values of African religion are evoked as instruments in the struggle to survive. The diasporan African community is located in a perpetual crossroads (which may support the idea that Eshu-Elegba, the spirit-guardian of crossroads, is even more important in the diaspora than in Africa). And *Daughters of the Dust* frames the attempted rejection of Yellow Mary as a particular crisis point for this society.

Yellow Mary's yellowness evokes both the fallenness and the impurity of the African community in the diaspora. Her arrival by way of the waters repeats the original African dispersal into the New World, and so she can stand for that diasporan experience. But she also stands as major symbol of the capacity to transform its conditions, or transcend them toward planes of existence where these epiphenomena no longer represent defeats. There is something of a symbolic triumph underlying Yellow

Mary's color difference from White Mary. Yellow emblematizes the "imperfect" origin of her beauty. Mary's yellowness raises a challenge before the *orixas*, whether they have failed their children by allowing them to suffer defeat and face genocide. Eli voices the skeptical question, "were the old souls too deep in their graves to give a damn about my wife while some stranger was riding her?" Eula's later reply, under possession of those ancestral spirits, confirms once again the need to maintain the life of the people through the conditions of "imperfect" beauty and history and tradition. Skepticism such as Eli's (and they are echoed by Haagar and others) amount to a challenge to recognize and build on the fundamental bonding principles of the group, despite such discouraging appearances.

Yellow Mary's principal role in the text is to return to the community, to present herself as reclaimant of her place there, and to be judged, like another Mary: Mary Magdalene. Her reception speaks to another important issue of the politics of difference. The Yellow Mary sequences question the value of the "positive image" criterion of representations. The thirst for positive imagery follows every repressed group and affects their representational strategies, almost inevitably, whether the form is culture, economics, gender, or religion. In feminist critical thought, the proposition gets reduced to such questions as whether a text that shows a woman being defeated in her goals can be deemed feminist.

The conception of the positive image demonstrates several important understandings—the power residing in "instruments of symbolic authority,"[13] the need for conflict in the arena of representational difference, the function of repetition as a signifying force controlled by dominant culture and the way symbol-making authority is used generationally to reproduce the culture in power. But the positive image concept also demonstrates several important denials, many of them arising from emotional more than strategic needs.

"The shameless hussy" spits one woman in the direction of Yellow Mary as a chorus gathers to condemn her. The positivist image position is widespread enough for us to remember the analogy of Mary Magdalene, though some positivists will resent citation from a Westernized text such as the Bible (forgetting that the values by which she is condemned are from the same source). Hostile to the shadings and gradations that bring dimension to representation, positivism tends to flatten into either/or totalities, and certain linearities, which prevent the perception of reality existing on multiple planes. So that it becomes impossible for the women of Ibo Landing to see Yellow Mary as the light-skinned woman who ran

off seeking adventure and became a prostitute and Yemanja, the mother of creation and all the *orixas*, at the same time.

To be clear, all politics of difference find the notion of positive image unavoidable in some form, except for the extreme, a-political irony that Hayden White isolated. There can be no politics of resistant representation without some idea that this is better than that, and as a guide for the project of recoding knowledge from this to that, from aestheticism to anaestheticism, for example. Limitations arise when positive surface appearance is insisted on through all stages of production and reception, formulaically, and to the exclusion of other, less binary ways of thinking.[14]

The crossroads judgment of Yellow Mary forms one crystallization of the historical crisis faced by the whole Ibo Landing group as symbol of the African diaspora poised between an attempt to live by the example of some real or imagined notions of purity before European-imposed slavery and colonization on the one hand or in light of the lessons and transformations imposed by the middle passage and the crisis of slavery on the other.

"As far as this place is concerned, we never enjoyed our womanhood. . . . Deep inside, we believed that they ruined our mothers, and their mothers before them. . . . Deep inside we believe that even God can't heal the wounds of our past or protect us from the world that put shackles on our feet," cries Eula. She renounces the fantasy of purity, either Christian or African. Purity has been obliterated. This can be affirmed despite instances such as communities in Brazil which have preserved African religious practices so completely that African researchers travel there to observe rituals now lost in Africa. But it is not possible to deny change.

Eula's moment of passion has the force of a break in time. Implicitly, she is rejecting the syncretism imposed on African people as a last-resort ruse to hold on to their gods. The most familiar practice of syncretism is the melding, by African captives in the New World, of Catholic saints with African gods and spirits. By this Aesopian stratagem, they managed to continue to worship in their native traditions while pretending to observe respect for the gods of their enslavers. It is a ruse founded on a sly understanding of the ironies of discourse. But a given of this irony is that one source of knowledge is supported by weaker political power than the other, hence located in "imperfection." Syncretism is a means of the weak to bide time, not a happy solution to a set of theological contradictions.[15] And Eula appears to be seizing the time to throw off this mask of compromise at the same time that she calls for a recognition of a new fusion,

not between African and European gods, but between African tradition and New World transformative experience: "If you love yourselves, then love Yellow Mary, because she's a part of you. Just like we're a part of our mothers."

Some of the ironies we have been examining converge in the cover photo to this book, by Brazilian photographer Bauer Sa, of Bahia. The posture of this beautiful woman recalls the mise-en-scène of Botticcelli's Venus, familiarly called "Venus on the half-shell." The veils, simulating the hair of the Venus, echo the hand of modesty. The beauty of this model is Achebian in contravening the Monopolated ideal of beauty located in the Botticcelli painting. Yet, it is clearly an alternative kind of beauty, one that would not find a place in a text by Sir Kenneth Clark. She stands in relation to Botticcelli's Venus as Yellow Mary stands to White Mary. As much as her beauty is outside the convention—the cloth-paper bracelet is almost certainly a spiritual artifact, possibly of Candomble—she reminds us that the liberation from aestheticism need not mean a sacrifice of beauty, grace, or pleasure. But almost as one final note of ironic distance from the "purity " of detached aesthetic experience, the beauty of this woman is enhanced by its connectedness to life, not its distance from it, as indicated by the fact that she is pregnant.

Like many another emergent narrative, but more powerfully, *Daughters of the Dust* both ruptures and renews the compact by which the African captives in America negotiated their survival. By doing so, it puts into play the vision of a new order of knowledge and action. Central to this order is the subversion of the codes of compromise, with Christianity, as represented by Viola, and with the dream of material comfort and security. By claiming African deities to preside over this prophetic course of development, the narrative puts an end to the syncretism that represents a subservient compromise with the gods of one's oppressors. In the train of this rupture, the guarantees of the Enlightenment are given about as much credibility as the promises of Prospero, the magician. The conversion of Mr. Snead implies a critique of the path of techno-material scrabbling the migrants are about to follow. The film is realistic enough to grant that Nana's victory may be temporary and merely symbolic. But within that moment we can find an opening of another way of attending reality, beauty, culture, truth, value, economy, science. *Daughters of the Dust* is then just a reminder, but a most potent reminder, of the more that exists under the heavens and on the earth than in aesthetic-materialist philosophy.

CHAPTER XIV

■

Conclusion

BUT IS IT ART?

> The screen that comes between the viewer and the
> artist is the thing that has been intellectualized and
> nurtured among Westerners. . . . Whatever disadvan-
> tage may be felt here can be turned to advantage if one
> completes the process—creates a full intellectualiza-
> tion so that the screen is known and hence can be sys-
> tematically disregarded.
> —Paul Bohannan and Philip Curtin,
> *Africa and Africans*[1]

> So we think that our moment has come, that at last
> the underdeveloped can deck themselves out as "men
> of culture." Here lies our greatest danger and our
> greatest temptation.
> —Julio García Espinosa, "For an Imperfect Cinema"

> Just as Picasso and other European artists took from
> African art what they considered useful without
> knowing the deeper contextual significance of these
> works, we should take whatever we consider useful
> and just ignore anything (western criticism) which
> could divert us from our path.
> —Rasid Diab, Sudanese artist,
> "Different Values—Universal Art:
> The State of Modern African Art"[2]

Key questions challenging the need for breaking the aesthetic contract
begin with, what would you put in the place of aesthetic reasoning? The
next puzzlement is what the world might look like without aesthetics,
quickly followed by a nervous confession: "I can't imagine it." Another
certain question: isn't breaking the aesthetic contract an act of die-hard

anti-Westernism (and hence anti-intellectualism)? But the most comprehensive question is, given the power and conventional respect achieved by aesthetic discourse, together with its positive contributions, wouldn't it be wiser to reform its shortcomings rather than to reject it wholesale, hence throwing the baby out with the bathwater? Here I want to respond to these questions, starting off with the last, more embracing one.

GIVEN THE HISTORY OF AESTHETIC REASONING, IS IT NOT BETTER TO REVISE THE CONCEPT, RIDDING IT OF SOME OF ITS REGRESSIVE TENDENCIES, THAN TO JUNK IT ALTOGETHER AND START OVER FROM SCRATCH?

We looked at this question in a more restricted form in the chapter "A Drowning Man Offers You His Hand." Here, we return to it as a general proposition.

Can we separate the idealistic, utopian intentions of aestheticism from the imperialist practices of the art-culture system? In view of the history of Eurocentrism the short answer must be no, not likely. Too many lies and misrepresentations have become entrenched, taken for granted as the sane and civilized way of thinking, to suppose that there could be much good faith available for serious revision.

The myth still thrives that artistic practice offers incontestable social benefit, as in the slogans that pop up whenever funding for the arts is threatened. The claim of social enrichment is made as if a transparent, self-evident proposition, drastically oversimplifying the many-faced links of artistic practices with the more general workings of society. The hand of privilege, biased cultural assessments and economic and ideological exploitation, would doubtless not disappear with the disappearance of aesthetic ideation. But the effects of these agents would rise clearer and plainer into view. The way aesthetic philosophy was constructed as a cog in a developing concept of humanity, while that humanity was endorsed in only one geographical and "racial" population, has influenced all the available notions of social uplift through the arts. The cyclical justification of "civilization" (that civilized behavior is what civilized people do, and vice versa) has heavily depended on aesthetic reasoning as a crucial link in the cycle. Without aestheticism, Sir Kenneth Clark's book *Civilization* makes no sense. Let's put aside the exclusion of all non-European

people from this text. What is equally symptomatic here is the marginalization of religion, technology, philosophy, science, economics, sociology in a book with such a title while concentrating on the arts of painting, sculpture, and architecture. But why can't we hold on to aesthetic idealism freed of Occidental chauvinism? Because, as we have already seen, thought filtered through a particular cultural symbolism cannot produce value perceptions valid for all other cultural situations. The pretense that this limitation can be overcome (or quietly ignored) has allowed aesthetic reasoning to deeply implant the subject position of Western consciousness until that consciousness and aesthetic sensibility have become virtually synonymous.[3]

Every once in a while, moreover, the barricades of privilege around aestheticism reveal themselves for a moment, dispelling the mystique and illusion of good feeling that surround its control of "culture." One such moment came in an essay by Arlene Croce, dance critic for the New Yorker. In "Discussing the Undiscussable," Croce declared, "I have not seen Bill T. Jones's 'Still Here' and have no plans to review it."[4] Croce regarded Jones's ballet as "beyond criticism" because it included videotaped interviews of terminally ill AIDS and cancer victims in a dramatic dance piece. Croce placed herself in revolt against what she called "victim art," part of "the pathology of art" that has spread since the anarchic 1960s, and including all "massed produced art of the 20th century" as well as "the grisly Holocaust movie, Schindler's List." Croce declared her resentment at being forced to feel sorry for "dissed blacks, abused women [and] disfranchised homosexuals."[5]

Croce's essay generated a swarm of criticism. Among the counter-statements, one of the more vigorous came from novelist Joyce Carol Oates: "Why should authentic experience in art render it 'beyond criticism'?"[6] asked Oates, citing several highly respected works based on painful autobiographical details including Dostoyevsky's House of the Dead, ex-slave narratives by Harriet Jacobs and Frederick Douglass, The Diary of Anne Frank, among many others. Deliberately or not, Oates's argument threw her in collision with some of the assumptions of aesthetic reasoning:

> What is particularly revealing in Ms. Croce's position is a revulsion for art with "power over the human conscience." But what is wrong with having a conscience, even if one is a professional critic? If art is too "raw" to be reviewed, shouldn't it be witnessed, in any case, as integral to cultural history? (Surely the critic cares for art even when it isn't for "review.")[7]

The tender nerves of aesthetic reasoning are once again exposed in this exchange. Does Oates slyly imply that for the aestheticist critic, art only becomes such under "review," with "review" synonymous with the aesthetic gaze which, for Croce, has nothing to feed on in unmediated human suffering? Croce's position is so retrograde as to recall Villiers De Lisle Adams's remark, "As for living, our servants will do that for us."[8] One is reminded also of Hugh Danziel Duncan's understanding of irony as something that fails "when there are wide gaps between social classes, or when status groups become strange and mysterious to each other."

Croce had inadvertently made visible the screen that Paul Bohannan talks about, the one that "has come between the viewer and the artist" and that has "been intellectualized and nurtured by Westerners." In response, Oates comes close to a decisive critique by upholding the possibility of conscience in interpretation, and the value of cultural history as a framework for reception. In short, Oates comes close, as one must in such cases, to breaking the aesthetic contract altogether. Croce's provocation draws the realization: there are several humanist frames of reference where her carping complaints are completely out of bounds—morally incomprehensible. What is needed to get beyond this point is to grasp the historical framework for this abstraction of art from general human experience, and to dispel its screens of self-protection.

These screens can be dislodged only by understanding their make-up, not only of aestheticist logic, but that logic as given force and respectability through Eurocentric practice. The aggrandizement of Euro-art values following the triumph of capitalism meant something more than the elevation of the tastes of a newly dominant social class. The aesthetic was not just another hierarchy of cultural tastes, just as Eurocentrism was not only another ethnic ego trip.[9] The invention of the one was inseparable from the construction of the other.

Taking the rhetoric of the art-culture establishment at face value, many are tempted by multi-aestheticism. Just because aesthetics-in-general has proved to be a corrupt paradigm, they reason, does that prevent some gain from fashioning, say, a Black aesthetic that limits its generalizations to African-based populations, and refrains from the aggressive universalizations of European philosophy and criticism? There is indeed nothing wrong, in fact, everything orderly, in every ethnic group developing its own hierarchy of values. This of course applies as well to the ethnography of Whiteness. In fact it is crucial for all such groups to acknowledge their cultural/ethnic particularity by way of surrendering their claims to be chosen people.

But multi-aestheticism holds the same limitations as multi-cultural-ism. By now we should know that the multiculturalism proposed by the art-cult system could at best only widen the Colonial District Commissioner's administrative view of things without reversing its biases. The debate between the multiculturalists and their more traditional opponents in fact recapitulates the difference between the indirect rule of British colonialism beside the more thorough *francité* of the French colonial policy. To offset these dangers a "polycentric multiculturalism" has been proposed by Robert Stam and Ella Shohat.[10] But there is no general salvation in separate but equal divisions of cultural labors. This is the limitation of polycentric multiculturalism. However equitably such a design is described, political reality warns that there will be a struggle over cultural turf, and a need to supervise the supervisors of this contest. A subconscious acknowledgment of the danger of resurgent entelechy lies in the redundant phrasing of "polycentric multiculturalism," which is rather like saying plural pluralism. There must be continuing struggle against Eurocentrism, no matter which formula achieves acceptance. In addition to respect for the cultural particularity of all groups, there must be continuing effort to build, and protect a democratic humanism that Western intellectual tradition has inspired and so far flunked.

The fatal problem with most schemes of multiculturalism and multi-aesthetics is that both are proposed to take place within an environment of unequal exchange. The way less powerful communities are exploited, for talent, as markets, as sources of ideas and cultural "goods," matches, by analogy, the way neo-colonial market forces convert once self-sustaining agricultural societies into single cash crop economies, for tobacco, sugar, coffee, or some other item contributing to unbalanced development. By the same measure, Hollywood drew on Step 'n Fetchit–styled stereotypic portraits as a single cash cultural crop extracted from Black culture in the 1930s and 1940s; mined for sensational Black exploitation images in the 1970s; and satisfied itself with guardian angel cameos in the 1980s and 1990s. Meanwhile, cultural "crops" that might sustain the exploited community, like the films *Do the Right Thing* by Spike Lee, and *Daughters of the Dust* by Julie Dash, encounter resistance because of their "imperfections" in the eyes of the Palace.

For emergent cultural producers—emerging from colonialism or apart-heid—the chance to at last become the subjects of the aesthetic gaze and the focus of art-cult attention is often too tempting to turn down. We can understand the practical considerations that would attract such producers to multi-aesthetics or ethno-aesthetics. The link between these

"minority" cultural producers and the aestheticized canons of Western knowledge is much like that of dominated groups who were once forced to forge syncretic fusions of their gods with the gods of the colonizers. But a Cyclopism that outlasts its historical justification must remain an object of pity. The damage of pointless self-deformations is better removed by desanctifying aestheticism than through syncretic compromises. Ironically, majority cultural thinkers grasp the rationales behind this need more readily than many emergent intellectuals.

The new liberalism that would allow each group its own localized aesthetic promotes a laissez-faire policy with a catch. Take for instance this comment in a letter responding to "Jungle Fever," an article in the *New Yorker* (November 6, 1995) about revisionist criticisms of Joseph Conrad's "Heart of Darkness": "The European expansion during the colonial period inexorably brought into the Western consciousness what had previously been unknown. Whatever Edward Said and Chinua Achebe may think and say, their non-Western analyses are irrelevant to the European experience of the 'other,' which Conrad evoked in truly exceptional images of pity and terror."[11]

True enough, as this writer asserts, Western consciousness has a right to the knowledge it scoops up through its interpretive skeins. Whatever one might say about cultural appropriations, arguments against them cannot take away the legit privilege of, say, White Americans viewing Black Americans through the lens of *Porgy and Bess*, or Ava Gardner interpreting a mulatta in *Showboat*. No more than we might deny Gabriel García Márquez or Jorge Amado the privilege of interpreting North Americans in their fiction. But this privilege is abused when the interpreted Other is monopolistically depicted and ritually deformed in the Western gaze.

What is disappointing and symptomatic of the imperial position of much Western criticism, like that of Canby and Croce, is the refusal of dialogue in a near-Despotic stance toward representations from inside the cultures under siege. It is only by powerful intellectual force and the provocations of the current knowledge crisis that persons like this letter writer are now forced to acknowledge Said and Achebe at all. As another mark of the crisis, unlike Euro-humanists of the past, he does not rest on the clichés of "the human condition," but accepts the Western perception as a particular one, waffling on the claim of universality for his taste system.

This may look like a healthy change until we realize that, since he dismisses "outside" commentaries as irrelevant, the only response left

would be the familiar Euro-humanist one, but universal now in the sense of being the only one left standing. This writer is symptomatic in willing away evidence that contradicts his aestheticized notion of "Africa," which he wants to protect with the key words from Aristotle, the "pity and terror." In other words he wants to experience only the pity and terror filtered through a congenial, filial consciousness, but, like Croce, opts to skip any pity and terror evoked by the viewpoints of Said and Achebe.

Beneath the impulse toward multi-aesthetics lies a generous, utopian sentiment that could only be made real by a persistent struggle against the worst effects of unequal development. This means, once again, that even the contemplation of such a utopian sentiment has to be foregrounded by the critique of representation as a more demanding priority. It will not be enough to say, hereafter we will try to put into practice a more equitable, tolerant system of organizing cultural knowledge. This kind of genteel ameliorism postpones a fundamental reckoning, and too casually allows the return of the repressive doctrine at the earliest opportunity. This is a strategy of cultural amnesia that wishes historical change without pain or sacrifice, that wants, in the words of the blues, "a cherry without a stone, a baby without no crying." This strategy would single out one or two oppressive features of aestheticism, its formalism, say, or its elitism. On the other hand, there is also the more radical road of engaged deconstruction, to which I will return.

LIFE AFTER AESTHETICISM

Yet the aesthetic continues to draw support from generous-minded individuals who regret its shady past, but hope its benefits outweigh its destructions. They force us to return to the question: what would you put in its place? This question ingenuously assumes that the art ideology is an inevitable construct, a necessary item of knowledge. One gain from seeing the aesthetic as a passing historical fancy is to understand that life once got along very well without it, just as valuable creative work continually goes on, as Oates notes, beyond the care-keeping of criticism. Tony Bennett was accurate in describing the aesthetic as "useless knowledge." To those who cannot imagine a world without the aesthetic gaze, a proposition: try to return your minds to an historical scene before the imposition of this code of taste. This might draw us to one of any number of intellectual landscapes, to a period when in Europe rhetoric satisfied the demands for analysis of public expression, or to the point where ob-

servers assert that the word "art" does not appear in West African languages. Once outside the contract, are there no possible frames of cultural knowledge consistent with your view of the world, minus the aggressions and false consciousness that are increasingly being identified with aestheticism? Once located in the Beyond Aesthetic Reasoning Zone, can't we manage without the brainstorms looming on the philosophical horizons? Are the gains to be made from this coming formulation so wonderful to your reasoned view of the world to offset the posturings of Romanticism, the class evasions, and rationalizations, the violent ethnocentrisms, the invidious cultural comparisons, justified by this pretentious "science" of beauty? What do these exercises in useless knowledge really contribute to your social ideal? Can you find no perspectives based on pre-aesthetic coordinates that differ positively from the world idealized through art?

The inevitability of aesthetic reasoning is contradicted by many historical circumstances. Anthropologists struggle unconvincingly to reconcile the inventions of traditional societies with aesthetic logic. The paintings of Australian Aborigines may appeal to Westerners and take a growing place in the art market, but the origin of these paintings as chartings of ancestral spiritual journeys denies their colonization as "art" in the Occidental context. These works become art only through violence done to their original meanings within the intersubjectivity of their makers.[12] Abdullah Ibrahim, the great South African musician, speaks of how traditionally in his culture, when a person showed talent for music, that person was immediately directed toward training as a healer, because the two skills were assumed to be related.[13]

Or consider the work displayed in the massive exhibition, *Africa, Art of a Continent*, at the Guggenheim Museum in 1996. Here is the dilemma—the powerful objects in this exhibition simply do not fit into the paradigm created in the West to house "art." Only about 2 percent of the objects in this mammoth exhibition fulfill Maquet's criterion for world art, namely non-functional ornamentation. But these objects are too grand, magnificent, highly structured, and individualized to rest comfortably in other categories of Western knowledge, like "Natural History," or "Primitive Art." The truth is, they were usually constructed to serve some higher significance than what the West has singled out since the humanist revolution as art.

One learns from the techniques of exhibition, both here and in many displays at the Museum for African art in New York. Five Kisongi-Ethiopian grave sculptures are displayed together—very erect (as in Egyptian

art) and five or six feet tall. Forgetting their compelling *presence* viewed singly, they make a far more haunting statement when grouped together. One sees this all the time in many African art exhibitions.

They are more powerful in combination because they insinuate a context, sometimes even a mythology, where one alone might not have the same impact on the eye and mind. It is as if they each suggest a god— actually they each honor an ancestor, who is now a spirit. Does the difference imply that Western art is always/already evoking only a monotheistic gaze? Maybe. There are other reasons why the impact of objects displayed in combination with each other is usually less forceful among Western art objects. For one, we always/already know the context of classical Western art, and are encouraged to look at its details rather than its sociability.

Once context is restored in the display of these works they dramatically overflow the presumptions of aestheticism. To make any sense of much African art, the art historian and curator must supply a context which, according to the pure formalist bias of aesthetic reasoning should be dispensable. And only a dishonesty of a sort we are familiar with will allow the curator to pretend that the contextual meaning of the work (its role in celebration of kingship, initiation, honoring of ancestors, propitiation of evil forces) is less important to the makers of the work than the considerations of "beauty" or satisfaction of the aesthetic gaze that the curator and her public is interested in. It is not only the peculiar ways of looking that make aesthetic reasoning stale, it is the basic assumptions of separation that are belied whenever context is reinserted.[14]

These are just a few instances where the diverse, vital motivations of traditional cultural practices confound the art-cult bias toward a nonutilitarian gaze and a formalist set of priorities. To offer one more example, the celebrated tomb of King Tut, young pharaoh of ancient Egypt, which was found loaded with arguably the richest concentration of exquisite objects in human history, was, when opened, a room full of objects not arranged neatly as in some museum, but heaped helter-skelter as in an untidy attic and then buried beneath the ground in hopes of hiding the existence of this treasure from any human eyes for eternity. One understanding of this untidiness is that when the King arose from the dead, his servants would put these household objects in order for his use. How to correlate ideas of aesthetic contemplation with these extraordinary works that were fashioned in the belief that they would never again be seen by human eyes is a question aesthetic science has not yet answered.

"From this perspective," writes V. I. Mudimbe, "one could note that, as

far as African art is concerned, a major philosophical problem has not yet been solved. What is called African art covers a wide range of objects introduced into a historicizing perspective of European values since the eighteenth century. These various 'objects' which, perhaps, were not 'art' at all, became art by being given, simultaneously, an aesthetic character and a potentiality for producing and possibly reproducing artistic forms. One could wonder whether, understood in their initial form and significance, they would not have created a radical 'mise en perspective' of Western culture."[15] Such cultural moments, apart from making life hard for aesthetic rationalization, point to spaces where cultural work goes on unauthorized by the limits confining European middle-class taste. To these might be added such venues as Outsider art and any number of other, unordained spheres of production and reception.

The extreme case is the misappropriated New Guinea mask paired with a work by, say, Vlaminck. But if we focus too narrowly on extreme cases like the ironies at work between "primitive" and avant-garde art, we might shortchange a less obvious cultural miscue, like that between the works of Latin Americans and their Euro-centered reception. But in venues where much is shared, or believed to be shared, the discursive irony may be even more wrenching than where the cognitive fields are more remote, say Papua and Paris. More important because less obvious. It could even be said that the New Guineans are not really injured by the appropriations that take place far out of their sight. By contrast, the assumed accessibility of, say, Toni Morrison's work, as a universally acclaimed Nobel prize writer, might mask serious misperceptions of that work.[16] It is the familiar story of two societies being *separated* by the same language. Extreme instances are useful to illustrate the pretensions of aesthetic knowledge, but the crucial damage may be in places where Western and non-Western cultures are in rapid and continuous exchange.

The victory of jazz over art-cult dominance did not outlast the concertization and academization of the music in recent years, but for most of its history jazz set an example worth remembering of a more productive resistance than avant-gardism, and symbolized the collective memory of cultural elimination defied. Jazz succeeded, and without resorting to "negative aesthetics." Familiar with transgression and parody, it also had other registers. It was not determined to be more highbrow than anything that came before. It was content to be popular, and to accept the assaults that came with that territory. It was not afraid to be positive, celebratory toward the possibilities of human existence. It recoded, for popular and resistant consumption, the whole of the musical vocabulary of its time.

And it provided a wedge behind which other forms of cultural resistance might develop.

Perhaps we experience difficulty in estimating these scenes of enlightenment outside aesthetics, because they do not come in the familiar package of art "movements." This may also help explain their exceptional value as alternatives. What we do *not* need is to replace art ideology with another like it. To break the aesthetic contract demands more force than can likely be mustered by surrogates like "anti-aesthetics" or postmodernism.[17] Without mounting a sharp encounter with cultural domination, various forms of "new theory" look like more Palace intrigue, not the revolution they romantically invoke. The link between these neo-movements and old-fashioned modernism bears the mark of a generational conflict, an "anxiety of influence."

The resemblance of these movements and their allies to older ones around the Palace is unmistakable. Particularly in terms of race and gender. There is a self-conscious effort at color-blindness and a politically correct openness to token inclusion of women and people of color (among the artist, at least, but breaking down to lip service among curators and other gate-keepers).[18] These movements seem never to enlist the allegiance of non-Western artists on the basis of mutual, Achebian resistance.[19] Affiliations with artists and theorists of color are seldom designed to give the disruption of ethnocentrism a high priority, but rather to demonstrate that the "new thing" is a "modern," i.e., postethnic thing. The range of significance in this debate, seen from this vantage point, extends from Tweedledum to Tweedledee.

The question, what life after aestheticism? has a special meaning for emergent intellectuals and artists, as potentially the hardest "sell." The question, what to put in its place? is pragmatic but misleading. Recognizing aestheticism as a kind of bondage, wouldn't replacement just exchange one set of restricted quarters for another? The culturally maligned have the option of reforming the aesthetic or of living without it. The ironies of this choice are very similar to the discursive ironies already examined; the options of Aesopianism, Cyclopism, or Achebian resistance are primary responses to a powerful but discredited ideology. Once the break is made out of that confining and distorting form of reasoning, the choice is either to start off afresh by shaping new concepts of cultural production and use, or recover guidance from old ones. Or both, simultaneously.

Rather than instant replacement of the aesthetic concept with another, the project of escape and repossession is nourished by remaining in in-

structed doubt. There are distinct advantages to what Tommy Lott calls a "no-theory theory."[20] One value of a no-theory theory is its implicit refusal of the terms of the ongoing discourse, the rejection of the given categories, and the history of the discussion so far. A no-theory theory is not a statement against theory as such, but only against the history of theorizing in a particular area.

To concoct a grand, overarching, formulaic replacement is a design for error. New definitions should always be framed with specific practices and purposes in mind. To do otherwise, to merely whisk definitions out of the metaphysical air, is to host a feast of false consciousness to serve individual egos. Before grand definitions are entertained, we need to know their purposes, origins, and as far as possible, their implications. If people liberated from the illusions of aestheticism are to create a new framework for working, why should they expect such a framework to be handed to them? Of what use would such a scheme be, not having arisen from practice and experience, trial and error, the rise and fall of favored positions? By looking for a neat prescription for cultural work, are we not really asking for the launching of a new wave, or movement, cycle, or generation, fashion, or label?

The greatest virtue of moving beyond aestheticism is the freedom that this allows, the openness, the investigatory license. Retiring the aesthetic takes a step toward fertile, regenerative otherness—heteroglossia. By the evidence accumulated in this study, the aesthetic has functioned as a definer, manipulator, policer of Otherness far more eagerly than it has as an explorer of the possibilities of reciprocally respected difference. To get past the categorical boundaries of the Other and into a frame where we can see a reflection of ourselves in others, we must disentangle ourselves from this crippling set of expressive expectations. Returning to the figure-ground illustrations of the first chapter, young people invariably want to deny as fatalist the position that one cannot see both the figure and the ground at the same time. They want to resist the view that we must see *either* the old, ugly woman *or* the young, pretty woman, *either* the white vase *or* the two black faces, but not both. Such a more complex, reconciliatory vision may be possible in a moral, if not physical reference, but only if we overcome the mental sets entrenched in aestheticism.

To "replace" aestheticism may be to miss a great opportunity. Rather than to find an agenda, ism, formulaic construction, hierarchy of stylistic traits, or scheme of interpretation to fit into the space vacated by a discredited dogma, there is the option of disengaging from all such tar babies and returning to the brier patch of uncharted, provisional, improv-

isatory reconstruction. Aesthetic reasoning needs to be subordinated to a very different discipline, the critique of representation. This critique radically departs from the grids and assumptions of the aesthetic because it recognizes no break with the political or the ordinary. As Lucy Lippard writes, "The real risk is to venture outside of the imposed art contexts, both as a viewer and as an artist, to live the connections with people like and unlike oneself. When culture is perceived as the entire fabric of life—including the arts with dress, speech, social customs, decorations, food—one begins to see art itself differently. . . . When it is fashionable for artworld insiders to celebrate meaninglessness and the parodists operate on the same level as the parodied, perhaps only those who have been forced outside can make a larger, newly meaningful contribution."[21]

The mechanics of the necessary disenchantment have already been fairly well established. We know them by such names as "recoding," "unnaming," "sampling," and "the commutation test," as well as the process of sifting through the ironies of discourse. The question of resituating ourselves within the Euro-canon can be approached through considering the *William Tell Overture*. It is almost impossible for any American of the Baby Boom Generation to hear it without thinking *The Lone Ranger*, and maybe automatically chiming in with "Hi Ho, Silver, away!" A cultural work that once had a certain deeply established identity, in support of a particular social narrative—the mythologized tale of a great archer who could shoot an apple off one's head, itself a popular transformation of another, nationalist narrative—has been again reshaped to coincide with yet another popular myth about another popular hero, this time a masked cowboy defending the weak.

Putting aside the intrusive question which use of the music is better, we should focus on the mechanisms of altering meaning. The overture can give us some idea of how an emergent cultural interpretation can reposition itself in relation to canonical classics and knowledge. As we have seen, classics like Shakespeare can be "rewritten," just as the overture has been rewritten. The question might then be, what does it take to hear the music of the overture without thinking Lone Ranger?

To free one's mind from some overpowering association, one obviously has to experience some new, intervening mental inputs—some new associations. In the case of the *William Tell* work, the listener with more developed technical musical knowledge might hold an advantage. With such knowledge, she might be able to dissect the passage and bring a technical-analytical attention to its parts and open the door to other ways of

experiencing it. At this point we hit upon an old question: whether an observer of a cultural work is better off to enjoy it innocently, without expert and technical knowledge, or through such trained appreciation. The answer now seems to be that it is better to have some deliberate framework of knowledge, some methodology in one's mind, in order to be able to escape the train of thought otherwise impressed on one's first, innocent attention.

And this answer holds when we view the "piece" under consideration to be not the *William Tell Overture* but the Western canon of classic literature, art, and film, or when we consider it to be the aesthetic. In either case, the best means of enabling oneself to elude the oppressive body of associations or meanings is a developed, critical, analytical sense of the issues at stake. When the body of domineering associations and meanings is the whole panoply of Euro-humanism, the technique of escape must include the critique of representation as well as the experience and analysis of declonization toward a more consciously democratic humanist frame of reference.

Many will understandably be reluctant to compromise their positions on the margins of the art-culture system by adopting a position certain to be framed as anarchic and demonic. The break with aestheticism, for those who can make it, may nevertheless mark out a liberated zone of thinking, free from the familiar canonical restraints, a mobile camp from which telling raids can be sprung upon the bloated pretenses of the paradigm. The effort to relieve ourselves of the smokescreens of high art dogma may help us extricate ourselves from the burden of Occidental cultural arrogance. The critique of aestheticism can support resistances to other Monopolated discourse. The delegitimation of aesthetics has important consequences for search-and-destroy missions against Eurocentrisms in disciplines such as philosophy, anthropology, art history, philanthropy, Euro-humanism, and theological studies.

ISN'T BREAKING THE AESTHETIC CONTRACT AN ACT OF DIE-HARD ANTI-WESTERNISM (AND HENCE ANTI-INTELLECTUALISM)?

Why is it that this next question always comes up? Once it is clear a fundamental critique of Western iconology is underway, solicitous concern for the critic's rational balance prompts the query: but you wouldn't

dismiss *all* Western knowledge, would you? The questioner is ready with commiseration for the pathetic unrealism of the argument, its chauvinistic immersion in some quaint ethno-philosophical perspective that cannot stand up for a minute beside the great accumulation of knowledge amassed in the institutions of the Palace. In fact, the critique of aestheticism does not impugn the humanity or relevance of White people, merely the universality of their cultural speculations. The critique provokes this question because of the prerogative inherited by Western humanism to serve as the generic model of the species. Challenges to this select identity raise a suspicion of blasphemy or heresy. The questioner really speaks for Western civilization, saying, "Don't you know who I am?" This privileged I.D. is one of the earliest sites of political correctness.

But this critique draws credibility from an alternate humanism that does not privilege Western definitions of the human, even while profiting from them. Why, then, is one so quickly accused of "throwing out the baby with the bathwater"? The accusers imply that there can be no humanism other than their own. They ignore a fundamental stipulation of any valid humanism, that it cannot exclude any group in its search for profitable definitions of the Group Self. How, then, can we dismiss *any* group, including Europeans, from our consideration of what is valuable in the calculations of human understanding? If we can imagine any group from which nothing can be learned, are we not then on the same self-limiting path as the misdirected Euro-enlightenment?

And because Western experience, through its acquisitions of power and technology, involves enormously rapid passages of historical change and development, extensively recorded, there is much that must be learned *through*, more than from, Western knowledge. (I am aware, even as I write this, that there is a long-established ritual of exacted or expected *testimonial allegiance*, performed by colonials, subalterns, and converted pagans that sits awaiting occasions such as this. Robinson Crusoe is always waiting for Friday to put Crusoe's foot on his head and call him "master.")

Yet something more pointed is called for than simply "decentering" the Western subject position. There cannot be a "let a thousand flowers bloom" reconciliation with aestheticism, because it is a totalitarian perspective. It has demonstrated its willingness to crush thousands of blooms rather than let them flourish. A continuing struggle against the art-ideology cannot hold a dominant priority in the effort to achieve a sane world order. But that struggle is necessary in the same way that the effort needed to resist anti-democratic impulses never ends.

I propose, then, an ongoing, engaged deconstruction of aestheticism simultaneous with a protracted and collective reconstruction of cultural knowledge, with the aim of establishing radically wider cultural democracy than now exists. This effort would have a broader aim than supplanting a regime of repressive categories of thought. It will not be enough to free oneself from the sanctioned tastes and canons of Westernized cultural history. It is more important to free oneself from the attitude of mind, the overcultivated subjectivity that feeds on those tastes and traditions, the structures of consciousness and individual selfhood that rise out of that kind of sheltered, curatorial subjectivity. Once we grasp the complete reflexivity of "art" and the art-cult, the co-dependency of the remarkable object and the eye of the beholder, we might regret all the more the self-satisfied smirk that is the mirror image of the aestheticized Western gaze. We might want to wipe the self-satisfied smirk off the observer's face that the remarkable object might see, gazing at it, and replace it with some of the more salubrious visages of reverence and respect available to unexpurgated humanity.

Uppermost is the necessity for keeping the engagement with aestheticism within a historical framework. The best response to those who contend that the erasure of aestheticism would make judgment and values relative is, no, it would make them historical. It is the present crisis of knowledge that brings us to the critique of aestheticism, and it is within that crisis that illumination may be found. This also means rewriting many of the designs and assumptions of Euro-enlightenment, proceeding to a deracialized, geographically decentered view of cultural production and use.

The engaged deconstruction of art-cult propaganda involves the reformatting of knowledge, redesign of categories and revised understanding of roles and activities. Part of the work of deconstruction is denial of the narrative *coherence* of the Western canon of knowledge: "And classicism begat romanticism and romanticism begat impressionism." This kind of biblical patrimony attached to Western experience needs to be dissolved as oppressive, whenever it pretends, as it often does, to be totally explanatory, leaving other forms of explanation marginalized. Adequate as this kind of narrative might be as provincial history, it needs to be dispersed as a constituent of world culture. For this kind of narrative continues to function as an enabling myth, a charter, a sort of apostolic succession of ideas, a lineage and cultural capital admitting only chosen initiates to participate in the dialogues of culture.

REDISCOVERING THE HUMAN

W. E. B. DuBois was right: the crisis of the twentieth century is the problem of the color line in the sense that the global grief of that century arose largely out of the European expansion, conquests, and exploitations of previous centuries. But the scrambles for power of Enlightenment Europeans in the fields of knowledge and culture have met with massive rebuttals in a crisis that may well be the intellectual problem of the twenty-first century. The present crisis of knowledge is provoked largely by the explosion of critical, disconfirming energy directed against the selective humanism and partial enlightenment of European expansion.

The energy that might be spent forging a replacement for aesthetic reasoning may be better spent in rethinking cultural and interpretive practices toward a more inclusive humanism. To replace the failed humanism of Eurocentrism we have to find a humanism of principles and not of ethnicities, classes, genders, or cultures, one that flourishes from the democratic empowerment of all these sources. The need is to find ways of looking at world culture to supplant the parochial enlightenment directed from the Palace. The crucial difference of this movement of thought and knowledge from its Occidental predecessor is its embrace of a reciprocal universalism. In the wake of European expansion, we cannot afford a retreat from universality. The new outlook seeks to know the world, and if possible, to find, without coercion, some characteristics common to most if not all human populations. But it seeks to know the world from as many cultural and societal perspective points as the world affords, not just from the Colonial District Commissioner's vantage point. The aspiration of such knowledge must be scientific.

In *The Invention of Culture*, Roy Wagner offers a valuable insight: that anthropologists, in pursuit of culture, largely invent the subject of their inquiry. He argues that in Western societies culture came to mean the refinement of the tools and inventions that enlarge control over nature and that reflect achievements of human consciousness. Culture also means the preservation and celebration of these activities, often viewed as a quest, or a purpose or meaning added on to life. By contrast, in what Wagner calls "tribal societies," the focus is not on artifacts, techniques, or achievements and their production, but on the production of people, through families. The significance of inventions, techniques, artifacts, etc., though these may be as wonderful or more wonderful than the works

of modern humanity, is wholly submerged within the process of human family and communal development. In a telling turn of phrase, Wagner contrasts the view from a society "where life serves some purpose, rather than the reverse."[22]

These speculations can help us understand the territory outside or beyond aestheticism a little better. The notion of cultural activities as means of serving life, rather then the reverse, can be illuminating, as long as we don't let it drag us into the fantasias of primitivism. To read Wagner accurately, or productively, is to underscore that the "life" pursued by these tribal or paganized societies is more than just material existence; and that the pursuit of "life," as opposed to the cultivation of achievements, that goes on within less mechanistic societies, embraces, in a different relation, much of what has come within the modernist narrative to be called "art" and civilization.

Wagner's speculations rehearse the familiar idea that in such societies, the goal is to live in harmony with nature, not to work to control nature. But this truism can be improved by our understanding that this life in harmony with nature is not synonymous with passivity, but includes much vehemently resolute activity, such as the invention of the dazzling array of artifacts that stock and perhaps even predominate in the world's museums, the world's wonders that have been made without aid of aesthetic theory. This thought might give us license to think further into this area that has been maligned and obscured by the art-cult and its values.

The thought and writing of Sylvia Wynter carry us somewhere beyond Wagner's thesis in a way that contributes to an emergent humanism. Wynter speaks of a "poesis of Being," supplanting the discourse of "man," embedded in the bourgeois-humanist interpretive grid, and its ally, the aesthetic, as the poetics of "economic man."[23] In her analysis the Euro-bourgeois master narrative revolves around the mythic conception of biological "man," whose existence must be struggled for in terms of natural scarcity, as articulated by political economists like Ricardo and Malthus, and who thereby becomes "economic man," with the male conceived as the breadwinner and the female as the housewife. And in such a system of natural scarcity, there must always be a permanent underclass, a pariah population, a body of homeless and a group biologically chosen for inferiority.

The conviction that man is a biological being determined by economic necessity and natural scarcity powerfully feeds the division of individuals between the saved and the damned. In the nineteenth century this conviction gave scientific authority to systems of definition that equated

some selected *Others* with failure, evil, or lack. Most societies infected with this reasoning carry the notion of a "significant ill," according to Wynter. For the Aztecs, that ill would be the lack of hearts sacrificed to keep the sun shining. For much of Africa, that ill has long been witchcraft. For Augustine, the significant ill was original sin. The laity were always fallen. In the nineteenth century, the color line will take the place of the spirit/earth line in Augustinianism. In the modern era, capitalism recreates the divisions based on biological identity and natural scarcity by recreating man as breadwinner facing down the significant ill for capitalist society: idleness and the welfare mom in the ghetto.[24]

To the idea of "man" in this biological/economical sense Wynter opposes the paradigm of the "human." The crucial marker of the human is not biological existence but the fabrication of cultural existence. The regularities of cultural-systemic behavior applicable to all societies, in Wynter's view, support the need for a new science of the human to complement the natural sciences. A founding observation of such inquiry would be to locate the human in *language*, not biology. When the first mammal spoke, that event ripped apart unalterably the human from the animal kingdom and from all explanations that resorted to a biological continuum between animals and human. "We have always realized ourselves through the mediation of the Word," she insists.[25] Wynter notes with irony the inevitability of the placement of one category of being in the role of "missing link" between animal and man. Without this eighteenth- and nineteenth-century biological concept of man, the value and relevance of racial types dissolves. The construct of "man," then, must be replaced by the idea of the human. The human is that practice of symbolic construction that knows it is constructing existence, that fully exercises a "poesis of Being."

In such a world-frame where the human is perceived as an operative within culturally systemic behavior, difference becomes merely difference, that need not be negotiated or rationalized, mediated, or evaluated in terms of one version being better than the other. A disbiologized conception of "man" might leave us in a cosmology where we can recognize differences in skin color, gender, language, dress, sexual orientation, but where they will not matter in the same meaning-frame as they do now, and hold far less consequence, where the inclination toward genocidal hostility on these or any other grounds will look like recrudescences of an outmoded system of knowledge and belief, like slavery or human sacrifice.[26]

To see the human as a fundamentally cultural being is to erase any

possibility of human existence apart from culture, to recognize the absurdity of "a-culturalism," the non sequitur of a person being "cultureless." There is the need to work ourselves beyond the anthropological premise that there can be a "universal man" that preexists human cultures. The popular entertainment of this idea can have brutalizing consequences. Wynter notes that around the time of the Rodney King incident, some members of the Los Angeles Police Department reported events over their two-way radios using the code phrase "NHI" meaning "no humans involved."[27] Typically, they used such terminology when referring to ghetto Black men who are now, as slaves were once before them, regarded as lineageless men. As we take such reasoning for granted even while we deplore it, we nevertheless cling to habits of thought such as the biological and not the cultural basis of humanity from which such racialized notions spring.

The long view of history offered in Wynter's vision allows us to see the grand design of Euro-enlightenment as falling short of its promise of a new beginning for humanity. Instead, what the philosophers of that movement did was to effect the highest and most powerful institutionalization and codification of "man" as dominating idea. In this, they concretized the limitations of past societies while trying to open up rational possibilities for a human future. They consolidated a "primitive," "animalistic" approach to planetary existence. Ironically, they were more backward in this respect than many societies they deemed, ethnographically, as culturally deficient. The Baga of West Africa, for instance, represent one society at least that in its preindustrialized development has shown an understanding of the *constructedness* of their belief systems. They may have been aided in this recognition by facing onslaughts against their religious and mythical observances from Christian imperialism and pressured Islamic conversion. Through these transitions, the Baga people have at different times repressed their rituals and beliefs, hidden them underground, or lost contact with them only to recreate new versions of them at later periods. In the eyes of David Lamp, curator and interpreter of Baga art and culture, "The Baga world is unique in their open admission that they created their spirits. It is not as though they believe these spirits created *them*."[28]

The notion of an aesthetic sense that is part of the make-up of human nature comes from a much less sophisticated style of thought. While it is doubtful that the Baga are unique, they are certainly more perceptive in this respect than most institutionalized thought in the West that continues to worship as transparent the gods residing in their belief systems,

embodied in techno-economic structures or disciplines of knowledge or so forth. Postmodernism, according to Lyotard, one of its principle prophets, means the end of the grand narratives. But while the credibility of these narratives is easily impugned, they not only persist in the minds of large populations, they manage to resurface even in the minds of their would-be discreditors. There is a kind of primitivistic return to an oppressive grand narrative in Lyotard's almost instantaneous retreat to the idea of art, avant-garde art, as redemptive agency in the absence of grand narratives. This is a cure as debilitating as the disease.

Issiaka Lalèyê has proposed that Departments of Philosophy need to be replaced by Departments of the Science of Human Thought. The kind of revision embodied in this suggestion might lead us toward a post-Eurocentric humanism. Within anthropology, too, signs can be found of efforts of intense self-scrutiny, toward less genocidal perspectives on human culture. We do not come to grips with the animalistic, tribalistic character of Euro-humanism unless we understand the extent to which aestheticism, of all approaches to culture, is deeply saturated with anti-humanistic, outmoded, and countersocial assumptions.

The emergent cultural producer, as Western-conceived "artist," may be the most fearful of this coming change. What is to be expected is the mobilization of revisionary humanism against die-hard Euro-humanists in a struggle that embraces all cultural producers and/or "artists." There is a historical "call" behind the present rise of emergent humanism, and the demands of the times will decide which temperaments and personalities will provide the best "response" in the role of cultural producers as artists, commentators, theorists, educators, etc. But we must be prepared for the irony that some of the cultural inventors whose narratives, films, novels, essays will contribute most valuably to the nascent paradigm will themselves be the last to surrender the perks, ego strokes, and delusions that the Palace will, in self-defense, increasingly dole out.

Emergent humanism is one of the ideological identities arising from the present crisis. Its advance is far too large an area of concern to depend on acceptance or rejection of art ideology alone. Emergent humanism will also have to find its vehicles through politics-in-general, and the political leadership of this movement (necessarily engaged in the programs and ideologies of thousands of political parties) will understand the need to include the politics of symbolic representation along with other modes of empowerment/disempowerment as basic social information, such as the politics of money, housing, health, education, security, environment, and so forth.

Yet at its peak strength and potential, the break with aestheticism might form one campaign within that larger historical drama. If the break is achieved with enough force and momentum, it could possibly maximize some of the assets of the new politics. In this kind of effort at historical change, some targets prove more vulnerable and opportunistic than others. With enough force and momentum, the break with art-cult ideology might nudge the culture struggle into a new, more progressive orbit. To counsel gradualism or reform is to sit back and wait for history to happen. Because aestheticism is one of the most glaring, weak links in the old humanism, the assault on its mendacities, like the demand for a cup of coffee at a Southern lunch counter, might highlight larger contradictions and ignite a valuable eruption.

NOTES

■

Epigraph

1. Quoted in Arnaldo Xavier, "The Greatest Poet God Creole," *Callaloo*, vol. 18, no. 4, 1995, 781.

1. Color-Coded Art Theory

1. Quoted in James Clifford, *The Predicament of Culture: Twentieth Century Ethnography, Literature and Art* (Cambridge, MA: Harvard University Press, 1988), p. 145. I am here following the practice of Lucy Lippard in *Mixed Blessings: New Art in a Multicultural America* (New York: Pantheon Books, 1990) of resupplying ethnic descriptions of some White authors, randomly, to underscore the absence of these descriptions as if corresponding to a normative, "general" category.

2. Addison Gayle, ed., *The Black Aesthetic* (Garden City, NY: Doubleday, 1971).

3. Addison Gayle, "Introduction," *The Black Aesthetic*, xxiv.

4. Addison Gayle, "Cultural Strangulation: Black Literature and the White Aesthetic," in Gayle, *The Black Aesthetic*, p. 46.

5. Toni Morrison, "Unspeakable Things Unspoken: The Afro-American Presence in American Literature," *Michigan Quarterly Review* (Winter, 1989), 1–34.

6. St. Clair Drake, quoted in Wahneema Lubiano, "Mapping the Interstices between Afro-American Cultural Discourse and Cultural Studies: A Prolegomenon," *Callaloo* 19, no. 1 (Winter 1996), 70.

7. Gayle, *The Black Aesthetic*, xxiii.

8. Ibid., p. 46.

9. James Emanuel, "Blackness Can: A Quest for an Aesthetic," in Gayle, p. 196. Several retrospective analyses of the Black aesthetic have been written, among them Houston Baker, in *Blues, Ideology, and Afro-American Literature* (Chicago: University of Chicago Press, 1984).

10. James Emanuel, "Blackness Can," p. 218.

11. C. Carr, "The Situationist Situation," *Voice Literary Supplement* (April 1990), 18.

12. Debord's book *The Society of the Spectacle* is the best-known artifact of this movement (Detroit: Red and Black, 1970).

13. Quoted in Thomas V. Levin, "The Cinema of Guy Debord," Elizabeth Sussman, ed., *On the Passage of a Few People through a Rather Brief Moment in Time: The Situationist International* (Cambridge: MIT Press, 1989), p. 95. See also Ken Knabb, *Situationist International Anthology* (Berkeley: Bureau of Public Secrets, 1981).

14. Contributions toward a Black cinema aesthetic include Teshome Gabriel, "Images of Black People in Cinema: A Historical Overview," *UFAHAMU* vol. 6,

no. 2 (1976), 133–67, particularly pp. 153–61; Gladstone L. Yearwood, "Toward a Theory of a Black Cinema Aesthetic," in Gladstone L. Yearwood, ed., *Black Cinema Aesthetics: Issues in Independent Black Filmmaking* (Athens, OH: Center for Afro-American Studies, Ohio University, 1982), pp. 67–81; and Clyde Taylor "Decolonizing the Image: New U.ɔ. Black Cinema," in Peter Steven, ed., *Jumpcut: Hollywood, Politics and Counter-Cinema* (New York: Praeger, 1985), pp. 166–78. This last essay was influenced by conversations with Teshome Gabriel.

15. *The Cambridge Dictionary of Philosophy*, Robert Audi, ed. (New York: Cambridge University Press, 1995), p. 10.

16. Martha Woodmansee, *The Author, Art, and the Market* (New York: Columbia University Press, 1994).

17. Sylvia Wynter, "The Ceremony Must Be Found: After Humanism," *Boundary* 2 (spring/fall 1984), pp. 19–70, passim. For related writings of Wynter, see Sylvia Wynter, "On Disenchanting Discourse: 'Minority' Literary Criticism and Beyond," in *The Nature and Context of Minority Discourse*, ed. Abdul R. JanMohamed and David Lloyd (New York: Oxford University Press, 1990), pp. 432–69; Sylvia Wynter, "Rethinking 'Aesthetics': Notes Towards a Deciphering Practice," in *Ex-Iles: Essays on Caribbean Cinema*, ed. Mbye Cham (Trenton, NJ: Africa World Press, 1992), pp. 237–79; Sylvia Wynter, *"Do Not Call Us Negroes": How "Multicultural" Textbooks Perpetuate Racism* (San Francisco: Aspire Books, 1990). My synopsis of ideas from Wynter makes use of my article "Black Cinema in the Post-aesthetic Era," in *Questions of Third Cinema*, ed. Jim Pines and Paul Willamen (Bloomington: Indiana University Press, 1989, pp. 90–110).

18. Sally Price, *Primitive Art in Civilized Places* (Chicago: University of Chicago Press, 1989), p. 17.

19. Karl Mannheim, *Ideology and Utopia: Essays in the Sociology of Knowledge* (New York: Harcourt, Brace, 1936); Michel Foucault, *Power/Knowledge* (New York: Pantheon Books, 1980).

20. Peter Berger and Thomas Luckmann, *The Social Construction of Reality: A Treatise in the Sociology of Knowledge* (Garden City, NY: Doubleday, 1967); Thomas Kuhn, *The Structure of Scientific Revolutions* (Chicago: University of Chicago Press, 1962).

21. Laura Kipnis, "Aesthetics and Foreign Policy," *Social Text* 15 (Fall 1986), 90.

22. Susan Kappeler, *The Pornography of Representation* (Minneapolis: University of Minnesota Press, 1986), p. 52.

23. For instance, one entry in the OED under "aesthetic" offers: **"1842** GWILT *Encycl. Architect. 673*. There has lately grown into use in the arts a silly pedantic term under the name of Aesthetics. . . . it is however one of the metaphysical and useless additions to nomenclature in the arts in which the German writers abound." Equally sharp-edged rejections can be found throughout the history of the concept.

24. Terry Eagleton, *The Ideology of the Aesthetic* (Oxford: Blackwell, 1990), p. 13ff.

25. Pierre Bourdieu, *Distinction: A Social Critique of the Judgment of Taste* (Cambridge: Harvard University Press, 1984).

26. Jean Baudrillard, *For a Critique of the Political Economy of Signs* (St. Louis: Telos Press, 1981).

27. Kappeler, *The Pornography of Representation*, p. 53.

28. Nicos Hadjinicolaou, *Art History and Class Struggle* (London: Pluto Press, 1978), p. 12. But also consider Paul de Man: "In the usual understanding of the concept the *aesthetic* is not a separate category but a principle of articulation between various known faculties, activities, and modes of cognition. What gives the aesthetic its power and hence its practical, political impact, is its intimate link with knowledge, the epistemological implications that are always in play when the aesthetic appears over the horizon of discourse." "Aesthetic Formalization: Kleist's *Uber das Marionetten-theater*," in Paul de Man, *The Rhetoric of Romanticism*, quoted in Michael Sprinker, *Imaginary Relations: Aesthetics and Ideology in the Theory of Historical Materialism* (New York: Verso, 1987), p. 11.

29. Eagleton, *The Ideology of the Aesthetic*, pp. 93–94.

30. Frantz Fanon, *The Wretched of the Earth* (New York: Grove Press, 1966), p. 31.

31. Jacques Maquet, *The Aesthetic Experience: An Anthropologist Looks at the Visual Arts* (New Haven: Yale University Press, 1986).

32. Sumaoro is portrayed as the evil sorcerer and chief adversary of Sundiata in many versions of the great West African epic; see among others, D. T. Niane, ed., *Sundiata: An Epic of Old Mali* (Harlow, Essex: Longman, 1965). Sumaoro's most secret chamber is lined with human skins, adorned with skulls, strange weapons, a monstrous snake, and three sleeping owls. In the interpretation of cultural theorist Vèvè Clark, this chamber allegorizes the mind of its owner.

33. George Dickie, "All Aesthetic Attitude Theories Fail: The Myth of the Aesthetic Attitude," in George Dickie and R. J. Sclafani, eds., *Aesthetics: A Critical Anthology* (New York: St. Martin's Press, 1977), pp. 800–815.

34. Tony Bennett, *Outside Literature* (London: Routledge, 1990), p. 151.

35. David Hume, quoted in Tony Bennett, *Outside Literature*, pp. 155–56.

36. Tony Bennett, *Outside Literature*, p. 165.

37. Sally Price, *Primitive Art in Civilized Places* (Chicago: University of Chicago Press, 1989); Mariana Torgovnick, *Gone Primitive: Savage Intellects, Modern Lives* (Chicago: University of Chicago Press, 1990). But see also Susan Hiller, ed., *The Myth of Primitivism: Perspectives on Art* (New York: Routledge, 1991).

38. Price, *Primitive Art in Civilized Places*, pp. 34–35.

39. Ngũgĩ wa Thiong'o, *Barrel of a Pen: Resistance to Repression in Neo-Colonial Kenya* (Trenton, NJ: Africa World Press, 1983), p. 55.

40. Sylvia Wynter, "The Ceremony Must Be Found: After Humanism," *Boundary 2* (spring/fall 1984), 34–44, passim.

41. Michel Foucault, *The Order of Things: An Archaeology of the Human Sciences* (New York: Vintage Books, 1970), ch. 5.

42. David Hume, quoted in Winthrop Jordan, *White Over Black: American Attitudes toward the Negro, 1550–1812* (Baltimore: Penguin Books, 1968), p. 253.

43. David Roediger, *The Wages of Whiteness* (London: Routledge, 1991), ch. 7.

44. Frantz Fanon, *Black Skins, White Masks* (New York: Grove Press, 1967).

45. "In using the word 'you,' she meant whites—people who look like me. I don't think it is a reference most white people are used to. Whites may identify themselves as Italian or Irish or Jewish or a mix of several European heritages,

but they see themselves as individuals. We have a habit of seeing others as a color, but ourselves—almost never." April Lynch, "Looking Past Color—The Lessons of L.A.," *San Francisco Chronicle*, May 25, 1992, p. 1.

46. My practice of capitalizing the racial descriptions Black and White is based partly on the reality that these social categories are as institutionalized in this society as any other identification. And that the eradication of these categories, or the damage done by them, can take place only if their force is realistically acknowledged.

47. Cornel West, *Prophecy Deliverance!* (Philadelphia: Westminster Press, 1982), p. 48. See also Richard H. Popkin, "The Philosophical Basis of Eighteenth-Century Racism," in Harold E. Pagliaro, ed., *Studies in Eighteenth-Century Culture*, vol. 3 (Cleveland: Press of Case Western Reserve University, 1973), pp. 245–62.

48. Johann Winckelmann, *History of Ancient Art* (Boston: J. R. Osgood, 1872–1973), vol. 1, p. 310.

49. Herbert Marcuse, *The Aesthetic Dimension: Toward a Critique of Marxist Aesthetics*, quoted in Bennett, *Outside Literature*, p. 146.

50. Winckelmann, *History of Ancient Art*, vol. 1, p. 293.

51. William Blake was enamored of correspondences, reflecting the influence of the Swedish mystic, Swedenborg, whose famous text of spiritualist musings is called *Correspondences*, and of the German mystic Joseph Boehme. Baudelaire's famous poem "Correspondences" is another notable reflection of this paradigmatic signifier.

52. Winckelmann, *History of Ancient Art*, vol. 1, p. 308.

53. Tony Bennett cites Herbert Marcuse's circular definitions of art: "I term those works 'authentic' or 'great' which fulfill aesthetic criteria previously defined as constitutive of 'authentic' or 'great' art. "To which Bennett comments, "In other words, the question as to what constitutes great art can only be resolved provided that it has already been determined." *Outside Literature*, p. 147. I am aware that aestho-philosophers rationalize this contradiction away through the special category of the sublime.

54. Frank Lentricchia, *Criticism and Social Change* (Chicago: University of Chicago Press), p. 157. Louis Farrakhan has been severely condemned for saying something similar.

55. Ibid., p. 157.

56. Thomas Jefferson, *Notes on the State of Virginia* (Chapel Hill: University of North Carolina Press, 1955), pp. 138–40, passim.

57. Winthrop Jordan, *White Over Black: American Attitudes toward the Negro, 1550–1812* (New York, 1968), p. 253.

58. Edgar Rubin, "Figure and Ground," in David C. Beardslee and Michael Wertheimer, eds., *Readings in Perception* (Princeton: Van Nostrand 1958), pp. 194–203.

59. Ibid., p. 202, italics in the original.

60. Ibid., p. 197.

61. Ibid., p. 202.

62. Ibid., p. 208.

63. Anthony Wilden, *System and Structure: Essays in Communication and Exchange* (London: Tavistock, 1972), chap. 7, passim.

64. Rubin, "Figure and Ground," p. 198.
65. Fanon, *The Wretched of the Earth*, p. 204.
66. Winckelmann, *History of Ancient Art*, p. 308.
67. Jean Toomer, *Cane: An Authoritative Text*, ed. Darwin T. Turner (New York: Norton, 1988), p. 29.

2. The Art of Ethnic Cleansing

1. LeRoi Jones, *Blues People* (New York: William Morrow, 1963), p. 29.
2. Harry Levin, *The Broken Column* (Cambridge: Harvard University Press, 1931), p. 75.
3. Jordan, *White Over Black*, p. 27.
4. One striking example of the trope of blondness is Ingmar Bergman's film *Virgin Spring*.
5. See George L. Mosse, *Toward the Final Solution: A History of European Racism*, pp. 10–12.
6. Stephen Jay Gould, "Petrus Camper's Angle," *Natural History* (July 1987), 13–18.
7. Ibid., p. 18.
8. Ibid.
9. Mosse, *Toward the Final Solution*, p. 29.
10. Ibid., p. 30.
11. Martin Bernal, *Black Athena: The Afro-Asiatic Roots of Classical Civilization*, vol. 1, *The Fabrication of Ancient Greece, 1785–1985* (New Brunswick: Rutgers University Press, 1987), p. 212.
12. Winckelmann, *History of Ancient Art*, vol. 2, p. 141.
13. Bernal, p. 2.; italics in the original.
14. C. W. Ceram, *Gods, Graves and Scholars: The Story of Archaeology* (New York: Alfred Knopf, 1951), pp. 15–16.
15. Winckelmann, *History of Ancient Art*, p. 148.
16. Harold N. Fowler and James R. Wheeler, *A Handbook of Greek Archaeology* (New York: American Book Company, 1909), p. 196.
17. M. H. Swindler, *Ancient Painting*, 1929, quoted in H. Osborne, "Colour Concepts of the Ancient Greeks," *British Journal of Aesthetics* 8, 3, (July 1968), p. 274.
18. Osborne, ibid.
19. Susan Woodford, *The Art of Greece and Rome* (Cambridge: Cambridge University Press, 1982), p. 57.
20. Winckelmann, *History of Ancient Art*, vol. 4, p. 111.
21. Fowler and Wheeler, *A Handbook of Greek Archaeology*, p. 132.
22. Ibid., p. 17.
23. Francis Haskell and Nicholas Penny, *Taste and the Antique: The Lure of Classical Sculpture, 1500–1900* (New Haven: Yale University Press, 1981), p. 120.
24. Heinrich Wölfflin, *The Art of the Italian Renaissance* (New York: G. P. Putnam's Sons, n.d.), p. 107.
25. Rhys Carpenter, *The Esthetic Basis of Greek Art* (Bloomington: Indiana University Press, 1959), p. 56.

26. Vincent J. Bruno, *Form and Color in Greek Painting* (New York: Norton, 1977), pp. 47–51.

27. Ibid., p. 50.

28. Winckelmann, *History of Ancient Art*, p. 149.

29. See Vincent J. Bruno, *Form and Color in Greek Painting*, p. 50.

30. Johann Joachim Winckelmann, *Reflections on the Imitation of Greek Works in Painting and Sculpture* (LaSalle, IL, 1987), p. 17.

31. Jonathan Z. Smith, "A Slip in Time Saves Nine: Prestigious Origins Again," in John Bender and David E. Wellbery, eds., *Chronotypes: The Construction of Time* (Stanford, CA: Stanford University Press, 1991), p. 68.

32. Ibid., p. 68.

33. Arthur Fairbanks, *Greek Art: The Basis of Later European Art* (New York: Cooper Square Publishers, 1963), p. 7.

34. Ibid., p. 4.

35. Ibid., p. 14.

36. Ibid., p. 3.

37. Jones, *Blues People*, p. 29. Italics in the original.

38. Levin, *The Broken Column*, pp. 71–75, passim.

3. Discipline and Punish

1. Victor Burgin, *The End of Art Theory: Criticism and Postmodernity* (Atlantic Highlands, NJ: Humanities Press International, 1986), p. 159.

2. Max Horkheimer and Theodor Adorno, "The Culture Industry: Enlightenment as Mass Deception," *Dialectic of Enlightenment* (New York, [1944] 1972), p. 133.

3. Sembene, speech at Indiana University.

4. The term "art-culture system" is borrowed from James Clifford's *The Predicament of Culture* (Cambridge: Harvard University Press, 1988).

5. Arthur Danto, "The Artistic Enfranchisement of Real Objects: The Artworld," in George Dickie and R. J. Sclafani, eds., *Aesthetics: A Critical Anthology* (New York: St. Martins Press, 1977), pp. 22–35.

6. Bennet, *Outside Literature*, p. 163.

7. Lentricchia, *Criticism and Social Change*, pp. 15–16.

8. White anthropologist Richard L. Anderson illustrates this persistence in his book on comparative aesthetics. Based in cultural anthropology, his work shows a sophisticated understanding of the dangers of imposing interpretation from outside, but he nevertheless calls his book *Calliope's Sisters* and examines several different cultures through the trope of the nine Greek muses. Richard L. Anderson, *Calliope's Sisters: A Comparative Study of Philosophies of Art* (Englewood Cliffs, NJ: Prentice-Hall, 1990).

9. Fredric Jameson, *The Political Unconscious: Narrative as a Socially Symbolic Act* (Ithaca, NY: Cornell University Press, 1981), p. 63.

10. bell hooks, *Ain't I A Woman: Black Women and Feminism* (Boston: South End Press, 1982), p. 138.

11. Kenneth Burke, *A Grammar of Motives* (New York: Prentice-Hall, 1945), pp. 260–61.

12. Pierre Bourdieu and Jean-Claude Passeron, *Reproduction in Education Society and Culture* (Newbury Park, CA: Sage, 1990).

13. Such activities as repressing modifiers, duplexing, capitalizing, or framing entelechial cognitions are not exclusive to Occidental hegemony. They are capacities of language frequently used in varied locations and historical circumstances. Anthropologists tell us that the name of many peoples they study, when translated, carry meanings such as "the people," or "the children of God," names that put other people in very different value contexts. It may be that such linguistic manipulations reflect either permanent or historical phases of human self-construction. The analysis of these manipulations is justified by the need to undo some of the violence involved in their exercise over less powerful populations.

14. "Denominational aesthetics" is from Michael Sahl, "Criticism or Control? Hegemonic Left Aesthetics," *Social Text* 15 (Fall 1985), p. 91.

15. This is a restoration of limits interestingly similar to one made by White aesthetic historian Thomas Munro: "If Western aestheticians wish to go on ignoring Oriental art and theory, they might more accurately entitle their books 'Western Aesthetics,' instead of seeming to make fake claims to universal scope." Thomas Munro, *Oriental Aesthetics* (Cleveland: Press of Case Western Reserve University, 1965), pp. 7–8. The two choices implied by Munro's position are either to be left out of the dominant discussion or to be subordinated within it as minor and derivative. Munro omits a third possibility: to contain and minimize aestheticism rather than to expand it, however democratically.

16. Vincent Canby, "Before the Revolution—and After," *New York Times* (May 29, 1988), H, 19, 37.

17. Kipnis, "Aesthetics as Foreign Policy," p. 90.

18. Vincent Canby, "Why Some Movies Don't Travel Well," *New York Times* (October 23, 1988), H, 13.

19. Gerald Mast, *A Short History of the Movies*, 4th ed. (New York: Macmillan, 1986), p. 479. Mast goes on to find the requisite irony and complexity in the films of Tomas Alea of Cuba and Ousmane Sembene of Senegal, but explains their departure from the Third World norm by their education in Europe.

20. Anand Amaladass, *Philosophical Implications of Dhvani: Experience of Symbol Language in Indian Aesthetics* (Vienna, 1984), p. 177. See also Daniel H. H. Ingalls, "Introduction" (editor and one of three translators), *The Dhavanayaloka of Anandavardhana with the Locana of Abhinavagupta* (Cambridge: Harvard University Press, 1990), and Thomas Munro, *Oriental Aesthetics* (Cleveland: Western Reserve University Press, 1965).

21. G. Hanumanha Rao, *Comparative Aesthetics: Eastern and Western* (Mysore, 1974), p. 179.

22. Ibid., p. 237.

23. Ibid., p. 179.

24. Tony Bennett, *Outside Literature* (London: Routledge, 1990), p. 152.

4. A Drowning Man Offers You His Hand

1. Gayatri Spivak, *In Other Worlds: Essays in Cultural Politics* (New York: Methuen, 1987), p. 95.

2. Pierre Bourdieu, *Distinction*, p. 491.

3. Christopher L. Miller, *Blank Darkness: Africanist Discourse in French* (Chicago: University of Chicago Press, 1985), p. 88.

4. Laura Kipnis, "Aesthetics and Foreign Policy," *Social Text* (Fall 1986), 98.

5. Zora Neale Hurston, *Their Eyes Were Watching God* (New York: Fawcett, 1969), p. 5.

6. See Eagleton, *The Ideology of the Aesthetic*, pp. 49–60.

7. Patrick Brantlinger, *Bread and Circuses: Theories of Mass Culture as Social Decay* (Ithaca: Cornell University Press, 1983).

8. Arnold Hauser, *The Social History of Art*, vol. 3 (New York: Vintage Books, 1958), pp. 118–21, passim.

9. The economic motive under the construction of idealized aesthetic discourse is no novelty in scholarship, of course. But the connection is pointedly exposed in Martha Woodmansee, *The Author, Art, and the Market: Rereading the History of Aesthetics*. What is new and invigorating in Woodmansee's treatment is her conclusion that aesthetic philosophy was never much separated from rationalization of professional and economic self-interest. See also the essay-review by Michael Lewis, "Paint by the Numbers: The Hype and Hypocrisy of the Art Market," *The New Republic* (April 25, 1994), 27–34.

10. Peter A. Foulkes, *Literature and Propaganda* (London: Methuen, 1983).

11. Ibid.

12. Michael Sahl, "Criticism or Control? Hegemonic Left Aesthetics," *Social Text* 15 (Fall 1985), p. 91.

13. Johann Christoph Friedrich Schiller, *On the Aesthetic Education of Man in a Series of Letters* (Oxford: Clarendon Press, 1967). Martha Woodmansee, "Aesthetic Autonomy as a Weapon in Cultural Politics: Rereading the *Aesthetic Letters*," *The Author, Art, and the Market*, pp. 57–86.

14. See Paul de Man, "The Rhetoric of Temporality," in his *Essays in the Rhetoric of Contemporary Criticism: Blindness and Insight* (Minneapolis: University of Minnesota Press, 1983), p. 196.

15. I use the term "aestheticism" in lower case for the acceptance of the premises of this ideology, while "Aestheticism" capitalized refers to the self-named art movement associated with Oscar Wilde, Aubrey Beardsley, and other late-nineteenth-century figures.

16. Peter Burger, *Theory of the Avant-Garde* (Minneapolis: University of Minnesota Press, 1984), p. 22.

17. The arbitrariness of definitions of art is the subject of much popular humor, the painting appreciated better when turned upside down, etc. Then there are other deflations of the rectitude of the art-culture system. Susan Kappeler relates Doris Lessing's mischievous experiment. Late in her well-established career, Lessing sent a manuscript of her latest novel to several publishers under a pseudonym, Jane Sommers. The publishers responded more alertly than the critics. Some turned the book down, but one bought it because it 'reminded him of the young Doris Lessing.' The book was then sent to all the critics who had written devotedly about Lessing's work in the past. Not one wrote a line about the pseudonymous novel. Without her well-known name in front of it, no well-established journals gave it a notice or review. Kappeler adds, "One fix of the cultural capital

accumulated in the commodity of Doris Lessing's name would suffice to ensure the commercial success of anything published under her name; no amount of injection of the literary quality of a Doris Lessing's writing will ensure the same success." Susan Kappeler, *The Pornography of Representation*, pp. 125–27.

18. Bourdieu, *Distinction*, p. 496.

19. See John Berger, *The Success and Failure of Picasso* (New York: Pantheon Books, 1980).

20. Quoted in Michael North, *The Dialect of Modernism: Race, Language and Twentieth-Century Literature* (New York: Oxford University Press, 1994), p. 66; and see North's chapter "Modernism's African Mask: The Stein-Picasso Collaboration."

21. Ibid., preface.

22. Ibid., p. 125.

23. Karl Polanyi, *The Great Transformation* (New York: Farrar and Rinehart, 1944).

24. Robert Stam, *Reflexivity in Film and Literature: From Don Quixote to Jean-Luc Godard* (Ann Arbor: University of Michigan Press, 198), p. 179.

25. Edward W. Said, *The World, the Text and the Critic* (Cambridge, MA: Harvard University Press, 1983).

26. The great playwright Jean Genet, in prison for thievery and other crimes, was released through the intervention of Jean-Paul Sartre and other intellectual colleagues who were impressed by Genet's prison writings. Norman Mailer also intervened in the prison system of Utah to engineer the release of Jack Henry Abbot, a long-time psychotic inmate, who within four months of being released stabbed a waiter to death outside a Lower East Side Restaurant.

27. Richard Taruskin, "The Dark Side of Modern Music," *The New Republic* (September 5, 1988), p. 34.

28. Ibid., p. 34.

29. David Carroll, *French Literary Fascism: Nationalism, Anti-Semitism, and the Ideology of Culture* (Princeton: Princeton University Press, 1995), p. 7.

30. Lee Baxandall and Stefan Morawski, eds., *Marx & Engels on Literature & Art* (St. Louis: Telos Press, 1973), p. 135.

31. Marx, in ibid., p. 135.

32. Terry Eagleton, *Criticism and Ideology* (London: Verso, 1978), p. 187.

33. Terry Eagleton, *Literary Theory: An Introduction* (Minneapolis: Minnesota University Press, 1983).

34. Eagleton, *The Ideology of the Aesthetic*, p. 415.

35. Ibid., p. 6.

36. Thurgood Marshall, "Remarks," on the Bicentennial of the U.S. Constitution, May 6, 1987, reported in the *New York Times*, May 7, 1987, 1, 19.

37. Ibid., 1.

38. Ibid., 19.

39. Tony Bennett, *Outside Literature*, p. 118.

40. The volume containing Schiller's essay.

41. Woodmansee, *The Author, Art, and the Market*, p. 56.

42. Ibid., p. 85.

43. Eagleton, *The Ideology of the Aesthetic*, p. 404.

44. Bennet, *Outside Literature*, pp. 148–49.

45. Adorno and Horkheimer, *Dialectics of Enlightenment*, p. 249.

46. Nina Baym, *Women's Fiction: A Guide to Novels by and about Women in America, 1820–1870* (Ithaca: Cornell University Press, 1978), p. 14.

47. Gayle, "Cultural Strangulation," p. 40.

48. These complicated issues are treated with much more complexity in Sander L. Gilman, "Black Bodies, White Bodies: Toward an Iconography of Female Sexuality in Late Nineteenth Century Art, Medicine and Literature," *Critical Inquiry* (Autumn 1985), pp. 205–42.

49. Rita Felski, *Beyond Feminist Aesthetics: Feminist Literature and Social Change* (Cambridge, MA: Harvard University Press, 1989).

50. Ibid., p. 171. These ideas suggest an obvious indebtedness to Stuart Hall.

51. Ibid., p. 176.

52. Ibid., p. 173.

53. See John Berger, *Ways of Seeing* (New York: Viking Press, 1973).

54. A bibliographical survey of debates around Mulvey's views is in Bill Nichols, ed., *Movies and Methods: An Anthology*, vol. 2 (Berkeley: University of California Press, 1985), pp. 303–304.

55. Mary Devereaux, "Oppressive Texts, Resisting Readers and the Gendered Spectator: The New Aesthetics," *The Journal of Aesthetics and Art Criticism*, special issue: *Feminism and Traditional Aesthetics* (vol. 48, no. 4, Fall 1990), pp. 344–45. Devereaux notes the male domination in the practice of the aesthetic as well its theorizing when she observes, "*The Journal of Aesthetics and Art Criticism* has prior to this printing never published a work of feminist theory," p. 338. Devereaux's article is reprinted with several other relevant discussions in Peggy Zeglin Brand and Carolyn Korsmeyer, eds., *Feminism and Tradition in Aesthetics* (University Park, PA: Pennsylvania State University Press, 1995). See also Hilde Hein and Carolyn Korsmeyer, eds., *Aesthetics in Feminist Perspective* (Bloomington: Indiana University Press, 1993).

56. Devereaux, "Oppressive Texts," pp. 345–46.

57. Kipnis, "Aesthetics and Foreign Policy," pp. 91–94.

58. Ibid., pp. 91–92. One begins to wonder whether the catalogue of cultural vacuity announced by David Hume and recurring in many other chauvinist texts is not an indispensable genre of Euro-transcendency. The kinship between Thomas's argument and Vincent Canby's assault on Chinese cinema is broken only by our realization that Canby waves the flag of Western preeminence mainly to protect his institutional turf.

59. Ibid., p. 98.

60. Kappeler, *The Pornography of Representation*, p. 101.

61. Kappeler, ibid., pp. 55–57. See also Bourdieu, *Distinction*, pp. 6–7.

62. Kappeler, *The Pornography of Representation*, p. 33.

63. Ibid., pp. 38–39.

64. Peggy Zeglin Brand, "Revising the Aesthetic-Nonaesthetic Distinction: The Aesthetic Value of Activist Art," in Peggy Zeglin Brand and Carolyn Korsmeyer, eds., *Feminism and Tradition in Aesthetics* (University Park, PA: Pennsylvania State University Press, 1995), p. 266.

65. Kipnis, "Aesthetics and Foreign Policy," p. 94.

66. In Claudia Tate, ed., *Black Women Writers at Work* (New York: Continuum, 1983), p. 184.

67. Gilman, "Black Bodies, White Bodies," p. 212.

68. Ibid., p. 213.

69. Ibid., p. 219.

70. Ibid., p. 229.

71. Ibid., p. 232.

72. An important exception to this chauvinist characterization of (White) feminist aesthetic theory is the practice of the Guerrilla Girls, most of whom are presumably White, who have taken many of the relevant issues "to the streets" so to speak. The Guerrilla Girls were established in 1985 "to combat sexism and racism in the art world" and declare themselves "the conscience of the art world." The smart graphic and leaflets carrying embarrassing statistics on the exclusion of women and artists of color from New York museums and galleries are clearly rooted in a politics of representation and a general politics wider than the "me too" arguments of many feminist aesthetic theorists. Some of their agitprop leaflets are reproduced in a collection of postcards published as *Guerrilla Girls Greatest Hits* (Roverdale, MD: Pyramid Atlantic, 1993).

73. See Barbara Christian, "The Race for Theory," in Abdul R. JanMohamed and David Lloyd, eds., *The Nature and Context of Minority Discourse* (New York: Oxford University Press, 1990), pp. 37–49.

5. The Rebirth of the Aesthetic in Cinema

1. Lewis Jacobs, *The Rise of the American Film* (New York: Teachers College Press, [1939] 1968), p. 171.

2. Lary May, *Screening Out the Past: The Birth of Mass Culture and the Motion Picture Industry* (New York: Oxford University Press, 1980), ch. 4.

3. A much-favored option is to defer this subject by referring without further examination to three specialized texts: Donald Bogle, *Toms, Coons, Mulattoes, Mammies, and Bucks: An Interpretive History of Blacks in American Films*, rev. ed. (New York: Continuum, [1973] 1989); Daniel J. Leab, *From Sambo to Superspade: The Black Experience in Motion Pictures* (Boston: Houghton Mifflin, 1976); Thomas Cripps, *Slow Fade to Black: The Negro in American Film, 1900–1942* (New York: Oxford University Press, 1977). A rather ironic example of this scholarly casualness, considering its title, is Gareth Jowett's *Film: The Democratic Art* (New York: William Morrow, 1976), which devotes one page to Black representation in American movies, largely a synopsis of these three texts. An important exception to this cavalier approach is Michael Ryan and Douglas Kellner, *Camera Politica: The Politics and Ideology of Contemporary Hollywood Film* (Bloomington: Indiana University Press, 1988), which makes original and insightful forays into Black representation.

4. Gerald Mast, *A Short History of the Movies*, 4th ed. (New York: Macmillan, 1986). All quotations are from pp. 63–69.

5. James Agee, "David Wark Griffith," in Fred Silva, ed., *Focus on "The Birth of a Nation"* (Englewood, NJ: Prentice-Hall, 1971), p. 17.

6. Gerald Mast's commentary does not ignore this statement, but rephrases it making a crucial substitution: "The Birth of a Nation recognizes the institution of slavery as the poisonous seed from which a social evil grew." Griffith had taken rhetorical pains to avoid the convenient term "slavery as cause of the national ills" in order to protect vital threads of Southern history and culture. Mast's reassertion of this most obvious word choice almost makes Griffith a post facto abolitionist.

7. This apocalyptic image is analyzed in the richly interpretive essay of Michael Rogin as it figures not only *The Birth of a Nation* but also the presidential imagery of Ronald Reagan. Michael Rogin, " 'The Sword Became a Flashing Vision': D. W. Griffith's *The Birth of a Nation*," *Ronald Reagan, the Movie* (Berkeley: University of California Press, 1987), pp. 190–235.

8. Cheryl Chisolm, "*The Birth of a Nation*: Toward an Analytical Reading of the Structural Position of Blacks in Classical Filmic Discourse," unpublished seminar paper, UCLA, December 1981.

9. Richard Schickel, *D. W. Griffith: An American Life* (New York: Simon and Schuster, 1984), pp. 33–34.

10. Ibid.

11. Ibid.

12. Ibid., p. 89.

13. Ibid., p. 578.

14. Joel Williamson, *The Crucible of Race: Black and White Race Relations in the American South since Emancipation* (New York: Oxford University Press, 1984), p. 165.

15. I have in mind the collective consciousness of the sort invoked by Frantz Fanon, removed from the biological determinism of Carl Jung. See Patrick Taylor, *The Narrative of Liberation: Perspectives on Afro-Caribbean Literature, Popular Culture and Politics* (Ithaca: Cornell University Press, 1989), pp. 38, 42.

16. Lewis Jacobs, *The Rise of the American Film*, p. 173.

17. This ritual is alluded to in Ralph Ellison's novel *Invisible Man* in the scene where the protagonist is in bed with a seductive matron and her husband returns to the apartment from a business trip, passes through the bedroom greeting his wife as though she were alone. It is also alluded to in the film *American Gigolo* where the male prostitute played by Richard Gere is hired for such an evening's entertainment. Gere's identification as a White male reminds us that this ritual of surrogate eroticism can and does use White male surrogates as well as Black. However, the use of a Black surrogate may be seen as a higher delicacy in this form of erotic consumerism. Moreover, an interesting case could be made that *American Gigolo* makes more sense as a film if Gere's role as protagonist were re-read as occupied by a Black man. I would argue that cinematic enunciation frequently operates displacement in the racial identity to take advantage of the force of subterranean desires without acknowledging them directly. This strategy would be similar to the displacement of gender identities in movies where a heterosexual relationship or a same-sex friendship is coded as a surrogate for the homoerotic expression implanted into the narrative. For one example, Gore Vidal has described the relationship between Ben Hur (Charlton Heston) and his boy-

hood friend Messala (Stephen Boyd) in the 1959 remake of *Ben Hur*, which he scripted, as such a displaced homoerotic attraction. See Vito Russo, *The Velvet Closet: Homosexuality in the Movies* (New York: Harper and Row, 1981), pp. 76-77.

18. Schickel, *D. W. Griffith*, p. 496. Schickel adds, "In his defense, it should be noted that Griffith was not the first nor the last foreign observer to return from Italy with glowing reports of a new spirit in these early days of fascism." However, I believe that Griffith's openness to particular currents of American fascism in different periods of his life prepared his enthusiasm for Mussolini's variety.

19. Ibid., p. 235.

20. Williamson, *The Crucible of Race*, pp. 5-7.

6. The Aesthetic, The Movie

1. James Monaco, *How to Read a Film: The Art, Technology, Language, History, and Theory of Film and Media* (New York: Oxford University Press, 1977); Bill Nichols, *Ideology and the Image: Social Representation in Cinema and Other Media* (Bloomington: Indiana University Press, 1981).

2. Lawrence Levine, *Highbrow/Lowbrow: The Emergence of Cultural Hierarchy in America* (Cambridge, MA: Harvard University Press, 1988), p. 215.

3. Debord, *The Society of the Spectacle*.

4. See Christopher Lasch, *The Culture of Narcissism: American Life in an Age of Diminishing Expectations* (New York: Norton, 1979).

5. Julio García Espinosa, "For an Imperfect Cinema," in Michael Chanan, ed., *Twenty-Five Years of the New Latin American Cinema* (London: British Film Institute, 1983), pp. 28-33.

6. David Bordwell, Janet Staiger, and Kristin Thompson, *The Classical Hollywood Cinema: Film Style and Mode of Production to 1960* (New York: Columbia University Press, 1985), p. 3.

7. Horkheimer and Adorno, *Dialectic of Enlightenment*, pp. 126-27.

8. David Bordwell, et al., *The Classical Hollywood Cinema*, p. 3. The Bordwell book has confined itself to formal considerations of the classical production code in this volume; its authors have announced their intention to follow it with another dealing with the ideological configurations of that practice.

9. Lary May, *Screening Out the Past*, p. 53.

10. Foulkes, *Literature and Propaganda*, p. 63.

11. Anne Richter, "Introduction." In Shakespeare, *The Tempest* (London, Penguin Books, 1960), p. 40.

12. Bordwell et al., *The Classical Hollywood Cinema*, p. 3.

13. Horkheimer and Adorno, *Dialectics of Enlightenment*, p. 13.

14. Hayden White, *The Content of the Form: Narrative Discourse and Historical Representation* (Baltimore: Johns Hopkins University Press, 1987).

15. Richard Dyer, "White," *Screen* 29, 4 (autumn 1988), p. 52.

16. David Roediger, *The Wages of Whiteness*, pp. 47ff.

17. Ibid.

18. Donald Spoto, *Camerado: Hollywood and the American Man* (New York: New American Library, 1978).

19. See Michael Ryan and Douglas Kellner, *Camera Politica*.

20. Phrase used by novelist Toni Cade Bambara in her commentary for the documentary film, *Midnight Ramble: The Life and Legacy of Oscar Micheaux*.

21. Clyde Taylor, "The Master Text and the Jedi Doctrine," *Screen* (autumn 1988), 96–104. The core of this interpretation came from a talk given by Robert Chrisman, publisher of *The Black Scholar*.

22. Pauline Kael, "Fun Machine," *The New Yorker* (May 30, 1983), 88.

7. The Ironies of Majority-Minority Discourse

1. LeRoi Jones, *Home: Social Essays* (New York: William Morrow, 1966), pp. 167–68.

2. Abdelkebir Khatabi, *Le Roman maghrebin* (Rabat, 1979, 70, translated and quoted in Barbara Harlow, *Resistance Literature* (New York: Methuen, 1987), p. 23.

3. Laura Bohannan, "Hamlet and the Tiv," *Psychology Today* (July, 1975), 62–66.

4. Ibid., p. 64.

5. Ibid., p. 65.

6. Ibid.

7. Ibid., p. 66.

8. Ibid.

9. Ibid.

10. Allen Tate, quoted in Kenneth Burke, *A Grammar of Motives and a Rhetoric of Motives* (Cleveland: World Publishing Co., 1968), pp. 513–14.

11. Hugh Danziel Duncan, *Symbols in Society* (London: Oxford University Press, 1968), pp. 226–27.

12. Ibid.

13. Richard Harvey Brown, "Dialectical Irony, Literary Form and Sociological Theory," *Poetics Today* 4, no. 3 (1983), 543–64.

14. Hayden White, *Metahistory: The Historical Imagination in Nineteenth Century Europe* (Baltimore: Johns Hopkins University Press, 1973), p. 38.

15. Walter Benjamin, *Illuminations* (New York: Schocken, 1969), p. 256.

16. John Brenkman, *Culture and Domination* (Ithaca: Cornell University Press, 1987), pp. 3–4.

17. The reference is to Plato's phrase in the myth of the metals, *The Republic*, Book III, 414: "Not all citizens are alike, and only the best should be guardians, the true aristocracy. How to convince everyone that this arrangement is best? Through a 'Noble lie,' a fiction that is good for everyone. The myth of the mixed metals. In our birth, Earth mixed gold in with those meant to become guardians, silver into the auxiliaries, iron and bronze with the farmers and other craftsmen. Sometimes children inherit different admixtures than their parents or class-standing, and should be tested for their best pace to be discovered." See Robert Cavalier, *Plato for Beginners* (New York: Writers and Readers, 1990, 1996), pp. 110–12.

18. Again I want to distance myself from a certain modernist, aesthetic irony:

"Given the unquestioned doctrine in dominant English criticism, which typically considers 'irony' to be the one universal feature of all imaginative literature, it is striking to see Gramsci's attack on 'irony' as the attitude of isolated intellectuals indicating the distance of the artist from the mental content of his own creation ... a distancing related to a more or less dilletantish scepticism belonging to disillusionment, weariness and 'superuominismo.' " Timothy Brennan, "Literary Criticism and the Southern Question," *Cultural Critique* (winter, 1988–89), p. 106.

19. V. N. Volosinov, *Marxism and the Philosophy of Language* (New York: Seminar Press, 1973), p. 23.

20. An excellent analysis of competing positions in political discourse and media usage is provided in television theorist Herman Gray's *Watching Race: Television and the Struggle for 'Blackness'* (Minneapolis: University of Minnesota Press, 1995).

21. Jochen Schulte-Sasse, "The Prestige of the Artist under Conditions of Modernity," *Cultural Critique* (Spring 1989), 90.

22. See also Michael North, *The Dialect of Modernism*, passim.

23. See William Empson, *Some Versions of the Pastoral* (London: Chatto and Windus, 1935).

24. An ambiguity must be respected. For some the strategy is to resist the impact of the missing modifier by claiming general, categorical descriptions for themselves. Others fit Hughes's diagnosis: " 'I want to be a poet—not a Negro poet,' meaning, I believe, 'I want to write like a white poet'; meaning subconsciously 'I would like to be a white poet'; meaning behind that, 'I would like to be white.' " Langston Hughes, "The Negro Artist and the Racial Mountain," in Henry Louis Gates, Jr. and Nellie McKay, eds., *The Norton Anthology of African American Literature* (New York: Norton, 1997), p. 1267.

25. Marcel Griaule (1951), quoted in James Clifford, *The Predicament of Culture*, p. 88.

26. Toni Morrison, *Playing in the Dark: Whiteness and the Literary Imagination* (Cambridge, MA: Harvard University Press, 1992), p. 17.

27. W. E. B. DuBois, *The Souls of Black Folk*, in Gates and McKay, *The Norton Anthology of African American Literature*, p. 615.

28. Jane Gaines, "White Privilege and Looking Relations: Race and Gender in Feminist Film Theory," *Screen* 29, no. 4 (autumn 1988), p. 26.

29. Donald Bogle, *Toms, Coons, Mulattoes, Mammies, and Bucks* (New York: Continuum, 1989), p. 59.

30. Ibid.

31. A final note on this theme: there is some kind of irony relevant to the politics of representation that the considerably more talented Zora Neale Hurston worked as private secretary to Fanny Hurst, in a relation that might be seen as not too far from that between Delilah and Bea.

8. The Ironies of Aesopianism

1. Jean Genet, "Introduction," *Soledad Brother: The Prison Letters of George Jackson* (New York: Coward-McCann, 1970). Anguish might more coolly be read as one

part of an irony that cuts both ways. The perspective of discursive irony shows us that the struggle over meaning can rage intensely among those who share the same language, in the sense of vocabulary and syntax, etc., but are alienated from each other by their different histories and social-political locations. An alienated group's use of a privileged language can evoke any manner of intended and unintended erosions. This is evident in the Despotic frustration of Police Captain Biff Musclewhite in Ishmael Reed's novel, *Mumbo Jumbo*: "Son, these niggers writing. Profaning our sacred words. Taking them from us and beating them on the anvil of Boogie Woogie, putting their black hands on them so they shine like burnished amulets. Taking our words, son, these filthy niggers and using them like they were their god-given pussy" (New York: Avon Books, [1972] 1978), p. 114.

2. Robert Stam and Louise Spence, "Racism, Colonialism and Representation," in Bill Nichols, ed., *Movies and Methods* (Berkeley, CA: University of California Press, 1985), vol. 2, pp. 639-41; and Clyde Taylor, "New Jack Criticism," *Black Film Review* (May, 1992), 7-8.

3. Ngũgĩ wa Thiong'o, *Decolonising the Mind: The Politics of Language in African Literature* (Portsmouth, NH: Heinemann, 1986).

4. Robert Hodge and Gunther Kress, *Social Semiotics* (Ithaca: Cornell University Press, 1988), p. 119.

5. See Geneva Smitherman, *Talkin' and Testifyin': The Language of Black America* (Boston: Houghton Mifflin, 1977); Claudie Mitchell-Kernan, "Signifying," in *Language Behavior in Black Urban Community*, by Claudie Mitchell-Kernan, reprinted in Alan Dundes, ed., *Mother Wit from the Laughing Barrel* (Jackson: University of Mississippi Press, 1990, pp. 311-28); Henry Louis Gates, Jr., *The Signifying Monkey: A Theory of African American Literary Criticism* (New York: Oxford University Press, 1988).

6. Ralph Ellison, *Invisible Man* (New York: Vintage Books, 1972), p. 16.

7. Gilles Deleuze and Felix Guattari, *Kafka: Toward a Minor Literature* (Minneapolis: Minnesota Press, 1986).

8. Richard Wright, "Blueprint for Negro Writing," reprinted in Addison Gayle, ed., *The Black Aesthetic*, p. 315.

9. The television show *In Living Color* often presented material that pandered to White supremacist mentalities while pretending to project signifyin' expressions of resistance, and vice versa. The show sometimes spoke Aesopianly by offering an item of rigorous Black militance, but in a marginally satirized manner, so both the supporters and patronizers of that posture might be amused.

10. Apparently, the ability to read and understand signifying and Aesopian expressions has declined in the African American community since slavery. Wendell Harris's intriguing film, *Chameleon Street*, shares some of these risks in a rather similar way. See Clyde Taylor, "Two Way Street," review of *Chameleon Street*, in *Black Film Review* (September 1990), 8-9.

11. Toni Morrison has given us an exquisite characterization of alienated, cosmopolitan Aesopianism in Jadine in *Tar Baby*.

12. Henry Louis Gates Jr., " 'Authenticity,' or the Lesson of Little Tree," *The New York Times*, Nov. 24, 1991, p. 29.

13. See Henry Louis Gates, Jr., *"Race," Writing and Difference* (Chicago: University of Chicago Press, 1986).

14. Biodun Jefrun, Roundtable Discussion, African Literature Association Conference, Cornell University, April 1987.

15. I take this burden to refer to the condition that Blacks are forced to carry the signifier of "race" while Whites are free of this signification; as Archie Bunker says, White people don't have to go around saying they are White.

16. Frantz Fanon, *Black Skins, White Masks* (New York: Grove Press, 1967); Alberto Memmi, *The Colonizer and the Colonized* (Boston: Beacon Press, 1967).

17. Chinua Achebe's novel *Things Fall Apart* elaborates this masculinist identity construction in the major character, Okonkwo.

18. Charles W. Chesnutt, *The Marrow of Tradition* (Ann Arbor: University of Michigan Press, [1901] 1969), p. 167.

19. Ibid., p. 233.

20. Ibid., p. 178.

21. Ralph Ellison, "Twentieth Century Fiction and the Black Mask of Humanity," *Shadow and Act* (New York: New American Library, 1966), pp. 42-60. But we should not forget the dangerous irony of Twain's best-known novel, which produces much debate about possible racism in the character of Nigger Jim, and has brought many highly publicized battles about the book's use in schools, with the NAACP most often taking the negative position.

22. The phrase is from a lecture by Juana Elbein dos Santos in Salvador, Brazil, July 18, 1992.

23. The relationship between individual social authors of collective narratives and the group master narrative is also the ground for the authentication of texts— the assumption of the reader that the author, let us say Dickens, is a legitimate co-author, with his society, of the narrative he proposes for sharing as "theirs."

24. Shelley Fisher Fishkin, *Was Huck Black? Mark Twain and African American Voices* (New York: Oxford University Press, 1993), p. 122.

25. Ibid.

26. Chesnutt, *The Marrow of Tradition*, pp. 295-96.

27. Quoted in Robert M. Farnsworth, "Introduction," *The Marrow of Tradition*, xv.

28. Ibid.

29. Fishkin, *Was Huck Black?* p. 112.

30. Ibid.

31. Whatever sediments of racism may have remained in Twain's personality, his anti-racist behaviors included the financial support of the professional education of more than one Black person. See Fishkin, passim.

32. This happened in colonialist Indian portrait and landscape paintings done in a style to suit European perceptions of India—and doubtless happens wherever tourist art prevails.

33. Chesnutt's practice of revoking dominant representations of Black Americans is most often noted in connection with his book *The Conjure Woman*, which offers different social interpretations to personalities iconized for American readers in the Uncle Remus stores of Joel Chandler Harris, and the faithful plantation darky stories of Thomas Nelson Page and other Southern local colorists.

9. Radical Ethiopicism

1. Ellison, *Shadow and Act*, p. 271.

2. Donald Bogle is insightful as usual in noting that "Forman seems to approach the emotional core of American life in a way no white American director would have considered: his black characters handle his most intensely felt moments. Without fuss, Forman walks head on into the issue of race and while the political line may not be clear to us, the emotional one is pure, direct, and moving." *Blacks in American Films and Television: Illustrated Encyclopedia* (New York: Simon and Schuster, 1988), p. 173. This valuable perception nevertheless has an uneasy way of reminding us of praise once heaped on *The Emperor Jones* for similar virtues.

3. This and other points are made in Ed Guerrero's searching discussion of the film in *Framing Blackness: The African American Image in Film* (Philadelphia: Temple University Press, 1993), pp. 44–50.

4. Ellison, *Shadow and Act*, p. 49.

5. Manthia Diawara, "Black Spectatorship: Problems of Identification and Resistance," in Manthia Diawara, ed., *Black American Cinema* (New York: Routledge, 1993), pp. 211–20.

6. Ellison, "Shadow and Act," in *Shadow and Act*.

7. Lewis Nkosi, quoted in *A Viewer's Guide for "In Darkest Hollywood": Cinema and Apartheid* (Vancouver, 1993), p. 6.

8. Ibid., p. 7, emphasis Nkosi's.

9. Ibid., p. 7.

10. Ibid., p. 23, my emphasis.

11. Sandra M. Gilbert and Susan Gubar, *No Man's Land: The Place of the Woman Writer in the Twentieth Century* (New Haven: Yale University Press, 1988), vol. 1.

12. Jürgen Habermas, *The Philosophical Discourse of Modernity: Twelve Lectures* (Cambridge: The MIT Press, 1987), p. 5.

13. Important texts in this connection include Edward Said, *Orientalism* (New York: Pantheon Books, 1978); Chris Miller, *Blank Darkness: Africanist Discourse in French* (Chicago: University of Chicago Press, 1985); Toni Morrison, *Playing in the Dark: Whiteness and the Literary Imagination* (Cambridge: Harvard University Press, 1992); Maria Torgovnick, *Gone Primitive*; Sally Price, *Primitive Art in Civilized Places*; and Michael North, *The Dialect of Modernism*.

14. Quoted by Basil Davenport in the BBC film, *Africa, Different but Equal*. Typical of the Euro-discourse of aestheticism, Hegel's rationality was busy creating a new mythology of the primitive, even as it claimed to rise above mythology: "This is the land where men are children. A land beyond the daylight of self conscious history, and enveloped in the black color of night."

15. Quoted in Habermas, *The Philosophical Discourse of Modernity*, p. 89.

16. Quoted in ibid., p. 94.

17. Scrutiny through the interpretive frames can raise the question of how difficult it may be for a Western narrative to present nobility in a non-Western personality without echoing the noble savage characterization. *Nothing but a Man*

manages to avoid this hurdle, and so do *Ragtime* and *The Cotton Club*, but *Brother from Another Planet* precisely reproduces this old stereotype.

18. Lawrence Hogue, *Discourse and the Other: The Production of the Afro-American Text* (Durham: Duke University Press, 1986).

19. Fanon, *The Wretched of the Earth*, p. 41.

20. Ibid., p. 162.

10. The Grammar of Resistance

1. Baraka, *Black Magic Poetry* (New York: Morrow, 1975), p. 121.

2. Dudley Randall, ed., *Black Poets: A New Anthology* (New York: Bantam Books, 1971), p. 27.

3. I confess to never having finished reading *Mister Johnson*. Joyce Cary was once much admired by me for his novel *The Horse's Mouth*. Gulley Jimson, the artist-hero of this novel, continually quotes William Blake, and the novel as a whole can be read as a gloss on Blake's grand, cosmological aestheticism. So it was natural that I interpreted *The Horse's Mouth* in my doctoral dissertation, *William Blake and the Ideology of Art*. (As one might guess from this title, the question of aesthetic ideology already preoccupied me, and this dissertation clearly served as preparation for this present work.) I confess to being a partisan lover of *The Horse's Mouth*, both the novel and the film with Alec Guiness's bravura performance. So, having heard Achebe's unflattering comments about another Cary novel, I began reading *Mister Johnson* with curiosity. Almost from the first few pages the mean-spirited pettiness of its satirical portrait of West African peoples rocked me, all the more by its contrast with the warm embrace in the other novel of a working-class British Protestant ethos, full of apparent generosity toward all human possibility. I backed out of the reading of that novel as one backs out of a stinking toilet, unable to return (though I have occasionally tried since). Another betrayal of Euro-modernism? It was another situation, like *The Birth of a Nation*, where the appeal of aestheticism worked to camouflage the most dehumanizing representation. To this bit of Despotic travesty came another installment: the appearance a few years ago of a film of *Mister Johnson* directed by Bruce Beresford. The subtlest, most genial Ethiopicism, sweetly rendered, but one wondered why it was needed, this covert nostalgia for bygone imperialism again, well-financed and produced, while Achebe's truly great novel goes unfilmed (except for a version made from London twenty or more years ago that was weak but not so weak that it should be suppressed as apparently it has been)? One might resist my argument that the master narrative endlessly reproduces itself (which is what a master narrative is supposed to do), but the burden then arises of producing counterevidence.

4. Tennessee Williams's plays allude to the possibility of an Achebian gaze by incorporating "minority" characters who as servants or underlings appear at significant moments and look upon the focused action just enough to remind an audience that there are others, often regarded as invisible, who might bring another moral perspective to the events unfolding. One such is the Spanish speak-

ing choral figure who interrupts the scene in *A Streetcar Named Desire* when Stanley is about to rape Blanche, hawking "flores por la mortes."

5. Toni Morrison, *The Bluest Eye* (New York: Washington Square Press, 1970), p. 88.

6. Ibid., pp. 97–98.

7. Sergio Giral, "Cuban Cinema and the Afro-American Heritage," interviewed by Julianne Burton and Gary Crowdus, in John Downing, ed. *Film and Politics in the Third World* (Brooklyn, 1987), p. 272.

8. In conversation. But see also Michael Chanan, *The Cuban Image: Cinema and Cultural Politics in Cuba* (Bloomington: Indiana University Press, 1985), p. 270.

9. Giral, "Cuban Cinema and the Afro-American Heritage," p. 271.

10. Jack David Zipes, *The Brothers Grimm: From Enchanted Forests to the Modern World* (New York: Routledge, 1988); also, Jack David Zipes, *Breaking the Magic Spell: Radical Theories of Folk and Fairy Tales* (Austin: University of Texas Press, 1978).

11. See Mary Nooter Roberts and Susan Vogel, *Exhibition-ism: Museums and African Art* (New York: Museum for African Art, 1994).

11. The Self-Authenticating Narrative

1. On this and related issues see Lawrence Hogue, *Discourse and the Other*.

2. I use this term differently from Robert Steptoe's pioneering formulation, itself a very useful contribution to the politics of representation and its study. Steptoe is concerned with the effort of minority authors to validate their works or authenticate their authorship themselves, rather than depend on majority gatekeepers and their stamp of approval. See Robert Steptoe, *From Behind the Veil* (Urbana, IL: University of Illinois Press, 1979).

3. Manthia Diawara, "Souleymane Cissé's Light on Africa," *Black Film Review* (Fall 1988), p. 13.

4. Fanon, *Wretched*, p. 179.

5. Ibid., p. 169–170.

6. These issues have of course been freely debated. For one side of this debate, see Chinweizu, Onwuchekwa Jemie, Ihechukwu Madubuike, *Toward the Decolonization of African Literature* (Washington, DC: Howard University Press, 1983).

7. Patrick Taylor, *The Narrative of Liberation: Perspectives on Afro-Caribbean Literature, Popular Culture and Politics* (Ithaca: Cornell University Press, 1989), pp. 2–3.

8. Zora Neale Hurston, "Art and Such," in Henry Louis Gates, Jr., ed., *Reading Black, Reading Feminist: A Critical Anthology* (New York: Penguin Books, 1990), pp. 25–26.

9. Ibid., p. 24.

10. Richard Wright, "Between Laughter and Tears," *New Masses* (October 5, 1937), p. 20.

11. Hurston, "Art and Such" (1938), p. 29.

12. Jennifer Jordan has made the case that Hurston's novel was not intended as a feminist text and is distorted if read so. See Jennifer Jordan, "Feminist Fantasies: Zora Neale Hurston's *Their Eyes Were Watching God*," *Tulsa Studies in Woman's Literature*, vol. 7, no. 1 (Spring, 1988), 105–117.

13. The novel's negative framing of Jody's race pride and community leader-ship resonates Hurston's anti-Black-consciousness position, which late in her life became part of a vehement right-wing ideology, seldom acknowledged by her left-liberal and feminist champions.

12. The Imperfect Narrative of Resistance

1. In Gayle, *The Black Aesthetic*, p. 5.

2. Trinh Minh-ha, *Woman, Native, Other: Writing Postcoloniality and Feminism* (Bloomington: Indiana University Press, 1989), p. 138.

3. Ishmael Reed, "Dualism: In Ralph Ellison's *Invisible Man*," in Gates and McKay, *The Norton Anthology of African American Literature*, p. 2292.

4. Julio García Espinosa, "For an Imperfect Cinema," in Michael Chanan, ed., *Twenty-five Years of the New Latin American Cinema* (London: British Film Institute, 1984), pp. 28–33.

5. Ibid., p. 28.

6. Ibid., p. 31.

7. Ted Gioia, *The Imperfect Art: Reflections on Jazz and Modern Culture* (New York: Oxford University Press, 1990).

8. Ibid., p. 55.

9. Frantz Fanon, *Black Skin, White Masks* (New York: Grove Press, 1967), pp. 109–110.

10. García Espinosa might have been influenced by Truffaut and other French New Wave critic-directors who saw themselves as revolting against a "cinema of quality."

11. Hollywood's monopolization of the perfect echoes the nineteenth-century dismissal of women's literature as the product of "those scribbling women." An apt sign for this kind of imposed imperfection is the nineteenth-century Euro-pean woman writer as infected by the "madness" of *The Madwoman in the Attic* (see Sandra Gilbert and Susan Gubar, *The Madwoman in the Attic: The Woman Writer and the Nineteenth-Century Literary Imagination* [New Haven: Yale University Press, 1979]). This figure of course reverberates a longer-standing discourse of the imperfectness of women generally, marked by too many signifiers, like, for in-stance, the ancient diagnosis of hysteria.

12. Syd Field, *Screenplay: The Foundations of Screenwriting* (New York: Dell, 1979).

13. Karl Philipp Moritz, *Versuch einer Vereinegung aller schonen Kunste und Wis-senschaften unter dem Begriff des in sich selbst Vollendeten (Toward a Unification of All the Fine Arts and Letters under the Concept of Self-Sufficiency)*, as quoted in Martha Woodmansee, *The Author, Art, and the Market: Rereading the History of Aesthetics* (New York: Columbia University Press, 1994), p. 32.

14. Martha Bayles, *Hole in Our Soul: The Loss of Beauty and Meaning in American Popular Music* (New York: Free Press, 1994).

15. Gaston Kabore, Burkina Faso director of *Wend Kuni*, explains the difference between the false illusion of general opulence and overwhelming technology in Western movies and the much more restrained use of cinema apparatus in Afri-

can films as reflecting "appropriate means" in the African productions. African film directors have so far been satisfied to establish a look in their films consistent with the actual level of development in African societies, unlike their Euro-commerical counterparts.

16. Ousmane Sembene, *God's Bits of Wood* (London: Heinemann, 1986), p. 57.

17. Ibid.

18. Ibid., pp. 57-58.

19. LeRoi Jones, *Home: Social Essays* (New York: Morrow, 1966), pp. 173-78.

20. Julio García Espinosa, "Meditations on Imperfect Cinema . . . Fifteen Years Later," *Screen* 26, nos. 3-4 (May–August 1985).

21. Richard Wright, "How 'Bigger' Was Born," *Native Son* (New York: Harper and Row, 1940), xxvii.

22. Teshome Gabriel, "Teaching Third World Cinema," *Third World Affairs* (London, 1985), pp. 60-64, 363-67.

23. One valuable account and analysis is Sonja K. Foss, "Ambiguity as Persuasion: The Vietnam Memorial," *Communications Quarterly* 34, no. 3 (summer 1986), pp. 326-40.

24. Ibid., p. 327.

25. Ibid., p. 333.

26. Much of the character of the memorial was stipulated in the charge of the commission that assigned the task, the inscription of the names, etc. This implies a historical consciousness wider and more complex than that of just one individual artist, however inspired.

27. Cynthia Ward, "What They Told Buchi Emecheta: Oral Subjectivity and the Joys of 'Otherhood,' " *PMLA*, vol. 105 (Jan. 1990), p. 86.

28. Foss, "Ambiguity as Persuasion," p. 332.

29. Ibid.

30. Ibid.

31. In a student paper by Young Chung, "Against the Wall: The Politics of the Vietnam Memorial & Other Decolonizing Texts," p. 16. The exclusion of the Vietnamese casualties of the war has been noted, and a counterwork has been constructed listing the names of the many thousands of the Vietnamese and Southeast Asian victims of the war.

32. The statue with the Caucasian soldier flanked by the Hispanic and the Black troops also looks like a cagy updating of the statue of Theodore Roosevelt outside the Natural History Museum in New York, where the two racial underlings clearly hold that position by virtue of their posture walking beside Teddy, mounted on his horse. The challenge to the myth of mastery of recent years has unhorsed the conquering Caucasian hero.

33. Spike Lee and Lisa Jones, *Do the Right Thing: A Spike Lee Joint* (New York: Simon and Schuster, 1989), p. 51.

34. Brent Staples in *The New York Times* lamented the lack of well-rounded characters in *Do the Right Thing*. Staples does not understand a concept of indifference to the middle-class narcissism of well-rounded characters. He echoes a routine complaint of "imperfection" against non-Western narratives for their lack of well-rounded characters, often aimed at African novels by Eurocentric critics. See

Chinweizu et al., *Toward the Decolonization of African Literature* (Washington, DC: Howard University Press, 1983), pp. 32–34, 84–86.

35. Sylvia Wynter, "Rethinking 'Aesthetics': Notes Towards a Deciphering Practice," in Mbye Cham, *Ex-Iles: Essays on Caribbean Cinema* (Trenton, NJ: Africa World Press, 1992), pp. 237–79.

36. Spike Lee and Lisa Jones, *Do the Right Thing*, p. 26.

37. Ibid., p. 60.

38. Among other places, this line of questioning gets intelligent treatment in *Camera Politica*.

39. See Daniel Bell, *The Cultural Contradictions of Capitalism* (New York: Basic Books, 1976).

40. García Espinosa, "For an Imperfect Cinema," p. 32.

41. Kenneth Coutts-Smith, "Some General Observations on the Problem of Cultural Colonialism," in Susan Hiller, ed., *The Myth of Primitivism: Perspectives on Art* (London: Routledge, 1991), p. 29. Italics in the original.

42. García Espinosa, "For an Imperfect Cinema," p. 33.

13. Daughters of the *Terreiros*

1. See Clyde Taylor, "The L.A. Rebellion in American Film," *Black Film Review* (spring 1986), 11, 29; Toni Cade Bambara, "Reading the Signs, Empowering the Eye: *Daughters of the Dust* and the Black Independent Cinema Movement," in Manthia Diawara, ed., *Black American Cinema* (New York: Routledge, 1993), pp. 118–44; and Ntongela Masilela, "The Los Angeles School of Black Filmmakers," in Diawara, op. cit., pp. 107–117.

2. Noliwe Rooks, *Hair-Raising: Beauty, Culture and African American Women* (New Brunswick: Rutgers University Press, 1996).

3. Independent film director Kathy Collins recalled a White woman who refused to lend her residence as setting for her film, saying, "Those aren't Black people!" The same experience has been recorded by Bill Gunn and Tim Reid.

4. Toni Cade Bambara, "Reading the Signs," p. 129.

5. Dash frequently used voice-over narrators in her earlier films; it is a device that projects a seldom-represented Black female subjectivity.

6. In the conquest of African cultures, the eternal, mythic, and abstract existence of the *orixas* was plunged into the condition of "imperfection," much like the god of the Almusseri in Charles Johnson's novel *Middle Passage* (New York: Atheneum, 1990).

7. Juana Elbein dos Santos, lecture notes, Salvador, Brazil, July 23, 1992.

8. Muniz Sodre, from lecture notes given in Salvador, Brazil, July 21, 22, 1992.

9. Elbein dos Santos, lecture notes, Salvador, Brazil, July 23, 1992.

10. Sodre from lecture notes given in Salvador, Brazil, July 21, 22, 1992.

11. The printed text of the filmscript spells out this designation. See Julie Dash, *Daughters of the Dust* (New York: The New Press, 1992), p. 163.

12. E. Franklin Frazier, *The Negro Family in the United States* (Chicago: University of Chicago Press, 1939).

13. Orlando Patterson, *Slavery and Social Death: A Comparative Study* (Cambridge, MA: Harvard University Press, 1982), p. 6.

14. Robert Stam and Louise Spence, "Racism, Colonialism and Representation," pp. 639–41.

15. See Ella Shohat and Robert Stam, *Unthinking Eurocentrism* (New York: Routledge, 1994), pp. 42–46, 235–41.

14. Conclusion

1. Paul Bohannan and Philip Curtin, *Africa and Africans*, 3rd ed. (Prospect Heights, IL: Waveland Press, 1988), pp. 102–103, passim.

2. Rasid Diab, Sudanese artist, "Different Values—Universal Art: The State of Modern African Art," quoted from a wall text in the exhibition, *Rise With the Sun: Women and Africa*, York Quay Gallery, Harbourfront Centre, Toronto, Canada, June 21–August 25, 1996.

3. Kipnis, p. 95.

4. Arlene Croce, "Discussing the Undiscussable," *The New Yorker*, vol. 70, no. 43 (Dec. 26, 1994), 54–60.

5. Ibid., p. 55.

6. Joyce Carol Oates, "Confronting Head On the Face of the Afflicted," in the *New York Times* (Sunday, Feb. 19, 1995, section 2, pp. 1, 22, 23.

7. Ibid., p. 22.

8. Quoted in Edmund Wilson, *Axel's Castle: A Study in the Imaginative Literature of 1870–1930* (New York: Scribner, 1969).

9. This is the major difference between aestheticism and the hierarchies of refined taste cultivated in historical Asian societies.

10. Ella Shohat and Robert Stam, *Unthinking Eurocentrism* (New York: Routledge, 1995), pp. 46–49.

11. Charles S. J. White, Washington, DC, *The New Yorker*, Dec. 25 1995 and Jan. 1, 1996, p. 12.

12. See Fred Myers, "Beyond the Intentional Fallacy: Art Criticism and the Ethnography of Aboriginal Acrylic Painting," *Visual Anthropology Review* 10, no. 1 (spring 1994), 10–43. To this battery of examples another can be added. Anthropologist Faye Ginsburg tells a story about an Australian Aboriginal painter visiting New York. She was taken to the Metropolitan Museum of Art and was shown the Degas. "Is this his dreaming?" she asked. When told no, she waved her hand and walked on, declaring "Rubbish!"

13. *A Brother with Perfect Timing*, videotape (New York: Rhapsody Films, 1988).

14. Of course, this resurgent importance of context has been demonstrated long since in Robert Ferris Thompson's interventions expressed in *African Art in Motion* (Los Angeles: University of California Press, 1974). And the issues of what important matter has been left out of most museum wall texts is illustrated in the show at the Museum for African Art called Exhibition-*ism*.

15. V. I. Mudimbe, "African Art as a Question Mark," *African Studies Review* 29, no. 1 (March 1986), p. 4.

16. Morrison relates a story where, reading at a predominantly White college,

she was asked whether *Cliffs Notes* existed for *Beloved*. She replied negatively, then suggested that a literature class produce its own version of this quick-recipe critical reference series. When the results were sent to her, they were admirably cogent and penetrating, except for one omission which she pointed out to them: they had virtually disappeared the issue of slavery.

17. See Hal Foster, *The Anti-Aesthetic* (Port Townsend, Washington: Bay Press, 1983); and Hal Foster, *Recodings: Art, Spectacle, Cultural Politics* (Port Townsend, Washington: Bay Press, 1985).

18. See Howardena Pindell, "Art World Racism: A Documentation," *New Art Examiner* 1, 7 (March 1989), 32–36; "Breaking the Silence," *New Art Examiner* 18, 2 (October 1990), 18–23.

19. See Maurice Berger, "Are Art Museums Racist?" *Art in America* (September 1990), 69–76.

20. Tommy Lott, "A No-Theory Theory of Contemporary Black Cinema," *Black American Literature Forum* 25, no. 2 (summer 1991), 221–36. "Hence, I want to advance a theory of black cinema that is in keeping with those filmmaking practices that aim to foster social change, rather than participate in a process of formulating a definition of black cinema which allows certain films to be canonized on aesthetic grounds so as to occupy a place in the history of cinema," p. 232.

21. Lucy R. Lippard, *Mixed Blessing: New Art in a Multicultural America* (New York: Pantheon Books, 1990), p. 14.

22. Roy Wagner, *The Invention of Culture*, Revised and expanded Edition (Chicago: University of Chicago Press, [1975] 1981).

23. Sylvia Wynter, from a speech in Sarasota, Florida, September 11, 1996.

24. Ibid.

25. Ibid.

26. Ibid.

27. Ibid.

28. David Lamp, from museum talk regarding Baga Art Exhibition at the Museum for African Art, New York City, October 10, 1996.

INDEX

Italicized page numbers refer to illustrations.

Clyde R. Taylor, film scholar and literary/cultural essayist, is Professor at the Gallatin School and in Africana Studies, New York University. His publications include *Vietnam and Black America* and the script for *Midnight Ramble*, a documentary about early Black independent cinema.